ANCIENT TEXTILES SERIES VOL. 12

TEXTILE PRODUCTION AND CONSUMPTION IN THE ANCIENT NEAR EAST

ARCHAEOLOGY, EPIGRAPHY, ICONOGRAPHY

edited by

M.-L. Nosch, H. Koefoed
and E. Andersson Strand

Oxbow Books

Oxford and Oakville

Published by
Oxbow Books, Oxford, UK

© Oxbow Books and the individual authors 2013

ISBN 978-1-84217-489-0

This book is available direct from
Oxbow Books, Oxford UK
and
The David Brown Book Company
PO Box 511, Oakville, CT 06779, USA
(Phone: 860-945-9329; Fax: 860-945-9468)
or via our website
www.oxbowbooks.com

A CIP record for this book is available from the British Library

Library of Congress Cataloging-in-Publication Data

Textile production and consumption in the ancient Near East : archaeology, epigraphy, iconography / edited by M.-L. Nosch, H. Koefoed and E. Andersson Strand. -- 1st [edition].
 pages cm -- (Ancient textiles series ; vol. 12)
 Includes bibliographical references.
 ISBN 978-1-84217-489-0
 1. Textile industry--Middle East--History. 2. Textile fabrics, Ancient--Middle East. 3. Copper age--Middle East. 4. Bronze age--Middle East. 5. Iron age--Middle East. I. Nosch, Marie-Louise, editor of compilation. II. Koefoed, H. editor of compilation. III. Strand, Eva B. Andersson, editor of compilation.
 TS1413.5.T48 2013
 338.4'76770956--dc23
 2012039276

Front Cover: Line drawing of CS 704 by Agnete Wisti Lassen. The drawing highlights clothing and textiles.

Printed in Great Britain by
Short Run Press, Exeter

Contents

Introduction:
Archaeology, Epigraphy, Iconography

Textile is attested for more than 10,000 years in the Ancient Near East. During the Bronze Age textile production developed from household production to standardised, industrialised, centralised production. In order to visualize how textile research can contribute to a better understanding of ancient societies, the workshop *Textile Production in the Ancient Near East Neolithic, Bronze Age, Iron Age* given at the 7th International Congress on the Archaeology of the Ancient Near East at the British Museum in April 2010 was organised by the Danish National Research Foundation's Centre for Textile Research, University of Copenhagen. During the workshop, interesting and well performed presentations were given by specialists in this research field. Furthermore, the workshop attracted a large audience and the discussions that followed the presentations were constructive, intense and scientifically well articulated. Many questions were raised and it was the impression of the organisers that a publication on these topics could contribute to a better understanding of textiles and textile production in the Ancient Near East. Additionally, it is important to analyse and discuss all the parameters of the technology and the development of textiles, their impact on society, and how textile tools and technology developed in this region. Thus, by combining epigraphic, iconographic and archaeological evidence with research on textile technology there is potential for discussion of the economic, social, and cultural impact of textiles on ancient society. In this publication several approaches are combined: textile tool studies, experimental testing, context studies and epigraphic as well as iconographical studies. The aim is first and most importantly to raise awareness of the existence of textiles and the importance of textile production and how it influenced early societies in this region. Furthermore the aim is also to demonstrate how, by combining different sources, new and important knowledge for the understanding of past can be obtained. Seventeen scholars have contributed in 13 articles. All these articles are written with different perspectives and aims but with one common thread to visualize textile and textile production in Ancient Near East.[1]

In his article *Textile, Value and Early Economics of North Syria and Anatolia,* David R. A. Lumb demonstrates the importance of a theoretical approach and an essential source critical awareness. Further he introduces the reader to the importance of applying the concept of *economic* and *symbolic value* but foremost the *operational value* when discussing archaeological textiles, textile tools and production of textiles in written sources. Via this approach and focus on production and consumption of textiles, the textiles' economic and socio-political significance can be highlighted during ancient times. For example, he suggests that with these perspectives one can question the traditional modes of independent and attached production in North Syria and Anatolia.

[1] Some of the papers that were presented at the workshop dealt with earlier periods and have been published in a separate volume (Breniquet *et al.* 2012).

Janet Levi and Isaac Gilead, in their joint paper *The Emergence of the Ghassulian Textile Industry in the Southern Levant Chalcolithic Period (c. 4500–3900 BCE)*, combine archaeological explorations and experimental archaeology. It is a truly interdisciplinary work containing tool studies, textile studies, contexts and an experimental part combined with ethnographic data. The interesting contribution is their aim to calculate and quantify the work process of linen fabrics in terms of labor, skill and time consume. The discussion of spindle whorls and loom weights at various Chalcholithic sites is confronted with the textiles from the Caves of Treasure and Cave of Warrior dated to 5th and 4th mill. The abundance of Chalcolithic textiles emphasizes how this craft is solidly established in the Chalcholithic era. This brings about the interesting observation that the Chalcholithic textiles have remains of sewing but no needle have ever come to light in the relevant Chalcholithic excavations. This enlightens how quite simple textile tools can be used for making quite complex textiles of considerable sizes and quantities. The authors conclude that a household economy can potentially provide all the necessary skill, tools and labor to produce Chalcholithic fabrics. Attached and specialised crafts people are not necessary to produce these complex fabrics.

How can scholars from a different research area contribute to a better understanding of written texts concerning textiles? In *Visualising ancient Textiles – How to make a Textile visible on the Basis of an Interpretation of an Ur III Text*, Eva Andersson Strand and Maria Cybulska are discussing textile technology. Via ethnographic knowledge of textile craft, experimental textile archaeology and mathematic calculations they conclude that all the information given in the text is realistic: it is actually a description of how this textile was going to be produced, how long it took to make and finally how much raw material was used.

In his paper *Considering the Finishing of Textiles based on Neo-Sumerian Inscriptions from Girsu*, Richard Firth shows how detailed information on the production of fulled textiles can be extracted from the Girsu tablets. By combing analyses of the texts with knowledge of different fulling processes and he discusses how different types of textiles can be related to the various process. For example, that more man-power and material such as oil and alkali are needed when fulling a high quality textile than for a low quality textile.

How different sources can be combined is excellently presented in several papers. Via *e.g.* written sources, studies of tools and iconographical sources Joanna S. Smith make the reader aware of the existence of exclusive tapestries in her article *Tapestries in the Bronze and Early Iron Ages of the Ancient Near East*. Via evidence from texts (*e.g.* Akkadian *mardatum* and Ugaritic *mrdt*), surviving textiles (*e.g.* from Egypt), iconography in a wall decoration from Mari, tools (*e.g.* bone beaters), and areas for manufacture like the specific areas in Kition, she explores the weaving technique of tapestry and further discuss the use of tapestries as prestige items.

In *Throwing the Baby out with the Bathwater. Innovations in Mediterranean Textile Production at the End of the 2nd/Beginning of the 1st Millennium BCE*, Laura B. Mazow argues convincingly that the many Aegean and Cypriot large containers interpreted as 'bathtubs' instead are fulling installations. Her arguments are both contextual (coexistence with textile tools) architectural (with drain systems), practical (inbuilt bathtubs fixed in the floor would not be practical for bathing). Her study of the archives room at Thebes, in particular, makes an attractive case. She explains this popular 'bathtub' interpretation as a mixture of modern western ideas of cleanliness and hygiene combined with an unfortunate lack of knowledge about textile techniques.

In Agnete Wisti Lassen's paper *Technology and Palace Economy in Middle Bronze Age Anatolia: the Case of the Crescent Shaped Loom weight,* it is clearly demonstrated how discussion on the economic and social impact of textiles production can benefit from combining written documentation from *e.g.* Kültepe (ancient Kanesh), archaeological materials, for example loom weights and spindle whorls and finally experimental archaeology. In the conclusion she suggests that twill weaving and the crescent shaped loom weights were characteristic features of the Anatolian economy and textile technology and furthermore, that they reflect elements of both organization and ethnic identity in local society.

With a perspective of historiography and feminist theory, Allison Karmel Thomason discusses in her paper *Her Share of the Profits: Women, Agency, and Textile Production at Kültepe/Kanesh in the Early Second Millennium BC* the documentation of the Old Assyrian letters and in particular the status of Assyrian women. She highlights how women, who are generally absent or passive in ancient documentation, in the Old Assyrian letters are active players and voiced producers. When we take a closer look into the case of these Assyrian women, we come to appreciate their agency in economic matters, both on the social stage, but foremost from how they use their labour to produce textiles, which were then used to negotiate their financial and kin-related situations. She demonstrates how these sources can be used to deconstruct the preconception of female labor as confined to the private sphere and male commercial activities to the public sphere. Feminist historians have argued that this dichotomy was constructed in an 18th century Europe marked by the industrial revolution and that it was instrumental in the gendered ideology of the emerging middle class.

Catherine Breniquet-Cory's article *Functions and uses of textiles in the Ancient Near East. Summary and Perspectives* gives, with a source critical approach, an overview on which sources can be used when studying textiles. She discusses the value and use of textiles and adds to this the practical and also symbolic value. A very interesting but often neglected topic is textiles and their magical protection but also textiles for burial uses and prestigious gifts. The paper also considers the economic value of textiles and concludes that the level of socio-economic development in a long term perspective seems to be the key parameter to understand the role of textiles.

In *The Costumes of Inanna/Ishtar* Bernice R. Jones demonstrates how iconographic interpretations can be done to gain a better understanding for dress and how different garments can have been worn. Via experimental archaeology and detailed analyses of costumes on the Mesopotamian goddess Ishtar she discusses how Ishtar's clothes are arranged in different situations and how the garments can be interpreted.

Nurith Goshen, Assaf Yasur-Landau and Eric H. Cline discuss in *Textile Production in Palatial and Non-Palatial Contexts: the Case of Tel Kabri* the difference in production between these types of contexts and also in the kingdom of Hazor. They conclude that Tel Kabri is located at the fringe of the Syro-Mesopotamian north–south trade networks that gave Kabri a very peripheral place in that interaction, and instead it turned towards the Aegean and Egyptian influences. This may explain why Tel Kabri did not develop the excessive textile production systems like neighboring cities and palaces further to the east. In their conclusion they argue for a difference in the organization of textile production that rather may be explained by different social-economic and political strategies than in palatial and non-palatial contexts.

Caroline Sauvage discusses in *Spinning from Old Threads: The Whorls from Ugarit* the Late Bronze Age spinning and textile industry in Ugarit from a carefully and well presented analysis of a large

group of spindle whorls from this area. She observes how the stone whorls primarily come from the settlement while bone and ivory spindle-whorls come from tombs. She also observes that both groups come in similar weight ranges, have similar morphologies and traces of wear, and she concludes that both stone and bone whorls had been in use, but are preserved in different contexts. Additionally, besides the interesting results on *e.g.* decoration, morphology and function, this study clearly demonstrates how new analyses of material from older excavations still can contribute to a better understanding of the textile production in the past.

Textile Production and Consumption in the Neo-Assyrian Empire is studied and discussed in detail by Salvatore Gaspa. Via documents from *e.g.* the archive of Nineveh he evaluates how raw materials and the finished products were managed by the central administration. The importance of textiles and textile production is clearly demonstrated via the rich terminology of textile products but also processes. Furthermore, he gives an overview of textile consumption within the palace, the government and private sectors and he discusses the consumption/production of textiles for different occasions, for example religious, military but also textiles mentioned in marriage contracts and given as gifts, and concludes that textiles have been powerful social indicators.

From Sir Leonard Wooley, we have an amusing statement, a quite significant attitude towards textile tools in archaeology:

> *"I suppose it was Schliemann who first brought the spindle-whorl into prominence – a venial error in his case, but today there is no excuse for wasting space and money on this monotonous and profitless material."*[2]

Authors in this volume, however, show that Schliemann was right and Wooley was wrong in the assessment of the potentials of spindle whorls. To this end all the papers in this volume clearly demonstrate the potential of textile research. We thank all authors for their important contributions.

Finally, we kindly thank The Queen Margrethe's and The Price Consort Henrik's Foundation and the Danish National Research Foundation who funded the organisation of the workshop and this publication.

Bibliography

Breniquet C., Tengberg, M., Andersson Strand, E. and Nosch M.-L. (eds) 2012. Prehistory of textiles in the Near East. *PALÉORIENT: Revue Pluridisciplinaire de Préhistoire et Protohistoire de L'Asie du Sud-Oust et de L'Asie Central / Pluridisciplinary Review of Prehistory and Protohistory of Southwestern and Central Asia*.

October 2012
M.-L. Nosch
H. Koefoed
E. Andersson Strand

[2] Wooley 1955, 271.

1. Functions and Uses of Textiles in the Ancient Near East. Summary and Perspectives

Catherine Breniquet

The world we live in only allows us to imagine very imperfectly the role material productions played in the past. No doubt certain difficulties are avoided by employing an unacknowledged form of ethnographic comparativism and by reinventing formulae and technical gestures using archaeometry and experimental archaeology. But what of a formerly dynamic society which knew how to invent the practices and analogical connections which give the world its hidden dimension and structure its harmony?

Here, we would like to take the example of textiles, omnipresent and commonplace in our western societies and attempt to detail their use in the Ancient Near East in order to contribute to the development of a critical method using all available sources and a comparative long-term vision. Archaic Mesopotamia will constitute our main framework (Fig. 1.1). Textiles from the region are found in a variety of situations: ritual, economic, political, and practical *etc.* that are difficult to consolidate under an overarching framework of understanding, but which are however, very closely interlinked. The exceptional roles they play are defined by three connected parameters: their role in kin relationships, their role as a person's double (for clothing), and their possible monetary role. This leads us to post the question of the origins of textiles, fabrics and clothing.

We deliberately use the term 'textile' rather than 'fabric'. This designates "any fibrous construction" with a certain degree of suppleness and allows us to widen the scope to include assembled bast structures which constitute a form of basket or wickerwork and felt. This approach therefore includes situations in which the prior existence of weaving looms has not been confirmed.[1] Finally, the functions are often substituted by uses, as they confine considerations to the utilitarian sphere. Our objective is to draw attention to the informative potential of these material productions and to demonstrate the coherence of Mesopotamian thinking with regard to this.

1. Sources

Due to the historical conditions in which it emerged, and the austerity of the field, the study of Ancient Near Eastern societies is divided into epigraphic studies and archaeological studies.

[1] Balfet and Desrosiers 1987; Emery 1994; Seiler-Baldinger 1994; Desrosiers 2010.

Catherine Breniquet

Dates BC	Periods	North Mesopotamia /Syria	South Mesopotamia	General Evolution	Textile Data
12,000		Natufian		Settlements	Twined textiles Bast fibres
		PPNA		Domestication of plants	
8000	Neolithic	PPNB	?	Domestication of animals	• Wool fibres • Suspended spindle • Weaving on loom
7000		≠			
	Cultures with ceramic	Hassuna	Ubaid 0–2	Agricultural societies	
		Samarra			
6000		Halaf			First selections of sheep
5000		Ubaid	Ubaid	Complex chiefdoms	Warp weighted loom?
4000	Chalcolithic	Gawra	3–5		↑
		Uruk Colonies	Uruk	Urbanisation	• Development of sheep husbandry • Two-bar loom?
3000		Niniveh 5		Writing	• First artisans
	Bronze Age	Early	Protodynastic	Independant city states	
			I–III		
2340		Djezira	Akkad	Political unification	↑
2000		0–5	Ur III	Centralised states	Manufactures

Figure 1.1. Chronology. Breniquet 2008, 21.

Whilst in practice the trend is for these two branches to come together, it is urgent that more ambitious multi-disciplinary approaches are implemented.[2] Given the technical nature of the question, at least six types of sources could be used and compared. It is illusory to search for places where they overlap, they should rather be compared in their historical context, and very often on a case-by-case basis.

[2] Recent studies on documentation from Arslantepe and Ebla demonstrate the benefits of this type of approach: Frangipane *et al.* 2009; Andersson *et al.* 2010.

Archaeological textiles

The first of these sources is direct evidence of textiles, in the form of miraculously preserved fragments, to which indirect evidence may be added, often in the form of imprints onto malleable materials (clay, plaster, bitumen).[3] These categories pose major problems in terms of representativeness, as they require an expert eye, adapted excavations and favourable taphonomical conditions to ensure the textiles are both preserved and identified in the field. With the exception of textiles used to wrap (to clothe?) metallic objects, transformed by oxidation, the textiles are most often found in funeral contexts and the use of anthropological methods has made a major contribution to the study of recent finds. Most commonly, these finds are only fragments (clothing, shrouds or strips, goods such as pillows, fabrics laid in tombs, and sometimes several categories at the same time, difficult to distinguish between). To draw a minimum number of conclusions requires detailed, repeated observations in the same context and the identification of recurrent points of comparison across different contexts. This reveals an overrepresentation of plain weaves and, to a lesser extent, twined textiles,[4] mainly linen and wool whilst all other fibres are unknown, rendering the conclusions unsafe. It is also very difficult to compare the observations from excavations to textual references, notably when they deal with day-to-day activities, which are not mentioned in the official documentation.[5] It is then vital that measures to preserve the remains are taken as quickly as possible, which is often impossible and a large number of isolated observations are made with no ensuing scientific study. The lack of attention paid to multiple cord imprints is also regrettable, notably from the back of sealings.[6]

Tools

Indirect archaeological documentation (needles, loom weights *etc.* or installations) may well also provide technical indications of the conditions in which textiles were produced. Once again in this field, the remains are ambiguous in the sense that they are altered over time (or have almost completely disappeared), difficult to identify (unbaked loom weights, for example) and frequently open to several interpretations involving other related techniques (leather or textiles work for example). Generally speaking, it is impossible to interpret such remains in isolation. For example, most woven textiles can be obtained from different installations, which can produce similar textiles. Finally, we tend to look for already known technical categories (horizontal looms, warp-weighted looms) without envisaging other possibilities (backstrap loom, simple wooden frame, boards, needle binding) which are commonly considered not to exist although they have simply not been identified/acknowledged.[7]

Written sources

As the most common source, the texts available are often solicited. These are divided into official sources drawn up by key authorities, administrative or legal texts, private or public archives. The difficulties they pose have been well documented: The dispersal of cuneiform sources (and

[3] Stordeur 1999; Breniquet 2008, 48–49.
[4] Breniquet 2008, 54–62 for the period 7th–3rd millennium.
[5] Durand 2009, 10.
[6] Frangipane *et al.* 2009, 15 (with references) for the counter-example of Arslantepe.
[7] Breniquet 2008, 182–192.

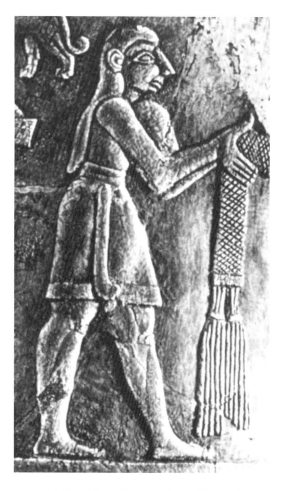

Figure 1.2. Detail from the top register of the Uruk Vase, c. 3000 BC, Iraq Museum, Baghdad.

the associated bibliographic documentation), the obscurity of ancient classifications, the use of terms which cannot be translated or correlated to an archaeological reality, the use of terms which are too precise or, conversely, too vague, the allusive nature of the mentions made, ancient translations which need revision, patchy information,[8] *etc.* As such the documentation is difficult to grasp, notably when not consulting the primary sources, and it is risky for a textiles specialist to venture unaided into this field of study. However, the essentially economic nature of the cuneiform documentation means that it has an unprecedented potential which has not yet been fully exploited[9] with regard to text sources from other relevant ancient periods and cultures.

Iconography

Iconography should be treated as a source in its own right. It provides scenes of people at work, although there are claims to the contrary, mostly based on an old religious interpretation.[10] Likewise, iconography provides images of textiles in all types of situation. However, the codification makes them difficult to read: Which objective elements allow us to identify textile as opposed to leather clothing in an image? Questions of representativeness (it is most often official clothing that is represented) and issues which have changed very little over time cloud our perception. It is rare to compare iconography and nomenclature from cuneiform sources.[11] Furthermore, details which are technically significant are rare and require an expert eye – and a certain amount of luck – to identify them. For example the stop knot at the join between the side borders and horizontal borders on the skirt of the assistant of the Priest-King on the Uruk Vase which proves the use of a vertical warp-weighted loom (Fig. 1.2). The most emblematic case is the Mesopotamian *kaunakes* from the first half of the 3rd millennium BC made from what are

[8] Whether due to duration: 50 years for the Mari palace archives: Durand 2009, 9, but only the first three years of the functioning of Ibbi-zikir in Ebla: Biga 2010, 148; or in terms of variety: The system of wool rations is not mentioned in archive L.2712 d'Ebla: Biga 2010, 147.

[9] Durand 2009; Biga 2010; Michel and Veenhof 2010 for recent thinking on this.

[10] Ellis 1976, 77: "the ideology did not encourage the representation of daily activities" *contra* Breniquet 2008, 268–324, for a reinterpretation of protodynastic glyptic of which 10–12% of the corpus shows scenes related to thread work. These include the best documented (banquet, ziggurat, *etc.*). See also Breniquet 2010.

[11] Michel and Nosch (eds) 2010 for first summary.

thought to be woolen tufts, and about which we know very little. The ancient name of this curious fabric is unknown.[12] Worn by all dignitaries and by individuals supported by the political powers, it takes the form of a skirt, robe, cape or 'scarf'. Despite close observation of the sculptures, it is neither possible to identify their material nor how they are made: Animal skin, an imitation of animal skin made by introducing a looping effect when weaving, tufts knotted into a net, sewn-on feathers *etc*. Since the borders indicated by oblique parallel lines are sometimes visible (Fig. 1.3), it would hence seem that this clothing is made up of a woven base or net onto which the finishing details are attached. Confirmation, however, can only come from reviewing all the available documentation.

Natural Sciences

The approaches and methodologies deriving from the natural science need to be applied more generally in order to identify the textile materials and the conditions in which they were processed. Palynology, paleoethnobotany and archaeozoology are now amongst the disciplines solicited when recently studying prehistory. They have made it possible to identify native and imported textile, tinctorial plants and animals, both domestic and

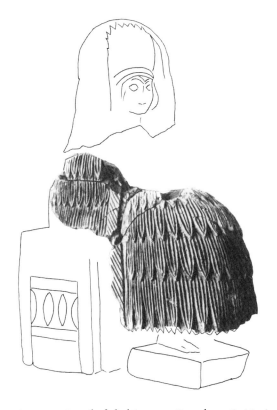

Figure 1.3. Detail of clothing on a Protodynastic Mari figurine. © The Mari Archaeological Mission, with the kind permission from Prof. P. Butterlin.

wild, from the immediate surrounding of the sites. However, these approaches are still rarely used to study sites from historical periods, despite the fact that they make it possible to document the know-how, techniques, trade movements *etc*. They also open up the vast field of investigation that is the development of none-food agriculture, which impacts on the gender distribution of work.[13]

In the Ancient Near East, textiles are almost exclusively made of two materials. Flax, one of the first plants grown by man along with cereals, became the fibre for major religious ceremonies (nuptial bed spread for the New Year festival, sanctuary curtain, sacerdotal dress) during the historical periods. Wool from sheep derived from domestication was probably the most prestigious of all fibres, before becoming commonplace.[14] It is, however, extremely likely that other fibres will be found: utilitarian textiles made from goat hairs[15] or various plant fibres,[16] exceptional

[12] Cherblanc 1937.
[13] Sigaut 2009, 192.
[14] Breniquet 2006 b. Wool and flax also dominate the texts: Durand 2009, 11.
[15] Waetzold 2007, 113.
[16] With an unexpected mention of tulips, cited by Francfort and Tremblay 2010, 146.

textiles made of rare fibres such as cotton or raw silk, imported or domesticated, at the end of the first millennium.[17] It is still exceptional to have a near-too complete list of plants for a site, with the notable exception of Shahr-i-Sokhta.[18] An even less explored area is the field of dyes and tinctorial plants which have gone virtually undocumented in the entire of the Ancient Near Eastern archaeology. Only very few identified finds or installations for the purpose of collecting murex have been located,[19] and much remains to be done.

The 'models'

Finally, models, or their minimal version in the form of ethnographic comparativism, should be included in this discussion, although strictly speaking they are not sources. There are few of these in the field of textile research, and Near Eastern archaeology makes little use of them. Models or comparisons can only be genuinely operational when they include societies with similar structure. In this regard neither geographical, nor chronological proximity constitute the determining parameters. In the 19th century BC, Assur merchants exported tin and cloth to Central Anatolia. These were either produced in Babylon, or locally in Assur by their spouses, and traded. The merchants brought gold and silver back home with them. The transactions were calculated in shekels of silver.[20] It is not certain that this model can be used as a universal model to reveal an 'invisible' trade (involving products which cannot be preserved) in Protodynastic times. Indeed, a major change in the social and economic structure took place during the Akkadian period. Here ended the lineage structure which was prevalent in southern Mesopotamia and allowed new social categories and new types of commercial transactions to emerge. Comparative studies by historians and ethnographers carried out on civilisations in the Americas[21] and Africa[22] seem relevant as they discuss comparable agricultural communities of lineage. Indeed they examine the mechanisms which govern the structure of societies.

2. Functions: Value in use

Origins of textile

Weaving is a mark of civilization by the same token as the transformation of food by cooking. Numerous myths reflect this and the *Epic of Gilgamesh* states it explicitly.[23] It is not, however, certain that we correctly have formulated the question of the origins of textiles and their function. Indeed, if we limit textiles to 'fabrics', we will only look for woven textiles and those made by using a specific tool, the loom.[24] On the contrary, if we understand by 'textile' any 'solid and flexible fibrous construction', the perspectives become vast and take us very far back in time.

We cautiously welcome the discovery of what is thought to be wild flax in sediment in the Dzudzuana cave in Georgia[25] and which apparently dates from 36,000 BC, *i.e.* prior to anything known

[17] Talon, 1986; Good *et al.* 2009; Betts *et al.* 1994; Moulhérat *et al.* 2002.
[18] Good 2007.
[19] Schaeffer 1951; Cardon 2003, 430, fig. 11; Edens 1999; Matthews *et al.* 2009.
[20] Michel and Veenhof 2010.
[21] Murra 1962; Costin 1993.
[22] Coquet 1998.
[23] See the description of Enkidu: Bottéro 1992, 70.
[24] As we have done to report on the archaeological documentation: Breniquet 2008.
[25] Kvavadze *et al.* 2009, 1359.

to date. These appear to have been twisted and even dyed in a variety of colours. Furthermore, the spores of a fungus normally found growing on fabric were found with these fibre fragments, thus reinforcing the excavators' theory according to which pre-historic man made clothing and worked animal skins in the cave. Unfortunately, nothing indicates that the twisting and dyeing is deliberate and not due to the find conditions. Indeed, linen is not likely to take on dyes except in the specific case of 'vat dyes',[26] which came into use much later. Furthermore, on the basis of a critical review of the excavators' conclusions (based on the comparisons of microscopic images of existing modern flax fibres and on the presence of 'flexing knots') it is impossible to identify definitively the fibres as flax, it is only certain that these were plant fibres.[27]

The most ancient evidence of textiles is plant based, at Pavlov I in Moravia (*c.* 27,000 BP). They are neither woven, nor made from netting but are twined *i.e.* hand or needle assembled.[28] This technique – amongst others – has also been observed in the Palestinian cave of Nahal Hemar.[29] The main commentators on the origins of textiles highlight the fact that roping constitutes one of the fundamental textiles categories and plays a part in producing various different types of nets (fishing nets, carrying nets, hair nets, basic structure for a more elaborate item of clothing, *etc.*).[30] In the Ancient Near East the most ancient rope traces are those from Ohalo II in Israel (*c.* 17,000 BC),[31] *i.e.* older than the string found at Lascaux, France. It is however difficult to assign them a 'textile' function, although the elementary component, sometimes twisted, is present.[32]

The first traces of woven textiles date back to the 7th millennium BC (plain tabby imprints, Jarmo)[33] and the first looms evidenced by archaeology are similarly dated (end Pre-Pottery Neolithic B (PPNB), at El Kowm).

Cords and bast fibres

Does this overview reflect past realities? Or is it simply a reflection of a biased archaeological reality? More specifically, can we see the origins of textiles here? The real question is what role plant fibres play in the process of invention of textiles. There is indeed an allusion to this in the Bible. Genesis (III, 7–15) recounts the episode where Adam and Eve, having become conscious of their nudity, sewed fig leaves together and covered themselves, and this, well before Yahweh made them tunics from animal skins. However, even excluding 1) the fig tree which is without doubt not the first plant fibre used for making clothing, 2) the invention of clothing for reasons of modesty, and 3) the origins of weaving through sewing, this does give us a glimpse of other techniques and other fibre materials used for clothing, combined with a primitivistic and reconstructed vision of its invention. Clothing made of bast fibres has been well documented in Neolithic Europe.[34] The Near East only recognizes flax as a plant textile fibre, but it would be highly surprising if there

[26] Cardon 2003, 13.

[27] Bergfjord *et al.* 2010, 1634.

[28] Soffer *et al.* 1996.

[29] Schick 1988, pl. XX.

[30] Hardy 2008; Desrosiers 2010, 34–36. Not all clothing can be assimilated to a textile. The origin of clothing (no doubt fur) is dated between 170,000 BP and 83,000 BP years on the basis of the emergence of bodily parasites (such as lice). Toups *et al.* 2010.

[31] Nadel *et al.* 1994.

[32] Desrosiers 2010, 33.

[33] See Jerf el Ahmar and Tell Aswad slightly earlier on. D. Stordeur, personal communication.

[34] Médard 2006.

were no others.[35] This singular omission would seem to be linked to the fact that we (almost despite ourselves) closely associate textiles, and even more so fabrics, with the function of clothing. However, we must learn to think in terms of techniques, uses and different materials. There is no doubt that all types of cordage and strings must have existed from the Upper and even Middle Paleolithic period as unambiguously demonstrate by female figurines (hair nets, "necklaces", cords for "new mothers",[36] the corded skirt of the Venus of Lespugue *e.g.*),[37] but there have been no finds in the Near East. We should therefore suppose that textiles made from cords and fibres existed in the Near East at times which are unfortunately impossible to date, and that these products may well have co-existed with the first woven textiles.[38] Contrary to popular belief, we will exclude felt which is being produced using a radically different technique which does not involve in advance prepared threads (and therefore is technically unrelated to woven fabric production) and requires a quality of wool which does not correspond to the first fleeces.[39]

Origins of clothing

Whilst it seems generally accepted that a wide diversity of textiles existed in the Near East at least from the Neolithic period,[40] there is however no certitude that these were originally used for clothing. The first complete textiles were the twined pieces found at Nahal Hemar.[41] Rectangular and of modest dimensions, these pieces were found in a context which does not allow us to extrapolate with regard to their intended use, as clothing or not. Furthermore, woven fabric was certainly not generalised from the time of its invention. Before the Uruk period, representations of clothed individuals are extremely rare (but it remains unknown in what their clothing consisted and in what material it was made?). Figures from Çatal Hüyük are said to be wearing leopard-skin loincloths;[42] rare *dancing-ladies* decorative borders on Halafian ceramics (Fig. 1.4); the "shaman" or master of animals at Luristan (Fig. 1.5). The vast majority of representations prior to the Uruk period show scarcely clad individuals (Fig. 1.6), or, to be more precise, people in state of adorned nudity (jewellery, labrets, belts, straps, scarification or tattoos, *etc.*). We do well to consider whether we have taken this to be the norm. The question should be posed in terms of cultural, technical and aesthetic choices: fabric was no doubt invented in diverse cultural contexts, in groups which favoured rudimentary clothing, associated with considerable bodily ornamentation. The very clement climate during the neolithisation of the east supports this hypothesis. We are not in a position to assess the diversity of these practices and it is likely that different traditions coexisted, as observed in Africa up until recent times.[43]

[35] Andersson *et al.* 2010, 169, a find at Ebla, unfortunately impossible to identify.

[36] Soffer *et al.* 2000; see also the more recent remarkable "headdress" from Nahal Hemar, and all documentation from the Near East: Shick 1988, pl. XVIII.

[37] See Barber 1991, 255 for a possible find at Çatal Hüyük in PPNB. Also see Bedaux and Bolland 1989 for exceptional African examples.

[38] D. Stordeur, personal communication, believes that basketwork and weaving appeared concurrently during the recent pre-history of the Levant, although this concerns utilitarian basketwork using hard fibres (baskets, boxes, *etc.*).

[39] Barber 1991, 215; Breniquet 2008, 73.

[40] See for example the exceptional collection of textiles at Nahal Hemar. Schick 1988.

[41] Shick 1988.

[42] Hodder 2006, 207, fig. 91 however these skins may well be dyed bast.

[43] Coquet 1998, 14.

Figure 1.4. Sherd from the Halafian period (6th millennium) a frieze of clothed dancers? M. von Oppenheim (1943) Tell Halaf I pl. XCI, fig. 1.

Figure 1.5. Prints of Luristan seals showing a person dressed in ceremonial, ornamented clothing. Amiet, 1981, no. 121, 122, 123.

Figure 1.6. Female figurine from Tell el'Oueili (LO 87 11), Obeid 1. © Larsa-Oueili Mission, with the kind permission of Prof. J.-L. Huot.

Catherine Breniquet

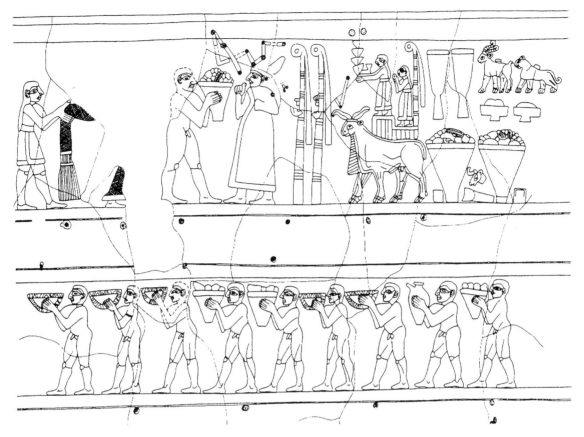

Figure 1.7. Upper registers of the Uruk Vase, c. 3000, Iraq Museum, Baghdad. E. Lindemeyer and L. Martin,
Uruk-Kleinfunde III, 1993, Taf. 39.

The Uruk period represents an end point: Woven clothing is attested in the archaic texts[44] and seems to be represented on sculptures and embossed on the Uruk vase (Fig. 1.7). All these examples are of fabrics in relation to positions of power: They are worn by dignitaries, Priest-Kings and their acolytes, goddesses and priestesses, whilst the men who present the offerings are naked. Woven clothing is a symbol of status and power and does not have any real utilitarian, nor moral, nor religious purpose.[45] It is no doubt the 'high tech' status and visual effect produced which impart these properties to the fabric. The fabric may be decorated within its structure using elaborate weaves, or warp and weft variations, or on the surface with sewn-on decoration such as embroidery, bracteates, various appliqués and even paintings or colours. This exceptional link between the elite of society and the fabric is rooted in the changing of the environment which accompanied the emergence of chiefdoms. More specifically, in Mesopotamia, it was no doubt the development of sheep farming[46] since the second half of the Ubaid period, which triggered the process.

[44] Englund 1998, 98.
[45] Barber 2007, 177.
[46] Breniquet 2006 b.

The immediate prestige and status of the elite presented by fabrics were certainly not the only reason why textiles were invented. The main use may well have been for burials. Once again our knowledge is limited: Were the dead buried clothed? The textile fragments found in burial contexts may be strips, covers or shrouds[47] made in the domestic setting, specifically for the deceased, and also by groups who did not wear fabrics themselves.[48] The practice of cremation also makes extensive use of fabrics, not as clothing but as "wrapping".[49] The production techniques provide significant additional information[50] and in the future we are likely to be presented with further evidence of the simple techniques and mass productions. Below we will consider the case of fabrics deposited in tombs as grave goods.

Practical usage

Other functions should also be considered. The most common are utilitarian: Fishing or carrying nets[51] and these develop over time. The most unusual, the use as a framework for pots of unbaked clay, has curiously gone largely unnoticed. A cord is wound up around itself in the form of a roll (the similarity is too striking to be insignificant), and the clay is plastered on the inside and outside of the structure[52] creating the illusion of a clay coil. There is evidence of this type of technique in Europe up until the Bronze Age.[53] The finds are relatively poorly documented and often confused with corded decorations where the external layer of clay has peeled off. How this should be interpreted is unclear: Is this an imitation by people who did not posses more sophisticated technology? Or an innovation due to the poor quality of local clay? It would no doubt be interesting also to look for signs of a possible corded frame at the mortar used in Neolithic walls, and to look at the southern Mesopotamian reed structures which had to be fixed together. We are also likely to find surprising results in terms of cord measurements in these contexts.

The other utilitarian uses (bags, packages, boat sails, furnishings) are not directly documented, except for a possible felt floor covering at Beycesultan.[54] It is most often through texts or iconography that we are able to determine these categories (floor coverings sculpted in stone in Neo-Assyrian palaces, the upholstery on Persian chairs, *etc.*).[55] The same is true for fabrics used in temples. The ultimate stage in fabric use is the recycling of rags used to wrap copper objects, as at Suse, or scribes' tablets[56] notably those intended to be reused by novices, or for cushion padding as found in the astonishing Roman collection from Didymoi.[57]

[47] For example the looping effect netting in a tomb at Karrana, assimilated to a skirt in the Uruk fashion Hagg 1993.
[48] Coquet 1998, 32.
[49] As mentioned in Homer.
[50] No systematic, technical and statistical studies have been carried out on the bandage-wrappings from Egyptian mummies.
[51] Good 2007.
[52] Shick 1988, pl. XVIII.
[53] Gomez de Sotto 1995, 122.
[54] Barber 1991, 217.
[55] Bier 1995.
[56] Garcia Ventura 2008.
[57] Cardon 2006.

3. Symbolic value

Fabric and clothing

It is very difficult to say when woven clothing became generalised across the Ancient Near East, perhaps this occurred from the start of the 4th millennium with the advent of urban, hierarchical societies. We only know about the clothing worn by society's elite.[58] It is a draped fabric which becomes fuller over time: A simple wraparound skirt in the Uruk period, *kaunakes* in Protodynastic times, a long skirt in the Akkad period, togas for Gudea and Paleo-Babylonian monarchs,[59] *etc.* This garment type is not tailored but worn whole. It is not until the 2nd millennium (and even the 1st) that the first indications of complex, cut[60] or assembled garments are seen, such as those in the Goddess of the Spouting Vase at Mari (Fig. 1.8). The first garments were presumably made of wool but the fibre of prestige changed may have over time.[61] If we are to judge from Inanna's lamentations, she who was used to the delicate touch of linen, refused to wear the "coarse clothing" made from "rough wool" which were all the low born Pastor had at his disposal in the 2nd millennium.[62]

Whatever it is made of, clothing accompanies man and punctuates the major social stages of his existence through rites of passage: birth, puberty, wedding, death,[63] for which specific garments are worn.[64] It is a favoured canvas to carried symbolic connotations. The use of natural fibres, notably plant fibres and bast fibres, are likely to create a special bond between man and the world, and they convey the very image of an ideal balance.[65] It is, however, hard to say how to prove

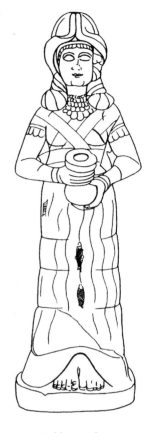

Figure 1.8. Goddess with spouting vase, c. 2000 BC, Mari.

this, except by reviewing the studies of hunter-gatherer populations from a fresh perspective.[66] Where textual or even iconographic sources are available, these have played a determining role in illustrating at least two complementary aspects of the role of textiles, precisely due to their use as clothing: As a substitute for the person and as a social bond. Stating that the clothing is the extension of the body that wears it is obvious, even if only due to its proximity with bodily

[58] And that of the gods.

[59] The royal wardrobe appears very differently through the texts of Mari: Official garments (are these those shown in the iconography?), shawls, shirts, shoes. Durand 2009, 23.

[60] Durand 2009, 10–13. The difficulty in identifying "cuts" and "garments" is revealing. Biga 2010, 150 and 158, notes that on pieces of fabric of unknown dimensions were found at Ebla.

[61] McCorriston 1997; Huot 2000.

[62] Kramer and Bottéro 1983, 85. See also Durand 2009, 15.

[63] The Urartian King Rusa slashed his clothing in grief after the sack of Musasir.

[64] Pasquali 2005, 165. There also seems to be a symbolic use of colour.

[65] Coquet 1998, 28.

[66] For example from the work of Ph. Descola 2005.

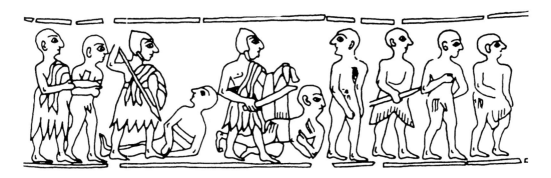

Figure 1.9. Standard of Ur Protodynastic III, war panel, middle register: Prisoners manhandled and naked, British Museum.

fluids. It is even a double in Mesopotamia, by the same token as jewellery, hair and nails.[67] The role of clothing on battlefields and in the practice of *sissiktum* (see below) is sufficiently convincing.

Magical protection and a person substitute

There are three Protodynastic iconographic standards which are particularly revealing. Those of Ur and Mari show prisoners brought naked and unceremoniously to the victorious king (Figs 1.9, 1.10) Their clothes are taken from them on the battlefield itself and kept as trophies by the victorious soldiers at Ebla (Fig. 1.11). As for the dead, they are represented as naked, disarticulated, and floating in the field in the picture or brutally ridden over by animals pulling chariots. The image is not just made up by conventions of representation. It shows a practice which deprives the others of a part of their personality, strength, their very existence.[68] Obtaining something precious is not the primary objective of the action.

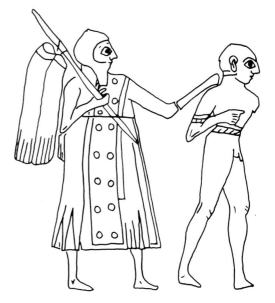

Figure 1.10. Standard of Mari showing clothing removed by the victors. Protodynastic III. J.-C. Margueron, Mari, métropole de l'Euphrate, 2004, 292, fig. 280.

Clothing is involved in practices as an efficient substitute for an individual. The *sissiktum* practice is well documented in the Paleo-Babylonian period; it becomes more rare later on, and involves applying the border or edge of the piece of clothing to an clay tablet at the moment a transaction takes place (Figs 1.12, 1.13). This action

[67] Finet 1969, 106.
[68] By the same token as the jewels which Ishtar must relinquish when passing the gates of Hell. Kramer and Bottéro 1983, 181; Da Silva 1991, 34–35.

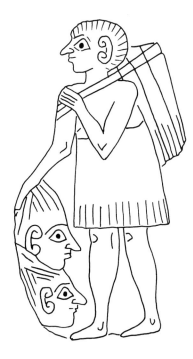

Figure 1.11. Detail of an inlaid panel from Ebla, showing clothing taken by the victors brandished at the point of a spear, 24th century BC. P. Matthiae, Aux origines de la Syrie: Ebla retrouvée, 1996, 77.

is often mistaken for an authentication in the modern sense of the word. Yet in fact it is a ritual act. Its finality is to materialize the presence of the contracting party(ies) and to guarantee the permanence of the act,[69] as an extension of the individual person concerned, transmitted by the mediation of the clothing, to the possession acquired.

The same idea is also present at the end of the 1st millennium BC, when the king of Assyria sent his cloak to represent him when he was indisposed, or when a sovereign passing through Babylon bowed to the cloak of Nabonidus, rescued from the chambers of Esagila, several centuries after his death.[70]

The clothing is the favoured support for the 'social fabric' no doubt because it is the gift *par excellence* between blood relations.

Alliances

The fabrics involved in rites of passage are often passed down from generation to generation, thus materializing kin relationships and are a direct link with the ancestors.[71] They play a role in weddings, including royal weddings, funeral rites, official visits and even property transactions. The logic of such practices is often wrapped in 'cultural' considerations which conceal this and blur our view. In this way, an archaic text from Uruk speaks of the distribution of fabrics as part of a religious festival, but is unfortunately very evasive.[72] The texts from Ebla provide clearer evidence of the role of fabrics in the coronation ceremonies of the kings of Ebla. These are described in elliptic, political and ritual terms which obscure our understanding but they certainly involved different types of garments in different colours.[73] This role echoes the part played by fabrics at the Inca court where the monarch received a garment woven by his future wife (and he gave her one too), and generously distributed others to the court and the population on this occasion,[74] thereby reaffirming the alliances which formed the very foundation of the empire.

The well-documented practice in Paleo-Babylonian Mesopotamia of materialising an alliance by making a knot in a piece of clothing or fringe which was cut in the event of divorce, is revealing;[75] however, this is merely a silent manifestation of a phenomenon which earlier took on greater proportions. Furthermore, all commentators insist on the similarities with the political act which, for a vassal involved "touching the hem" of his overlord's garment.[76]

[69] Cassin 1987, 268–269.
[70] Joannès 2001, 359.
[71] Weiner and Schneider 1989, 16.
[72] Englund 1998, 127, fig. 44.
[73] Pasquali 2005, 172–173; Biga 2010, 164–165.
[74] Murra 1962.
[75] Finet 1969, 126; Cassin 1987, 333; Da Silva 1993.
[76] Finet 1969, 128.

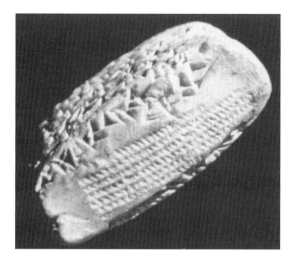

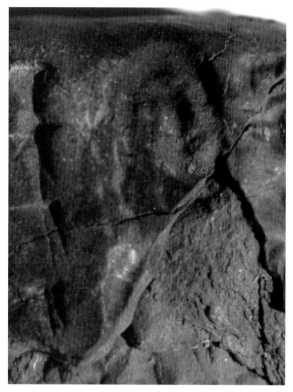

Figure 1.12. Tablet from Terqa showing a fabric imprint.
© IIMAS – The International Institute for Mesopotamian Area Studies, with the kind permission of Prof. G. Buccellati.

Figure 1.13. Detail of the imprint from the fringed border of an item of clothing on a tablet from Tell Ahmar (C-T20_seal-TAH97_341) © The Tell Ahmar Archaeological Mission, with the kind permission of Prof. G. Bunnens.

Such practices have also been documented for the Paleo-Babylonian period: Hammurabi sent two emissaries with gifts for the newly crowned King of Andarig. These included garments and a variety of adornments. The recipient thanked him profusely and explicitly called Hammurabi, his "father".[77] These fabrics thereby materialise kin relationships even, as in this case, symbolic ones.

Burial uses
The uses of textiles in burial rites are not limited to clothing the dead or the grave furnishing. Certainly the deceased is wrapped in and surrounded by fabrics, the quantity of which is generally proportional to the status of the deceased. For the Fali in Cameroon,[78] such fabrics are provided by the family, neighbours, friends, and other dependents, despite the fact that the livings make so little use of woven clothing. Some are redistributed to the sons of the deceased. This practice reaffirms the bonds and alliances which connect the group to other generations and other groups, and ensures that the deceased is recognized and welcomed by his own ancestors. Experts on Africa report that this wrapping is likely to develop into spectacular proportions, with the very form of the human body disappearing under the layers of fabric,[79] a demonstration of social power.

[77] Charpin 2003, 188.
[78] Coquet 1998, 32.
[79] Coquet 1998, 32, fig.17.

We do not know of any cases of this type for the Ancient Near East but we do know that there are exceptional tombs containing considerable quantities of fabrics (Ur, Qatna *etc.*). The practice has also been documented in the texts from Ebla.[80] The origins of these fabrics remain unknown; however, one can easily imagine the immense potential such fabric collections would offer for retracing exchanges between allies and as well as kin if only we could access what has not been preserved. In the cases documented by ethnographers, the fabrics assembled for funerals are often the best the dependents posses. They are displayed with the deceased, in a well-established order and ritual (sometimes becoming more of an attraction than the deceased themselves!).[81]

Social and political values of these fabrics are evident, but cannot be limited to accumulation. Indeed scholars of Inca history insist on the existence of religious ceremonies organised by the authorities where fabrics were burned as substitutes for physical individuals; other societies (*e.g.* the Maya) would have sacrificed these individuals.[82] This raises the question of whether the accumulation of fabrics in the tomb might be a type of substitute for the terrible practice of 'sacrificial' burials. This has only been seen in the royal tombs of Ur and reflects both the political omnipotence of the kings but also the complex relationships of dependence (and kin relationships) which link sovereigns to their entourage. This practice also exists elsewhere and died out over time to be replaced by animal sacrifices or the deposit of figurines.[83] These fabrics, deposited in great quantities in the graves, might also be substitutes, at least earlier times. Is not filling one's grave with fabrics given by the household not also a way of ensuring pleasant but socially connoted passage?

Distributions of prestige

Distribution of prestige in the form of garments is documented in the Ebla texts. Such distributions seem to map major events in the life of the court: Births, weddings, rituals, military campaigns, diplomatic relations, *etc.*[84] In the Paleo-Babylonian period distributions also took place on the arrival of emissaries, messengers and ambassadors. They would be received at court according to their rank (and the diplomatic stakes). They would be housed and receive 'rations' of products of which clothing took pride of place. King Hammurabi himself would decide upon such distributions (as well as the recriminations which sometimes ensued).[85]

This practice can be compared to the more modest practice which involved clothing guests when they are welcomed into a Mesopotamian house. One could have the tendency to reduce these habits to a simple display of the wealth of the host. Whilst this is no doubt the case, it is also a way of integrating foreigners so they resemble their hosts, a way of showing them that they are now part of the family (or not).

Property transactions

One very singular practice involving fabrics and clothing has been studied in detail by E. Cassin.

[80] Biga 2010, 168.
[81] Coquet 1998, 34.
[82] Murra 1962.
[83] A. Testart has linked this to the emergence of a form of State where personal relationships are no longer all-important. Testart 2004, 62.
[84] Biga 2010, 148–149, 164–169.
[85] Charpin 2003, 181–182.

It illustrates very precisely the social nature of fabric-gifts. This practice seems to be mostly characteristic of the Protodynastic and Akkadian periods. It involves paying the seller the price of the property (or *nig-sam*) in metal, and then making two further payments: one in metal, a kind of surcharge (the *nig-diri*), and the other in fabrics (the *nig-ba*) and food (sometimes paid in the form of a meal).[86] The recipients are the sellers, their family, and their neighbours.[87] The *nig-ba* explicitly designates the payment as a 'gift' and not a commission.[88] This may well be explained by two economic and social parameters. The first is that until the advent of urban, hierarchical and bureaucratic societies, land was an asset which could not be transferred and the custom was no doubt to allocate land to families according to their needs. The other is the introduction of metal as part of the economy. Indeed, the Mesopotamian economy was not monetary and used two forms of 'currency': One currency in the form of perishable goods, raw or worked (cereals, raw wool, fabrics), and another currency for trade using weighed metal. Products charged with the symbols of agricultural communities are contrasted with something unalterable,[89] with no personality. However, the latter could never totally replace the former. This is the crux of the problem: Weighed metal is so abstract that it cannot fully replace a meaningful asset such as land. For a transaction to be feasible, the land must remain within the social network of the extended family. It is therefore important to treat the seller as part of the family by giving him, in addition to the cost of the asset, the gift *par excellence* between relations: fabrics, impregnated with the personality of the buyer, a quality that weighed metal cannot replace.[90] No trace has been found of any form of rates for *nig-ba*: It may be made up of fabrics given by weight, or a simple garment.[91] We do, however, understand that the proximity is the determining factor for the kin relationship between buyer and seller. The less closely related, the higher the actual sale price, the bigger the surcharge and the greater the number of gifts required.[92] The objective does not seem to be directly economic, it seems more focused on producing social obligations. The historical perspective suggests that this practice was transitory and accompanied a change in social structure. This fact is undisputed but the evolutionist interpretation does not explain everything: The practice of *nig-ba* is not attested after the Akkadian period, except periodically and only far later in the Neo-Babylonian period.[93] It does not completely die out.

4. Uses. Exchange value

The role played by fabrics in property sales emphasises their dual social- and economic function. Their exchange value is confirmed by their inclusion in the Mesopotamian ration system from the Uruk period onwards. However, in all cases there is one additional determining characteristic: These are all wool fabrics.

[86] Cassin 1987, 24, 316. See also Glassner 1985.
[87] Cassin 1987, 25.
[88] Cassin 1987, 322.
[89] Cassin 1987, 23–24.
[90] Cassin 1987, 27; Vidal 1991, 482.
[91] Cassin 1987, 318, note 100.
[92] Cassin 1987, 327.
[93] Cassin 1987, 334–337.

The rations system

From the dawn of hierarchical and urban societies in the Uruk period, there was a specific system for remunerating workers in place in Mesopotamia.[94] It consists of a system of payments in kind with cereals, oil, fabrics (or clothing) and wool making up the essential components. These so-called subsistence rations presumably replaced a simpler system based on mutual assistance or *corvée* for which the beneficiary could hold a collective banquet in recompense for the services rendered. The increased complexity of society and the scope of major works undertaken, *e.g.* the Eanna complex at Uruk, required labourers to be drafted from their agricultural work and meant the shortfall in men had to be met. However, this ration system was extremely complex as it did not constitute a salary as such but rather an individual allocation, made up according to largely unknown parameters, but which once again seem to reflect the status of the individuals and their kin relationships. The cases in which workers receive remuneration for their work are extremely rare in the first half of the 3rd millennium.[95] This system remained in place until very late. The trials and tribulations of the 18th century BC Mari paymaster, Mukannišum dealing with the recrimination of palace employees waiting for their clothing allocations,[96] and wool rations are still recorded at the Ebabbar temple in Sippar at the end of the 1st millennium BC.[97]

However the fabrics involved in this system are never described, even their nomenclature escapes us and we know little of how they were produced, although we do have evidence of the existence of workshops.[98] We can assume that they conform to production standards imposed by the authorities and that they did not constitute the most elaborate productions, these would probably have been reserved for specific royal or religious uses. It is even rather difficult to know if they were pieces of fabric or items of clothing. This is a significant difference as an item of clothing can be worn, especially in a society in which fabric is not widespread, while a fabric may constitute a genuine form of currency. The same is valid for wool: It can be transformed into thread or fabric,[99] but can also be exchanged for other goods. In this way wool provides access to other goods and to a rudimentary and no doubt regulated market.

Fabric as a currency?

A currency is generally defined through its various functions: Means of exchange, standard of value, store of value, means of payment. Economists, anthropologists and historians examine the question of the existence of primitive currencies in very different terms, depending on whether they focus on the economic or the social aspects[100] or on the universality of the concept.

Fabric currencies are known to exist in ancient Africa and China. Some of these are made up of commonplace fabrics, others are specific fabrics not intended to be worn and woven from materials that have no other purpose than to be used as a currency. Equivalents in rare goods (horses or

[94] Gelb 1965.
[95] Glassner 2001, 62.
[96] Rouault 1977, 135.
[97] Zawadski 2002.
[98] Breniquet 2006 a.
[99] The Ebla texts seem to identify it as a gift primarily for women, including high born women: Biga 2010, 151–152. In the same context, women of the court seem to supervise the production workshops. See also Pasquali 2005, 179.
[100] Testart 2001, 12, 14, 37, 40, *etc.*; Vidal 1991.

slaves) and fluctuations in price according to the time of year or the availability of weavers (or conversely their absence when labouring the fields) have been documented for rolls of cotton made by the Wolof people in Africa.[101] Regrettably we know very little about the Mesopotamian fabrics involved in transactions, whether simple everyday fabrics or cloth produced for this very purpose.[102] Fabrics do, however, play a monetary role, although this must be further nuanced.

The Mesopotamian economy is not a monetary one, in the sense that it does not use coinage, although until late in history it does use several 'currencies' simultaneously: Barley, metals (copper and silver), wool and fabrics. Only the first two were still in use beyond the 3rd millennium, perhaps due to their durability. These monetary forms constitute both common goods, forms of wealth, and prestige goods from ancient times. It could be thought that weighed metal replaced all other types of currency onwards from its introduction in the 3rd millennium. However, this is not the case: There are no known cases of standard measuring prior to the Paleo-Babylonian period[103] and up until at least the Akkadian period, metal is only 'worth' the amount of barley it can be used to obtain.[104]

Wool and fabrics are used as means of payment and/or to compensate someone for a service rendered. This is, however, a hybrid system, somewhere between actual payments and 'gifts' (which require the recipient to return a gift at a later date, making it a form of debt) as the personal relation of the transaction is a determining factor.[105] Other types of payment involving wool and fabrics no doubt existed, to pay for weddings, fines or various sanctions but we have no trace of these, except from royal weddings: the bridal trousseau of the princesses of Ebla included fabrics.[106]

Wool and fabrics also play a role in international exchanges. We could therefore ask ourselves whether Mesopotamia compensated for its lack of raw materials by embarking on a market economy for which it would have produced fabrics and traded them in a particularly vigorous import-export dynamic.[107] Fabrics are also used in long distance exchanges for internal trade between city-states, as is the case for wool, but also as compulsory diplomatic 'gifts' alongside offerings of grain. Texts from the very beginnings for the Bronze Age mention exchanges with the Gulf region and record between twenty and sixty pieces of fabrics, often of very mediocre quality,[108] and over two tons of wool! This is no 'market' exchange, nor even bartering, although it is not a selfless act of course. The goods exchanged remain within elite circles who used them as they wished under the system for internal redistribution to their own dependents.

It is also difficult to confirm that fabrics were used as a standard of value in Mesopotamia, as prices are only rarely given in terms of fabric[109] and we do not know of any prices calculated by the multiplication of a currency of measurement. This is perhaps merely a problem of documentation given that the phenomenon is attested in Egypt.[110]

[101] Coquet 1998, 22–23; Ames 1955.
[102] See the raffia currencies batéké and babunda from the DRC in Coquet 1997, 23, fig. 10 and 25, fig. 11.
[103] Joannès 2001, 458.
[104] Cassin 1987, 323, note 118.
[105] Vidal 1991, 482.
[106] Biga 2010, 164.
[107] Crawford 1973.
[108] Edens 1992, 127; Pettinato 1972, 94.
[109] Glassner 1985, 48.
[110] Menu 2001, 85.

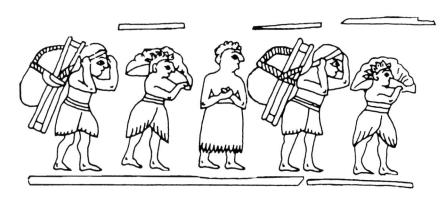

Figure 1.14. Standard of Ur Protodynastic III, peace panel, lower register: Carriers of woolpacks, British Museum.

Finally, do fabrics constitute a store of value? The answer is yes both for wool and for linen. Wool warehouses were recorded in the texts dating from the Uruk period, although archaeologists have been unable to identify them archaeologically.[111] The main representative of society at this time the EN (the King), seems to control all or most of the wool production. He distributed rations to compensate the individuals in charge of monitoring stocks in the warehouses that also held agricultural goods in sealed jars and fabrics.[112] He probably also received exceptional textiles himself.[113] On some occasions, in particular during religious ceremonies, the EN sampled the fabrics in the warehouse and was also allowed to use the fabrics in pure virgin wool from the fleeces of young sheep, partly produced in a 'workshop' where women work, while the weaving took place elsewhere.[114] These fabrics and the wool they are made from were no doubt kept in woolpacks: Is this not what the conquerors are shown removing on the Standard of Ur (Fig. 1.14)? Finally, we have the eloquent expression the 'House of Wool' (é-siki)[115] – by which the Ebla texts designate by metonymy warehouses of gold and silver. As for flax, this no doubt replaced wool as the fibre of prestige once wool became generalized. A form of official, royal or religious monopoly probably governed the use of the plant from the 3rd millennium. It was transformed into fabric in the workshops attached to the palace which supplied the temples, in the form of offerings to statues of divinities[116] (Fig. 1.15), or even in temple workshops such as the *arua*.[117] These are goods which are likely to be placed in reserve, as found in Egypt,[118] hence constituting a form of savings.

Some Mesopotamian uses of fabric resemble those of an actual currency. However, the

[111] Biga 2010, 153, for Ebla. Note that the Spanish at the time of the conquests saw that Incas had warehouses of fabrics filled to the rafters but did not understand why.
[112] Charvat 1997, 45–46; Englund 1998, note 349, 152.
[113] As found later at Ebla: Biga 2010, 161.
[114] Charvat 1997, 47–48.
[115] Archi 1993, 47; Biga 2010, 153.
[116] Biga 2010, 169.
[117] Gelb 1972.
[118] Menu 2001, 85.

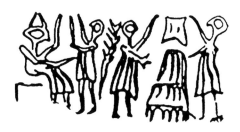

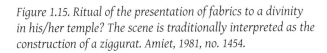

Figure 1.15. Ritual of the presentation of fabrics to a divinity in his/her temple? The scene is traditionally interpreted as the construction of a ziggurat. Amiet, 1981, no. 1454.

phenomenon seems to fluctuate over different periods, certain characteristics becoming dominant, meaning it is impossible to propose a monolithic definition. Furthermore, fabric and wool seem to be in competition, and in Mesopotamia, wool seems to play a more significant role than fabrics.

Back to the origins

Which mechanisms have led to the situation where fabrics form a '*fait social total*' (M. Mauss)? The steady introduction of fabric to populations which use weaving but not necessarily fabrics, the role of fabrics in kin relationships and the control affecting them, definitely play a determining role. However, without scientific arguments based on a documentation which regrettably still largely remains to be assembled, we are limited to conditional conclusions.

The rarity of fabrics used as clothing in Mesopotamia prior to the urban revolution is supported by the fact that fixed weaving installations in homes were very rare. Certainly we may not know how to identify these, and perhaps they were temporary.[119] However, it cannot be excluded that their presence relates to the status of the owner of the residence. Furthermore, if we consider that there was a 'fabric revolution' in Mesopotamia, this is inextricably linked to the generalisation of sheep farming and of wool. Sheep farming becomes a feature of the Ubaid society around 5000 BC. Our documentation lacks details due to the state of research in the field, but the question should be asked as to whether the sheep does not become the animal of prestige *par excellence*, like pigs in New-Guinea.[120] The general context in which chiefdoms were emerging favours this interpretation. However, we should note that sheep husbandry couldn't perhaps arise before the complete retreat of the Persian Gulf during the 3rd millennium BC and the advent of a drier landscape.[121] All members of the community owned some animals but the head of the community had more and used them to gain personal power. The sheep are eaten but also provide wool. The processing of wool fibres dates back to long before this period and traces have been found as early as the PPNB,[122] but there is a change of scale at this time. Owning larger flocks was an undisputable sign of prestige, but power also derived from their use, accumulating the outcome (including soliciting one's dependents) and redistributing the goods *i.e.* by controlling the chain of production and distribution. This control is exerted over wool and wool fabrics which are also seen as external symbols of social status. It is difficult to know whether wool fibres were

[119] Breniquet 2008, 198–200.
[120] Breniquet 2006b.
[121] Pournelle 2011, 141.
[122] Helmer 1992, 128–131.

Figure 1.16. Fabric offerings, Nereid monument beginning of the 4th century BC. W. Childs and P. Demargne Fouilles de Xanthos VIII, 1989, Pl. LXXVIII.

used directly within households or whether they were already at an early stage subject to a form of monopoly or taxation in kind. The only scenes of giving fabrics as gifts date from much later: The Persepolis staircase, the Nereid monument (Fig. 1.16). Given all these parameters, this archaic taxation may well involve skeins of wool (which would explain the quantity of spindle whorls found everywhere, in contrasts to the absence of looms). It even leads us to ask whether the authorities themselves distributed the raw wool for combing and spinning. Conversely, the weaving of fabrics is probably done by specialists,[123] some of whom may well be women from dominant lineages, as seen in Pre-Inca America,[124] and the wearing of woven garments was no doubt regulated by an emerging State organization. Their rarity and circulation within complex kinship networks might explain why fabrics are not (or rarely) directly purchased until late on in the 3rd millennium. Dignitaries, state civil servants and soldiers received an allocation of clothing,[125] which may well have included *kaunakes*. These fabrics would have conformed to strict production standards: The archaic texts of Uruk use ideograms which designate fabrics and also seem to refer to measurements.[126]

Another history of Mesopotamian textiles and fabrics would seem to emerge from this, which requires us to use all available sources and work with a long-term perspective. The question cannot, however, be tackled in a uniform manner across history of the Ancient Near East. The level of socio-economic development seems to be the key parameter to understand the role of textiles but our sources demonstrate how their symbolic significance is never fully superseded by their economic value. No one historical, technical, symbolic or social approach can fully reveal their role alone.

Acknowledgements
I would like to thank my colleagues G. Buccellatti, G. Bunnens, P. Butterlin, J.-L. Huot, C. Michel and O. Rouault for their assistance as well as the editors of this volume.

[123] From the Uruk period, genuine workshops seem to exist under the authorities and/or the temple. Breniquet 2008, 213–215.
[124] Costin 1993, 4–5. See also Biga 2010, 152 for comments on the role the women of the court played in supervising workshops.
[125] According to a system very close to that used by the Inca Empire, Murra 1962.
[126] Englund 1998, 151, 153.

Bibliography

Adovasio, J. 1975–1977. The Textiles and Basket Impressions from Jarmo. *Paléorient* 3, 223–230.

Ames, D. 1955. The Use of a Transitional Cloth-Money Token among the Wolof. *American Anthropologist* 57–5, 1016–1024

Amiet, P. 1981. *La glyptique mésopotamienne archaïque*. Paris.

Andersson, E. *et al.* 2010. New Perspectives on Bronze Age Textile Production in the Eastern Mediterranean. The First Results with Ebla as a Pilot Study. *Proceedings of the Sixth International Congress of the Archaeology of the Ancient Near East 1*. Wiesbaden, 159–176.

Archi, A. 1993. Trade and Administrative Practice. The Case of Ebla. *Altorientalische Forschungen* 20, 43–58

Balfet, H. and Desrosiers, S. 1987. Où en sont les classifications textiles? *Techniques et culture* 10, 207–211.

Barber, E. J. 1991. *Prehistoric Textiles. The Development of Cloth in the Neolithic and Bronze Ages, with Special Reference to the Aegean*. Princeton.

Barber, E. J. 2007. Weaving the Social Fabric. *In* C. Gillis and M.-L. Nosch (eds) 2007, Oxford, 173–178.

Bedaux, R. and Bolland, R. 1989. Vêtements féminins médiévaux du Mali: les caches-sexe de fibre des Tellen. *In* B. Engelbrecht and B. Gardi (eds) *Man Does not go Naked . Textilien und Handwerk aus Afrikanischen und anderes Ländern*, Basel, 15–34.

Bergfjord, C. *et al.* 2010. Comment on "30,000-Year-Old Wild Flax Fibers", *Science* 328, 1634.

Betts, A. *et al.* 1994. Early Cotton in North Arabia. *Journal of Archaeological Science* 21, 489–499.

Bier, C. 1995. Textile Arts in Ancient Western Asia. *In* J. Sasson (ed.) *Civilizations of the Ancient Near East*, New York, 1567–1588.

Biga, M. G. 2010. Textiles in the Administrative Texts of the Royal Archives of Ebla (Syria, XXIV Century BC) with Particular Emphasis on Coloured Textiles. *In* C. Michel and M.-L. Nosch (eds) 2010, Oxford, 146–172.

Bottéro, J. 1992. *L'Epopée de Gilgamesh. Le grand homme qui ne voulait pas mourir*, Paris.

Breniquet, C. 2006a. Tissage et spécialisation du travail en Mésopotamie, du Néolithique au IIIème millénaire. *In* A. Averbouh, P. Brun and S. Mery (eds) *Spécialisation des tâches et société*, *Techniques et culture* 46, 249–268.

Breniquet, C. 2006b. "Dans le mouton, tout est bon". Remarques sur les usages socio-économiques des animaux en Mésopotamie de la préhistoire récente au IIIe millénaire avant J.-C. *In* C. Michel and B. Lion (eds) *De la domestication au tabou: le cas des suidés dans le Proche-Orient ancien*, Paris, 247–255.

Breniquet, C. 2008. *Essai sur le tissage en Mésopotamie, des premières communautés sédentaires au milieu du 3e millénaire avant J.-C.* Paris.

Breniquet, C. 2010. Weaving in Mesopotamia during the Bronze Age: Archaeology, techniques, iconography. *In* C. Michel and M.-L Nosch (eds) 2010, Oxford, 52–67.

Burkett, M. 1977. An Early Date for the Origins of Felt. *Anatolian Studies* 27, 1–115.

Burnham, H. R. 1965. Çatal Hüyük. The Textiles and Twined Fabrics. *Anatolian Studies* 15, 1 69–17 4.

Cardon, D. 2003. *Le monde des teintures naturelles*. Paris.

Cardon, D. 2006. Haillons précieux : développements du tissage et de la teinturerie en Egypte romaine d'après de récentes découvertes de textiles archéologiques. *In* B. Mathieu *et al.* (eds) *L'apport de l'Egypte à l'histoire des techniques – méthodes, chronologie et comparaisons*, Le Caire, 45–61.

Cassin, E. 1987. *Le semblable et le différent. Symbolismes du pouvoir dans le Proche-Orient ancien*, Paris.

Charpin, D. 2003. *Hammu-rabi de Babylone*, Paris.

Cherblanc, E. 1935. *Mémoire sur l'invention du tissu*, Paris.

Cherblanc, E. 1937. *Le Kaunakès. Etude critique d'après les textes, les monuments figurés et les survivances supposées du tissu*, Paris.

Charvat, P. 1997. *On People, Signs and States. Spotlights on Sumerian Society, c. 3500-2500 B.C.*, Prague.

Coquet, M. 1998. *Textiles africains*, Paris.

Costin, C. 1993. Textiles, Women, and Political Economy in Late Prehispanic Peru. *Research in Economic Anthropology* 14, 3–28.

Crawford, H. 1973. Mesopotamia's Invisible Exports in the Third Millennium. *World Archaeology* 5, 231–241.

Da Silva, A. 1991. La symbolique des rêves et des vêtements dans les mythes sur Dumuzi. *BCSMS* 22, 31–35.

Da Silva, A. 1993. La symbolique des vêtements dans les rites du mariage et du divorce au Proche-Orient ancien et dans la Bible. *BCSMS* 26, 15–21.

Descola, P. 2005. *Par-delà nature et culture*, Paris.

Desrosiers, S. 2010. Textile Terminologies and Classifications: Some Methodological and Chronological Aspects. *In* C. Michel and M.-L. Nosch (eds) 2010, Oxford, 23–51.

Durand, J.-M. 2009. *La nomenclature des habits et des textiles dans les textes de Mari*. T. 1. Paris (ARM 30).

Edens, C. 1992. Dynamics of Trade in the Ancient Mesopotamian 'World System'. *American Anthropologist* 94–1, 118–139.

Edens, C. 1994. On the Complexity of Complex Societies: Structure, Power and Legitimation in Kassite Babylonia. *In* G. Stein and M. Rothman (eds) *Chiefdoms and Early States in the Near East. The Organizational Dynamics of Complexity*. Madison Wis., 209–223.

Edens, C. 1999. Khor Ile-Sud, Qatar: the Archaeology of Late Bronze Age Purple-Dye Production in the Arabian Gulf. *Iraq* 61, 71–88.

Ellis, R. 1976. Mesopotamian Crafts in Modern and Ancient Times: Ancient Near Eastern Weaving. *AJA* 80, 76–77.

Emery, I. 1994. *The Primary Structures of Fabrics. An Illustrated Classification*, Washington DC (reprinted).

Englund, R. K. 1998. The Texts from the Late Uruk Period. *In* J. Bauer, R. K. Englund and M. Krebernik *Mesopotamien Späturuk-Zeit und Frühdynastiscghe Zeit*, Göttingen, 15–233.

Finet, A. 1969. Les symboles du cheveu, du bord du vêtement et de l'ongle en Mésopotamie. *Annales du Centre d'Etude des Religions* 3, 101–130.

Francfort, H.-P. and Tremblay, X. 2010. Mahrasi et la civilisation de l'Oxus. *Iranica Antiqua* 45, 51–224.

Garcia Ventura, A. 2008. Neo Sumerian Textile Wrappings. *Zeitschrift für Orient-Archäologie* 1, 246–254.

Gelb, I. 1965. The Ancient Mesopotamian Ration System. *JNES* 24, 230–243.

Gelb, I. 1972. The *Arua* Institution. *RAAO* LXVI-1, 1–32.

Gillis, C. and Nosch, M.-L. (eds) 2007 *Ancient Textiles. Production, Craft and Society*. Ancient Textile Series 1, Oxford.

Glassner, J.-J. 1985. Aspects du don, de l'échange et formes d'appropriation du sol dans la Mésopotamie du IIIe millénaire, avant la fondation de l'empire d'Ur. *Journal Asiatique* 273, 11–59.

Glassner, J.-J. 2000. *Ecrire à Sumer. L'invention du cunéiforme*, s.l.

Glassner, J.-J. 2001. Peut-on parler de monnaie en Mésopotamie au IIIe millénaire avant notre ère? *In* Testart (ed.) 2001, Paris, 61–71.

Gomez de Sotto, J. 1995. *Le Bronze moyen en Occident: la culture des Duffaits et la civilisation des tumulus*. Paris.

Good, I. 2007. Invisible Exports in Aratta: Enmerkar and the Three Tasks. *In* C. Gillis and M.-L. Nosch (eds) 2007, 179–184.

Good, I. *et al.* 2009. New Evidence for Early Silk in the Indus Civilization. *Archaeometry* 51 (3), 457–466.

Hagg, I. 1993. The Textile Fragment from Burial 14. A Contribution to the History of Near Eastern Textile Technology. *In* C. Wilhelm and C. Zaccagnini (eds) *Tell Karrana 3. Tell Jikan, Tell Khirbet Salih*, Mainz am Rhein.

Hardy, K. 2008. Prehistoric String Theory. How twisted fibres helped to shape the world. *Antiquity* 82, 271–280.

Helbæk, H. 1959. Note on the Evolution and History of Linseed. *Kuml*, 103–129.

Helbæk, H. 1963. Textiles from Çatal Hüyük. *Archaeology* 16, 39–46.

Helmer, D. 1992. *La domestication des animaux par les hommes préhistoriques*, Paris-Milan-Barcelone-Bonn.

Hodder, I. 2006. *Çatalhöyük The Leopard's Tale. Revealing the Mysteries of Turkey's Ancient 'Town'*, London.

Huot, J.-L. 2000. Existe-t-il une "révolution de la laine" au début de l'âge du Bronze oriental? *In* Matthiae P. *et al.* (eds) *Proceedings of the Ist International Congress on the Archaeology of the Ancient Near East*. Rome, 640–642.

Joannès, F. 2001. Tissage. *In* F. Joannès (ed.) *Dictionnaire de la civilisation mésopotamienne*. Paris, 854–856.

Kvavadze, E. *et al.* 2009. 30,000-Year-Old Wild Flax Fibers, *Science* 325, 1359.

Kramer, S. and Bottéro, J. 1983. *Le mariage sacré à Sumer et à Babylone*. Paris.

Matthews, A. J. *et al.* 2009. High Prestige Royal Purple Dyed Textiles from the Bronze Age Royal Tomb at Qatna, Syria. *Antiquity* 83, 1109–1118.

McCorriston, J. 1997. The Fiber Revolution. Textile Extensification, Alienation and Social Stratification in Ancient Mesopotamia, *Current Anthropology* 38–4, 517–549.

Médard, F. 2006. *Les activités de filage au Néolithique sur le plateau suisse. Analyse technique, économique et sociale*. Paris.

Menu, B. 2001. La monnaie des Egyptiens de l'époque pharaonique (de l'Ancien Empire à la 1ère domination perse). *In* A. Testart (ed.) 2001, Paris, 73–108.

Michel, C. and Nosch, M.-L. (eds) 2010. *Textile Terminologies in the Ancient Near East and Mediterranean from the Third to the First Millennia BC*. Ancient Textile Series 8, Oxford.

Michel, C. and Veenhof, K. 2010. The Textiles Traded by the Assyrians in Anatolia (19th–18th Centuries BC). *In* C. Michel and M.-L. Nosch (eds) 2010, Oxford, 200–269.

Moulherat, C. *et al.* 2002. First Evidence of Cotton at Neolithic Mehrgarh, Pakistan: Analysis of Mineralized Fibres from a Copper Bead. *Journal of Archaeological Science*, 29.

Murra, J. 1962. Cloth and its Function in the Inca State. *American Anthropologist* 64–4, 710–728.

Nadel, D. *et al.* 1994. 19,000-Year-Old Twisted Fibers from Ohalo II. *Current Anthropology* 35–4, 451–458.

Pasquali, J. 2005. Remarques comparatives sur la symbolique du vêtement à Ebla. *In* L. Kogan *et al. Memoriae Igor Diakonokk. Babel und Bibel 2*. Winona Lake, 165–184.

Pettinato, G. 1972. Il commercio con l'estero della Mesopotamia meridionale nel 3.millenio av. Cr. Alla luce delle fonti letterarie e lessicali sumeriche. *Mesopotamia* 7, 43–166.

Pournelle, J. 2011. Did the First Cities Grow from Marshes? *Science* 331, 141.

Rouault, O. 1977. *Mukanniŝum: l'administration et l'économie palatiales à Mari*, (ARM 18) Paris.

Ryder, M. 1965. Report of Textiles from Çatal Hüyük. *Anatolian Studies* 15, 175–176.

Schick, T. 1988. Nahal Hemar Cave. Cordage, Basketry and Fabrics. *'Atiqot (English Series)* XVIII, 31–43.

Schaeffer, C. 1951. Une industrie d'Ugarit, la pourpre. *Annales Archéologiques de Syrie* I-2, 188–192.

Seiler-Baldinger, A.-M. 1994. *Textiles. A Classification of Techniques*. Bathurst.

Sigaut, F. 2009. Propos contre-révolutionnaires sur le Néolithique, l'agriculture, *etc*. *In* J.-P. Demoule (ed.) *La révolution néolithique dans le monde*. Paris, 181–196.

Soffer, O. *et al.* 1996. Les tissus paléolithiques de Moravie. *L'archéologue* 25, 9–11.

Soffer, O. *et al.* 2000. The "Venus" Figurines. Textiles, Basketry, Gender and Status in the Upper Paleolithic. *Current Anthropology* 41–4, 511–537.

Stordeur, D. 1989. Vannerie et tissage au Proche-Orient néolithique: IXe–Ve millénaires. *In Tissage, corderie, vannerie. Approches archéologiques, ethnographiques, technologiques*. Juan-les Pins, 19–39.

Stordeur, D. (ed.) 2000. *El Kowm 2. Une île dans le désert. La fin du Néolithique précéramique dans la steppe syrienne*. Paris.

Szarzinska, K. 1988. Records of Garments and Clothes in Archaic Uruk/Warka. *Altorientalische Forschungen* 15, 220–230.

Talon, P. 1986. Le coton et la soie en Mésopotamie? *Akkadica* 47, 75–78.

Testart, A. (ed.) 2001. *Aux origines de la monnaie*. Paris.

Testart, A. 2002. Le prix de la fiancée. Richesse et dépendance dans les sociétés traditionnelles. *La Recherche* 354, 34–40.

Testart, A. 2004. *Les morts d'accompagnement. La servitude volontaire* I. Paris.

Toups, M. *et al.* 2010. Origin of Clothing Lice Indicates Early Clothing Use by Anatomically Modern Humans in Africa. *Molecular Biology and Evolution Advance Access* published September 7, 2010. http://mbe.oxfordjournals.org/

Van Zeist, W. and Bakker-Heeres, J. 1974. Evidence for Linseed Cultivation Before 6000 BC. *Journal of Science* 2, 215–219.

Vidal, D. 1991. Monnaie. *In* P. B. M. Izard (ed.) *Dictionnaire de l'ethnologie et de l'anthropologie*. Paris, 482–484.

Waetzoldt, H. 1980. Leinen. *Reallexikon der Assyriologie und vorderasiatischen Archäologie*, 583–594.

Waetzoldt, H. 2007. The Use of Wool for the Production of Strings, Ropes, Braided Mats and Similar Fabrics. *In* C. Gillis and M.-L. Nosch (eds) 2007, Oxford, 112–121

Weiner, A. and Schneider, J. (eds) 1989. *Cloth and Human Experience*. Washington and London.

Zawadski, S. 2002. Payment of Wool in the Economy of the Ebabbar Temple at Sippar. *RAAO* 96, 149–167.

2. The Emergence of the Ghassulian Textile Industry in the Southern Levant Chalcolithic Period (*c.* 4500–3900 BCE)

by Janet Levy and Isaac Gilead

Introduction

The dominant Chalcolithic entity of the southern Levant is the Ghassulian culture, named after the type-site Teleilat Ghassul. It is dated by carbon 14 to *c.* 4500–3900 cal BCE. and is found mainly in the northern Negev, the Dead Sea basin, the southern and central coastal plain, the Shephella, and the Jordan valley (Fig. 2.1). Its cultural assemblages are characterized by V-shaped bowls, churns, and cornets, vessels with lug handles and/or red painted bands, narrow backed sickle blades and microliths. Also worth noting are basalt bowls, copper artefacts, broad room architecture, and primary burials in habitation sites and secondary burials with clay ossuaries in off settlement community cemeteries.[1]

The study of Ghassulian crafts and craft specialization is one of the major keys for a better understanding of its social and economic organization. The copper industry is the best known expression of Chalcolithic craft specialists.[2] Aspects of craft specialization have been recently considered also in studying assemblages of pottery and flint.[3] The linen fabrics uncovered in the Cave of the Treasure and the Cave of the Warrior are impressive products of an additional Ghassulian craft: the textile industry.[4] Beyond descriptions of products, there is yet no overview of this important industry, and the recent syntheses of the Chalcolithic period hardly mentions it.[5] It is our intention to discuss below the tools and products of the Ghassulian textile industry and its relation to social and economic aspects.

Materials

Textiles of the Chalcolithic period were uncovered in the southern Levant only within the western perimeter of the Dead Sea basin. Likewise, sites with a sudden and dramatic profusion of spindle

[1] Gilead 2009, 345.
[2] Bar-Adon 1980, 15–133.
[3] Roux 2003; Gilead *et al.* 2004.
[4] Bar-Adon 1980, 153–185; Schick 1998, 3–22.
[5] Rowan and Golden 2009.

whorls, Bir es-Safadi, Teleilat Ghassul and Gilat, are an evidence of an intensification of spinning and occur only in the semi-arid zone. Herein lays the dichotomy. Flax which appears to be the sole material used for the manufacture of textiles during the Chalcolithic period[6] cannot grow under these conditions even if precipitation was 100–150mm greater than today, as proposed by a number of scholars.[7] Nor yet do the said regions have surplus water requisite in flax processing.

Flax cultivated in the Mediterranean zone and the tropics requires average annual precipitation ranging from 450–750mm or carefully controlled irrigation with perennial sources.[8] The flax, uprooted after *c.* three months, is dried and subsequently laid to ret in pools of slow running water, or in closed pools in which the water is changed frequently. Retting, a stinking and polluting biological process, of *c.* 15 day's duration causes the decomposition of the outer cortex and some of the pectin. This is the critical stage of flax processing; over-retting will cause the decomposition of too much pectin, resulting in weak fibres, and under-retting will cause the retention of extraneous material that will be difficult to remove mechanically.[9] After re-drying, the straw is subject to a sequence of labour intensive processes to disengage the fibres[10] resulting in a 5% fibre yield; *c.* 3% line, 30–90cm in length, textile quality, and the remaining 2%, shorter, coarse tow suitable for rope.[11]

In the first half of the first millennium AD, textual evidence attests to the Jordan and Beit Shean valleys as the primary loci of flax cultivation in the Southern Levant.[12] It is quite possible that during the Chalcolithic period flax was also cultivated in the same region.[13] Considering the low yield of flax fibre to straw, the harsh conditions of the Judean desert and accompanying difficulties in transport, it would appear unlikely that 95% of extraneous straw was transported to the Beer Sheva valley sites (Fig. 2.1), an area with limited water resources but which are requisite in the processing of flax. It appears more reasonable that it underwent primary processing in the area of cultivation.

The Cave of the Treasure in Nahal Mishmar in the Judean Desert (Fig. 2.1) is one of the two most important sites for the study of the earliest Levantine textiles. The cave yielded a hoard of over 400 Ghassulian copper artefacts which is regarded as the earliest, largest and most sophisticated collection of metal object.[14] Bar-Adon, who excavated the site, lists the following layers (Fig. 2.2): the Roman period layer I (1st–2nd centuries AD) which is underlain by layer II, an intermediate layer that contains a mixture of artefacts from layer I and layer III below which is the Chalcolithic period,[15] dated to the fifth millennium.[16] Of the 112 textiles listed in the publication, mostly linen textiles, eight woollen fabrics were reported from layer III.[17] We suggest that they are intrusive and that they originate in the Roman layer. Woollen textiles from all three strata are characterized

[6] Schick 2002, 238.
[7] Levy 2006, 22 with references.
[8] Renfrew 1973, 124.
[9] Weindling 1947, 234–243.
[10] Baines 1989, 15–17, 167–181.
[11] Weindling 1947, 251.
[12] Alon 1980, 168.
[13] Schick 2002, 238.
[14] Moorey 1988, 173–174.
[15] Bar-Adon 1980, 2–5.
[16] Aardsma 2001.
[17] Bar-Adon 1980, 153.

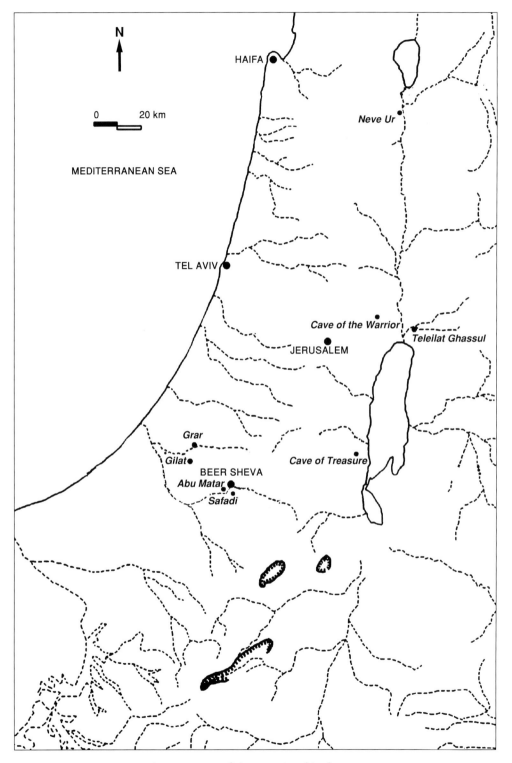

Figure 2.1. Map of sites mentioned in the text.

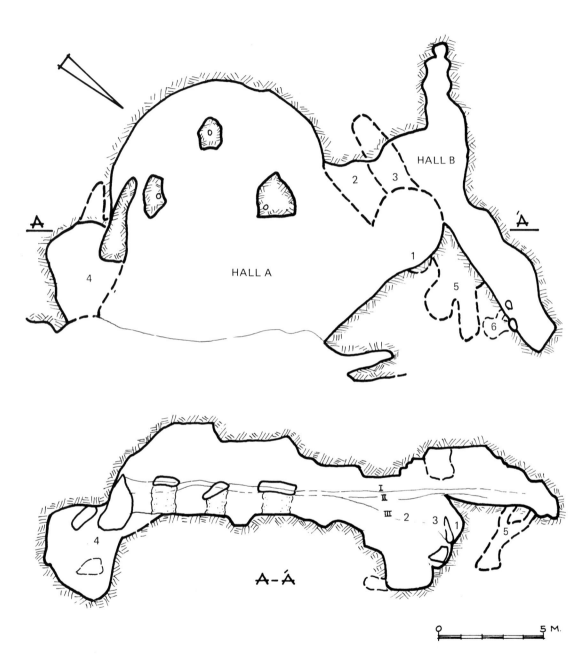

Plan and section of Cave 1.
The Strata: I – Bar-Kokhba; II – Intermediate; III – Chalcolithic.

Figure 2.2. Nahal Mishmar, Cave 1: plan and section (from Bar-Adon 1980, 4). Courtesy of the Israel Exploration Society.

by single ply, a feature alien to Chalcolithic spinning but characteristic of late spinning.[18] One woollen textile attributed to the Chalcolithic stratum is Z spun.[19] The feature is alien to the Chalcolithic period but normative for woollen textiles of the Roman period of Greek or Italian origin.[20] Furthermore, it is to be observed that the "Chalcolithic" woollen textile 61–22/8–h,[21] has an identical counterpart 61–45/6–b in the Intermediate level.[22]

Bar-Adon cites Crowfoot stating that the Badarian textiles 'are mostly linen and the rest woollen.'[23] However, Crowfoot clearly states that the said textiles are mostly linen and the remainder of an unidentified plant fibre.[24] Wool is not mentioned. Bar-Adon states that all the textiles recovered from Çatal Höyük are woollen.[25] Ryder on the basis of fibre diameter, microscopic examination and identification of the fibres and a series of chemical tests identifies the fibres as flax.[26] Subsequent SEM examination rejects the possibility of wool and confirms that the textiles were made of bast fibres probably flax.[27]

To reiterate, the Cave of the Treasure is the only Chalcolithic site to which woollen textiles are attributed. Samples of these textiles were examined by Ryder who defined them as late.[28] Supporting evidence that wool bearing sheep were not present in the southern Levant in the Chalcolithic period is the ram figurine from Gilat,[29] which sports a primitive throat fringe, characteristic of hairy sheep.[30]

The Tools of Production

Of the spindle, the composite tool of developed spinning, only the spindle whorls survive the millennia, as they mostly are made of stone or ceramic whereas the shafts of wood are rarely encountered intact.[31] Lightweight discoid whorls are generally used with dropped spinning, a technique still common throughout western Asia and the fusaïole (heavy ceramic whorls) with supported spinning, a technique no longer extant in the Old World but still practiced by the Navajo and the tribes of equatorial South America.[32] Supported spinning is an older, slower technique in which the three processes of yarn production, drafting spinning and winding on are carried out in sequence, whereas in dropped spinning, drafting and spinning are carried out simultaneously, resulting in not only longer lengths of more uniform and hence stronger yarn spun with greater rapidity, but also finer yarn.[33]

The whorls of the Chalcolithic period of the southern Levant are of two distinct types: the first

[18] Cindorf *et al.* 1980, 231.
[19] Bar-Adon 1980, 153.
[20] Sheffer and Granger-Taylor 1994, 236.
[21] Bar-Adon 1980, 158, ill. 26.3.
[22] Bar-Adon 1980, 174,Ill. 47.3; Cindorf *et al.* 1980, 230.
[23] Bar-Adon 1980, 153 note 71.
[24] Crowfoot 1954, 431.
[25] Bar-Adon 1980, 153 note 72 citing Mellaart 1963.
[26] Ryder 1965, 175–176.
[27] Vogelsang-Eastwood 1987, 18.
[28] Schick, personal communication.
[29] Commenge-Pellerin *et al.* 2006, fig. 15.5.
[30] Ryder, personal communication.
[31] Hochberg 1977, 11.
[32] Frödin and Nördenskiold 1918, figs 8, 9, 43.
[33] Barber 1991, 42–44; Crowfoot 1931, 7–21, Crowfoot 1954, 434; Kissell 1918, 24–26.

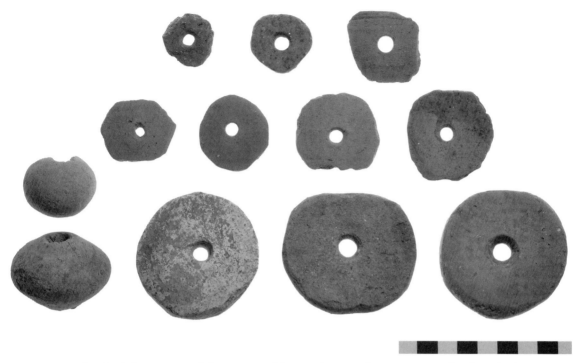

Figure 2.3. Spindle whorls from Bir es-Safadi. Courtesy of the French Research Centre at Jerusalem (CRFJ). Photographed by Alter Fogel.

discoid/lenticular in form with a biconical perforation manufactured from ground down sherds or limestone and the second spheroid or biconical in form with a straight perforation manufactured from low fired clay. We examined 381 whorls (Fig. 2.3) from various Chalcolithic sites (excluding the Gilat repertoire which was not available) and selected 320 for analysis. Sherd whorls constituted the majority (47%) with an average diameter of 40mm and an average weight of 20g. The second type (17% of the sample) has an average diameter of 45mm and an average weight of 65g.[34]

Both types of whorls are known from the Pottery Neolithic period but in very limited numbers (*e.g.* seven from Sha'ar Hagolan and 25, the greatest number, recorded from Jericho).[35] They also appear throughout the Chalcolithic sites but are still a minor phenomenon (*e.g.* eight at Nahal Mishmar).[36] Only in the Beer Sheva valley sites, at Gilat and at Teleilat Ghassul is there a dramatic increase in their numbers. Whorls are encountered in the Golan sites in domestic contexts adjacent to doors.[37] In the Beer Sheva valley sites and at Gilat they are found on the surface, in fills and in pits.[38]

Spinning bowls, or fibre wetting bowls are heavy, well-fired bowls with internal handle(s)

[34] Levy 2006, 113, 117.
[35] Garfinkel 1999: 29, Wheeler 1982, 626–630, pl. 255.
[36] Bar-Adon 1980, 183–184, ills 57, 58.
[37] Epstein 1998, 28, 42, 64, 71, 93, 109, 127.
[38] Levy 2006, 121; Levy *et al.* 2006, table 14.1.

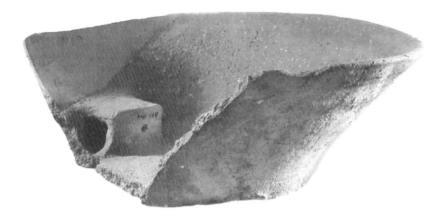

Figure 2.4. Fibre wetting bowl from Bir es-Safadi (from Commenge-Pellerin 1990, Planche VII/9). Courtesy of J. Perrot, C. Commenge-Pellerin and the CRFJ.

Figure 2.5. Representation of a horizontal ground loom from Badari (from Brunton and Caton-Thompson 1928, pl.XLVIII/ 70k).

used to hold water and provide the necessary traction for the spliced/knotted bast fibres which are drawn through the handle under tension, in the process of being spun into yarn. They are recorded from Early Bronze II horizons in Crete, Middle Kingdom Egypt, and Late Bronze and Iron Age horizons in the Southern Levant and contemporary Japan.[39] The earliest of all, however, are recorded from two Chalcolithic sites in the Southern Levant; Neve Ur and Bir es-Safadi, (Fig. 2.4) both reported in the same article.[40]

There are no representations of the horizontal ground loom in the southern Levant but one was found in Badari, an Egyptian site (Fig. 2.5). The Badarian culture dates mainly to the second half

[39] Barber 1991, 70–75.
[40] Perrot *et al.* 1967, 223, pl. 42: 9, 10.

of the 5th millennium and thus is contemporary with the Ghassulian.[41] Archaeological evidence, from both the Badarian and the Ghassulian sites attests to a transitional process from the use of skins to textiles.[42]

A bowl recovered from a female grave depicts a horizontal ground loom with all its components[43] and what appears to be the presence of a weft fringe as found on the wrapping sheet and kilt from the Cave of the Warrior (discussed below). Two figures stand to one side of the loom, at each end of a horizontal line over which are looped pendant, parallel lines of equal length; apparently double weft lengths ready for weaving as recorded from the Cave of the Warrior and in Early and Middle Kingdom Egypt.[44]

Several pieces of wood, some smooth, some processed and others with friction marks excavated from the Chalcolithic layer of Nahal Mishmar (Fig. 2.6) cave were reconstructed as a horizontal ground loom, based primarily on local Bedouin analogies.[45] The reconstruction is problematic. There are incongruities, textual and graphic, within the publication, between the published artefacts and the artefacts held at the IAA facility in Jerusalem, and technical problems with the loom reconstruction and the ancillary weaving equipment. Despite the problematic nature of the material and its reconstruction, it is possible, as the excavator suggests, that the two major pieces with deep wide notches a few centimetres before each end (1 and 2 in Fig. 2.6), the point where the lashings of the loom were attached, were indeed breast and cloth beams.[46] However, not from the same loom but from two distinct looms.

To conclude, the inhabitants of some of the Ghassulian sites were spinning flaxen fibres into linen yarn using fibre wetting bowls, primarily in the dropped spinning technique using spindles with discoid sherd whorls. The yarn, continuous and double weft lengths, was woven into textiles on horizontal ground looms using heddle technology.

Products

As stated earlier, most Chalcolithic textiles are from the Judean desert and the Dead Sea basin cave sites (Fig. 2.7).[47] In addition, two fragments were reported from Teleilat Ghassul[48]. The assemblage is characterized by homogeneity of raw materials and techniques of production. The linen, neither dyed (apart from 42m of black weft yarn and 63m of black warp yarn in the wrapping sheet of the Cave of the Warrior[49]) nor bleached, ranges in colour from white and pale yellow to dark brown undoubtedly primarily influenced by the micro-environments of preservation loci, but also by the initial retting conditions.[50] Decorative elements are rare, although one is recorded at the Cave of the Treasure,[51] and three in caves VI/46 and VIII/9 in the northern Judean desert.[52]

[41] Koehler 2010, table 2.1.
[42] Brunton and Caton-Thompson 1928, 16, 237; Levy 2006, 126.
[43] Brunton and Caton-Thompson 1928, pl. XLVIII/70k.
[44] Barber 1991, 83 note 2, 151; Landi and Hall 1979, 143.
[45] Bar-Adon 1980, 177–182, ill. 56.
[46] Bar-Adon 1980, 179.
[47] Aharoni 1961, 15, pl. 7, A, B, C, D; Bar Adon 1980; Cindorf *et al.* 1980, 229–234; Schick 1998, Schick 2002, 223–239.
[48] Crowfoot 1948, 140; Crowfoot 1954, 432; Mallon 1933, 296.
[49] Schick 1998, 9–12.
[50] Cindorf *et al.* 1980, 229.
[51] *Ibid.*
[52] Schick 2002, 231–235.

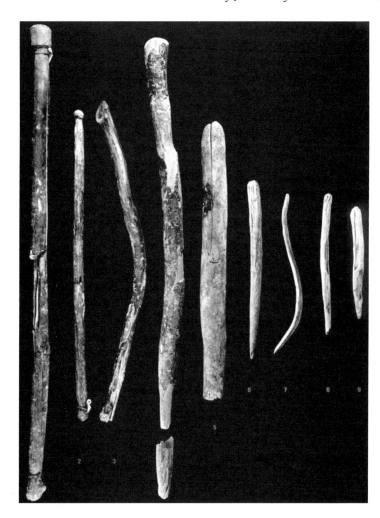

Figure 2.6. Components of a horizontal ground loom(s) and accessories from Nahal Mishmar (from Bar-Adon 1980, ill.56). Courtesy of the Israel Exploration Society.

The textiles are woven in plain weave, in which the warp count is greater than the weft (warp faced), or in which the warp and weft are equal in both systems (balanced weave).[53] The yarn count, threads per cm (tpc) can be divided into three categories, low – 8 × 8, 9 × 9, 10 × 11, 12 × 7, medium – 14 × 12, 16 × 13, 18 × 14 and high – 28 × 18 tpc. Selvedges are predominantly simple, sometimes with supplementary warps sewn along the outermost warp threads or with grouped outer warps or outer warps slightly thicker than those of the body of the textiles.[54] Most of the sewing structures, hems or seams are crudely sewn in two, three and four ply threads and on one occasion with double thread.[55] However, no sewing needles have ever been recovered from any Chalcolithic site.

The textiles of the Cave of the Warrior near Jericho (Fig. 2.1) constitute an exception to the

[53] Cindorf *et al.* 1980, 229; Schick 1998, 231.
[54] Cindorf *et al.* 1980, 230; Schick 1998, 231.
[55] Bar-Adon 1980, ills 27, 31, 36; Cindorf *et al.* 1980, 232.

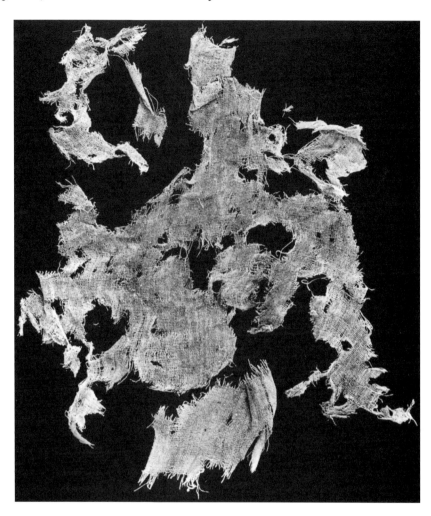

Figure 2.7. Textile from Nahal Mishmar (from Bar-Adon 1980, ill. 32). Courtesy of the Israel Exploration Society.

fragmentary and predominantly plain weave of the earliest fabrics. Six textiles were uncovered at the cave. Three of them (Textiles A, B, and C) are associated with a primary burial ("The Warrior"), of the stratigraphic Phase B which is radiometrically dated to *c*. 3,800 cal. BC. An additional three textiles (D, E, and F) were associated with a Phase C burial of a child, radiometrically dated to *c*. 4,300–4,250 cal B.C.[56] Although an Early Bronze Age was favoured for the "Warrior" burial,[57] it is worth noting that the textiles of the child burial that are centuries earlier are very similar to the "Warrior" fabrics.

The major textile (Fig. 2.8) – Textile A – is a wrapping sheet (shroud). Its size, 7 × 2m, is unprecedented in this time bracket in western Asia and the Nile Valley.[58] The wrapping sheet and the two additional textiles associated with the burial, the kilt (B) and the sash (C), are

[56] Barshad and Shaked 1998, 4–5; Jull *et al.* 1998.
[57] Schick *et al.* 1988, 127.
[58] Schick 1998, 127.

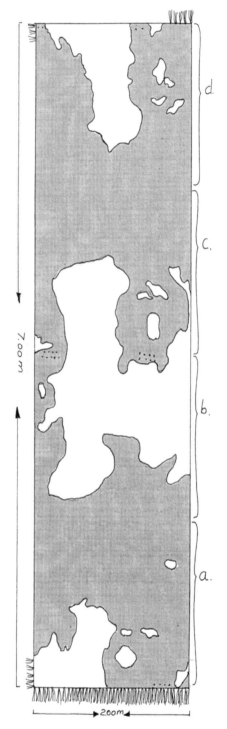

7.00 m

200m

morphologically intact with ends and selvedges and in contrast to other desert sites their stratigraphic context has not been disturbed by later occupation.[59]

Textile A ranges in colour from off-white to dark brown. The major determinants for the colour variations appear to be the ochre, which was sprinkled over the body or cloth, and the effect of the decomposing body. Technologically, the body of the textile is as other Chalcolithic period textiles; warp faced in plain weave with a middle range thread count, 15 × 20–11 × 13 tpc of predominantly s2S spun yarn.[60]

At the extreme ends of the textile are decorative bands, two at each end, executed in black, weft threads in basket weave, half basket weave and triple threads in one shed over paired warps. The black weft threads were dyed after plying with an unidentified substance.[61] The ends of the textile terminate in twisted, plied and knotted warp fringes c. 18cm long.[62]

The three outermost warp threads of one selvedge, also dyed black, have been woven as a single unit to create a decorative, reinforced selvedge.[63] A narrow black warp stripe, six warp threads wide flanked by 11 outermost non-dyed warp threads forms the second selvedge, although this is not a conventional selvedge. The cloth was not woven from continuous yarn but yarn two weft picks long. After every two weft picks, the two protruding weft threads were wound around the four outer warp threads and tied in a quasi buttonhole stitch to form a weft fringe 10cm in length.[64]

The second textile, a wrap-around kilt, measuring 1.4m × 0.9m was a standard item of male attire with pictorial representations from Egypt and Mesopotamia.[65] It is also a plain weave, warp faced textile woven from s2S spun linen yarn, morphologically similar to the wrapping sheet, with a decorative band in dyed black yarn at each end, a weft fringe and a twisted and knotted warp fringe at one end.[66]

[59] Schick 1998, 4, 7, 13.
[60] Schick 1998, 7–8.
[61] Koren 1998, 105.
[62] Schick 1998, 10–11, pl. 3.7.
[63] Schick 1998, fig. 3.22.
[64] Schick 1998, 12, fig. 3.26.
[65] Schick 1998, 21.
[66] Schick 1998, 15, figs 3.35, 3.36.

Figure 2.8. The Cave of the Warrior wrapping sheet (from Schick 1998, fig. 3.6). Courtesy of the Israel Antiquities Authority.

The third textile, a sash *c.* 2m × 0.2m, a customary element of Egyptian male dress worn by all social levels, is attested from the Old Kingdom (3000 BCE) onwards.[67] The width varies from 16–25cm and the yarn count from 13 × 13–21 × 16 tpc. The inability to preserve uniform width indicates lack of skill. The sash woven from s2S spun linen yarn is a natural beige colour with simple selvedges and decorative bands, two at each end of countered, weft twining terminating in warp fringes.[68]

Textile D, the largest of the three textiles, recovered from the earliest phase of the Cave of the Warrior measures *c.* 1.4m × 0.07m with paired outer warp threads at the selvedges. It is woven in plain weave from s2S linen yarn with a medium range thread count of *c.* 19 × 15 tpc.[69] The textile is similar technologically. Material, spin, weave and selvedge type is similar to a textile recovered from the Cave of the Treasure.[70]

The Textile Economy in Context

It is our intention to discuss below the way in which the textile production was incorporated into the socio-economic system of the Ghassulian culture. Textiles of the size similar to the shroud of the Cave of the Warrior, albeit in coarse wool, were still produced until 30 years ago amongst the peasantry of the Hebron hills by kin groups, primarily for wedding needs.[71] The production process appears complex, but when reduced to units of production, its simplicity is revealed (see appendix for a detailed arithmetic break down of all stages of production and person power).

Splicing, the first stage in processing of ancient linen yarn, entails moistening and gluing end-to-end two or three fibres, preferably with saliva which interacts with the pectin resulting in a strong bond, and subsequently pressing the join down on a smooth hard surface. The joined fibres are given an initial twist on the thigh and the resultant rove wound into skeins or balls for spinning.[72] Splicing is depicted in Middle Kingdom Egyptian tomb scenes in textile workshops, as one of the several stages in the intensive conveyer belt style of production, carried out by young girls.[73] We propose that splicing was a sedentary, daylight, all season activity suitable for older women, skilled in fibre craft, but no longer physically capable of herding or agricultural labour. Alternatively, it could have been a summer activity for all the female members of a household during the agricultural off-season. This fits the simpler nature of the Chalcolithic economy compared with the complex Egyptian economy of the Middle Kingdom. Rates of production are calculated for this reconstruction as those of dropped spinning, since the inserted twist is minimal (not as in thigh spun yarn) with most of the twist inserted during spinning.

We stated earlier that Chalcolithic yarns were spun and plied (s2S) in the dropped spinning technique, the predominant technique of the period.[74] Ethnographic rates for spinning flax in this technique are not available. However, an average Peruvian spinner, spinning since childhood, spinning wool without a distaff and using a spindle without a hook, spins 62m per hour and plies

[67] Vogel-sang Eastwood 1993, 86.
[68] Schick 1998, 15–17, figs 3.48, 3.49, 3.51.
[69] Schick 1998, 17–18, figs 3.52, 3.56.
[70] Bar-Adon 1980, 162, pl. 35.4; Cindorf *et al.* 1980, 229.
[71] Vogel 1989, 85; Weir 1970, pls 10, 11.
[72] Barber 1991, 46–48.
[73] Davies 1913, pl. XXXVII.
[74] Schick 2002, 238; Schieck 1998, 20.

95m per hour.[75] The advantages of dropped spinning *vis à vis* sedentary supported spinning are mobility and duality. It is an automatic skill that can be carried out together with any non-manual activity and does not impinge on the primary task. It is the prime example of female multi-tasking in all periods and is particularly smoothly integrated into year-round herding.[76]

The Cave of the Warrior wrapping sheet measures 7 × 2m with 3,500 warp threads and 8,400 weft picks. The extrapolated yarn length is 41,300m.[77] Thus the total time expended in the manufacture of the yarn for the textile, splicing, spinning and plying calculated according to the above mentioned rates of production, is 248 single person days (see appendix). However, herding with simultaneous spinning and plying is generally carried out by two or three young females of an extended family.[78]

Schick proposes that the textile was woven on a wide horizontal ground loom as still used in the Hebron heights.[79] A loom is a piece of household equipment of an extended family used as required and passed from generation to generation. Ethnographic analogies from the mid 20th century from Yemen to Norway, attest to the nature of this household craft.[80] The two metres width of the Cave of the Warrior wrapping sheet, determined the minimal size of the horizontal ground loom that was probably used.

The loom, stretched out to the full length until its completion of the projected textile, is set up by the weavers using heavy mallets and rocks.[81] Warping begins at one side of one end with a weaver sitting behind each beam. Both in Cisjordan and Transjordan a child runs back and forth between two weavers with the ball of yarn,[82] 24.5 kms in the case of the wrapping sheet (see appendix). Weaving on a horizontal ground loom is always conducted during the summer by both local peasants and Bedouin and the pastoral nomads of central Asia.[83] An average healthy adult walks 4.3 km per hour.[84] One may assume that a healthy child walks the same distance in twice the number of hours. Taking into consideration local summer temperatures, lack of shade and a child's stamina, three days were allotted for warping.

The leashes of equal length, attached in succession to each alternate warp thread, and the heddle rod are manufactured of multiple ply string to withstand the friction and tension during weaving. In this reconstruction they are calculated as made specifically for the project but in traditional economies they are unknotted after use, kept and reused.[85] Each leash, 30cm long, will be considered to be of four ply yarn. Thus the time expended in leash yarn production calculated according to the aforementioned criteria is ten single person days. Preparing the leashes involves measuring, cutting and tying a double knot at the end. The time expended in their preparation is five single person days. The time expended in attaching the leashes to the alternate warp threads with a slip knot and slipping on two loops at the other end to the heddle rod calculated

[75] Bird 1968, 14.
[76] Hochberg 1977, 50–51, unnumbered figs.
[77] Schick 1998, 8–13.
[78] Personal observations.
[79] Schick 1998, 20, pl. 3.12.
[80] Goitein 1955, 7; Hoffman 1964, 39 note 19.
[81] Crowfoot 1921, 26.
[82] Crowfoot 1945, 40.
[83] Carrington-Smith 1975, 5; Harvey 1996, 67.
[84] Harris and Nicholas 1998, 340/4.
[85] Hoffmann 1964, 41,43.

(based on our own timed experimentation – J. L.) is ten single person days (see appendix). Stages one and two of heddle production are the type of tasks that are carried out simultaneously by a number of persons whereas the final stage, with the need for accuracy, was probably carried out by a single person as attested by contemporary practices.[86]

We propose that the wrapping cloth was woven by two skilled weavers and three unskilled children. The role of the children was simply to pass the ball of weft yarn from one to another through the sheds. The weavers sat on either side of the loom receiving and transferring the weft yarn, ensuring there was no loss of textile width and knotting the weft fringe. As the weaving progressed, the children could no longer access the yarn from the rear and sat on the woven textile. Analogous practices are documented with the manufacture of textiles from the Hebron hills and with the manufacture of reed and palm matting from Egypt and Persia.[87] The time to weave the body of the textile (minus weft fringes, warp fringes and decorative bands) is based on the calculation that it takes seven spinners to supply the needs of one weaver.[88] The weft fringe, 4200 double wefts knotted in a quasi-buttonhole stitch around four outer warps was produced at the same time as the weaving of the body of the textile.[89] The time allotted for its production is based on our own timed experimentation – J. L. (see appendix). Thus the body of the textile with its weft fringe could have been easily woven by two skilled women and three unskilled children in 28 days working six hours a day.

At each end of the textile are two decorative bands, 35 and 37 pick rows wide, in basket weave and half basket weave and plain weave in black dyed yarn.[90] We suggest that the bands were inserted manually by two kinswomen working simultaneously. The figures for the rate of production are based on our own experiments with interlacing – J. L. (see appendix). Thus five days are allotted for the production of these bands. The textile terminated at both ends in a warp fringe of 180 twisted, plied and knotted tassels. We propose that the tassels were also worked simultaneously by two kinswomen and to those we allot two days. All stages of splicing, preparation of heddle leashes and weaving are based on a six hour working day assuming the women had to tend to other daily chores, *e.g.* grinding grain, collecting firewood, cooking and baby minding. Warping is based on a four-hour working day since it is small children who expend most of the energy in this activity. To reiterate, weaving is conducted in the open without shade and late summer temperatures in the region run as high as 42˚C.[91] Spinning and plying are calculated on an eight-hour working day. Although the same temperatures prevail in both situations, sheep and goats and shepherds/shepherdesses tend to rest in the shade during the heat of the day.[92]

In sum, we propose that spinning and plying were carried out simultaneously and incessantly, then as now, with herding, the primary task. As such spinning and plying of unlimited quantities of yarn would not have impinged or brought into disequilibria the agricultural-animal husbandry cycles of the extended households. In the southern Levant, weaving with a horizontal ground loom is a summer activity. The manner in which the loom is pegged out until the textile is completed

[86] Hilden 2010, 140–141.
[87] Crowfoot 1933, pl. 6; Weir 1970 pl. 10; Wulff 1966, 220.
[88] Barber 1994, 87.
[89] Schick 1998, 12.
[90] Schick 1998, 9–10.
[91] Beer Sheva October 2010.
[92] Personal observations.

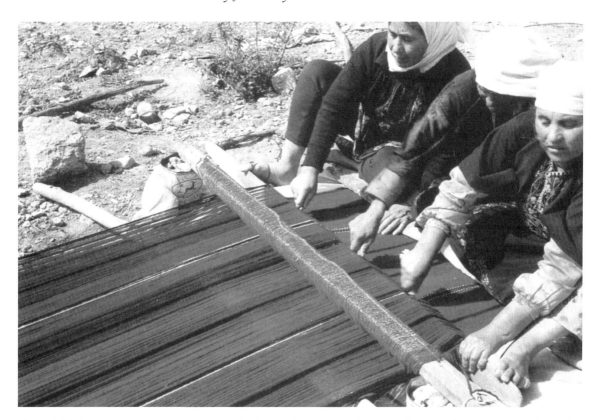

Figure 2.9. Women weaving on a ground loom in the Southern Hebron Hills, October 1986. Village traditional weaving (from Schick 1998, pl. 3.12). Courtesy of Tal Vogel.

demands assured dry weather. The Chalcolithic subsistence agriculture was based primarily on wheat, barley and pulses.[93] In such an economy agricultural activity ceases after harvesting the wheat and lentils at the end of May–June and resumes after the advent of the winter rains. Thus, weaving could have been carried out during the agricultural off-season when labour was not required and as such smoothly integrated into the existing economic regime.

Although this reconstruction is theoretical, it is supported by local ethnographic analogies. A photograph taken forty years ago in a hamlet in the Judean heights shows a textile of similar dimensions to the one from the Cave of the Warrior woven by three women on a horizontal ground loom.[94] An almost identical photograph, taken in the same area ten years later, shows the same tool and the same mode of weaving (Fig. 2.9). No one would suggest it was other than an initiative of a household. The above reconstruction is both compatible with the human resources and organisational abilities of an extended family in an agricultural community in the Chalcolithic period. The production of large textiles would not have caused any major disruption in a household subsistence economy. On the contrary, it would have been grafted onto an existing structure which

[93] Gilead 1988, 420.
[94] Weir 1970, 17, pl. 8.

itself was geared to textile production for domestic consumption. In fact, we calculate that it was possible for an extended family to manufacture yarn and weave with ease two such textiles per annum. Thus, it is not only possible but also probable that textiles such as those found in of the Cave of the Warrior were the product of small-scale entrepreneurial activity within an extended family of one of the settlements of the region with access to raw materials.

In the light of our reconstruction we express reservations regarding the proposal of Levy *et al.* for the presence of an attached textile workshop at the purported sanctuary at Gilat.[95] They infer the presence of such a workshop from the presence of a number of awls and a comparatively large whorl assemblage.[96] However, neither do awls, which are primarily associated with leather craft and basketry,[97] nor does the high frequency of whorls at Gilat (N=163) indicate the presence of a sanctuary workshop, since whorls also occur in almost identical numbers at Bir es-Safadi (N=161), for example, but in household contexts.

'Two enigmatic concave mud basins' located in the middle of the sanctuary were proposed as retting basins for the flax used in Gilat linen production.[98] To ret is the Old English causative verb to rot. Retting is a stinking, bacteriological process defined by Baines as odious and by Carrington-Smith as nauseating.[99] Without unduly belabouring the point, the middle of the sanctuary is not a suitable locus of operation.

In sum, the domestic mode of production rejected by the excavators and analysts,[100] would appear to be an appropriate context in which textile production was conducted at Gilat, Bir es-Safadi and other Chalcolithic sites.

Conclusions

During the first half of the 1st millennium AD, the Jordan and Beit Shean valleys were famous for their linen. It is probable that flax was cultivated in the same area during the Chalcolithic period too. Fibre wetting bowls are encountered at the northern end of the Jordan valley and in the Beer Sheva valley. Frequently, raw materials and the associate technology travel in tandem. A north-south axis of dissemination of innovative technology and movement of associate raw material via the Judean Desert is reasonable, and the large assemblage of whorls from Teleilat Ghassul located at the southernmost end of the Jordan valley is worth noting. Thus, one may posit that flax was both grown and underwent primary processing in the Jordan valley and arrived in the Beer Sheva valley sites as processed fibre ready for spinning.

Whorls are encountered in domestic contexts in concentrations no larger than the domestic mode of production. There is no material evidence for either specialized workshops producing textiles for exchange or the hierarchy to support the system. It would appear that the textile production of the Chalcolithic period, even the manufacture of large textiles, was an integral component of the household economy, as confirmed by local ethnographic observations, adjusted to the rhythm of a mixed farming economy.

[95] Levy *et al.* 2006, 706, 735.
[96] Grigson 2006, 696; Levy *et al.* 714, 717.
[97] Campana 1989, 54.
[98] Levy *et al.* 2006, 735.
[99] Baines 1989, 15; Carrington-Smith 1975, 22.
[100] Levy *et al.* 2006, 720.

Acknowledgements

We wish to extend our thanks to Hamoudi Khalaily who drew our attention to the unpublished spindle whorl assemblages from Bir es-Safadi and Abu Matar. We also wish to express our gratitude to the staff of the CRFJ for their hospitality. Further more, we wish to thank the IAA staff at Beit Shemesh and at Jerusalem, particularly Galit Litani, who facilitated access to the spindle whorl assemblages and pertinent organic artefacts recovered from the Judean desert.

We wish to thank Tamar Schick who was generous with her time and shared difficult to obtain publications. In addition we thank both Catherine Commenge and Tal Vogel for the permission to use images from their publications. Thanks are also due to Alter Fogel who photographed a selection of Bir es-Safadi whorls.

Special thanks are extended to, Roi Levy, Tal Rosenman, Davida Degen, Karni Golan and Milena Gošić for help and encouragement. We also wish to express our thanks to Elizabeth Barber, Catherine Breniquet and Irene Good with whom we corresponded and who helped bring various aspects of this research into focus.

This research was funded by the Israel Science Foundation, grant No 395/05.

Appendix

Person-power investment in the production of the Cave of the Warrior wrapping sheet: from processed fibre to finished product.

Task	Length of yarn in metres/number of items	Rate of production per hour	Number of working hours per day	Work-person days
Splicing	41,300[1]	62m	6	111
Spinning	41,300	62m	8	83
Plying	41,300	95m	8	54
Warping*	24,500[2]	2150m	4	9
Spinning leash yarn	2,100[3]	62m	8	4
Plying and replying leash yarn	2,100[4]	95m	8	0.7
Preparation of leashes	1,750	60	6	5
Insertion of leashes	1,750	30	6	10
Weaving body of textile**	41,300[5]	62m	6	80
Knotting weft fringe***	4200[6]	60	6	60
Decorative bands	72	1.33	6	9
Twisting, plying and knotting warp tassels	360[7]	12	6	5
Total				**430.7**

Notes

[1] See text
[2] Based on 3,500 warp threads × 7m
[3] 1750 alternate warp threads × 0.3m × 4ply
[4] 2,100 ÷ 4 (ply yarn)
[5] Spun yarn divided by 7 (ratio of spinners to weavers)
[6] Double weft threads
[7] 180 tassels in each warp fringe

* warping requires a crew of three people
** weaving requires a crew of five people
*** knotting the weft fringe is done by one person alone while the other four members of the crew sit idle awaiting its completion

Bibliography

Aardsma, G. 2001. New Radiocarbon Dates for the Reed Mat from the Cave of the Treasure, *Radiocarbon* 43:3, 1247–1254.

Aharoni, Y. 1961. Expedition B. *Israel Exploration Journal* 11, 11–24.

Alon, G. 1980. *The Jews in their Land in the Talmudic Age* (70–640 CE), Jerusalem.

Baines, P.1989. *Linen: Hand Spinning and Weaving*, London.

Bar-Adon, P. 1980. *The Cave of the Treasure*, Jerusalem.

Barber, E. 1991. *Prehistoric Textiles*, Princeton.

Barber, E. 1994. *Women's Work: The First 20,000 Years*, New York.

Barshad, D and Shaked, I. 1998. The Discovery of the Cave and its Excavation. *In* T. Schick (ed.) *The Cave of the Warrior: 3–5*, Jerusalem.

Bird, J. 1968. Handspun Yarn Production Rates in the Cuzco Region of Peru. *Textile Museum Journal* 2:3, 9–16.

Brunton, G. and Caton-Thompson, G. 1928. *The Badarian Civilization*. British School of Archaeology in Egypt and Bernard Quaritch, London.

Campana, D. 1989. *Natufian and Proto-Neolithic Tools*. BAR International Series 494, Oxford.

Carrington-Smith, J. 1975. *Spinning, Weaving and Textile Manufacture in Prehistoric Greece.* Unpublished PhD Dissertation, Hobart: University of Tasmania.

Cindorf, E., Horowitz, S. and Blum, R. 1980. Textile Remains from the Caves of Nahal Mishmar. *In* P. Bar-Adon *The Cave of the Treasure*, Jerusalem, 229–234.

Commenge, C., Levy, T. Alon, D. and Kansa, E. 2006. Gilat's Figurines: Exploring the social and Symbolic Dimensions of Representation. *In* T. Levy (ed.) *Archaeology, Anthropology and Cult*, London, 739–830.

Commenge-Pellerin, C. 1990. *La Poterie de Safadi (Beershéva) au IVe milléaire avant l'ère chrétienne.* Paris.

Crowfoot, G. 1931. *Methods of Hand Spinning in Egypt and the Sudan.* Bankfield Museum News, Halifax.

Crowfoot G. 1954. Textiles, Basketry and Mats. *In* C. Singer and E. Holmyard (eds) *A History of Technology* Vol. 1, Oxford. 413–455

Davies, N. 1913. *Five Theban Tombs.* Egypt Exploration Fund. London

Dempsey, J. 1975. *Fibre Crops*, Gainesville, Fla.

Frödin, O. and Nordenskiöld, E. 1918. *Über Zwiren und Spinnen bei den Indianern Südamerikas*, Göteborg

Garfinkel, Y. 1999. *The Yarmukians*, Jerusalem.

Gilead, I. 1988. The Chalcolithic Period in the Levant. *Journal of World Prehistory* 2.4, 397–437.

Gilead, I. 2009. The Neolithic-Chalcolthic Transition in the Southern Levant: Late Sixth-Fifth Millennium Cultural History. *In* J. Shea and D. Lieberman (eds) *Transitions in Prehistory*, Oxford, 115–355.

Gilead, I., Marder, O., Khalaily, H., Fabian, P., Abadi, Y. and Yisrael, Y. 2004. The Beit Eshel Chalcolothic Flint Workshop in Beer Sheva: a Preliminary Report. *Journal of the Israel Prehistoric Society* 34, 245–263.

Goitein, S. 1955. Portrait of a Yemenite Weavers' Village. *Jewish Social Studies* XVII, 1, 3–26.

Grigson, C. 2006. The Worked Bone from the Chalcolithic Site of Gilat: Interim Report. *In* T. Levy (ed.) *Archaeology, Anthropology and Cult*, London, 685–702.

Harris, C. and Nicholas T. 1988. *Time-Save Standards for Landscape Architecture: Design and Construction Data,* New York.

Harvey, J. 1996. *Textiles of Central Asia*, London.

Hilden, J. 2010. *Bedouin Weaving of Saudi Arabia and its Neighbours*, London.

Hochberg, B. 1977. *Handspindles.* Santa Cruz.

Hoffman, M. 1964. *The Warp-Weighted Loom.* Oslo.

Jull, A. Donahue, D. Carmi, I. and Segal. D. 1998. Radiocarbon dating of Finds. *In* T. Schick (ed.) *The Cave of the Warrior*, Jerusalem, 110–112.

Kissell, M. 1918. *Yarn and Cloth-Making: An Economic Study.* New York.

Koehler, E. 2010. Prehistory. *In* A. Lloyd (ed.) *A Companion to Ancient Egypt,* Vol. 1, Malden, MA, 25–47.

Koren, Z. 1998. Color Analysis of the Textiles. *In* T. Schick (ed.) *The Cave of the Warrior*, Jerusalem, 100–106.

Landi, S. and Hall, R 1979. The Discovery and Conservation of an Ancient Egyptian Tunic. *Studies in Conservation* 24, 141–151.

Levy, J. 2006. The *Chalcolithic Textile Industry in the Southern Levant: Tools, Technology and Products.* Unpublished MA Thesis. Ben-Gurion University of the Negev, Beer Sheva

Levy, T. 2006. Archaeology, Anthropology and Cult: Exploring Religion in Formative Middle Range Societies. *In* T. Levy (ed.) *Archaeology, Anthropology and Cult*, London, 3–33.

Levy, T. Connor, W. Rowan, Y. and Alon, D. 2006. The Intensification of production at Gilat: Textile Production. *In* T. Levy (ed.) *Archaeology, Anthropology and Cult*, London, 705–738.

Mallon, A. 1933. Les Fouilles de l'institut Biblique Pontifical dans la valle du Jourdain. *Biblica* 14, 294–302.

Moorey, P. 1988. The Chalcolithic Hoard from Nahal Mishmar, Israel in Context. *World Archaeology* 20/2, 171–189.

Perrot, J. 1967. Neve Ur, nouvel aspect du Ghassoulien. *Israel Exploration Journal* 17.4, 201–231.

Renfrew, J. 1973. *Paleoethnobotany*, New York.

Roux, V. 2003. A Dynamic Systems Framework for Studying Technological Change: Application to the Emergence of the Potter's Wheel in the Southern Levant. *Journal of Archaeological Method and Theory* 10/1, 1–30.

Rowan, Y. and Golden, J. 2009. The Chalcolithic Period of the Southern Levant: A Synthetic Review. *Journal of World Prehistory* 22, 1–92.

Schick, T. 1998. *The Cave of the Warrior: A Fourth Millennium Burial in the Judean Desert.* Jerusalem.

Schick, T. 2002. The Early Basketry and Textiles in the Northern Judean Desert. *'Atiqot* 41.2, 223–239.

Vogel, T. 1989. Village Weaving in the Southern Hebron Hills. *Ariel* 75, 75–87.

Vogelsang-Eastwood, G. 1993 *Pharaonic Egyptian Clothing*, Leiden.

Weindling, L. 1947. *Long Vegetable Fibers*, New York.

Weir, S. 1970. *Spinning and Weaving in Palestine*, London.

Weir, S. 1976. *The Bedouin*, London.

Wheeler, M. 1982. Appendix F. Loomweights and Spindle Whorls. *In* K. Kenyon (ed.) *Excavations at Jericho* Vol. IV, London, 623–637.

Wulff, H. 1966. *The Traditional Crafts of Persia*, Cambridge, Mass.

3. Textile Production in Palatial and Non-Palatial Contexts: the Case of Tel Kabri

Nurith Goshen, Assaf Yasur-Landau and Eric H. Cline

The textile industry had a prominent place in the commercial enterprises of the ancient Near East during the Middle Bronze Age. We read in Old Assyrian texts about trading caravans transporting textiles, along with tin, from the east to Anatolia.[1] The volume of textile transported in those caravans – three times larger than that of the tin – and the potential profit of about 200% demonstrates their economic importance at the time. It is no surprise, therefore, that both in Mesopotamia as well as in the Aegean, the production of textile was under close control, probably palatial.

However, in recent years, we have come to appreciate the diversity of control strategies over manufacture and distribution. On the one hand, palatial workshops existed in Mari, as shown by correspondence between Zimri-lim[2] and the head of the workshops, Mukkannishum. In one of these letters, Zimri-lim orders Mukkannishum to send him 200 purple garments, 100 blue, 100 white, 100 black and 100 green garments. This letter gives us an insight into the scale of palatial production and control over the products. Similarly, in a letter found in Hazor, probably addressed to the king of Hazor from a Mesopotamian ruler (possibly Yasmah-Addu of Mari), he and other subjects are ordered to send a long list of thousands of garments of varied quality to Mari, in preparation for a celebration.[3] On the other end, in Ebla, as Peyronal suggested, alongside the industrial operation that is reflected in the texts, private manufacture also took place at the palace.[4]

Another, later, case is that of the Mycenaean palaces, which controlled all the phases of textile production – from the cultivation of flex and the raising of palatial herds for wool[5] to the manufacture of textiles. This was done through a complex system of palatial workshop and the collection of textiles as taxes from private manufacturers.[6] The control strategy, however, was not uniform. Work allocation differed from palace to palace, as the cases of the production at the

[1] Veenhof 1972, 25.
[2] *ARM* XVIII, 11; Ziffer 1990, 51*; Durand 2009.
[3] Horowitz and Oshima 2006, 83–85.
[4] Peyronal 2008, 27.
[5] Halstead 2001; Burke 2010.
[6] Killen 2008.

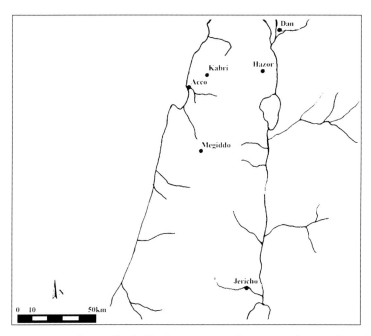

Figure 3.1. General map of Kabri in the Eastern Mediterranean (by Nurith Goshen).

palace at Knossos *vs.* the palace at Pylos demonstrate.[7] Gordion presents another case where textile manufacture was part of the political economy of Phrygia. There, large scale textile production was standardized and closely controlled by the local elite.[8] Interestingly, this industry was closely connected with food preparation activities.

The work of Nosch and Perna has stressed the important place of the cultic sector in production and in the use of textiles according to the textual evidence.[9] They demonstrate that while under palatial control, the loci of production were mostly outside the palace itself, and were not identified in the archaeological record. A different case of textile production under religious control is the Northern Workshops at the cultic precinct at Kition, in which large numbers of loom-weights, found in a non-domestic, LCIIIA industrial structure, indicate the role of textile production in the Cypriot temple economy.[10]

While ample attention has been given to the study of textiles in palatial contexts in both the Aegean and Syro-Mesopotamia, very little work has been dedicated to the role of cloth in the Canaanite palaces of the Middle and Late Bronze Age.

At the palace at Tel Kabri – the capital of a Middle Bronze Age Canaanite kingdom located in the western Galilee region of modern Israel (Fig. 3.1) – the evidence points to small-scale production that has much in common with the evidence of textile manufacture in Kabri's private

[7] Burke 2010, 97.
[8] Burke 2010, 152.
[9] Nosch and Perna 2001.
[10] Yasur-Landau 2010, 153–154.

dwellings dating to the same period, as well as with the evidence from other private dwellings in Canaan, such as those excavated in Jericho. In fact, the continued absence of palatial workshops or administrative control in Canaanite palaces, despite over a century of excavations, suggests that this small-scale manufacture was common practice in this part of the world.

Tel Kabri was first excavated by Aaron Kempinski and Wolf-Dietrich Niemeier from 1986–1993. They opened five excavation areas on the tel. Relevant for our discussion are Areas C, D, and F. In Area C, at the north of the tel, parts of the city rampart and adjacent residential houses were uncovered. In Areas D and F – north and south of the old Nahariya-Meona road – excavations revealed the remains of a monumental building, a palace.

A new project co-directed by Yasur-Landau and Cline began at the site in 2005, renewing the excavations in Areas D and F. As no textual or relevant iconographic evidence were found on site, with the exception of one Syrian seal from Tomb 984, on which a figure dressed in Syrian-style tunic closed on one shoulder by a toggle pin is depicted, the evidence of textile manufacturing recovered at the site – both in the earlier and in the later excavations – is limited to spindle whorls and loom-weights.[11]

More than 70 loom-weights and 12 spindle whorls have so far been recovered at Kabri, originating from both palatial and residential contexts of the Middle Bronze Age. Other finds, such as bone needles and perhaps a weaving plate, will not be discussed here. It is also important to note that whereas the loom-weights are associated with the introduction of the vertical warp-weighted loom, textile production by a horizontal-loom could have taken place at the site but left no evidence.

The vast majority of the evidence for textile production at Tel Kabri, namely 63 MBA loom-weights out of the total of 73 found at the site, comes from the palace area – Areas D and F. There the area that yielded the largest concentration of weights was the official part of the palace, which also contained the well-known painted floor and fragments of wall fresco decorated in Aegean style. Most of these loom-weights and spindle whorls were deposited during the final destruction of the palace, at the end of the Middle Bronze II B period, in the middle of the 16th century BCE.

In a previous study of the material, three concentration spots were identified in the palace, although conceivably all could have belonged to the same assemblage that fell from the second floor (Fig. 3.2). The first is Room 690, where 26 loom-weights were originally found, along with 10 more from immediately nearby, as well as five more found during the 2009–2010 season of excavation, bringing the total count to 41. The second concentration is in the north-eastern corner of the palatial area, where six loom-weights were found. The third concentration spot is in the north of Room 751, where another six loom-weights were found.

As a rule, the loom-weights were not found in a primary context - and were not found organized in a line or a group on the floor. Instead, they were found in destruction debris that was the result of the collapse of the second floor.[12] This interpretation is also supported by the scattered pattern of the loom weights. So, even though the loom weights were found in the official area, i.e. the first floor, of the palace, we should not reconstruct the textile production as occurring in this area, but rather in an area above it, *i.e.* on the second floor. Specifically, we would like to

[11] Kempinski 2002, 344, fig. 9.12.
[12] Oren 2002, 363.

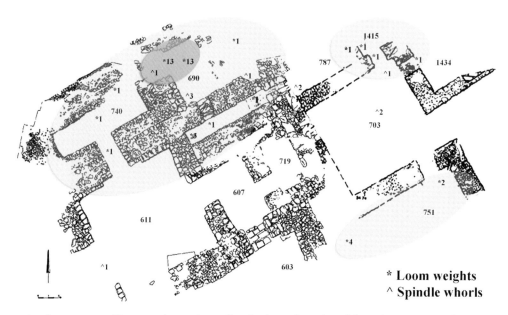

Figure 3.2. Distribution map of loomweights and spindle whorls in the palace (plan of western part by Dov Porotzky, eastern part plan after Kempinski 2002, fig. 4.69).

point to the room directly above Room 690, *i.e.*, immediately above the spot where the largest deposit of loom-weights was found (Fig 3.3). This room is delimited with the newly identified external wall of the palace, wall 673. Assuming that a window was fixed in this wall, it could have had the necessary amount of light needed for weaving activity, perhaps like the large window in room 3 of the West house in Thera, where a concentration of loom-weights was also found.[13]

The loom-weights typical of MB Tel Kabri (and of the entire region at the time) are made of fired clay (Fig. 3.4). Most of the loom-weights (42) have a conical shape, while a few (9) are conical truncated. Unfortunately, the preservation state of the others (21) does not allow us to reconstruct their shape. In general, their weight ranges from 235g–600g and their thickness varies between 55–72mm. However, the weight range of the loom-weights in the deposit in and around Room 690 is smaller, between 280–550g. A difference of over 200g, however, still leaves us with a dispersed pattern. Only four of the loom-weights weigh between 500–550g. Four more are between 401–450g. The majority, more than 21, are between 300–400g. Loom weights of great weight difference are unlikely to have been used together on the same loom. We can point to two groups of weights that may have been used for the manufacture of different fabrics: *i.e.* the heavier weights and the smaller weights.

All of the weights could have been used for tabby or twill weaving, but since twill weaving was not common at this time, we will limit our current calculations to tabby weaving. While the smaller range weight would ideally be used with threads needing 10–15g tension – 0.2–0.3mm thick – the heavier weights would be better suited with threads needing 20–30g tension – 0.4–1.2mm thick. In both cases, 4–8 threads will ideally be used per centimetre, yet the width of the thread would

[13] Tzachili 2008, 191.

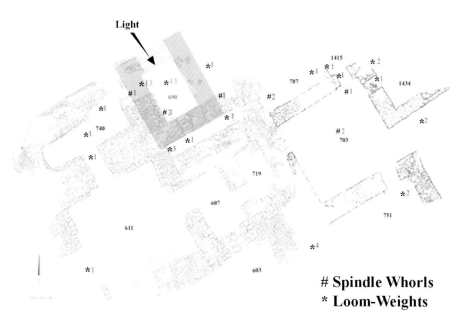

Figure 3.3. Suggested reconstruction of a second floor (by Nurith Goshen).

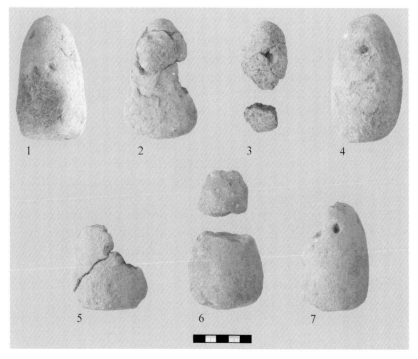

Figure 3.4. Examples of loom weights from the palace at Kabri (photo by Pavel Shrago).

be different. Therefore they are unlikely to have been used in the same setup. Thus, production of at least two different types of cloth can probably be hypothesized at Tel Kabri.

This comes as little surprise, since the above mentioned Middle Bronze Age II tablet from Hazor mentions 20 different types of textile items, of varying quality.[14] The terms used there for regular clothes and delicate clothes ([túg] SI.SÁ.[SAG/ÚS] and [túg] SAL.LA[SAG/ÚS]) show that both come in two categories of quality; we may have a similar variation at Kabri.

Conversely, unlike the large scale production at Hazor, as attested by the text just mentioned, the situation from the archaeological finds in Kabri is of a different scale. Considering that the width of all the loom-weights on the site was fairly regular, ranging from 52–69mm and with the majority between 55–65mm, the number of loom-weights needed to create a 1m wide cloth was about 20–40 in the front row and 20–40 in the back row. Therefore, according to the number of loom-weights that we found (63), it is unlikely that more than one or two looms were positioned in the upper floor of the palace.

The evidence from the residential area – Area C – does not amount to much. Only six loom-weights were found in this area. They were not found in a single context but rather were scattered in different rooms of a residential unit. Like all the weights found at the site and dated to the MB, these were also conical in shape and made of fired clay. Their size and width are compatible with the heavier loom-weights found in the palace, averaging *c.* 450g.

At Um-Tumma – an MBA village site in the vicinity of Tel Kabri – the same type and size of loom-weights were found in a survey, indicating a similarity between the city and rural areas.[15] Garstang's excavations in the domestic quarter at Jericho uncovered a house whose lower floor was used as a shop, while the upper floor was used as living quarters for the inhabitants, as well as for textile production on a domestic scale.[16] This domestic environment is similar to that found in the Palace at Kabri.

Out of the 73 MB loom-weights found at Kabri, six weights bear impressions of scarabs.[17] One was found on the surface of the residential quarter, one was found on the upper tel (Area E), and four were found in the palace. Two at the latter location were found among the large concentrations of weights in and around Room 690 and another was found among the weights in Room 751. Only one impression is actually legible; it was found on the surface and bears a scarab stamp with traces of a ring press. It was dated to the 12th–13th Dynasties.[18] The others bear the oval shape of the scarab, with the frame distinguishable.

The stamped weights do not have common properties when it comes to size, weight, or even the location of the stamp. It has been suggested that the stamps indicate the marking of loom-weight sets or even of workshops or further, as Kempinski suggested, a marker of ownership, mainly of the loom, by local officials.[19] However, a stamped weight which was found in the residential area indicates that the practices in and out the palace were similar.

The phenomenon of scarab-stamped weights is not unique to Kabri, since examples are known in the Levant from Ta'anach, Megiddo, Tel Nami, Gezer, and other sites.[20] This phenomenon of

[14] Horowitz and Oshima 2006, 83–85.
[15] Frankel and Getzov 1997, fig. 4.62.2.
[16] Ziffer 1990, 18, 17.
[17] Oren 2002, Fig. 10.8.
[18] Mizrachy 2002, 338–339, fig. 9.5.
[19] Oren 2002, 372.
[20] Ta`anach: Lapp 1969; Megiddo: Loud 1948, pl. 164; Tel Nami: Artzy and Marcus 1995, 174–194; Gezer: Macalister

stamped loom-weights has been also attested in the Aegean at sites on Crete such as Knossos and Zakros. The nature of this practice is not yet fully understood.

In the Middle Bronze Age, scarabs were adopted by the Canaanite population and were, for the most part, locally produced.[21] Their use was modified to satisfy local habits. The absence of any seal impressions in any clear administrative context in the palace of Kabri, and indeed in any of the Canaanite palaces, strongly negates any connection between these stamped loom-weights and palatial administration.[22] Instead, it has been attested that, in the Levant, scarabs were mainly used in funerary contexts.[23] At Kabri, indeed, all uses of scarabs, besides stamping loom-weights, are limited to amulets in burials.[24] Therefore, we may suggest that the stamping of the weights was not connected with regulating

Figure 3.5. Decorated spindle whorl from room 690 (2302-2) (Photo by Jonathan J. Gotlieb).

administration by a centralized power but may be better interpreted as imbued with symbolic affinities.

In addition to the loom-weights, 11 spindle whorls were found in the earlier excavations in the palace area and four more in the renewed excavations. They were made of various materials such as stone, bone, and clay, and differed in shape and weight. The analysis of the spindle whorls suggests production of thin to medium spun yarn (c. 0.3–0.7mm), such that matches the ideal thickness to be used with the local loom-weights.[25] Their distribution is also compatible with that of the loom-weights (Fig. 3.2).

During the 2009–2010 season of excavation at Tel Kabri, a decorated ivory spindle whorl was discovered in Room 690, in the same approximate context as the loom-weights (Fig. 3.5). Comparanda for this spindle whorl come from Megiddo and the palace of level VII at Alalakh.[26] Unfortunately, the exact provenance at Alalakh is not given, as Woolley simply stated: "I suppose that it was Schliemann who first brought the spindle-whorl into prominence – a venial error on his case, but today there is no excuse for wasting space and money on this monotonous and profitless material."[27] This decorated spindle whorl, although not unique at the time, may suggest an elevated status of those using the loom which was situated in the palace.

1912, 74.

[21] Ben-Tor 2010, 92.

[22] Scarab stamps on jar handles are known in the Levant, for example at Tel Akko: Beeri 2008, 330. This practice has no attestation at the Kabri palace. Its meaning also remains unclear.

[23] Ben-Tor 2010.

[24] Mizrachy 2002, 319.

[25] Andersson in this volume.

[26] Loud 1948, 16–17, pl. 171; Woolley 1955, 275.

[27] Woolley 1955, 271.

The evidence discussed so far does strongly points to two modes of small-scale production at Tel Kabri – one in the palace, the other in private houses.

The ivory spindle whorl from Room 690, the only one of its type at the site and a rather uncommon find in Canaan, hints at the co-occurrence of spinning and weaving in the royal apartments on at the second floor of the palace. It may well be that the small-scale textile production in the palace was domestic in nature, meant to answer the needs of the rulers of the site and their families. While it remains a possibility that large textile palatial workshops will be found in the second, unexcavated half of the palace, we believe that this is an unlikely scenario, as, to date, no workshop of any type – pottery, metal, faience, bone/ivory – has been located within the palace.

This small-scale textile production from both the palace and domestic structures at Tel Kabri strongly contrasts with textual evidence indicating the existence of large-scale textile workshops at the Canaanite city of Hazor, which manufactured fine clothing intended for international trade:. In a letter found at Hazor, dated to the Middle Bronze Age, the king of Mari asked a number of subordinates, one of whom must be the king of Hazor, to send him a long list of precious items, including at least 20 types of textile products, which include, among others, fine delicate (wool) clothing, finest linen clothing, regular wool and linen clothing, shirts of different styles, and headbands.[28] The reputation of Hazor as a place of textile manufacture continued in the Late Bronze Age, as evident in two Amarna tablets (EA 22 ii 41, and EA 25 iv 40) mentioning a "Hazor-(style) garment" and a fine linen article.[29]

The difference between Hazor and Kabri in terms of the nature of textile production may be explained by the different socio-economic and political strategies taken by the rulership of both sites. The kingdom of Hazor was closely connected to the Syro-Mesopotamian trade routes of which Kabri, with a coastal and more Mediterranean orientation, was not a part. The different cultural and economic affinities of both sites led also to deliberate choices in representational arts.[30] While the kings of Hazor commissioned only Syrian-style stone and bronze sculpture, the Kabri rulership seemed to have avoided any form of Syrian-style art, commissioning instead only Aegean-style frescoes and painted floors. We may therefore cautiously suggest that it is possible that lack of access to eastern markets interested in textile products limited textile production at Kabri to a small domestic scale in both palatial and extra-palatial contexts.

Abbreviations

ARM A. Parrot, and Dossin, G. (eds). 1950. *Archives royales de Mari*
EA Knudtzon, J. A. 1915. *El Amarna*. London.
IEJ *Israel Exploration Journal*

[28] Horowitz and Oshima 2006, 83–85.
[29] Horowitz and Oshima 2006, 83, note 21.
[30] Cline and Yasur-Landau 2007.

Bibliography

Beeri, R. 2008. *Tel Akko and the Urbanization of Akko Plain in the First Half of the Second Millennium BCE.* Unpublished PhD dissertation, University of Haifa.

Burke B. 2010. *From Minos to Midas, Ancient Cloth Production in the Aegean and in Anatolia.* Oxford.

Cline, E. H. and Yasur-Landau, A. 2007. Poetry in Motion: Canaanite Rulership and Minoan Narrative Art at Tel Kabri. *In* S. P. Morris and R. Laffineur (eds) *Epos: Reconsidering Greek Epic and Aegean Bronze Age Archaeology, Aegaeum 28,* 157–166.

Durand, J.-M. 2009. *La nomenclature des habits et des textiles dans les textes de Mari. Archives Royales de Mari XXX.* Paris.

Frankel, R. and Getzov, N. 1997. *Archaeological Survey of Israel. Map of Achziv (1) Map of Hanita (2).* Jerusalem.

Halstead, P. 2001. Mycenaean Wheat, Flax and Sheep: Palatial Intervention in Farming and its Implications for Rural Society. *In* S. Voutsaki and J. Killen (eds) *Economy and Politics in the Mycenaean Palace States,* 38–50.

Horowitz, W. and Oshima, T. 2006. *Cuneiform in Canaan, Cuneiform Sources from the Land of Israel in Ancient Times.* Jerusalem.

Kempinski, A. 2002. *Tel Kabri, the 1986–1993 Excavation seasons,* Tel Aviv.

Killen, J. T. 2008. Mycenaean economy. *In* Y. Duhoux and A. M. Davies (eds) *A Companion to Linear B: Mycenaean Greek Texts and their World,* Volume 1, 159–200.

Knudtzon, J. A. 1915. *Die El-Amarna-Tafeln.* Leipzig.

Lapp, W. P. 1969 The 1968. Excavations at Tell Ta'anek. *Bulletin of the American Schools of Oriental Research* 195, 2–49.

Loud, G. 1948. *Megiddo II.* Chicago.

Macalister, R. A. S. 1912. *The Excavation of Gezer.* London.

Marcus, E. S. and Artzy, M. 1995. A Loom-weight from Tel Nami with a scarab seal impression. *IEJ* 45, 136–149.

Mizrachy, Y. 2002. Glyptic Finds. *In* A. Kempinski (ed.) *Tel Kabri, the 1986–1993 Excavation seasons,* 319–348.

Nosch, M.-L. B. and Perna, M. 2001. Cloth in the Cult. *In* R. Laffineur and R. Hägg (eds) *Potnia: Deities and Religion in the Aegean Bronze Age. Aegeaum 8,* 471–477.

Oren, R. 2002. Loom Weights and Spindle Whorls. *In* A. Kempinski (ed.) *Tel Kabri, the 1986–1993 Excavation seasons* 363–372.

Parrot, A. and Dossin, G. (eds) 1950. *Archives royales de Mari.* Paris.

Peyronal, L. 2008. Spinning and Weaving at Tell Mardikh-Ebla (Syria): Some Observations on Spindle Whorls and Loom-Weights from the Bronze and Iron Age. *In* C. Gillis and M.-L. Nosch (eds) *Ancient Textile, Production, Craft and Society.* Ancient Textile Series 1. Oxford, 26–35.

Veenhof, K. R. 1972. *Aspects of Old Assyrian Trade and Its Terminology.* Leiden.

Yasur-Landau, A. 2010. *The Philistines and Aegean Migration at the End of the Late Bronze Age.* Cambridge.

Ziffer, I. 1990. *At that Time the Canaanites Were in the Land: Daily Life in Canaan in the Middle Bronze Age 2, 2000-1550 BCE.* Tel Aviv.

4. Textiles, Value, and the Early Economies of North Syria and Anatolia

David R. A. Lumb

> "My eyes were not always so red and sore as you
> now see them. My nose did not always touch
> my chin, nor was I always a servant. You must
> know that I am the daughter of Pope Urban X,
> by the Princess of Palestrina. Till the age of
> fourteen I was brought up in a castle, to which all
> the castles of the German Barons would not have
> been fit for stabling, and so costly was my dress
> that one of my robes was of more value than half
> the province of Westphalia."
>
> – Voltaire, *Candide*, Chapter 11.

With its treatment of the shifting scales of beauty, status and wealth, all in relation to the single metaphorical datum of a costly garment, the history of the Old Woman of Voltaire's *Candide* provides an appropriate prelude to a discussion that will focus on concepts of value, and the multiple scales upon which human is measuring worth.

Despite the fact that textiles have been carefully collected from archaeological sites for over a century, textile production has often been overlooked in studies concerned with the economic dynamics of the ancient Near East. In fact, until relatively recently, the study of textile crafts has been marginalized in studies of craft production (and consumption); thankfully this trend has begun to change.[1] The fibre crafts in general, however, continue to receive considerably less attention than metal working, for example. This phenomenon has been attributed, at least in part, to the fact that textile production in ancient times was generally perceived by scholars to have been women's work.[2] The rarity of textile finds in archaeological contexts has also contributed to a general lack of interest in the production of these materials.[3] This study examines concepts of value in relation to the production and consumption of textiles, while considering the often

[1] Good 2001, 210.
[2] Miller 2007, 66.
[3] Barber 1994, 5; Good 2001, 209.

noted, yet relatively poorly understood, economic role of these items during the Early Bronze Age in North Syria and Anatolia.

Although it is apparent that textiles were an important commodity in North Syria and Anatolia during the Early Bronze Age, it has often been difficult to identify and discuss the ways in which these materials were integrated into the overall cultural framework of the period. In particular, the role of textiles, as important items of exchange, has been indicated by contemporary historical sources, namely those contained in the tablet archives at Ebla.[4] At the same time, essential to our understanding of these items is an assessment of their cultural significance as consumables with perceived social value as well as inherent functional attributes.[5] In this regard, textiles straddle traditional categories of classification. As necessities of everyday life, items such as garments and clothing, or coverings for shelter and warmth, represent a broad range of utilitarian goods. Many of these same goods, however, have historically been considered sumptuous or elite items.[6] These categorizations, as humble commodities or exotic goods, are reflective of a tendency among archaeologists to view modes of craft production along a continuum between the extremes of independent and attached forms of specialization.[7] The prevailing assumption, of course, is that utilitarian goods are the product of independent specialists while prestige items are produced by attached specialists working to meet the needs of an elite.[8] This characterization assumes a relationship between the modes of production, and the circumstances of consumption, that is, how textiles were made and used. A closer examination of the role of textiles, however, brings into question the universality of these categories as individual items often fall into both categories at the same time, or can be categorized as the former or the later sequentially, switching from one role to the next depending on the social circumstances or physical context. For this reason, this study proposes an approach based on a more generalized discussion of *value* in relation to the production and consumption of textiles, while considering the often noted, yet relatively poorly understood, economic role of these items during this early period.

Value

The concept of *value* has been considered from multiple perspectives in many different fields; as noted by Renfrew "... it is one of the most elusive of concepts".[9] As a noun, it can pertain to 'worth' or 'cost', 'significance', 'usefulness', or 'merit'; as a verb, one may 'appreciate' or 'respect', even 'treasure' or 'cherish'; and an object may be 'valued' or can be 'valuable'. The notion is almost exclusively qualitative. Yet value, particularly with regards to material objects, is rarely discussed without a clear understanding of the quantitative implications of the concept. Most often these quantified notions have at their root an intrinsic form of value, manifest in the characteristics of the object itself, which is quantified in a relativistic sense. Karl Marx characterized this form of value as *use-value*, which he defined in opposition to *exchange-value*.[10] This is established in his well known work *Das Kapital,* where he states: "The usefulness of a thing, makes of this thing a

4 Matthiae 1981, 179; Pettinato 1981, 165–172.
5 Appadurai 1986, 40.
6 Helms 1993, 237-238.
7 Lewis 1996, 358.
8 Flad 2007, 111.
9 Renfrew 2001, 133.
10 Hollier and Ollman 1992, 7.

use-value".[11] Economic value, on the other hand, is derived from the recognition of *exchange-value*, whereby certain items have value relative to other items.[12] While *use-value* is based on the concept of 'utility', *exchange-value* combines notions of 'measure' and 'cost of production'.[13] Other forms of value are often conceptualized along similar scales, that is, from more to less or from less to more. This accumulative notion or sense of 'keeping score' as it were, establishes a conceptual basis for quantification along multiple scales of value.

The notion of multiple currencies has been an important element of anthropological considerations of value and has formed the basis for a considerable body of work in the field of economic anthropology.[14] Among researchers, the recognition of diverse scales of value came about largely as a response to the ecological approaches of processual archaeology.[15] In particular, it was felt that subjective criteria, such as belief systems and world view, were not afforded sufficient consideration in explanations of cultural and social change. Attempts to understand past ideological and symbolic systems formed the basis for work by Kent Flannery and Joyce Marcus, for example, who utilized ethnographically derived parallels to interpret the cosmological belief systems of the Formative Oaxaca.[16] Similarly, the role of artefact style as a means of information exchange was the focus of research carried out by Martin Wobst who explored the use of headdress to communicate group affiliation.[17] Both of these studies have been noted for their emphasis on understanding the subjective contextual meaning of archaeological materials and have been influential in the development of cognitive archaeology.[18] This connection has not gone unnoticed by researchers, as Robert Hall points out:

> "Cognitive archaeology begins with the assumption that we cannot really interpret prehistory without making a conscious attempt to understand the nature of humans as symbol-using social animals affectively involved in a perceived world that they have helped to create."[19]

Studies of symbolic systems have often been the focus of cognitive processual studies, a branch of cognitive archaeology concerned with communication and information storage.[20] These studies highlight the importance of scales of value outside of the economic and utilitarian realms. Similar approaches have also been developed along related theoretical branches.

The French sociologist Pierre Bourdieu explored the notion of multiple currencies in his consideration of the use of language and his writings on representation and symbol.[21] In particular, he was interested in the effect of sociopolitical context on the establishment of dominant language patterns. Through a critique of structuralism and Saussurian linguistics he established the framework for a theory that sought to explain communication.[22] In his view, the type of structuralist linguistics practiced by Saussure (and others) tended to view a single

[11] Marx 1965, 2.
[12] Marx 1965, 2.
[13] Chattopadhyay 1994, 55.
[14] Renfrew 2001, 125.
[15] Gibbon 1984, 171.
[16] Flannery and Marcus 1976, 374.
[17] Wobst 1977.
[18] Gibbon 1984, 171–179; Pruecel 2006, 148–158.
[19] Hall 1977, 515 cited in Pruecel 2006, 149–50.
[20] Preucel 2006, 148.
[21] Bourdieu 1977.
[22] Bourdieu 1977, 14.

aspect of linguistic practice, the dominant aspect, as the whole, thus inadequately addressing the social and historical processes that served to establish both dominant and subordinate linguistic practices.[23] In examining the historical development of linguistic traditions, Bourdieu considered multiple aspects of social relations and interaction, on the one hand, and symbolic representation, on the other, to develop his "theory of practice" which focused on, among other things, the social conditions of communication.[24] His emphasis was on the role of speech acts, that is, linguistic utterances or expressions, and the contexts of communication, which he viewed as linguistic markets. These markets were in essence arenas of exchange for linguistic capital in the form of socially symbolic utterances.[25] I would like to apply a similar perspective to the use of textiles. I propose that textile items be considered socially significant symbols of such things as wealth or status and, more generally, of aspects of identity. These items are imbued with a socially significant symbolic value that may be conceptually quantified and exchanged within the context of a *symbolic market.*

Certainly, the notion of a *symbolic market* has much in common with ideas developed in relation to *political economy.* Similarly, the symbolic significance of material objects, not only as signs and signifiers, but also as external storage devices embodied with cultural memory, has been well examined in the anthropological literature.[26] Material objects are generally viewed to be constitutive of symbolic meaning with the potential to impact upon individual social interactions and possibly even broader cultural trajectories.[27] Furthermore, the active role of material culture in shaping and not just reflecting social realities has been widely discussed, most notably in the work of Ian Hodder, among others.[28] In his study of human cognition, for example, Colin Renfrew also explores the process of human interaction with the material world.[29] He identifies the emergence of these new forms of symbolic interaction, which he refers to as "the substantive engagement process", as critical components of fundamental developments in human history.[30] I will return to this point later but for now it is sufficient to recognize that material objects often act, and indeed are actively employed by human agents, as socially significant symbols. In the form of everyday utilitarian objects, textiles can exist devoid of symbolic power, but they can also act as social signifiers, steeped in symbolic meaning.[31] As such, they cannot be addressed solely from the perspective of prestige goods (as signs of wealth and power) or as simple utilitarian items (devoid of all such meaning). The degree to which each of these modes of operation come into play necessitates that they should be considered more generally and at the same time. That is, it must be recognized that textiles operate on multiple levels within varying culturally contingent contexts.

The combined notions of 'multiple currencies', and 'the symbolic power of material objects', provide a general framework for a consideration of the multiple scales of value upon which textiles

[23] Bourdieu 1977, 23–25.
[24] Bourdieu 1977, 78-82.
[25] Thompson 1991, 18.
[26] Preucel 2006, 153.
[27] Appadurai 1986, 40; Preucel 2006, 148; Renfrew 1998, 1.
[28] Hodder 1982a, 212; 1982b, 4; Renfrew 2001, 126.
[29] Renfrew 2001, 124–29.
[30] Renfrew 2001, 127–28.
[31] See for example Wobst 1977; Wiessner 1983; Sackett 1985.

operate as both material objects and socially significant symbols. In this regard, I propose that textile objects are constitutive of what may be defined as a contextually dependent *operational value.* Within various conceptual and physical contexts, the *operational value* of textile objects changes depending upon the relevant value scales. Varying modes of *operational value* gain legitimacy based upon socially contingent circumstances, and within culturally specific frameworks, that may or may not be perceived by textile consumers. Such modes can represent everything from heavily symbolic value scales, such as those for status and religion, to the most basic of modes, that of the *use-value* described by Marx. *Operational value* is meant to reflect the more general concept of *value*, as described above, while recognizing the importance of *context* during *acts* of consumption. For textiles, these acts constitute any form of use. In my opinion, such consumption can be viewed, at least in some instances, as symbolic gestures that, in this regard, take on an operational quality much the same as the "speech acts" or "linguistic utterances" discussed by Bourdieu. This form of reference has slowly come to characterize my perspective on the subject, replacing an earlier tendency to try and relate to textiles as objects characterized as "goods" ranging in value from utilitarian to prestige items. As far as I am aware, *operational value* is not generally used to describe archaeological materials and any parallels with other uses of the phrase are unintended (it appears, for instance, within a substantial body of literature on the subject of modern day warfare describing the use of military intelligence and weapons). In general, the sense of the phrase, as it is used here, is that of 'realizing value through *operation*' and that, in essence, describes all of the modes of value discussed above. In contrast, Marx's *use-value* is limited to the material, non-symbolic realm; "... an edible material is useful in that it may be eaten.", for example.[32] Textiles derive their value through *operation*, and as we shall see, they often operate on several levels at once. *Operational value* defines the context dependent nature of the notion of multiple currencies. Let us now consider the case of textile production and consumption in North Syria and Anatolia during the Early Bronze Age.

Archaeological Textiles

A survey of the available evidence for textile production, and use, during the Early Bronze Age reveals, not surprisingly, a body of data fraught with gaps and holes, characterized by poor recording, poor publication, inattention to detail, and an overall lack of interest. This, thankfully, was more the case for studies in the past than it has been in recent years. It is, or course, common knowledge by now that ancient textiles rarely survive outside of specific circumstances. As a result, the study of textiles, and the fibre crafts in general, have taken a back seat to more clearly apparent, and more readily tangible, forms of material culture studies. On the other hand, the dry heat and salt-laden conditions of Egypt, or conversely, the moist, nitrogen rich bogs of northern Europe, for example, have both proven suitable environments for the preservation of textiles.[33] This can be attributed to the ability of these disparate environments to achieve a similar end, that is they both serve to inhibit the growth of bacteria, and this is key to the survival of the organic fibres that constitute nearly all the textiles of ancient times. More recently, there has been a growing interest in the study of these elusive objects as archaeologists and historians alike have

[32] Renfrew 2001, 133.
[33] Wild 2003, 7–8.

come to recognize the value of such "mundane" pursuits.[34] Through studies of craft production in regions where textiles do survive, as well as the emphasis by the New Archaeologists on the use of ethnographic comparison and analogy, it has been recognized that textiles themselves need not be present in order to explore questions of the production and use of these items in ancient times. An approach emphasizing the archaeological identification of 'activity areas', and associated 'activity sets' or 'tool kits', is perhaps the most appropriate method for the study of a ubiquitous craft, such as textile production, for which few and perhaps none of the products ever survive.[35] Certainly, it can be acknowledged that the nature of archaeological textile studies has truly been defined by the very absence of the subject matter, demonstrating to some extent the positive value of negative evidence. In most cases, the primary information on textile manufacture comes almost entirely from secondary evidence such as tools, zooarchaeological and paleoethnobotanical remains.[36] But the tools and accoutrements of textile production represent only a portion of the available evidence for the manufacture and use of these items.

In North Syria and Anatolia, the evidence for textile production during the Early Bronze Age is only just beginning to coalesce. The dramatic finds of the Ebla archives, no doubt have played a role in the growing appreciation of the significance of textile items in ancient times. It is significant that the archives are perhaps most well known for their extensive lists of textile consignments to and from the palace of the IIB1 settlement.[37] These lists, in addition to mention of specific items of dress and the contexts of production, provide a source of data unparalleled by any archaeological evidence from the period. In the shadow of such monumental historical sources, an interpretation of the sparse archaeological finds associated with textile manufacture becomes an invariably humbling task. As is often the case, however, a holistic approach, incorporating archaeological and historical data, reveals that the role of textiles during this period was both more widespread and more diverse than suggested by either the archaeological data or economic documents of the historical sources alone.

Before the advent of modern chemistry, and the introduction of synthetic materials, all textiles were produced from natural fibres. The development of techniques for processing these fibres into useable cloth has been considered by many to represent a technological revolution on par with crucial developments in the refinement of metals and the production of pottery.[38] In fact, it has been demonstrated that the fibre crafts predate both the ceramic and metal industries and were of major importance in ancient times.[39] Textile production in particular is a dynamic process that involves many stages. It demands raw materials such as wool, flax or cotton and an extensive amount of labour to process these materials into fibres suitable for later stages of production. Fibres must then be twisted into yarn or thread through the use of hand spinning, and some form of loom employed to weave the thread into cloth. Not only are these stages time consuming but they require a high degree of skill and organization. Among the many approaches to the study of ancient craft, production-process diagrams present a useful way to evaluate

[34] Good 2001, 209–211.
[35] Flannery and Winter 1976, 34.
[36] Barber 1991, 5; Brumfiel 1991, 226–227; Wattenmaker 1994, 95.
[37] Matthiae 1981, 179; Barber 1991, 166; Cooper 2006, 175.
[38] Barber 1991, 27.
[39] Barber 1991, 4; McCorriston 1997, 517; Good 2001, 209.

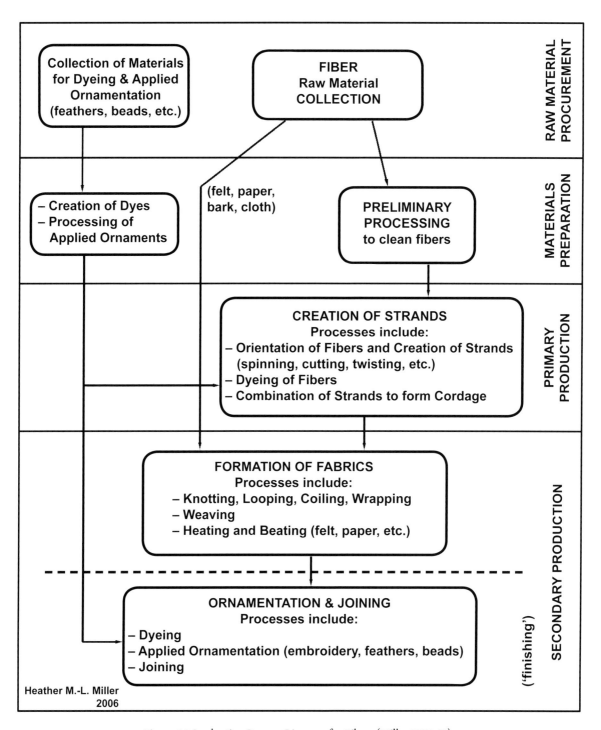

Figure 4.1 Production Process Diagram for Fibres (Miller 2007, 69).

the various stages involved in the manufacture of craft products.[40] For textiles, this approach can be particularly useful in identifying the various stages of production for which observable archaeological correlates may be found. Heather Miller has outlined, in general, these stages as they occur in the production of cloth (Fig. 4.1).

It is important to note, however, that specific stages of the production process can differ greatly depending on the type of organic fibre being used to produce the textile. Joy McCorriston has compared the processing requirements of flax and wool and notes significant disparity between the two processes.[41] As she points out, differences in the technologies required for the processing of each fibre source illustrate some of the ways in which changes in textile production have the potential to influence aspects of social organization and production cost.[42] Furthermore, the differing labour requirements of the two processes have the potential to conflict with, or complement, other areas of craft production and subsistence.[43] These dynamics, however, are not the focus of the current study. What is important to note here is the fact that each of these stages could potentially leave traces in the archaeological record, particularly those stages involving the use of tools. It is not surprising therefore that these tools constitute the majority of the archaeological evidence for the manufacture of textiles during the Early Bronze Age.[44]

A growing recognition of textile related tools in the archaeological record has broadened our understanding of the role of textiles and the fibre crafts during all stages of human history. A deeper knowledge of the tools themselves has also furthered our understanding of their roles as textile tools tend to be reflective of particular types of production that were taking place.[45] For example, spindle whorls, indicative of drop spinning, are a common find on archaeological sites. These artefacts indicate that a particular kind of thread production was likely taking place. However, the presence of such objects does not rule out the possibility that other forms of spinning were also in practice. Thigh spinning, for example, leaves no archaeological imprint.[46] Other common tools tend to include loom weights, wooden and bone awls, shuttles, heddles, beaters, spindles, and combs.[47] The contexts of these finds are often indicative of where these processes where taking place. Due to the mobility of many of these activities it is critical that contextual analysis be very carefully considered. A consideration of the mobility of textile production activities is something that I have found to be lacking in the literature. In addition, a whole host of installations and related artefacts can be indicative of secondary processing activities that include dying, fulling and washing of textiles as indicated by various containers, vats and platforms. The identification of these facilities remains problematic in many situations, yet with careful study they present excellent opportunities to expand our understanding of textile manufacture and the organization of production.

[40] Miller 2007, 22–30, 69.
[41] McCorriston 1997, 522.
[42] McCorriston 1997, 521–523.
[43] McCorriston 1997, 526.
[44] See Cooper 2006, 175.
[45] Barber 1991, 3–5; Wild 2003, 31–41.
[46] Barber 1994, 80.
[47] Wild 2003, 31–41.

Early Bronze Age Textiles of North Syria and Anatolia

As has already been mentioned, archaeological evidence for textile production in the Near East has suffered from a lack of proper recording and publication. Despite this fact, a general picture is now beginning to emerge as a result of the increased identification and reporting of such finds.[48] A survey of the finds reveals that many of these identifications remain tenuous, particularly as regards attempts to characterize the scale and organization of production. In general, however, an emerging trend suggests that in North Syria and Anatolia during the Early Bronze Age textile production was largely a domestic activity.[49]

In the upper Euphrates valley, evidence consists mainly of scattered remains such as 'terra-cotta bobbins', 'pierced clay disks', 'circular wheels' and 'post holes', overwhelmingly from domestic contexts.[50] The 'terra-cotta bobbins', found at Jerablus Tahtani, could be indicative of thread storage or perhaps weaving, if they were used as loom weights.[51] Such functionally derived interpretations are not especially well supported as yet. At Tell es-Sweyhat (phase 5) 'pierced clay disks' are likely candidates for spindle whorls, however, it must be recognized that these items are indicative of *thread* making activities and do not necessarily point to the production of 'cloth' in these areas, as was suggested by the site's excavators.[52] The 'circular wheels' found at Tell Banat are also likely candidates for spindle whorls, again indicative of thread production.[53] In this situation, the additional identification of 'post holes' presents an intriguing possibility of looms, but caution is still called for given the circumstantial nature of such evidence.[54]

Similar forms of evidence for the manufacture of textiles characterize the available data across the region. In the Amuq, recent excavations at the site of Tell Tayinat have produced numerous loom weights and spindle whorls dating to Amuq Phase J, the period just after the destruction of the palace G at Ebla.[55] This evidence is indicative of both weaving and thread making activities. Similarly, the burned wooden remains of two looms discovered below the destruction debris sealing Phase IIA at Tell Abu al'Kharaz in the central Jordan Valley provide direct evidence for weaving activities.[56] Here the presence of basalt loom weights indicates the use of the warp-weighted loom, while spindle whorls point to the production of thread.

Attempts on the part of researchers to identify textile production activities are encouraging. However, in many cases this new emphasis has also been problematic when identifiable textile related evidence is lacking. In such situations, archaeologists are faced with a dilemma. Often forced to choose between conclusions based on an absence of evidence or speculation about as yet uncovered contexts of production, researchers have struggled to make headway in this important area of research. Patricia Wattenmaker, for example highlights this dilemma in suggesting a reason for a lack of textile evidence at Kurban Höyük stating:

[48] for example see Wattenmaker 1998.
[49] Cooper 2006, 178; Richmond 2006, 215.
[50] Cooper 2006, 177–78.
[51] Peltenburg *et al.* 1997, 7.
[52] Holland and Zetter 1994, 139.
[53] Porter and McClellan 1998, 16.
[54] Porter and McClellan 1998, 16.
[55] Welton *et al.* 2011, 160.
[56] Fischer 2008, 202.

"It is also possible that horizontal ground looms, rather than warp-weighted looms, were used; the former do not generally leave archaeological traces".[57]

In most instances, and with frustrating regularity, it is simply the case that the available data is not conclusive, at least not beyond a general indication that some form of textile related activity had taken place. At Umm el-Marra, for example, "un-baked biconical spindle whorls" are "possibly indicative of specialized textile production".[58]

In my view, the explanatory connections between specific tool types and stages of production (*i.e.* spinning *vs.* weaving), much more than entire modes of organization (*i.e.* attached vs. independent), must be made explicit. Suggestions by Heusch and others that the 'plastered basins' and 'platforms', associated with 'yellow and red pigments' at Tell Habuba Kabira (level 7) are the remains of a textile dying facility are perhaps overly optimistic.[59] This type of data needs to be supported with proper scientific analysis in order to demonstrate the veracity of the claims. The types of interpretations described here are no longer considered insightful or rigorous by textile researchers, nor are they sufficient to answer the types of questions currently being asked. In the future, archaeological field work will be required to adopt specific analytical methodologies designed to support the research goals of textile studies intended. Such approaches have proven extremely informative when undertaken.[60]

At Kurban Höyük the evidence for EBA textile production is exceedingly sparse, as noted above. In total, the evidence is limited to four possible loom weights in period IV.1 and 10 possible spindle whorls ranging from periods IV.1–4.[61] Despite this fact, Wattenmaker provides a convincing interpretation of this "lack" of evidence. In contrast to the trend elsewhere in the Euphrates valley, the evidence from Kurban Period IV seems to suggest that textile related production activities did not take place within household contexts at this site.[62] This is supported by excavations within elite and non-elite household contexts (particularly sub-period IV.2), and the very low numbers of textile production related tools produced.[63] These interpretations are strengthened as a result of Wattenmaker's emphasis on an assessment of craft production activities within elite and non-elite contexts specifically, and the use of an appropriate field methodology. The use of 0.5cm mesh during the screening of surfaces, for example, is conducive to the identification of textile related tools.[64] At the same time, Wattenmaker notes that alternative modes of textile manufacture, not visible in the archaeological record, may have been in use.[65] As pointed out above, it should be emphasized that such evidence is not visible in the archaeological record, *given the field methods employed*. A sampling strategy attuned to the identification of textile fibres could possibly identify areas of textile production activities where the tools associated with this production have not survived. The identification of textile related activities or a lack thereof, necessitates a careful consideration of the sample from which conclusions are drawn, as we shall see. Regardless, it

[57] Wattenmaker 1998, 148 citing Barber 1994, 80–81.
[58] Curvers *et al.* 1997, 207.
[59] Heusch 1980, 168.
[60] see Lass 1989.
[61] Wattenmaker 1998, 146–148.
[62] Wattenmaker 1998, 146–147.
[63] Wattenmaker 1998, 147–148.
[64] Wattenmaker 1998, 33.
[65] Wattenmaker 1998, 146–148.

would seem that at Kurban Höyük household production of textiles did not occur during the Early Bronze Age.

The evidence from across Anatolia is much the same, consisting of assemblages of textile tools, often studied in insufficient detail to identify modes of production or systems of organization. Joanna Richmond has surveyed the available evidence from three sites across Asia Minor in an attempt to interpret the importance of textiles during the third millennium BC.[66] Her assessment of previously un-documented finds from Hisarlik, the site of ancient Troy in the west, Alişar Hüyük, in central Anatolia, and Şos Höyük, in the east, concludes that textile production was largely a household activity.[67] These evaluations, based on textile tools like the case studies above, also used the find contexts of these tools to define specific activity areas.[68] Richmond suggests that this evidence is indicative of a mode of production operating with a minimum of "centralized control", an interpretation reflective of the utilitarian–elite dichotomy discussed earlier. She has selected three sites that represent different kinds of settlements as well as a broad geographical area. While Troy and Alişar Hüyük can be characterized as larger urban centres, Şos Höyük is decidedly smaller. However, in all three locations, textile production activities were located within or near domestic areas.[69] The evidence can be summarized as follows:

At Troy (phases I to III) the excavations produced numerous spindle whorls, looms weights, and bone awls in addition to abundant faunal remains indicating the presence of large numbers of sheep and goat.[70] The remains of an *in-situ* loom appear to have been preserved as two postholes in room 206 (phase II). Richmond summarizes the findings of the excavators as follows:

> "Lying in near perfect formation between the holes and the wall were several neat rows of loom weights, indicating that the postholes had once contained the remnants of two uprights of a warp-weighted loom. Furthermore, scattered in the earth around the loom weights were hundreds of small gold beads that had apparently fallen from the cloth when the loom was abandoned during the fire that destroyed the house".[71]

While the most abundant textile related tools at Troy were spindle whorls, the assemblage clearly identified modes of spinning, weaving, matting and 'cloth maintenance'.[72]

The evidence from Alişar Hüyük was also dominated by spindle whorls, but also included bone awls, spools and spatulas, an assemblage characteristic of spinning and cloth maintenance activities, and loom weights indicative of weaving.[73] It is also noteworthy that extant textiles were recovered from late Chalcolithic burials at this site.[74]

The evidence from Şos Höyük was the least descriptive consisting of only a handful of spindle whorls and bone awls.[75] It is significant that all of these spindle whorls were made of bone.[76] Faunal data suggest that sheep and goat were abundant although the age of the animals at death

[66] Richmond 2006.
[67] Richmond 2006, 204–215.
[68] Richmond 2006, 205–206.
[69] Richmond 2006, 216–217.
[70] Richmond 2006, 207–210.
[71] Richmond 2006, 209 citing Blegen *et al.* 1950, 350–351.
[72] Richmond 2006, 209.
[73] Richmond 2006, 211.
[74] Barber 1991, 167; Richmond 2006, 211.
[75] Richmond 2006, 238.
[76] Richmond 2006, 213.

indicates that the primary use for these animals was for meat; direct evidence for weaving was not found.[77]

In general, the overall trend in Anatolia, as presented here, appears to coincide with the evidence for domestic production in North Syria. Similar data has also been documented at Arslantepe, Turkey. As part of a research initiative undertaken by the Danish National Research Foundation's Centre for Textile Research (CTR) at the University of Copenhagen researchers from archaeological projects across the Central and Eastern Mediterranean were invited to submit their data related to textile finds in an effort to address some of the publication problems discussed above. With an emphasis on the 3rd and 2nd millennia BC, and following a standardized reporting format, the evidence from Arslantepe was compiled and is available through the CTR web page.[78] The main periods of interest are periods VIa and VIb, from which evidence for textile production includes: 21 loom weights, nine spindle whorls, five possible bone 'shuttles', one bone comb, one bone needle and a possible spool dating to period VIa; and two loom weights, 25 spindle whorls and a single possible bone shuttle from period VIb.[79] In both cases the evidence was recovered overwhelmingly from 'household' contexts and can be seen to reflect spinning, weaving and cloth maintenance activities.[80]

Also among the participants in the CTR project were the researchers from Tell Mardikh (Ebla), Syria.[81] Surprisingly, of all the material, ranging in date from 2600–1400 BC, only a total of 141 textile related tools were recovered.[82] Perhaps more significant is the fact that from this material only 39 spindle whorls and 6 needles can be attributed to the period of the Palace G archives.[83] The disparity between the relatively scarce textile production activity, evidenced by the archaeological data, and the widely cited economic importance of these items suggested by the tablet archives is striking. It should be noted, however, that archaeological exposures from this period are limited almost entirely to the palace contexts.[84] In this light, it is somewhat understandable that the data sets could point to such opposite conclusions, the implication being that the contexts of production, dating to the IIB1 settlement, have yet to be found or perhaps did not survive. While we may rest assured that our interpretive frameworks remain sound, the lesson of the case in point cannot be overlooked. Indeed, a closer examination of the evidence, on both sides of the question, is called for.

The archaeological evidence from the period of the Palace G archives (Period IIB1) at Ebla is characteristic of spinning and cloth maintenance activities. Peyronel has studied the materials and provides some quantitative data, noting that the spindle whorls reflect "… a preference for small, high-domed or truncated-cone whorls (with masses clustered between 6 and 20g) in limestone or basalt …"[85] These masses suggest that the whorls were used to produce both fine and coarse thread, although this cannot be confirmed.[86] Peyronel suggests that this represents "common"

[77] Richmond 2006, 213.

[78] Andersson and Nosch 2007.

[79] Andersson and Nosch 2007, 2–7.

[80] Andersson and Nosch 2007.

[81] Andersson *et al.* 2007, 1.

[82] Andersson *et al.* 2007, 1.

[83] Andersson *et al.* 2007, 1; Peyronel 2007, 27.

[84] Matthiae 1984, 48–51.

[85] Peryonel 2007, 27.

[86] Mårtensson *et al.* 2006, 7.

spinning by members of the palace.[87] This is an interesting proposition, because it suggests that the members of the palace were involved in everyday, independent production separate from the economic activity described by the archival evidence. He continues, pointing out "... it is very probable that in the workshops wooden spindle-whorls were employed, as suggested by the term *gis* (wood) before the word *bala* (spindle) in some texts"[88] While I do not wish to dwell on the interpretation of the term *gis bala*, it is worth mentioning that "spindles" usually are of wood and "spindle whorls" of stone or clay. The use of wooden spindle whorls, however, has been well documented ethnographically.[89] Peyronel shares the conventional view among scholars, suggesting that the 'workshops' discussed in the archives were located elsewhere outside the palace.[90] Considering the available evidence, I would agree with this position. However, given the mobility of spinning activities, in contrast to some forms of weaving, I am hesitant to conclude that the spinning activities evidenced by the palace finds need be considered separate from the overall textile production of the workshops. It has been noted elsewhere, for example, that spinning activities often constitute a "... bottleneck in the textile chain of production".[91] In light of this, spinning activities might be expected to dominate other weaving activities and therefore may have been more widespread as well. This may also account for the dominance of spindle whorls in the assemblages from across Anatolia. The evidence from the Ebla archives provides a means by which to evaluate some of these discrepancies.

The Palace G Archives at Ebla

The tablet archives at Ebla are overwhelmingly characterized by administrative and economic documents and they are extensive.[92] They contain documents relevant to the study of textile production and consumption describing the receipt and redistribution of textiles themselves, as well as a significant body of secondary information useful for understanding the role of these items. Information relating to livestock holdings, land use, and the payment of rations in exchange for spinning and weaving activities illustrate just a few of the many possible avenues from which to consider textile production.[93] At the same time, descriptions of specific garment types, and the distribution and exchange of these articles to particular individuals, illustrates aspects of consumption and use that could previously only be guessed or assumed. In order to provide some structure to this assessment I will consider aspects of production and consumption in turn.

In considering aspects of production it is logical to begin with the earliest stages of the process, that is, the procurement of raw materials. It is clear from the archives that textiles of linen and wool, Eblaite *gada* and *siki* respectively, were being manufactured at Ebla.[94] That the raw materials were being produced within the kingdom also seems clear. Situated in the plain of Idlib approximately 55 km south-southeast of Aleppo, Ebla is recognized as having possessed abundant agricultural land, as well as substantial territory for the herding of sheep and goats.[95]

[87] Peyronel 2007, 27.
[88] *Ibid.*
[89] Watson 1979, 179.
[90] Archi 1982, 209.
[91] Tiedemann and Jakes 2006, 305.
[92] Matthiae 1984, 150–158; Pettinato 1981, 44.
[93] Matthiae 1981, 178–182; Pettinato 1981, 155–179.
[94] Sollberger 1986, 6–7.
95 Archi 1993, 45–46.

Despite this fact, out of nearly 2000 tablets, only 40 texts concern the agricultural organization of the rural territory, specifically in the form of land allotments.[96] In addition, "some dozens" of texts relate to the delivery of agricultural produce to the palace; a delivery of "apples" and another of "garlic", appropriately in exchange for "fabric", provide a good example.[97]

The production of linen would have required agricultural land and for this we have evidence for two types of land allotment:1) *gána-kešda-ki* "bound land", which was palace owned and considered "fields for sowing", and 2) *GIŠ-ì-giš* or *GIŠ-ì-geštin* "olive groves" or "vineyards".[98] While fields for flax (linen) are never specifically mentioned, it can be assumed with some confidence that the "fields for sowing", *gána-kešda-ki*, would include this production. The production of wool can be indirectly considered through documents accounting for sheep, which are mentioned in monthly statements concerning supplies consumed by the city. Among these, Archi identifies three types: 1) animals supplied to the temples, 2) animals supplied to the court, and 3) animals designated as "travel provisions" or *nìg-kaskal* and *kaskal-kaskal*.[99] Animals designated under the first two types are together referred to as *gaba-ru* and constitute the total consignment to the *SA.ZA*, or "... the Palace in the widest sense ..."[100] Exact quantities of wool are difficult to determine based on these statements as they reflect the number of sheep slaughtered and do not necessarily account for the collection of wool; totals are between 800 and 1500 animals monthly.[101] On the whole, the number of sheep controlled at any one time by the *SA.ZA* was considerable, ranging from 80,000 to 110,000 animals, which could produce as much as 64 'tons' of wool based on estimates that each sheep would supply 800g of wool.[102] Given these numbers, it is clear that the city had at its disposal rather large quantities of raw material. However, these numbers can only be taken as general indicators of possible production capacity; they do not reflect actual wool consignments as far as we know. As noted by Archi, assessments of production capacity at Ebla have also been exceedingly difficult, particularly with relation to the amounts of cereals being produced.[103] In both the case of wool and linen, among other commodities, specific production quantities are almost impossible to estimate largely as a result of insufficient chronological details regarding the amounts of materials listed in the texts.[104]

In his assessment, Archi has totalled the amounts of incoming metals and textiles for periods of chronological certainty. These accounts are recorded on a type of document characterized by the word *mu-DU* or "delivery".[105] The lists describe deliveries from individuals, officials and administrative heads and include consignments of textiles ranging from 15 to 20 garments, from individuals, to as much as 2800 garments, from the administrative heads.[106] During the 17 years in which Ibrium was head of the Eblaite administration, between 1300 and 2800 garments were consigned to the city annually for a total of between 22,100 and 47,600 garments, likely in the

[96] Archi 1990, 50; 1992, 25.
[97] Archi 1990, 50.
[98] Archi 1992, 26; 1990, 51; 1982, 214–215.
[99] Archi 1982, 214.
[100] Archi 1982, 211–214.
[101] Archi 1982, 214.
[102] Archi 1993, 47.
[103] Archi 1993, 46.
[104] Archi 1993, 47.
[105] *Ibid.*
106 Archi 1993, 47–48.

range of 30,000.[107] Ibrium's son, Ibbi-Zikir, accounted for the delivery of 51,600 pieces of cloths and nearly an equal number of belts over a 10 year period, an average of 5160 garments per year.[108]

In general, these deliveries indicate that the productive capacity for linen and wool was quite large. The texts, however, are somewhat ambiguous as to how this production may have been organized. In Archi's view, the general picture offered by the land allotment texts suggests that middle and high officials were assigned plots of land which were probably cultivated by people living in the communities of that area in the form of "work-squads" or "corveés".[109] In one document (TM.75.G.1444) cited by Archi, the name of a local village is used as a reference for a plot of land assigned in a royal decree. This decree also included a "land-house" and an "oil-mill", *ki-é ì-giš* and *GIŠ-geštin* respectively.[110] The documents describing land allotments take the general format of *x gána-kešda-ki GN*, that is, "x measures of (sowable) land in village (general name)".[111] While a few texts indicate ownership of goods by specific individuals, it has not been possible to determine to whom the products of agricultural production belonged specifically, or what proportions were surrendered to the Palace.[112] Other texts are more specific in assigning large plots of land for the "maintenance" or *kú* of workers and officials.[113] In these cases production was collected by the palace and redistributed as *še-ba* or "rations".[114] While alternative interpretations of the social organization of the Eblaite state have been put forward, of interest for the moment are the demographics indicated by the archives.[115] It is, however, important to note that competing societal models do exist and that a focus the textile evidence may be an informative avenue of investigation for the interpretation of these models.

The Eblaite term *é-duru* was used in some cases to refer to the "work-squads" described above, which were comprised of 20 individual "workers" or *guruš*.[116] According to Archi, as many as 500 *é-duru* were dependent on the *SA.ZA*.[117] The organization of these work-units remains somewhat ambiguous as it appears that many *é-duru* clearly resided within the city, while others did not.[118] Texts describing the distribution of barley rations provide a useful means of assessing the dependents of the Palace, which suggests a total population of nearly 20,000 people residing within the city, either dependent on, or "indirectly bound" to the Palace.[119] The demographics are described as follows:

> "... one hundred members of the royal family; a few hundred high officials and members of the nobility and their families; and over 5000 Palace male servants, craftsmen and simple workers ... (and their families) ..."[120]

[107] Archi 1993, 48.

[108] *Ibid.*

[109] Archi 1992, 26; Archi 1990, 54–55.

[110] Archi 1990, 52.

[111] Archi 1992, 25.

[112] Archi 1992, 26–27.

[113] Archi 1990, 55.

[114] Archi 1992, 27.

[115] For an alternative assessment, see Schloen 2001, 267–283.

[116] Archi 1992, 25.

[117] Archi 1982, 212.

[118] Archi 1992, 25.

[119] *Ibid.*

[120] *Ibid.*

Based on these numbers, the annual textile consignments to the palace are barely sufficient to clothe the Palace servants, craftsmen and workers, let alone the royal family and the members of the nobility, allowing for a single garment annually.

The ration lists also provide an insightful look at the production of textiles at Ebla. In Archi's view, these lists suggest that 800 women were employed by the Palace for weaving, flour grinding and cooking.[121] Another text describes barley rations distributed to women as follows: 5 *dam Dar* and 36 *dam túg-n u-tag*, 5 "dye workers" and 36 "weavers" respectively.[122] As mentioned above, the location of these weaving and dying activities remains to be determined. However, references to different locations within the city may provide clues to its topographic layout.

Among the locations identified in the texts is the *é-sig*, translated by Pettinato as the "spinning mill" or "house of wool".[123] This would suggest that spinning activities took place in a designated location, separate from weaving activities. At the same time, a place called the *é-siki* or "wool-house" has been interpreted by some to indicate the place of weaving, but is more generally considered a location of wool storage, and later a repository for gold.[124] In addition, the *é-ti-TÚG* or "drapery warehouse", has also been identified as a place where textiles and gold were stored.[125] The term *ti-TÚG*, has been interpreted by Archi to mean "ribbed, pleated cloth" or "drapes".[126] If the *é-siki* does represent a weaving facility early on, its location may be indicated by its later use as a storage facility for gold, assuming that this commodity would be stored on the acropolis. While the same could also hold true for the *é-ti-TÚG*, such conclusions are only speculative.

Several attempts have been made to determine the topographic layout of the city of Ebla based on distributions of rations and other goods.[127] Based on these documents, the city appears to have been comprised of eight administrative units, four belonging to the Palace administration, the *SA.ZA*: 1) *é-en* "palace of the king", 2) *é-mah* "principle palace", 3) *gigir* "stables", and 4) *é-am* "house of the handmaid" or "people", and four belonging to the lower town: 5) *é-duru-ma* "the main district", 6) *é-duru-2* "district-2", 7) *é-duru-3* "district-3", and 8) *é-duru-4* "district-4".[128] As mentioned above, the texts indicate that as many as 800 women were assigned to weaving as dependents of the *SA.ZA*. This suggests that weaving facilities were part of the four administrative units of which the Palace was comprised, the most likely possibly being the *é-am* or "house of the handmaiden". This further suggests a location for these activities somewhere on the acropolis. At this point, however, we have no way of assessing to what extent textile production activities were limited only to these locations. In addition, the texts only point to production activities carried out under the Palace administration. This traditionally would represent a form of attached-specialization and the textiles being produced under this system would be classified as prestige goods. To what extent independent production activities may have been taking place is not clear based on the evidence from the archives. Furthermore, many important questions regarding the organization of production under the Palace administration have yet to be answered.

[121] Archi 1992, 25.
[122] Davidović 1987, 300–301.
[123] Pettinato 1981, 165.
[124] Archi 1993, 47.
[125] Archi 1999, 48.
[126] Archi 1999, 47.
[127] Arcari 1988; Pettinato 1976, 1981.
[128] Arcari 1988, 125.

In particular, a clearer understanding of the nature of *še-ba*, interpreted as 'rations' as opposed to 'wages', would have important implications for our interpretation of systems of power and control at Ebla. Fortunately, some of these questions can be addressed through a consideration of consumptive practices for which the tablet archives provide many clues.

The documents contained in the Ebla archives provide two key pieces of information regarding the consumption of textiles. The archive provides 1) a descriptive account of the types of items being taken in and redistributed by the Palace, and 2) accounts of the individuals involved in these transactions and the quantities of materials being exchanged. Let us deal first with the types of items described by the texts.

As indicated by the *mu-DU* accounts listed above, by far the most common textiles referred to in the Ebla archives are in the form of garments.[129] Among these, three pieces of clothing are regularly referred to: *á-da-um-TÚG*, a "cloak", *aktum-TÚG*, a "tunic" or "robe", and *íb-TÚG*, a "belt".[130] Additional items of clothing include: the *sal-TÚG*, which often appears in place of the *aktum-TÚG*, and a garment called a *gu-mug-TÚG*, identified by Archi as a simple item "… perhaps a kilt …" made of "shoddy wool" or *mug* and accompanied by some wool for a "waistband" or *íb*.[131] Archi has also identified a *sal-mug-TÚG*, which I would take to be a type of *sal-TÚG*, but also of "shoddy wool", this was also accompanied by an *íb*.[132] Other items include: the *ti-TÚG*, "ribbed cloth" or "drapes" as mentioned above; *gada-TÚG* "a cloth of linen for a garment"; *zara-TÚG*, which seems to be some form of "women's garment", likely a long robe; *gíd-TÚG*, a long garment or "shawl"; *túg-NI.NI*, another "robe" or "shawl" for women; *du-za-mu* a seemingly precious type of cloth used as a "cloak" or to make cloaks; *dúl-TÚG* a second quality type of "cloak" given in place of the *á-da-um-TÚG*; and finally *gu-zi-tum-TÚG*, again a type of "cloak" often in place of the *á-da-um-TÚG*.[133] There are of course individual cases where other items are mentioned, but on the whole this list is reflective of the range of garment types mentioned in the archives. Based on these types it is possible to identify what appear to be conventional forms of dress.

Furthermore, variations within the conventional forms may be reflective of socially contingent modes of operation. The basic assemblage appears to consist of three items: 1) a cloak, 2) a tunic or robe and 3) a belt.[134] Among these, several varieties or each are apparent, these can be organized as shown in Table 4.1.

While the conventional 'outfit' consisted of a cloak, a robe and a belt, it is clear from the archives that not everyone was afforded the whole assemblage. Often workers were given only a robe and a belt and did not receive a cloak.[135] In other cases, individuals were given items of seemingly lesser quality as indicated by the "shoddy wool" used to contruct the *sal-mug-TÚG* and *gu-mug-TÚG*, which it should be noted were accompanied only with an *íb* and not an *íb-TÚG*.[136] Other substitutions of lesser quality items may be indicated by the allotment of *dúl-TÚG* and *gu-zi-tum-TÚG* "cloaks" in

[129] Archi 1993, 51.
[130] Archi 1993, 50.
[131] Archi 1999, 48.
[132] Archi 1999, 27.
[133] Archi 1999, 46–50.
[134] Archi 1999, 45.
[135] Archi 1999, 46.
[136] Archi 1999, 46–47.

"Cloak"	"Tunic/Robe"	"Belt"	"Kilt"	"Shawl"
á-da-um-TÚG	*aktum-TÚG*	*íb-TÚG*	*gu-mug-TÚG*	*gíd-TÚG*
dúl-TÚG	*sal-TÚG*	*íb*		*túg-NI.NI*
gu-zi-tum-TÚG	*sal-mug-TÚG*			
du-za-mu	*zara-TÚG*			

Table 4.1. *Garments mentioned in the archives organized by type.*

place of the *á-da-um-TÚG* variety.[137] It is not always possible though to identify if these variations reflect levels of quality or perhaps some other criteria. For instance, the *zara-TÚG*, also thought to be a form of "robe", are clearly allotted only to women and therefore are reflective of gender based conventions of dress. The *á-da-um-TÚG*, on the other hand, were generally only given to men, though, as Archi points out "... sometimes it was also given to women, perhaps for their men and men of their retinue".[138] The situation is further complicated by the fact that statues of both male and female deities were also clothed in the *zara-TÚG*. The *túg-NI.NI*, also appear to reflect gender based conventions, often being allocated to *ne-de*, "she-dancers", as well as to the "nurses" and "midwives" of the queen.[139] Interestingly, *túg-NI.NI* were also given to the "priests of the gods" and to the "servants of the god Kura", the main deity at Ebla, as well as those "... taking part in the marriage ceremony of the royal couple".[140] In such instances it would appear that the garment could be used by men in the context of religious practice.

Additional variations among textiles are also indicated in the texts and include reference to single or multicoloured items, indicated by the terms *bar* and *gùn*, respectively, as well as garments, such as the *á-da-um-TÚG* and *íb-TÚG*, described as: single (I), double (II), triple (III) and even quadruple (IV) "folded" varieties.[141] These "folded" varieties were thought, early on, to possibly reflect levels of quality in the sense of "1st" and "2nd" quality.[142] Archi's interpretation of these designations as "folded" variations suggests a similar form of value scale; multiple folds would, in a very practical sense, require more cloth. He has also identified the term *sa*, which he interprets to indicate "of the finest quality".[143] Finally, the use of the term *du-za-mu*, seems to occur only in reference to the garments of the king, the vizier and the princes.[144] In this basic assemblage then we have already numerous possibilities for defining levels of status, wealth and aspects of identity in general. What then can be said about the *operational value* of these items and to what extent do they inform us about the economic role of textiles at Ebla?

In general, all of these garments can be said to have operated as basic functional items of clothing; in this sense, they are constitutive of Marx's *use-value*. At the same time, allotments of specific types of garments to groups of individuals characterized as workers, dignitaries and

[137] Archi 1999, 45–48.
[138] Archi 1999, 48.
[139] Archi 1999, 49.
[140] *Ibid.*
[141] Archi 1999, 45.
[142] Pettinato 1981, 165; Sollberger 1986, 7.
[143] Archi 1999, 45.
[144] Archi 1999, 49.

members of the royal family show clear patterns that appear to reflect aspects of social status, wealth and occupation as well as gender and religion. All of these represent operational modes in which textiles exist. The use of terms such as *bar* and *gùn*, to identify colour or decoration, and *mug* and *sa*, to characterize the quality of raw materials, indicate that measures of seemingly economic nature were also important. In this regard, some level of social differentiation is clearly reflected by the various types of garments described by the archives, as well as their distribution among the members of the Palace administration and its dependants. In my opinion, the conventional form of dress described by the cloak, robe and belt is reflective of a broadly defined social group, possibly an upper class. This segment of the population appears to be much better provisioned, for example, than the workers who received only a robe of "shoddy wool". The first level of social differentiation at Ebla, at least as it was defined by textiles, is indicated by the combination of garments that an individual received. Garments clearly operated as visual indicators at this level of differentiation. Within these groups, further differentiation is also evident, as indicated by the multiple varieties of each type of garment, the various types of cloaks for example, and the levels of quality as indicated by decoration, material type and the number of "folds", likely an expression of the amount of fabric to some extent. This level of differentiation is also reflective of an operational mode.

At this point it is difficult to accurately quantify these various operational modes. Quantification along culturally contingent scales becomes extremely difficult as this requires a consideration of specific items and their use, that is, particular types of garments and the contexts in which people wear them. In terms of economic value, it has also been extremely difficult to arrive at estimates of *exchange-value* largely as a result of the format of the documents themselves. As noted by Archi, the texts generally inform us of the exchange of multiple types of items of various quantities as a whole, failing to indicate unit cost.[145] What is significant is the fact that textiles clearly operated on multiples levels and served as everyday utilitarian items as well as social signifiers of culturally defined aspects of identity.

Given the enormous quantities described in the archives, it has often been noted that textiles must have constituted the main industry at Ebla.[146] As discussed above, however, these documents are almost exclusively related to garments, a majority of which appear to have been redistributed to the dependants of the Palace administration. In this light, it must be questioned to what extent the textile holdings recorded in the archives represent "merchandise" to be traded, as opposed to consignments within a complex redistributive system? That textile items were being exchanged with other city-states is not in question. The quantities in which they were exchanged though do not appear to have been as significant as once thought.[147] It would seem that documents describing the clear exchange of goods in trade are exceedingly rare with the majority of texts reflecting either redistribution within the Palace administration, or a system of reciprocal exchange between city-states.[148]

Archi continues to point out that:

[145] Archi 1999, 45.
[146] Pettinato 1981, 202; Matthiae 1981, 179.
[147] Archi 1993, 54.
[148] Archi 1993, 53–54.

"Data regarding Harran, Imar, Mari and Tuttul have been gathered in particular studies in order to illustrate these relations between states. The picture is constant: shipments by Ebla (according to an undeterminable frequency) of clothing for the king and elders of those cities (to each a complete outfit); and similar consignments to some other officials; in addition, gifts, *níg-ba*, of objects in precious metals for special occasions. A flow of more of less analogous items in the opposite direction balanced these expenditures from Ebla."[149]

This then would suggest that the value of textiles, as commodities of exchange, was perhaps of less significance than their use as utilitarian items and the role they played in social differentiation and gift exchange. Such a view would be consistent with the organizational structure of the Eblaite state recently put forth by David Schloen.[150]

As the products of a centrally organized palace administration these items reflect the traditional categorization of "attached – specialization" constituting prestige, or luxury goods. Evidence suggesting that exchange with other city-states happened mainly on the level of gift exchange would therefore seem to fit the traditional categories of classification. On the other hand, it is clear that the consumption of textiles took place largely within the Eblaite state and was practiced by identifiable socially differentiated groups representing both elite and non-elite segments of the population. In this regard, textile consumption does not appear to reflect an elite-utilitarian dichotomy but rather an extensive system of hierarchical organization with the palace administration at it's top. While this system does not fit the conventional model, it does however reflect a mode of consumption noticed by Patricia Wattenmaker in her study of elite and non-elite consumption at Kurban Höyük. In particular, she has pointed out that the appearance of non-elite consumption of specialist produced goods at Kurban corresponds to an increased level of sociopolitical complexity at the site.[151] A similar correlation, between the development of multiple social classes, and an increase in specialization has also been noted in the Indus valley.[152] The evidence from Ebla would suggest that a broadening of the range of socially identifiable garment types was taking place and may reflect that a process of social stratification was underway.

The archaeological evidence from North Syria and Anatolia reflect a similar situation if we consider, for example, the gold beads found in room 206 at Troy. This secondary form of decoration can be viewed as an indication that value-added garments were being produced. Gold beads are a clear sign of *economic-value* but at the same time, it is likely that such garments had an *operational value* as a marker of social identity. It is interesting to note that at Ebla, the garment type which displayed the greatest range of variability was that of the cloak. This item was an overt social marker, differentiating between those who had one, and those who did not. In this regard, it was a distinguishing piece of the assemblage that characterized an "elite class", that is, those individuals who wore the conventional three piece outfit. This was in contrast to the various individuals for whom only a robe and belt of varying quality were supplied. Furthermore, within this defined 'elite class' there appears to have been a high degree of internal differentiation, as illustrated by the many varieties of 'cloak'. Whether these various types were signifiers of wealth, status, or some other characteristic or social role, such as kinship affiliation, is extremely difficult to say. It is also important to recognize that classifications of 'elite' status can be misleading in contexts were

[149] Archi 1993, 55.
[150] Schloen 2001, 267–283.
[151] Wattenmaker 1998, 17.
[152] Miller 2006, 214–215.

we have only just begun to identify the components of social differentiation. It would be worth while, for example, to focus attention on the demographics of these social groups noting that the group defined by 'cloaks' is also characterized by a high degree of internal differentiation. Does this group represent a majority of the population or only a segment of the whole? Could we be dealing with an emerging 'middle class' and what does this indicate about the overall prosperity of the Eblaite state? These and other questions illustrate the many potential avenues for future research.

From a broader perspective, the total evidence for textile production and consumption at Ebla is selective in that it reflects only the activities of the Palace administration. As researchers we are left to compare this data with a body of archaeological evidence from the surrounding region that is of a comparatively 'rural' character. While the data from Ebla suggests social differentiation and attached modes of production, the evidence from the surrounding regions reflects domestic, independent specialization. This disparity seemingly points to a strong urban/rural dichotomy; however, it may simply reflect of the nature of the data from each of these differing sources. The evidence from Troy, for example, illustrates archaeologically many of the trends indicated only by the archival data at Ebla. At the same time the amount of specialist-produced garments at Ebla has been shown to barely have met the needs of the population within the city suggesting that additional production must have been taking place. Taken as a whole, it is tempting to interpret the evidence less in terms of a dichotomy between urban and rural society and more along the lines of a broad single system model, incorporating all members of society such as that put forth by David Schloen as what he calls the "Patrimonial Household Model".[153] In his view, the Eblaite state can best be understood as homogeneous system in which all members of society are organized into an extended household made legitimate by metaphorical kinship ties based upon patriarchal, patrilineal, and patrilocal hierarchy.[154] In contrast to Archi's understanding of the organization of the Eblaite state, in which palace organized work units were "staffed" by direct royal dependents, Schloen's proposed alternative suggests that these units are better viewed as "...ordinary households of farmers and professional specialist who give part time service to the king or to one of his high officials" in exchange for supplementary rations.[155]

The ubiquity of domestic production across North Syria and Anatolia may indicate that a high degree of independent production was still taking place. Furthermore, the non-elite consumption of specialist produced textiles at Kurban Höyük, as well as the broadening of social identifiers at Ebla points to an overall trend of social stratification for which the traditional modes of independent and attached production, and elite/non-elite consumption no longer hold true. Despite their relative scarcity in the archaeological record, a focus on the production and consumption of textiles has the potential to highlight both economic and sociopolitical developments during ancient times. Given the multiple scales upon which these items operate, an approach which considers textile objects from the more general perspective of *value* ultimately allows them to serve as a datum from which to measure the increasingly complex cultural framework of North Syria and Anatolia during the Early Bronze Age.

[153] Schloen 2001, 267–283.
[154] Schloen 2001, 282–283.
[155] Schloen 2001, 278.

Acknowledgements
I would like to acknowledge the assistance of Professor Timothy P. Harrison, Professor Douglas Frayne, and Professor John S. Holladay whose encouragement and support made this study possible. This research was supported by the Social Sciences and Humanities Research Council of Canada.

Bibliography

Andersson, E. and Nosch M.-L. 2007. *Technical report on textile tools, Arslantepe, Turkey.* Web-published research report http://ctr.hum.ku.dk/

Andersson, E., Lassen A. W. and Nosch M.-L. 2007. *Technical report on textile tools, Ebla, Syria.* Web-published research report http://ctr.hum.ku.dk/

Appadurai, A. 1986. Introduction: Commodities and the Politics of Value. *In* A. Appardurai (ed.) *The Social Life of Things: Commodities in Cultural Perspectives,* New York, 3–63.

Arcari, E. 1988. The Administrative Organization of the City of Ebla. *In* H. Waetzoldt and H. Hauptmann (eds) *Wirtschaft und Gesellschaft von Ebla,* Heidelberg, 124–129.

Archi, A. 1982. About the Organization of the Eblaite State, *Studi Eblaiti* 5, 201–220.

Archi, A. 1990. Agricultural Production in the Ebla Region, *Annals Archéologiques Arabes Syriennes* 40, 50–55.

Archi, A. 1992. The City of Ebla and the Organization of its Rural Territory, *Altorientalische Forschungen* 19, 24–28.

Archi, A. 1993. Trade and Administrative Practice: The Case of Ebla, *Altorientalische Forschungen* 20, 43–58.

Archi, A. 1999. Cloths at Ebla. *In* Y. Avishur and R. Deutsch (eds) *Michael: Historical, Epigraphical and Biblical Studies in Honor of Prof. Michael Heltzer,* Tel Aviv, 45–54.

Barber, E. 1991. *Prehistoric Textiles: the development of cloth in the Neolithic and Bronze Ages with special reference to the Aegean.* Princeton.

Barber, E. 1994. *Women's work: the first 20,000 years; women, cloth, and society in early times.* New York/London.

Blegen, C. W., Caskey, J. L., Rawson, M. and Sperling, J. 1950. *Troy: General Introduction, the First and Second Settlements, Vol. I, part I: Text, Vol. I, Part 2: Plates.* Princeton.

Bourdieu, P. 1977. *Outline of a Theory of Practice* (translated by Richard Nice). Cambridge.

Brumfiel, E. 1991. Weaving and Cooking: Women's production in Aztec Mexico. *In* J. M. Gero and M. W. Conkey (eds) *Engendering Archaeology: Women and Prehistory,* Oxford, 224–251.

Chattopadhyay, P. 1994. Marx's First Critique of Political Economy, 1844–1994. *Economic and Political Weekly* 29 (31), 54–59.

Cooper, L. 2006. *Early Urbanism on the Syrian Euphrates.* London.

Curvers, H. H., Schwartz, G. M. and Dunham, S. 1997. Umm el-Marra, a Bronze Age Urban Center in the Jabbul Plain, Western Syria, *American Journal of Archaeology* 101 (2), 201–239.

Davidović, V. 1987 The Women's Ration System in Ebla, *Oriens Antiquus* 26, 299–307.

Flad, R. K. 2007. Rethinking the Context of Production through an Archaeological Study of Ancient Salt Production in the Sichuan Basin, China. *In* Z. Hruby and R. K. Flad (eds) *Rethinking Craft Specialization in Complex Societies: Archaeological Analyses of the Social Meaning of Production,* 108–128.

Flannery, K. V. and Marcus J. 1976. Formative Oaxaca and the Zapotec cosmos, *American Scientist* 64, 374–383.

Flannery, K. V. and Winter, M. C. 1976. Analyzing Household Activities. *In* K. V. Flannery (ed.) *The Early Mesoamerican Village,* New York, 34–47.

Gibbon, G. 1984. *Anthropological Archaeology.* New York.

Good, I. 2001. Archaeological Textiles: A Review of Current Research. *Annual Review of Anthropology* 30, 209–226.

Hall, R. L. 1977. An Anthropocentric Perspective for Eastern United States Prehistory, *American Antiquity* 42, 499–517.

Helms, M. W. 1993. *Craft and the Kingly Ideal: Art, Trade, and Power.* Austin.

Heusch, J. C. 1980. Tall Habuba Kabira im 3. und 2. Jahrtausend: Die Entwichlung der Baustruktur. *In* J. C. Margueron (ed.) *Le Moyen Euphrate,* Leiden, 159–178.

Hodder, I. 1982a. *The Present Past: An Introduction to Anthropology for Archaeologistst.* Batsford: London.

Hodder, I. 1982b. Theoretical Archaeology: a reactionary view. *In* I. Hodder (ed.) *Symbolic and Structural Archaeology,* Cambridge, 1–15.

Holland, T. and Zetter R. 1994. Sweyhat. *In* H. Weiss (ed.) Archaeology in Syria. *American Journal of Archaeology* 98, 139–142.

Hollier, D. and Ollman L. 1992. The Use-Value of the Impossible, *October* 60, 3–24.

Lass, E. 1994. Quantitative Studies in Flotation at Ashkelon, 1986 to 1988, *Bulletin of the American Schools of Oriental Research* 294, 23–38.

Lewis, B. 1996. The Role of Attached and Independent Specialization in the Development of Sociocultural Complexity, *Research in Economic Anthropology* 17, 357–388.

Matthiae, P. 1981. *Ebla: An Empire Rediscovered* (translated by Christopher Holme).

Mårtensson L., Andersson E., Nosch, M.-L. and Batzer, A. 2006. Technical report part 2:2, experimental archaeology. Web-published research report. http://ctr.hum.ku.dk/

Marx, K. 1965. *Capital/Edited by Frederick Engels.* New York.

McCorriston, J. 1997. The Fiber Revolution: Textile Extensification, Alienation, and Social Stratification in Ancient Mesopotamia. *Current Anthropology* 38 (4), 517–549.

Miller, H. 2006. *Archaeological Approaches to Technology.* London.

Peltenburg, E., Campbell S., Carter S., Stephen F. and Tipping R. 1997. Jerablus Tahtani, Syria, 1996. Preliminary Report, *Levant* 29, 1–18.

Pettinato, G. 1976. Aspetti amministrativi e topografici di Ebla nel III Millennio a.C, *RSO* 50, 1–15.

Pettinato, G. 1981. *The Archives of Ebla: An Empire Inscribed in Clay.* Garden City: NY.

Peyronel, L. 2007. Spinning and Weaving at Tell Mardikh – Ebla (Syria): Some Observations on Spindle-Whorls and Loom-Weights from the Bronze and Iron Ages. *In* C. Gillis and M.-L. Nosch (eds) *Ancient Textiles: Production, Craft and Society.* Ancient Textiles Series 1, Oxford, 26–35.

Porter, A. and McClellan T. 1998. The Third Millennium Settlement Complex at Tell Banat: Results of the 1994 Excavations, *Damaszener Mitteilungen* 10, 11–63.

Preucel, R. 2006. *Archaeological Semiotics.* Oxford.

Renfrew, C. 1998. Cognition and Material Culture: The Archaeology of Symbolic Storage. *In* C. Renfrew and C. Scarre (eds) *Mind and matter: cognitive archaeology and external symbolic storage,* Cambridge, 1–6.

Renfrew, C. 2001. Symbol before Concept: Material Engagement and the Early Development of Society. *In* I. Hodder (ed.) *Archaeological Theory Today,* Cambridge, 122–140.

Richmond, J. 2006. Textile Production in Prehistoric Anatolia: A Study of Three Early Bronze Age Sites, *Ancient Near Eastern Studies* 43, 203–238.

Sackett, J. R. 1985. Style and ethnicity in the Kalahari: a reply to Wiessner, *American Antiquity* 50, 154–159.

Schloen, J. D. 2001. *The House of the Father as Fact and Symbol: Patrimonialism in Ugarit and the Ancient Near East.* Studies in the Archaeology and History of the Levant 2.

Sollberger, E. 1986. Administrative texts chiefly concerning textiles (L. 2752). *Archivi Reali di Ebla VIII.*

Tiedemann, E. and Jakes K. 2006. An Exploration of Prehistoric Spinning Technology: Spinning Efficiency and Technology Transition, *Archaeometry* 48, 293–307.

Thompson, J. 1991. Editor's Introduction. *In* J. Thompson (ed.) *Language and Symbolic Power.* (translated by Gino Raymond and Matthew Adamson), Cambridge MA, 1–31.

Voltaire, F. 1759. *Candide: Or All for the Best.*

Watson, P. J. 1979. *Archaeological Ethnography in Western Iran.* Tucson AZ.

Wattenmaker, P. 1994. Household economy in early state society: Material value, productive context, and spheres of exchange. *In* E. Brumfiel (ed.) *The economic anthropology of the state,* 93–101. Monographs in Economic Anthropology 11.

Wattenmaker, P. 1998. *Household and State in Upper Mesopotamia: specialized economy and the social uses of goods in an early complex society.* Washington.

Welton, L., Batiuk, S. and Harrison T. 2011. Tell Tayinat in the Late Third Millennium: Recent investigations of the Tell Tayinat Archaeological Project, 2008–2010, *Anatolica* 37, 147–185.

Wiessner, P. 1983. Style and Social Information in Kalahari San Projectile Points, *American Antiquity* 48, 253–276.

Wild, J. P. 2003. *Textiles in Archaeology*. Buckinghamshire.

Wobst, M. 1977. Stylistic Behavior and Information Exchange. *In* E. H. Cleland (ed.) *For the Director: Research Essays in Honor of James B. Griffen*. Ann Arbor, 317–342.

5. Technology and Palace Economy in Middle Bronze Age Anatolia: the Case of the Crescent Shaped Loom Weight

Agnete Wisti Lassen

Sources for understanding Anatolian society at the beginning of the 2nd millennium BC fall in two main groups: an extensive written documentation coming mostly from the Assyrian merchant colony at Kültepe (ancient Kanesh) in Central Anatolia, and material culture remains produced by archaeological excavation of the ancient sites in the region.[1] The texts record the Assyrian part of a wider international trade, in which interlocking networks of exchange ultimately connected Central and Western Asia to Mesopotamia, Asia Minor, Egypt and the Aegean.[2]

The Assyrians transported large amounts of tin and woollen textiles to Central Anatolia for retail. During the 1900s BC they established permanent trading colonies across Syria and Central Anatolia, and hundreds of Assyrian merchants and their families owned houses and lived abroad.[3] In addition, the Assyrian merchants took up a local trade in commodities, such as copper, meteoric iron, wool and locally produced textiles,[4] thereby partaking in the distribution of raw materials that were vital for the thriving Anatolian economies of the period.

The Assyrian records portray a decentralised system of micro-states and city-states in Anatolia, each governed by a ruling couple and an extensive palace bureaucracy. A number of official titles related to important local institutions are listed in their records, suggesting that the Anatolian palaces were extensive institutions with a substantial number of attached individuals.[5] The fundamentals of the Anatolian society in the Old Anatolian period are still poorly understood, but it seems clear that, at least in Kanesh, private ownership of property existed alongside an elaborate system of *corvée* labour related to the control of land and houses.[6]

[1] Preliminary excavation reports on Kultepe can be found in the journals *Belleten* and the *American Journal of Archaeology*. More comprehensive monographs on the excavations ther have been published by T. and N. Özgüç but cover only some seasons in detail: T. Özgüç 1950; N. Özgüç and T. Özgüç 1963, T. Özgüç 1969; 1986; 2003. Only about a quarter of the written documents have so been published, cf. Michel 2003, Michel 2005–2006.

[2] For a resent summary cf. Barjamovic 2011, chapter 1.

[3] Cf. Barjamovic, Hertel and Larsen forthcoming.

[4] For the trade in copper, cf. Dercksen 1996, for the trade in wool, cf. Lassen 2010, for textiles in the Old Assyrian period, cf. Michel and Veenhof 2010.

[5] For a list of the Anatolian officials and their functions, cf. Veenhof 2008, 219–233.

[6] See Dercksen 2004.

The texts do not yield satisfactory information on the organisation of local production, but the mere presence of Assyrian merchants indicates that foreign traders were in a position to exploit favourable economic conditions and cater to a wealthy political and social elite.[7] The textual sources offer only scant information on the subsistence economy of Anatolia.

In addition to a number of religious festivals, agricultural events appear to have made up the main chronological frame of reference in Kaneshite society. The local month-names provide evidence for the most important events during the year, but only one month bears a name related to animal husbandry: the month of 'plucking (the wool)' (*buqūnum*), implying that Anatolian society understood itself to be primarily agricultural.[8] The textual sources do not point to anything definitive about the organisation of sheepherding – only, one can say that the plucking was a sufficiently important to enter the calendar. Although the official title 'chief of herders' is attested, no officials said to be in charge of weavers or woollen textiles appear in the records.

The Assyrian records relate to a system of city-states in Anatolia where the foreign traders settled, and to some degree appropriated important economic functions in local society. Yet, Anatolia was not an economical and political vacuum until the Assyrians built their colonies, and a developed political, social and physical infrastructure had to be in place for the trade to function.[9] The Anatolian palaces became closely connected to the foreign merchants because of their economic importance, and due to their ability to provide both strategic resources (tin) and luxury commodities (textiles). It is with this socio-economic frame in mind that one should interpret the evidence for Anatolian textiles.

0 1 2 3 4 5 cm

Figure 5.1. Electrum middle whorl spindle from the Early Bronze Age Tomb L at Alaca Höyük (drawing from Barber 1991, 60)

In terms of textile technology Anatolia was a frontier zone between the Near East and Europe. Where the Near East traditionally used the high-whorl spindle, and Europe the low-whorl, Anatolia used the middle-whorl (Fig. 5.1). In its choice of loom Anatolia was part of a European or Aegean tradition, which made use of the warp-weighted loom (see Fig. 5.2).[10] Unfortunately, only very few actual textile remains have been discovered in Bronze Age Anatolia,[11] but some types of tools are preserved in the archaeological record. It is beyond the scope of the present paper to investigate

[7] Note that it has been argued that textiles functioned as a kind of currency in the Aegean and Anatolia in the Bronze Age, see Burke 2010.

[8] The other months are: the (time of) 'picking of the grapes' (*qitip kerānim*), the 'ploughing (and seeding)' (*erāšum*), 'when the sown comes up' (*inūmi eršum uṣi'u*), 'the sprouting' (*buqlātum*), 'when the grain is ripe' (*kubur uṭṭitim*), 'seizing the sickle' (*ana ṣibit niggallim*), 'harvesting' (*esādum*), 'harvest' (*ebūrum*), 'threshing floor' (*adrum*) (cf. Veenhof 2008, 238–246.) Plucking of wool is also mentioned in the Early Dynastic calendars of southern Mesopotamia, see Waetzoldt 1972, 10.

[9] Barjamovic 2011.

[10] Barber 1991.

[11] Skals, Möller-Wiering, Nosch forthcoming.

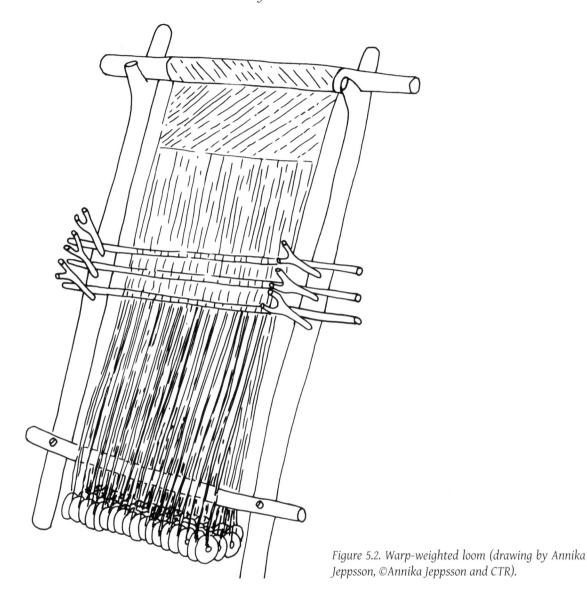

Figure 5.2. Warp-weighted loom (drawing by Annika Jeppsson, ©Annika Jeppsson and CTR).

the various types of textile tools and focus will be on one unusual type of textile tool, which is commonly found in excavations in Anatolia: the crescent shaped loom weight (Fig. 5.3).

Crescent shaped loom weights have been found in most sites in the central part of Anatolia (see Fig. 5.4) and distinguishes themselves in the repertoire of loom weights by often carrying seal impressions or other types of marks.[12] Presumably, it is this feature, which has led to a certain amount of debate about their identification and function as a textile implement. In an experiment performed at the Lejre Experimental Centre in Denmark in 2007 with a batch of

[12] See *e.g.* Alp 1968.

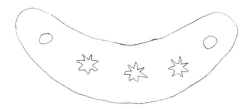

Figure 5.3. Crescent shaped loom weight from Karahöyük Konya (Alp 1968, 187 no. 574). Drawing by author.

Figure 5.4. Map of the distribution of crescent shaped loom weights in Turkey (map by A. W. Lassen).

reconstructed crescents on a warp-weighted loom, I was able to demonstrate how such objects could have functioned as highly sophisticated textile tools, and how the crescents would enable a craftsperson to produce some of the most complicated weaves of the Bronze Age, such as different types of twill and patterned weaves, with relative ease.[13] I will in the following present some conclusions.

The previous reconstruction of their use, first suggested in 1964, has the crescents hanging side by side in one row on the loom (Fig. 5.5).[14]

This setup was not tested experimentally until 2003, and the test was inconclusive, perhaps due to the very limited scale of the experiment.[15] In my own reconstruction the loom weights were hanging in two rows instead of just one (Fig. 5.6).

Thereby it is possible to exploit the advantages of the so-called separate weights system, which has one row of loom weights for each thread layer (Fig. 5.7).[16] In addition, the crescents avoid some of the problems of interference encountered with the separate weights system (Fig. 5.8).

[13] For a detailed technical description, see Lassen forthcoming.
[14] Castiglioni 1964.
[15] Baioni 2003.
[16] Haynes 1975.

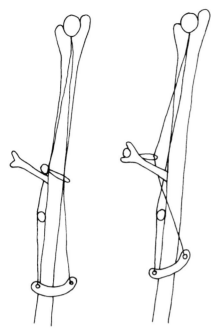

Figure 5.5. O. C. Castiglioni's suggested one-row reconstruction from 1964 (drawing by Annika Jeppsson, ©Annika Jeppsson and CTR).

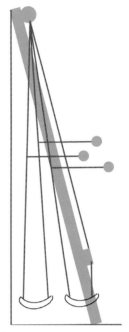

Figure 5.6. Schematic representation of the warp-weighted loom equipped with crescent shaped loom weights (drawing by A. Wisti Lassen).

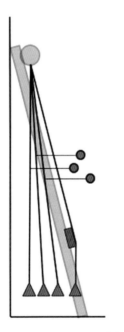

Figure 5.7. Schematic representation of the warp-weighted loom with the 'separate weights' system (drawing by A. Wisti Lassen).

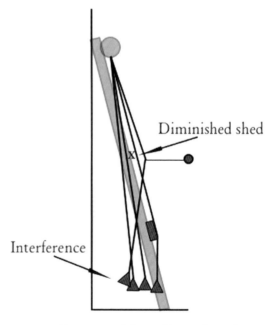

Figure 5.8. Illustration of the problems of interference encountered with the 'separate weights' system (drawing by A. Wisti Lassen).

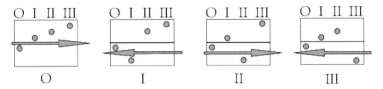

Figure 5.9. Diagram of the 3/1 twill shedding pattern. The arrow represents the weft and the dots the warp (diagram by A. Wisti Lassen).

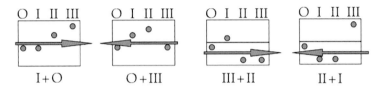

Figure 5.10. Diagram of the 2/2 twill shedding pattern. The arrow represents the weft and the dots the warp (diagram by A. Wisti Lassen).

Figure 5.11. 2/2 twill woven on a warp-weighted loom equipped with reconstructed crescent shaped loom weights (photograph by A. Wisti Lassen).

Figure 5.12. 3/1 twill woven on a warp-weighted loom equipped with reconstructed crescent shaped loom weights (photograph by A. Wisti Lassen).

Figure 5.13. Patterned weave woven on a warp-weighted loom equipped with reconstructed crescent shaped loom weights (photograph by A. Wisti Lassen).

Loom weights with two holes make it possible to create four thread layers with only two rows of loom weights, thus avoiding the interference problem. Also, the crescent shape draws the point of gravity to the bottom of the loom weight, thus facilitating a steady, smooth movement, when the thread layers are pulled forward and one end of the loom weights is lifted. To exploit this advantage, the loom weights can be used in a loom set up with three heddle rods. The result is a very flexible unit that can change instantly between 2/2 and 3/1 twill, tabby, panama, as well as pattern weaves, that has 4 threads as its basic pattern unit (Figs 5.9 and 5.10).

Furthermore, if a row of regular loom weights was attached to one thread layer in front of the shed bar, and two thread layers were tied to the two holes in a row of crescent shaped loom weights behind the shed bar, it would also be possible to weave 2/1-twill and pattern weaves

Figure 5.14. Crescent and pyramidal loom weights excavated at Demircihöyük (Photo from Baykal-Seeher and Obladen-Kauder 1996, 239).

Figure 5.15. Fragment of a twill cloth from a Chalcolithic burial at Alishar, Turkey (Photo courtesy the Oriental Institute of the University of Chicago).

Figure 5.16. Reverse of bulla kt 90/k 499 (Photo from Özgüç and Tunca 2001, pl. 107).

with three threads as the basic pattern unit. Presumably, this type of setup was found in Early Bronze Age Demircihüyük, where pyramidal and crescent shaped loom weights were excavated together (Fig. 5.14).[17]

Plainly, a successful experiment does not prove that the crescents actually *were* used in this particular way, but their shape, dimensions and expediency suggest that they could have been.

Twill weave is often connected to Iron Age Europe, from where many archaeological textiles have survived.[18] Anatolia has not produced similar finds, and so far only a handful of tiny scraps have been found. One, however, is relevant in this connection, as it is clearly twill (Fig. 5.15).[19] It derives from one of the Central Anatolian sites from the Chalcolithic period.

This fragment shows that twill was present in the area, although it is almost a millennium older than the period in focus here. Another source of information dated to the Middle Bronze Age is impressions of textiles in clay. The Anatolian palaces attached lumps of clay (*bullae*) to a range of objects, including doors, jars and textiles. Sometimes short inscriptions were written into the clay, and always the clay lump was stamped with a seal, signifying ownership or responsibility. When the door or jar was opened the *bulla* was removed and either stored or discarded. The reverse of the *bullae* would carry the impression of the material the clay was attached to, including textiles. In the Middle Bronze Age this sealing system was widely used in the palace administrations, and the inscriptions and impressions on the *bullae* can be used to date them very accurately. Several *bullae* from Middle Bronze Age Kültepe carry textile imprints, and one can tentatively be identified as a twill (Fig. 5.16).[20]

[17] Baykal-Seeher and Obladen-Kauder 1996, 239.
[18] Cf. Hundt 1970 with further references.
[19] Fogelberg and Kendall 1937, 334–335.
[20] Personal communication A. Batzer 2007.

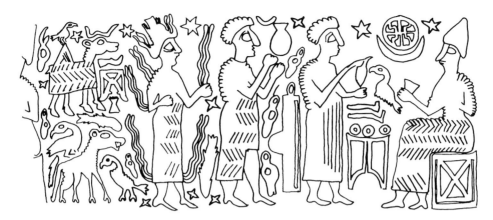

Figure 5.17. Seal in Anatolian style from Kültepe. The seal is impressed on the envelopes ICK 1, 45a=Ka 82A, kt 94/k 892, kt 94/k 1643. Drawing by author.

Herringbone patterns in glyptic iconography

It is possible to expand the focus further than the technical function of the crescent shaped objects by examining available contemporary iconographic evidence. A source of evidence that should be drawn into consideration is the pictorial representation of dress on the Anatolian seals. As can be seen in Figure 5.17a and b, the garments are sometimes marked by oblique lines etched across the surface. The same patterning can be found on fabric in other Anatolian art forms. Seal expert B. Teissier connects this particular way of rendering surface with techniques derived from Anatolian stone and metal craftsmanship. However, the patterning does not occur randomly and seem to represent more than simple artistic convention.[21] For instance, there is clear distinction in the representation of the different types of dress.[22]

The herringbone pattern is consistently associated with a type of dress worn by deities or kings, the so-called flounced dress. The dress itself is not unique to Anatolian style seals, but appears as the conventional divine garment the Mesopotamian glyptic tradition.[23] Only the use of pattern is distinct.[24]

Another place in which the herringbone pattern is encountered is on the chair or throne of the seated figure in the introduction scenes, and it sometimes appears as decoration on the so-called 'bull altars'.[25]

As seen in Figure 5.18, the herringbone pattern is not used on animals in general, but appears only on the body of the bull altars. That the herringbone pattern is found on dress and chairs, but not on animal bodies, suggests that the pattern signifies cloth; in the case of the bull altar, I would therefore suggest that what is depicted is probably a piece of cloth lying over the bull altar.

[21] Note however that herringbone patterns and oblique lines are also encountered in Syria. Cf. *e.g.* Pinnock 2004, figs 7–8.

[22] Özgüç 1965.

[23] Houston 1954, 123–124. The same type of flounced dress is also attested in Bronze Age Crete, see Barber 1991, 324.

[24] Note a few examples of herringbone patterned dress on non-Anatolian style seals: CS 770, OrNS 52, 1a and CS 620.

[25] See *e.g.* CS 243, CS 310, CS 311, CS 502, CS 680, CS 826. For a discussion of the bull altar motif, cf. Lassen 2012.

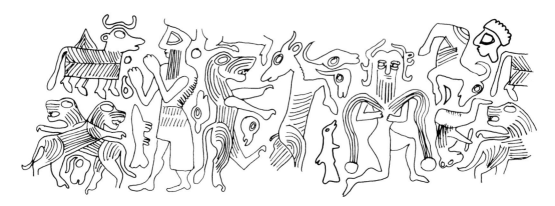

Figure 5.18. Drawing by author of CS 680 (cf. Özgüç 2006, 227 and pl. 239).

The herringbone patterning appears not to be an iconographic convention without meaning, but an Anatolian rendering of a specific type of fabric. It is possible that this was a distinct Anatolian convention for depicting flounced cloth, but my tentative suggestion would be that it is a particular way of depicting twill fabric, which is characterised by oblique lines and herringbone patterns (Figs 5.11–5.13).

The use of herringbone pattern would not be the only way of rendering textile patterns found among the cylinder seal styles represented at Kanesh. For instance, CS 704, which is cut in the so-called 'Old Syrian' style, shows what appears to be a patterned dress (Fig. 5.19). Two seated figures face each other: the one to the right is dressed in the typical flounced robe and a peaked cap. Teissier has suggested that this figure represents a North-West Syrian or Eblaite ruler.[26] The seated figure to the left is wearing a robe with what could be a floral pattern. Since the seal depicts two figures in contrasting patterned fabrics, we are not simply dealing with a poor rendering of another flounced dress. The detailed and finely modelled quality of the seal also strengthens this hypothesis.

Another example is CS 767 (also in the Old Syrian style), in which the 'ruler with the peaked cap' is standing behind a seated deity and pouring a libation (Fig. 5.20). In front of him is a naked female with a long ponytail. The dress of the ruler is patterned with either a floral design or perhaps tufts of hair.[27] Details on the dress on the other characters on the seal are also emphasised. It seems possible that this particular seal shows an attempt to depict dress in imagery, and to show details, such as whether the fabrics were woven, sown or printed. The designs depicted on the royal dress could resemble lotus flowers, such as those seen *e.g.* on the Neo-Assyrian stone rugs in Figure 5.21.[28]

Textual sources also refer to dress with imagery.[29] For instance, one *mardatu*-textile carrying

[26] Teissier 1993, 606.

[27] It is difficult to make out any details on the dress on the basis of the black-and-white photo provided in the publication, but the drawing made of the seal clearly shows a motif not unlike the one seen on CS 704, see Özgüç 2006, pl. 68, pl. 76.

[28] Dalley 1991.

[29] Lassen 2010, 276–278.

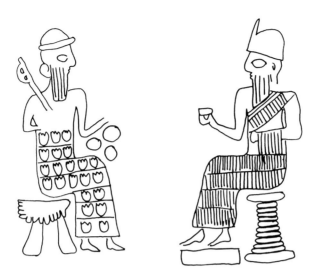

Figure 5.19. Drawing by author. For visual simplicity the drawing includes only information which is relevant to the present context and does not represent the entire composition (from Özgüç 2006, pls 68 and 246).

the image of a *lamaštum* was given by a certain Mukanniŝum to the king of Babylon.[30] A Middle Assyrian inventory text also mentions textiles decorated with floral motifs.[31]

It seems possible that the depictions of fabric in the seals need not be simply stylistic conventions, and I would suggest that the herringbone pattern was used by Anatolian seal cutters to add their own conception of fabric texture to the seal design. If this were indeed the case, the diagonal lines in the fabric might very well signify twill. This would in turn relate to the distinct Anatolian textile technology, associated with the warp-weighted loom and the crescent shaped loom weights.

Crescent shaped loom weights occur in both the Early and Middle Bronze Ages in Anatolia, but it is important to note that in the earlier period their weight and size make them unsuited for the production of twill (Fig. 5.23).[32] Furthermore, the pattern of seal use on the crescent shaped loom weights differs markedly from that known from *bullae* and other well-known administrative devices used widely in the palace institutions. Instead of reflecting a hierarchical system, the sealings on the crescents present a flat structure with most of the seal owners each using their seal only once (cf. Fig. 5.24).[33] In addition, a number of the crescents are not marked by seals at all, but carry impressions made by toggle pins, fingernails or incision.

This suggests that the users of the crescents were not part of a regular palace administration, and that they represent an outside group that would not always own a seal.[34] Accepting that the crescents functioned as loom weights, it is possible to propose the existence of a system in

[30] Durand 1983, 410.
[31] Barrelet 1977; Köcher 1958.
[32] See Lassen forthcoming.
[33] Weingarten 1990, 73–74.
[34] *Ibid.*

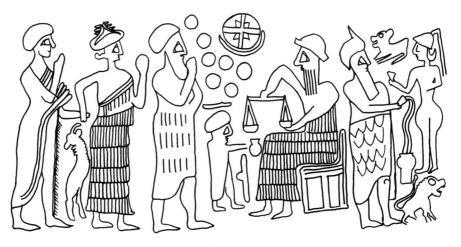

Figure 5.20. Drawing by author of CS 767 (cf. Özgüç 2006, 239 and pl. 246).

Figure 5.21. Neo-Assyrian door sill carved as a rug (AN217288001 © Trustees of the British Museum)

Figure 5.22. Baked clay bas-relief (AN108748001 © Trustees of the British Museum).

which the owners of the crescents held an obligation or labour-tax toward a central institution[35] to produce a certain amount of textiles within a given period of time. A stamped or marked crescent functioning as a 'signature' would be handed in with the finished work to the palace administration as part of the transaction. The distribution pattern of the crescent shaped loom weights suggests that the actual production did not take place in the palace, but that it may have happened in private homes or open workspaces.[36]

In conclusion, it appears that twill weaving and the crescent shaped loom weights were characteristic to the Anatolian economy and textile technology, and that they reflect elements of both organisation and ethnic identity in local society. The omnipresence of marked crescents implies that their use was adopted by palace administrations throughout Central and Western Anatolia on par with seals and sealing-technologies, and that their production and yield was subject to some degree of centralised control. Furthermore, the fact that the dimensions and use pattern of the crescent shaped loom weights appears to change with the rise of the palace

[35] See Dereksen 2004.
[36] At Kültepe *e.g.* crescent shaped loom were found in the houses in the lower town, not in palatial areas on the mound, see Özgüç and Özgüç 1953.

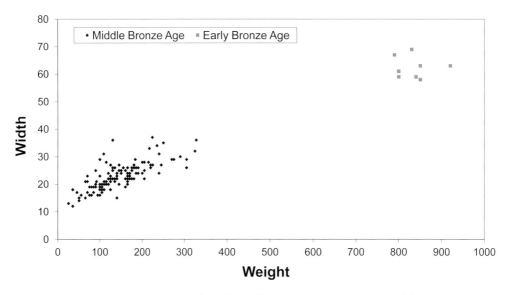

Figure 5.23. Weight and size distribution of Early and Middle Bronze Age crescent shaped loom weights (chart by A. Wisti Lassen).

Seal owner	Number	%
Most active seal owner	15	5,9%
Second most active seal owner	5	2,9%
Less active (stamped 2 or 3 times)	-	-
Least active (stamped once)	155	88,6%
Total	175	100%

Figure 5.24. Sealing hierarchy at Karahöyük Konya.

economies of the Middle Bronze Age suggests that the technology was intimately connected to the palace institutions and the structure of palace economy. In this way the organisational context of the technology reflects the institutional structure of the state. It is thus possible to argue that the crescent shaped loom weights represent a central, and hitherto unrecognised, feature of palace economy itself, and that the state-administered production of textiles was a key aspect of social and political organisation in Middle Bronze Age Anatolia.

Bibliography

Alp, S. 1968. *Zylinder- und Stempelsiegel aus Karahöyük bei Konya.* Türk Tarih Kurumu Yayınları V/26.

Baioni, M. 2003. Prova sperimentale di produzione di pesi reniformi e loro applicazione a un teleio verticale. In M. Bazzanella *et al.* (eds) *Textiles – intrecci e tessuti dalla Preistorica Europea,* 104–109.

Barber, E. J. W. 1991. *Prehistoric Textiles: the developement of cloth in the Neolithic and Bronze Ages with Special Reference to the Aegean,* Princeton.

Barjamovic, G. J. 2011. *A historical geography of Anatolia in the Old Assyrian Colony period.* CNI publications 38, Copenhagen.

Barjamovic, G. J., Hertel, T., and Larsen, M. T. (forthcoming). *Ups and Downs at Kanesh* PIHANS, Leiden.

Barrelet, M.-T. 1977. Un inventaire de Kār-Tukultī-Ninurta: Textiles décorés Assyriens et autres. *Revue d'Assyriologie* 71, 51–92.

Baykal-Seeher, A. and J. Obladen-Kauder. 1996. *Demircihüyük: die Ergebnisse der Ausgrabungen 1975-1978 Vol. 4, Die Kleinfunde.*

Burke, B. 2010. *From Minos to Midas: Ancient Cloth Production in the Aegean and in Anatolia.* Ancient Textiles Series 7, Oxford.

Castiglioni, O. C. 1964. I "reniformi" della Lagozza – Origine e distribuzione eurasica dei pesi da telaio con fori apicali contrapposti *In* A. Noseda *Comum – Miscellanea di scritti in onore di Federico Frigerio*, Como, 129–185.

Dalley, S. 1991. Ancient Assyrian Textiles and the Origins of Carpet Design. *Iran* 29, 117–135.

Dercksen, J. G. 1996. *The Old Assyrian copper trade in Anatolia.* PIHANS 75. Leiden.

Dercksen, J. G. 2004. Some Elements of Old Anatolian Society in Kaniš. *In* J. G. Dercksen (ed.) *Assyria and Beyond. Studies presented to Mogens Trolle Larsen*, PIHANS 100, Leiden, 135–177.

Durand, J.-M. 1983. *Textes Administratifs des Salles 134 et 160 du Palais de Mari.* Archives royales de Mari 21.

Haynes, A. E. 1975. Twill Weaving on the Warp-Weighted Loom. *Textile History* 6, 156–164.

Hundt, H.-J. 1970. Gewebefunde aus Hallstattzeit *In Krieger und Salzherren: Hallstattkultur im Ostalpenraum*, Naturhistorisches Museum (Austria) and Römisch-Germanisches Zentralmuseum Mainz, 53–71.

Köcher, F. 1958. Ein Inventartext aus Kār-Tukultī-Ninurta. *Archiv für Orientforschungen* 18, 300–313.

Lassen, A. W. 2010. Tools, Preocedures and Professions: A Review of Akkadian Textile Terminology. *In* C. Michel and M.-L. Nosch (eds) *Textile Terminologies in the 3rd to 1st millennium BC in the Ancient Near East and Eastern Mediterranean*, Ancient Textiles Series 8, Oxford, 270–280.

Lassen, A. W. 2010. Wool trade in Old Assyrian Anatolia. *Jaarbericht Ex Oriente Lux* 42, 159–179.

Lassen, A. W. 2012. *Glyptic Encounters: A Stylistic and Prosopographical Study of Seals in the Old Assyrian Period – Chronology, Ownership and Identity.* PhD dissertation, University of Copenhagen, Copenhagen.

Lassen, A. W. (forthcoming). Weaving with Crescent Shaped Loom Weights. An investigation of a special kind of loom weight. *In* E. Andersson-Strand and M.-L. Nosch (eds) *Tools, Textiles and Contexts*, Ancient Textiles Series, Oxford.

Michel, C. 2003. *Old Assyrian bibliography of cuneiform texts, bullae, seals and the results of the excavations at Assur, Kültepe/Kanis, Acemhöyük, Alisar and Bogazköy.* PIHANS 97, OAAS 1.

Michel, C. 2005–2006. Old Assyrian Bibliography 1. *Archiv für Orientforschung* 51, 436–449.

Michel, C. and K. R. Veenhof, 2010. The textiles traded by the Assyrians in Anatolia (19th–18th centuries BC). *In* M.-L. Nosch and C. Michel (eds) *Textile Terminologies in the Ancient Near East and Mediterranean from the Third to the First Millennia BC*, Ancient Textiles Series 8, Oxford, 209–269.

Özgüç, N. 1965. *Kültepe mühür baskılarında Anadolu grubu/The Anatolian group of cylinder seal impressions from Kültepe.* TTKY v/22.

Özgüç, N. 2006. *Kültepe-Kaniš/Neša: Seal Impressions on the clay envelopes from the archives of the native Peruwa and Assyrian trader Uṣur-ša-Ištar son of Aššur-imittī.* TTKY V/50.

Özgüç, N. and Tunca, Ö. 2001. *Kültepe-Kaniš. Sealed and inscribed clay bullae.* TTKY V/48. Ankara: Türk Tarih Kurumu Basimevi.

Özgüç, T. 1950. *Kültepe Kazisi Raporu 1948/Ausgrabungen im kültepe 1948. Bericht über die im Auttrage der Turkischen Historischer Gesellschaft 1948 durchgeführten ausgraben.* TTKY v/18. Ankara: Türk Tarih Kurumu.

Özgüç, T. 1959. *Kültepe-Kaniš. New Researches at the Center of the Assyrian Trade Colonies.* TTKY v/19. Ankara: Türk Tarih Kurumu.

Özgüç, T. 1986. *Kültepe-Kaniš II. New Researches at the Trading Center of the Ancient Near East.* TTKY v/41. Ankara: Türk Tarih Kurumu.

Özgüç, T. 2003. *Kültepe-Kaniš/Neša, The Earliest International Trade Center and the Oldest Capital City of the Hittites.* Tokyo: The Middle East Culture Centre of Japan.

Özgüç, T. and Özgüç, N. 1953. *Kültepe Kazısı Raporu 1949 Ausgrabungen in Kültepe. Bericht über die im Auftrage der Türkischen Historischen Gesellschaft 1949 durchgeführten ausgrabungen.* TTKY v/12. Ankara: Türk Tarih Kurumu Basimevi.

Pinnock, F. 2004. Change and continuity of art in Syria viewed from Ebla. *In* J.-W. Meyer and W. Sommerfeld (eds)

2000 v. Chr. Politische, wirtschaftliche und kulturelle Entwicklung im Zeichen einer Jahrtausendwende, Colloquien der Deutschen Orient-Gesellscshaft 3, 87–118.

Skals, I., Möller-Wiering, S. and Nosch, M.-L. (forthcoming). Survey of Archaeological Textile Remains from the Eastern Mediterranean Area. *In* E. Andersson Strand and M.-L. Nosch (eds) *Tools, Textiles and Context. Textile Production in the Mediterranean Bronze Age.* Ancient Textiles Series, Oxford.

Teissier, B. 1993. The Ruler with the Peaked Cap and Other Syrian Iconography on Glyptic from Kültepe in the Early Second Millennium BC. *In* M. J. Mellink, E. Porada and T. Özgüç (eds) *Aspects of Art and Iconography, Anatolia and its Neighbors. Studies in Honor of Nimet Özgüç.* Ankara.

Teissier, B. 1994. *Sealing and Seals on Texts from Kültepe Kārum Level 2.* PIHANS 120, Leiden.

Waetzoldt, H. 1972. *Untersuchungen zur neusumerischen Textilindustrie.* Studi economici e tecnologici, 1.

Weingarten, J. 1990. The sealing structure of Karahöyük and some administrative links with Phaistos and Crete. *Oriens Antiquus* 29, 63–95.

6. Her Share of the Profits: Women, Agency, and Textile Production at Kültepe/Kanesh in the Early Second Millennium BC

Allison Karmel Thomason

Say to Pūšu-kēn, thus speaks Lamassī:

Kulumāya is bringing you nine textiles. Iddin-Sin is bringing you three textiles...Please my master, don't get angry because I haven't sent you the textiles you asked for in your letter. Oh, how the little one has grown and I had to make a couple of thick blankets for the cart. You see, I've only been making things for the house and the family, that's why I haven't sent you any textiles [to sell]. OK, I'll send all of the textiles that I can produce on the next caravan.

About Abum-ilī's house, Ikuppīya built his walls on top of your walls and when I objected, he just said: 'One common wall was built.' In no case should it be built! But then he built the wall and left! You, there, ask him why he built his walls on your walls? Act like a real master and protector!

As for the bread and beer that you wrote me about, rest assured the bread and beer are made and are ready. [Your] little girl has grown so much; get on the road, come to place her in the womb of Assur and kiss the feet of your god![1]

Thus wrote the Assyrian woman, Lamassī, to her husband who was traveling abroad conducting mercantile business in Anatolia. This letter is a window into the nature of the production of textiles, as it illuminates the nature of the micro-industries of textile production that both created and responded to supply and demand pressures in the Mesopotamian economy. In these few lines, probably written by Lamassī herself, we learn how in the context of producing textiles for consumption in a foreign land, Lamassī and her husband negotiated the difficulties of long-distance caravan travel by donkey, exchange rates, foreign city officials, royal taxes, and credit and loan-advancing entities. The letter gives us a glimpse into a sophisticated economy – surprisingly so according to the first Assyriologists working on the corpus of tablets – that was centered around the trade in textiles, silver, gold and tin.

The letter is found on a cuneiform tablet that was excavated from the site of modern Kültepe in east-central Anatolia, which was called *kārum* Kanesh by its ancient inhabitants. *Kārum* is the Akkadian word for 'market' or 'trading spaces' of a city, and often refers to activities occurring either within the city's walls or at its entrance gates. The letter from Lamassī is one of more than 23,000 similar tablets that were originally kept in archives from households in the lower city, the 'commercial quarter' of Kanesh. Veenhof estimates that 80 to 100 archives may eventually be reconstructed from the Kanesh tablets dating to Level II of the *kārum*.[2] It is commendable that the

[1] Michel 2001, 434–435.

[2] For number of known tablets, see Veenhof 1972, xxv; Veenhof, Eidem and Wäfler 2008, 46; Michel 2009, 265; and

painstaking research that goes into deciphering these texts and assigning them to archives, that is making sense of them and putting them into historical context, has resulted in the publication of approximately half of the 23,000 tablets excavated and known.

The archives contain any number of different types of cuneiform documents, the most common of which are letters to and from traders to other business people and their family members.[3] Other texts include: lists, memoranda, receipts and contracts accounting the exchange of goods, land and people; undated inventories and caravan account lists; legal statutes, treaties and judicial decisions; official administrative decrees and calendars, called eponym lists; and occasional religious and literary texts.[4] The Assyrian traders had traveled from their home city of Ashur in northern Mesopotamia, a distance of 621 miles (1000 km) or six to eight weeks' journey by donkey caravan, and set up households and storage facilities to trade their textiles and tin produced or procured in Ashur in exchange for the silver, gold and copper obtained within Anatolia. There are a number of fascinating aspects of the Kanesh tablets that illuminate a great deal about the economy of Old Assyrian long-distance trade, and the daily lives of the inhabitants of Ashur and *kārum* Kanesh, and their relationships to textiles. The picture that emerges from the seemingly endless mundane concerns of the correspondents in the tablets is that of an entrepreneurially inclined society, with highly evolved institutions designed to facilitate the lucrative trade in metals and textiles. While Ashur and its 'trade colony' in Anatolia must have been in some ways typically Mesopotamian – for example in the use of cuneiform for documentation, or in calendrical and legal practices and religious beliefs – it was also extraordinary due to the number of people traveling long distances in the society, the long periods away from the Assyrian homeland experienced by the traders, the frequency of their encounters with non-Assyrians, and their degree of literacy. It has been likened, therefore, to a 'frontier society' where the ordinary and extraordinary intermingled on a daily basis.[5]

The tablets document the commercial activities and daily lives of a number of fairly successful family firms based at Ashur that had sent members abroad to negotiate transactions in Anatolia. The term 'family firm' is used only loosely here, as we are probably witnessing groups of individuals aligned commercially. Larsen has shown that while most members of these firms were related (whether distantly or closely), the businesses also incorporated unrelated individuals.[6] The Assyrian 'colonists' and their families, after all, were not trading and living in a vacuum as they frequently interacted with, contracted with, and even married local Anatolians. The traders and their families also negotiated on a daily basis with people in their home city of Ashur, including the king's officials and members of the city assembly at the Ashur city-hall.[7] Aside from officials fostering and, in some cases, hindering the commerce, there were many supporting actors living in the Ashur and Kanesh communities, including extended families of the traders with women and children, servants and slaves, messengers and couriers, traders from other cities in Anatolia, and caravan travelers who did not necessarily own the goods that they transported.

Edward Stratford, personal communication, March 2010.

[3] Michel estimates that between 30–40% of the texts are letters (2009, 254).

[4] For a brief discussion of the range of texts at Kanesh, see Veenhof, Eidem and Wäfler 2008, 44.

[5] Lumsden 2008.

[6] Larsen 2007.

[7] As ordered in the Kültepe Eponym List, published in Veenhof 2003a.

Textiles in the Old Assyrian Trade

Finished textiles played perhaps the most significant role in the trade, and one estimate places the total amount of textiles mentioned in the texts at approximately 100,000 pieces, which were traded along with more than 13 tons of tin.[8] The textiles would have been produced in Ashur or other parts of Mesopotamia and sold along the caravan route, at Kanesh, or at other trading cities in Anatolia. The texts reveal a great deal about the amount and prices of the wool used in the production of the textiles. The weavers and traders also produced limited amounts of linen textiles.[9] The traders and scribes used many vocabulary terms that refer to specific types of cloth, and occasionally finished garments, produced by the Assyrians; however, the bulk of the trade took the form of woven wool textiles that were not necessarily finished into any specific form of garment.[10] From these studies, we know that the colony members chose the typical Sumerian ideogram TÚG to refer in general to textiles, frequently substituting idiomatic expressions and words peculiar to the Old Assyrian texts and their region to further designate either the type of weave, the quality of the fabric, or the origin of the textile.[11] For example, the traders referred to fine quality textiles, such as *raqqutum*, and *ṣubātum qatnum,* which were marked by their tiny weave, large number of threads, softness, or "thin" feel.[12] The traders also discussed the relative quality of the textiles for sale, which ranged from textiles of "royal class" (*ša šarruttim*), usually imported from southern Mesopotamia, to those "lacking in quality" (*maṭium*).[13] The local Anatolian textiles, cheaper and rougher in quality than the Assyrian products, were often called *pirikannum*.[14]

While the logistics of the trade in textiles has been the subject of a great deal of interest in the literature about the colony archives, Michel has concluded that the texts contain relatively little information about *how* the cloth was produced.[15] Assyriologists have therefore relied upon relevant texts regarding textile production from earlier periods in southern Mesopotamia to supplement the direct information gleaned from the Kanesh tablets. In part biased by the largely administrative nature of information about textile production, the majority of these related studies, however, are concerned with the relationship of textile production to state authority and the economic aspects of the trade.[16]

The exceptional secondary analysis is an extensive summary of information about textile production found in Veenhof's 1972 work, *Aspects of Old Assyrian Trade*, which is cited subsequently

[8] Lamberg-Karlovsky 1996, 166. For methodological issues related to estimating total numbers of textiles, see Veenhof, Eidem and Wäfler 2008, 90.

[9] Michel and Veenhof 2010, 216–218.

[10] Michel and Veenhof 2010, 211.

[11] For example, the phrase "Abarnian" (Akkadian *ša abarnīum*) probably refers to textiles that were originally produced by the region of Abarnia, but eventually were imitated in Ashur and produced in the "Abarnian" style (Waetzoldt 1972, 123; Veenhof and Michel 2010, 219).

[12] For a thorough discussion of the terms used to designate different types of textiles, see Veenhof and Michel 2010.

[13] Veenhof and Michel 2010, 246.

[14] For an in-depth discussion of these and other terms referring to specific types of textiles, see Veenhof 1972, 89–91, 123–125, and 143–180. In one of the earliest and best documented occurrences of economic protectionism in the world, the "Abarnian" textiles were heavily taxed by the authorities at Ashur in an attempt to keep the price of Assyrian textiles high and prevent the market from being flooded with cheap "imports" (Waetzoldt 1972, 126–128; and Michel and Veenhof 2010, 226).

[15] Michel 2006a, 290–293.

[16] See, for example, Waetzoldt 1972.

as the authoritative work on the subject. More recently the Danish National Research Foundation's Center for Textile Research in Copenhagen has published several chapters on Mesopotamian textiles and weaving, including a detailed article by Veenhof and Michel, two of the most prominent scholars of the *kārum* period, regarding textile terminology in the Old Assyrian tablets.[17] It is upon the shoulders of these scholars that I can build many of my own observations about the textile trade in Mesopotamia and Anatolia during the early second millennium BC.

Most of the textiles exported by the Assyrians to Anatolia were produced in Ashur. The Assyrians also imported a substantial amount of cloth from Babylonia, which they called "Akkadian" textiles, perhaps conflating all of southern Mesopotamia under this term and yet contrasting those inhabitants culturally with Assyrians and Amorites.[18] On a few occasions, the traders also purchased textiles *en route* to Anatolia for resale at Kanesh. Or, they bought textiles in the market at Kanesh and brought them back to Ashur for either personal use or resale. As Veenhof notes, the primary weavers and garment finishers in the Old Assyrian world were women.[19] The picture that emerges from the Kanesh tablets indicates that the women weaving at Ashur were not wards or dependents of the state, as in the Ur III period in southern Mesopotamia, but were local entrepreneurs working out of their homes in 'cottage industries'. The women were either self-employed or working under the auspices of their family 'firms' exporting their textiles to Anatolia. Letters to and from the women textile producers and their family members selling the textiles abroad are especially informative about the production and sale of textiles. The letters refer to specific consignments for sale by male relatives or by the women themselves, and often address the size, quality and cut of the garments produced. They indicate that the textile process involved first acquiring the wool, which was usually bought in Ashur or from Babylonia, but occasionally sent from Anatolia.[20] Then the women producers spun the wool and wove the cloth; they also pieced the fragments together to make larger textiles (as the horizontal loom limited the maximum width of any single weaving). There is some indication that other female members of the households in which they lived worked on textiles, or even that the Assyrian women hired unrelated women or used slaves to produce the cloth.[21] Then, the textiles went through the processes of fulling, which included pressing or combing and finishing the cloth to make the surface smoother.[22] The letters do not mention the dyeing or laundering of the cloth, but they do list colored textiles for sale, including red, white, yellow and black cloth; thus, the women probably contracted with other service providers for those finishing treatments.[23]

The women were then responsible for insuring that their textiles reached Anatolia. They located caravans, contracted with caravan agents, and prepared the textiles and bundled them

[17] Michel and Veenhof 2010, 210–271.

[18] Veenhof 1972, 101.

[19] Veenhof 1972, 100.

[20] Probably because the price of wool was cheaper in Anatolia at times, see Waetzoldt 1972, 116. Some wool was acquired from the herds of the so-called Sukhu nomads, who grazed their sheep west of Ashur in the area along the Middle Euphrates near Wadi Tarthar, see Veenhof, Eidem and Wäfler 2008, 83.

[21] Although there is no direct evidence for this, Veenhof suggests that the quantity of textiles sent to Kanesh and mentioned in the letters is so large in some cases, that one woman could not have produced them by herself. In addition, many of the women in Assyria and Anatolia owned slaves, see Veenhof 1977, 113–114. See for example a contract between two women mentioning the sale of an Anatolian slave girl, Donbaz 1989.

[22] Michel and Veenhof 2010, 249–252.

[23] The fullers and launderers were probably mostly male, according to later texts from southern Babylonia, as discussed in Waetzoldt 1972 and Waerzeggers 2006.

for transport with string and muslin sealed by clay tags. They also arranged for the payment of tithes and taxes in order to avoid pre-emptive confiscation of their textiles by local Anatolian officials once the goods had reached Kanesh.[24] The women were especially keen to trace whether their textiles reached Anatolia, and frequently wrote to their contacts there to ensure their safe arrival. The textile producers were principally concerned as well with receiving silver – their *tadmiqtum* – in exchange for the products of their labor, and it is quite clear that the silver was considered in most cases to be their own; it might, but did not automatically, revert to their husbands' or the family firms' accounts.[25]

Tracing the activity of individual women will demonstrate the prominence and prevalence of women within this textile trade and illuminate the lives of female textile entrepreneurs/producers. By looking at correspondence and associated other tablets mentioning the women or written by or to the women, we can ascertain the extent of their involvement in the textile industry. In an effort to trace these activities and make some generalizations about the behaviors of women textile entrepreneurs, I have created a database that encodes the activities of more than 80 women mentioned in a majority of the published tablets. From this dataset, I can conclude that the women of Ashur and Kanesh participated in the following list of more than 25 activities in their roles as members of their family firms, heads of households and textile producers:

1. write and receive letters;
2. hire scribes to write and read letters;
3. produce, own, buy, or sell textiles;
4. buy wool;
5. contract with fullers and dyers;
6. deal with city authorities, taxes or tariffs, and court procedures;
7. deal with other traders, firms, associates;
8. own or sign with seal;
9. own, buy or sell property, including slaves and houses;
10. arrange for/contract with transport agents or caravans;
11. borrow and lend silver;
12. act as co-signers for loans;
13. enact "currency" exchanges/rate conversions;
14. participate in ikribum – or sale lots shared with other traders;
15. enter into marriage and divorce and remarriage contracts;
16. marry Anatolian husbands;
17. inherit land and property (occasionally ahead of younger brothers);
18. leave last wills and testaments;
19. purchase grain and brew beer;
20. hire laborers and repair houses;
21. argue with their male and female relatives;
22. travel to, from and within Anatolia;
23. guard archives and storerooms;
24. read documents/sealings;
25. rent out or lease houses;
26. attend to ancestors/spirits of the dead;
27. attend to personal/family religion and deities (visit shrines, give prayers and votive offerings);
27. serve as ugbabtu (speciailised, elite) priestesses;
28. provide for/take care of children and other relatives (e.g. elderly)

[24] Dercksen 2004, 173; Veenhof, Eidem and Wäfler 2008, 83; and Michel and Veenhof 2010, 215.
[25] Veenhof 1972, 121–123.

While this list will give the reader an idea of the diversity of activities generated by the female textile entrepreneurs at Ashur and Kanesh, a detailed, if impressionistic, analysis of a few of the most relevant letters can provide a window into the world of the Assyrian female textile entrepreneurs.

Textiles and Profit

The archive of the Assyrian trader, Pušu-kēn, contains many letters to and from the various female members of his family, including his wife, Lamassī, whose words opened this chapter, his daughters Ahaha and Waqqurtum, and his sister, Tariš-matum. In a typical exchange of letters between Lamassī, who lived in Ashur, and Pušu-kēn, who traveled in Anatolia, we learn about several activities with which the female textile entrepreneurs concerned themselves. Most interesting is the precise and assured way in which Lamassī followed her consignments of textiles. She wrote to her husband about a group of textiles that she had sent by caravan for him to sell in Anatolia: "Concerning the thick textiles that I sent ... Try to confirm that they arrived and send me the silver or its equivalent in merchandise that I have been awaiting for years!"[26] We know that Lamassi either produced or procured the textiles at Ashur, arranged for them to be packed in a caravan to Anatolia, and expected to receive payment for her work. She also distributed wool to others in Ashur and received silver as compensation.[27] We also learn that she understood the exchange rates for textiles and silver, and that she relied on her payments to purchase other objects. Finally, we see how she rhetorically emphasized the importance of the payments to her by exaggerating how long she had been waiting for her payment, thus putting more pressure on her partner/husband to expedite the transaction. Her husband wrote back to her explaining that the profit from the sale of her textiles had been distributed to other parties, and he requested more textiles "of good quality" from Lamassī.[28]

In further correspondence, we learn that Lamassī had the ability to procure or produce different qualities of textiles at Ashur, and that they were relatively valued within the market. She continued in another letter: "Why do you write me all the time: 'the textiles that you sent me each time aren't good'? Who is the fellow, who lives in your house, who is decrying the textiles when they arrive before him? As for me, for my part, I do my best to make and send you textiles before each trip, at least ten shekels of silver should arrive here."[29] At one point, she sent several different types of textiles to her husband, including those described as *kamsum, manšuḫum* and *nibrarum*.[30] In several letters, she also discussed with her husband the cost and amount of wool used in producing the yarn for the textiles: "When you send me my share of the profits, throw in some wool [from Anatolia] because wool in Ashur is very expensive."[31] She experienced the classic capitalist's conundrum; in order to realize a profit, she had to strike a delicate balance between

[26] Michel 2001, 427–428.
[27] Veenhof 1972, 113.
[28] Michel 2001, 428–430.
[29] Michel 2001, 430 and Veenhof 1972, 114.
[30] Michel 2001, 430–431. Compare the letter written by their daughter (*ibid.* 444–445), Waqqurtum, which mentions several qualities of wool and textiles. On the translation of the Assyrian terms describing different varieties of finely woven textiles, see Michel and Veenhof 2010.
[31] Michel 2001, 433.

the amount of capital that she invested in the raw materials, and the quality of goods that she produced as finished products. Understandably, she was concerned about quality control, and she was aware of the potential marketability and buyers' demands for her textiles. Her concern with the impression of the quality of her textiles was not within the context of pride of workmanship, but rather referred to the amount of silver that her products would fetch in the market. Like a Wall Street banker, she never lost sight of receiving her share of the profits.

Eventually, we understand that she needed the silver to repair a crumbling house. She explained in a letter to her husband that she paid a worker to purchase new wooden beams to repair the house, and that they developed cracks after he had set them in place. Here, she rhetorically emphasized the desperate state of the family's current house: "Since you left, Šalmi-aḫum has already rebuilt his house twice! As for us, when will we be able to do the same?" She appended this discussion with a statement that reveals a laser-like concern for her profits: "As for the textiles that Aššur-malik brought you, why don't you send me the equivalent in silver?"[32] Perhaps she also needed the silver to pay off the family's debts and overdue taxes. She explained in one letter that she deftly fended off the tax collector: "As for the mina of silver that you sent me [to pay off] your export tax, the *musum*-official came to take it, and I was a little bit afraid for you, but I told him 'Oh, but the eponym official came to me and looked everywhere, but I haven't anything to give him.'" In the same letter, Lamassī contrasted her own craftiness with her husband's sense of honor and reputation: "Show your-self as a man of honor! Come and fulfill your obligations."[33] Her rhetoric was aimed at inducing shame in him to act, as she claimed that she was reduced to selling gifts: "Your own sister gave me a slave girl, but I had to sell her for 14 shekels of silver."[34] Lamassī's plaintive tone belies her drive for profit. In a patriarchal society as Assyria was, we might not expect to see the wife blatantly disrespecting her husband or trying to control his behavior; however, Lamassī did not hesitate to do so – and emphatically accentuated her situation in order to ensure that her silver arrived. She utilized such rhetoric shrewdly and expressed herself with such vehemence not because of her feminine nature or her particularly "emotional" personality, as some scholars have asserted,[35] but rather to ensure her own profits and her family's material health. This is a rhetorical strategy that we will see often in the letters from female entrepreneurs. Lamassī's rhetorical vehemence apparently benefitted her as she had intended, as we have several account records referring to payments of silver and goods that she received.[36]

More letters reveal that Lamassi and Pušu-kēn's daughter, Ahaha, was apparently a "chip off the old block"; she was an involved businesswomen and effective correspondent in her own right. Her letters are lengthy and contain many details about the family's financial situation. She was concerned with the estate of her deceased father, and instructed her brothers to take care of his holdings in Kanesh. Her rhetoric is straightforward, emphatic, and dictatorial; yet she also appealed to her brothers' sense of honor:

> As for the letter that you wrote concerning Kulumaya [an Anatolian indebted to the family]. Don't reject it or let it embarrass you. His payments are in arrears for three years! Since he left, he discredited the

[32] Michel 2001, 433–434.
[33] *Ibid.*
[34] *Ibid.*
[35] Larsen 1982; Larsen 2001.
[36] Veenhof 1972, 118.

spirits of the house of our father and for us, he treats us like 'petty men' ... You and Šat-Aššur, go into the house of [Kulumaya], acquaint yourselves with what's in it and seal it up. But don't give any of the tin or textiles to anyone else. Convert the certified tablets (containing the receipts and completed orders) into silver for our Anatolian and Assyrian creditors... [the letter continues with more commands].[37]

While she did not appear to be involved in the immediate production of the textiles, she was a recipient of the silver profits derived from their sale by the family firm. However, her letters reveal that ultimately she was more concerned for her own financial fortunes than for that of her family. She wrote to Puzur-Aššur, one of her father's debtors,

All of the capital of our father has been dispensed. Why, therefore, don't I have my supplementary part? ... As for Dan-Aššur's silver that I've been waiting for, you gave it to [my brother] Buzāzu. Then Buzāzu didn't give it to me. What kind of a brother refuses to give something to his sister, like Buzāzu has with me? ... You know well that I have no one else to turn to. But I keep hearing that you are holding the silver to give to Inna-Sin. Don't give it to my brothers ...[38]

In order to maintain their wealth, the Assyrian women continued to use a rhetoric of desperation and shame to ensure that they received their share of the profits. Ahaha's sister, Waqqurtum, wrote to her brother: "I have put four textiles under my seal and carried them to the man ... You are my brother and my master...Don't ruin me! You are my brother, sell my textiles for silver, then seal the silver and send it to me. Act properly in front of the spirits and gods so that I am not ruined."[39] Waqqurtum was an entrepreneur, as she was involved in the production and sale of textiles. Letters to her from her colleague, Puzur-Aššur, indicate that she paid strict attention to the construction, finishing and quality of her textiles in order to make them the most desirable on the market. Puzur-Aššur instructed her:

Make sure that only one side of the textile is combed, and it shouldn't be sheared. The weave should be dense. Compared to the textiles that you sent me before, add a mina of wool to each (of the other textiles), and make sure that they're thin! The other side should be lightly combed, and if it is slightly hairy, then it will turn out like one of those *kutanum*-textiles.[40]

Whatever quality of fabrics she sent her colleague, Waqqurtum's fortunes, however, might have continued to decline as her rhetoric to extract silver profits from the sale of her textiles from her brothers became increasingly desperate.[41] It is possible that the market forces had changed for Waqqurtum, and she had to carefully negotiate and reserve her capital. However, she must have had enough silver in capital to purchase goods, as Puzur-Aššur continues, "If you don't have time to make fine textiles, I've learned that there are many for sale there; so buy them and send them to me! The textile that you buy must be nine cubits wide and eight cubits long."[42] She also continued to send many lots of textiles to other trading partners. Like her mother, Lamassī, Waqqurtum had to make careful determinations as to the profitability of such capital and labor investments.

Waqqurtum's aunt, Tariš-matum, was no less resourceful and aware of the balance between

[37] Michel 2001, 440–441.
[38] Michel 2001, 441.
[39] Michel 2001, 443.
[40] Michel 2001, 444–445. Adapted from Veenhof 1972, 104–105.
[41] Michel 2001, 445–446: "You are my brothers and my masters, but I sit in an empty house ... miserable ...".
[42] Michel 2001, 444–445.

capital investment and profit, as she revealed in her own letters to and from her children and husband. Like Lamassī, she claimed to have a crumbling house in Ashur and saw to the physical repair of its walls herself: "On the subject of the house that we live in, oh, how much the house has deteriorated! I'm worried so I made some bricks in the springtime, and then I piled them up. As for the cement that you already wrote me about, send me the necessary silver so that I can buy some cement."[43] She also used forceful rhetoric to convince her brothers and direct their behavior. She wanted them to send the proper consignment of silver and share of the proceeds from the family textile sales that she felt she deserved:

> Because of the [small amount?] of votive silver to our father [god?], Belātum [her daughter] is sick and we are mistreated by the demons and spirits of the dead. You are our brother! Over there, tell Pušu-kēn so that he'll sell all of the tin and textiles, to seal the silver [in a packet] and send it to us in order to save our lives … Not a single one of you should touch that silver, not even a single cent.[44]

We also learn that Tariš-matum, like many of the other women, owned a share in a sophisticated Old Assyrian investment vehicle called a *tadmiqtum*, which she entrusted to a merchant to sell and return a profit.[45]

Anatolian women,[46] too, acted as entrepreneurs, as was the case for a woman named Sišahšušar, who was the *amtum*, or secondary wife, of the prominent Assyrian trader Aššur-nādā.[47] Her concerns centered around the receipt of silver to maintain the family compound in Kanesh. She wrote frequently to her husband requesting silver to purchase wheat and other staples, and also asked him to send her fine, imported oils from his travels. While evidence referring to this woman is limited in comparison to others, her correspondence reveals that her contact with textiles was as a consumer rather than a producer, as her husband assured her that he would bring a garment to their daughter, Ahar, when he arrived home.[48] Another daughter, Ishtar-lamassi (II), followed in her mother's footsteps and continued to live and travel throughout Anatolia with her husband, Puzur-Ishtar.[49] A woman named Lamaša was involved in the wool and copper trade and the production of household and dress items made of copper and wool in Anatolia. She instructed her colleague, Buzāzu, to send her some "good quality [copper] shoe-buckles" and she purchased copper to convert into implements. She also received large quantities of wool to re-sell.[50] She stood guard over her own storehouses, and owned a seal. In a series of letter, she precisely enumerated to her sister, Musa, possessions that she wished to extract from a house in Kanesh, including several tablets that probably referred to business deals or property: "three *kusītum* textiles, two *sum*-stones, 200 vats of beer, 20 sacks of grain, seven *arhalum* objects, … seven weights of silver, two of copper, 11 beams and a box of wood … three tablet-boxes are sealed by my seal. You are my sister, go over to Pušu-kēn's house, enter it and get all of the stuff. Give

[43] Michel 2001, 447–448.

[44] Michel 2001, 451.

[45] For the meaning of *tadmiqtum*, see Veenhof 1972, 110–111. For Tariš-matum's *tadmiqtum*, see Michel 2001, 452–453.

[46] Assyriologists are able to distinguish the ethnicity of the correspondents through orthography.

[47] The difference between primary and secondary wives in the Old Assyrian system seems to be one of legal technicality. Secondary wives could be either Assyrian or Anatolian, but could not legally reside in the same city as the primary wives (*aššatum*). They were not necessarily lower status than the primary wives. For a discussion of marriage in the Old Assyrian period, see Michel 2006b.

[48] Michel 2001, 479–480.

[49] Michel 2001, 481.

[50] Michel 2001, 483–485.

the tablets to Pušu-kēn."[51] From this letter we see a woman with her thumb on the pulse of her possessions and property. Regarding consumption of textiles in particular, we know that women owned their own finished garments, as they mention them in their letters.[52] For example, Ummi-Ishara wrote to her brother, asking "Why did you hold back the garment my sister sent for me to wear?"[53] To add to their profits, some women stripped wrapped garments off their own backs to include in lots of textiles for sale to both men and women.[54] This action reveals that when the women did produce finished garments at Ashur, they must have been in the form of a 'standard type', which could have been worn by either males or females.[55] It also shows the existence of a women-to-women network that allowed goods to circulate throughout the region and that created a parallel commerce in movable property and other services. Certainly the women transacted business with each other with regard to textile production and the family's capital. Carol Meyers has used archaeological evidence in combination with Biblical texts to trace similar "women's informal associations, or networks in Israelite agrarian communities"[56] of the Iron Age. There is no doubt that the men involved in the 'Cappadocian trade' formed informal as well as formal associations with each other, as well as with women, in order to conduct their commerce. Several studies have demonstrated the existence of such business entities in the Old Assyrian system; for instance, many male traders took part in *naruqqums*, which have been likened to joint stock funds that advanced credit and distributed profits and dividends to shareholders.[57] So, too, women facilitated the transfer of property by exchanging goods with each other and carefully tabulating those exchanges.

Another effective method that the women deployed to insure their profits was to appeal to their husbands' sense of religious duty and fear of the gods' reprisal. The master at such rhetoric was a woman named Taram-kubi, wife of the trader Innaya. Taram-kubi had a long life of helping to run the family firm and producing textiles. She gave birth to several children, outlived her husband, and came to some prominence on her own in Ashur. Her frequent references to deities and omens have led some scholars to conclude that she (and other women like her) were more superstitious or religious than the men; however, we must caution that there were men in the tablets who were equally 'superstitious.' The women deployed the rhetoric that they felt necessary in order to receive their silver: "If you are my brother, who else can I rely on? Kutallanum came and you didn't give him anything to bring to me. I will pray in front of my god for you."[58] Taram-kubi tried to remind her son to be more thrifty and pious, which was the main purpose of her entreaty; however, she appended her letter with a final sentence regarding his most important duty (emphasized in *italics*): "Here at Ashur, we consulted the omen priests, the diviners and the spirits; the god Aššur can't stop you: you love silver too much and will ruin your life! Don't you want to please the god Aššur in the city? Please, if you get this letter, come home, visit Ashur's

[51] Michel 2001, 486–487. For another woman seal-owner, see the letters written by Walawala (p. 500).
[52] Michel and Veenhof 2010, 263, 265.
[53] Michel and Veenhof 2010, 265.
[54] *Ibid.*
[55] Michel and Veenhof 2010, 263, argue that "there is almost no evidence of specific textiles meant as garments for women".
[56] Meyers 1999.
[57] Veenhof 1978; Dercksen 2004.
[58] Michel 2001, 469–470.

temple and save your life! *Why haven't you sent me the profits from my textiles?*"[59]

While Kunnanīya's husband was alive, she did not appear to have produced textiles, but requested them for her own family to wear as she confidently managed a large household in Kanesh that owned several slaves.[60] Among other things, Kunnanīya was responsible for raising the pigs owned by the family. She was also responsible for guarding the storehouses containing the couple's inventory and most importantly, for maintaining the family's archives, which contained important documentation concerning her husband's inheritance from his father and other property. Consequently, she was probably literate, as she often had to account for and retrieve specific tablets in the archive.[61] She moved unimpeded around the Anatolian countryside and to Ashur in her husband's absence, as he frequently reproached her for leaving the house unguarded. According to her correspondence, she became embroiled in a dispute with her deceased husband's relatives over his estate.

Kunnanīya's travails indicate that many of the women from the Old Assyrian period were financially independent enough to act as their own guardians and make their own decisions regarding where and how they wanted to live – they were the primary agents in their lives. We also see this in the correspondence and contracts of several *ugbabtum*-priestesses, specialized religious personnel from elite families who lived in cloister. These elite women were prohibited from marrying; thus they lived independently, produced textiles, and controlled their own financial affairs.[62] They have been compared to the famed *naditu*-priestesses of southern Mesopotamia.[63] One *ugbabtum*, Ahatum, was addressed honorifically by several young male relatives when they used the same rhetoric of obeisance that the women often reserved for their male relatives: "You are my mother, my mistress."[64]

The testaments of widows especially reveal this financial agency, as the women left their estates to their heirs as they saw fit. For example, Lamassatum directed her 'masters' to pay off her taxes and debts in Ashur: "If you are my fathers, to pay the tax bill on the house in Kanesh: seal up everything it contains – the furniture, the servants, the tablets, the silver hoards. Don't leave even one shekel and bring them to me. Please, don't sell the slave or the textiles."[65] Perhaps the textiles were important family possessions or a nest-egg to keep for lean times; or perhaps Lamassatum was waiting for better market conditions to sell her textiles at a good price. Ishtar-lamassi had enough property left in her name when she died to require her to write a *simtum*, or testament which was disputed by her heirs after her death.[66] The estate of Ishtar-lamassi must have been substantial enough to warrant the flurry of letters concerning its distribution that were preserved at Kanesh.

[59] Michel 2001, 470.

[60] There are a few contracts mentioning the purchase and sale of slaves by Kunnanīya.

[61] See for example Michel 2001, 496–497.

[62] For example, the priestess Ab-šalim (Michel 2001, 459–464). Several other *ugbabtum* priestesses are mentioned in contracts, see for example Ishtar-lamassi II (Michel 2001, 482).

[63] See Harris 1987.

[64] Michel 2001, 504–505.

[65] Michel 2001, 503–504.

[66] Many examples of *simtum* of men have been found amongst the tablets at Kanesh. They refer to the dispensation of probate matters regarding the estate of the deceased (*e.g.* taxes and debts owed) and list the inheritance passed down to each of the trader's heirs. Ishtar-lamassi's is the only known *simtum* of a woman. For a general discussion of testaments and wills in Ashur and Kanesh, see Veenhof 2008a and references cited therein.

We also hear frequently of women who repeatedly "bucked the system" by refusing to comply with either the wishes of their male relatives or even the legal authorities. Some daughters left their fathers' homes to live with others, either in Anatolia or Ashur, perhaps because of their financial independence. For example, Aššur-rabi wrote to his daughter, Maganika, who apparently rented out her family's house and went to live with her boyfriend: "Why do you let someone unknown live in our house while you leave to live with a man? If you are my daughter, watch over the house. I'll be home in ten days."[67] Elsewhere at Ashur, the granddaughters of the trader Imdīlum left and abandoned their elderly relative on their own accord. He complained bitterly of their departure to his son, Aššur-nādā: "I raised your son, but he said 'You are not my father!' He got up and left. Also your daughters have I raised, and they said: 'You are not our father!' On the third day they got up and left to go to you."[68] One could speculate that textile production and sales could have allowed these daughters' independent actions, but no evidence exists beyond these letters to confirm such speculation.

The most actively defiant and financially independent woman was Ishtar-bašti. Her correspondence shows that she moved to Kanesh to take care of family business affairs there, perhaps against the wishes of her father, Imdi-īlum. Upon hearing that she married an Anatolian man,[69] he wrote: "Me and my sons, we're not important to you. If we were important to you, you would honor me like a daughter [should]. Since I left Ashur I have lost a lot of money, but you ignore me." In spite of this, Ishtar-bašti was clearly irreplaceable to her family and through her textile production and shrewd lending practices, as well as attention to laws and suits, she directed much of the firm's business while her brothers traveled abroad. She wrote, "about the Kura family affair, Puzur-Aššur was worried, but we told him: 'Don't worry, let it go', the man went to the authorities, but I asked him, and then he settled [with us]."[70] And, "Relating to the thick textile that I gave you for the *tadmiqtum*-loan. If you are my master, sell it for a profit and give the silver, the price of the thick textile, to Amur-ili so that he can bring it to me."[71] Another letter written by her brother indicates that he conformed to her requests: "Say to Ishtar-bašti. I got 15 shekels of silver from your brother for your *tadmiqtum*...You're my sister, don't get mad at me."[72] In fact, it was Ishtar-bašti upon whom their father, Imdi-īlum, relied to keep her brothers on task in Anatolia. Like other female traders, she rhetorically emphasized the family's respectability and reputation to bring her brothers into line: "Inform [your brother] Amur-ili that he ought to respect people. He shouldn't think only about eating and drinking, he should be a respectable man."[73] Consequently, she wrote to her brother Puzur-Ishtar: "Be a respectable man and mind your father's instructions ... Come quickly so that I can leave with you and I can survey our father's house and guard it in Kanesh."[74] It is Ishtar-bašti, therefore, who seems to have controlled a good part of the family's purse strings, perhaps due as much to her abilities as to the profits that her textiles produced. Her father wrote to her: "I beg of you, make your merchandise available to sell

[67] Michel 2001, 458.

[68] Larsen 2001, 276.

[69] He had already given dowry money to another suitor. Thus, he would be seen as breaking a contract.

[70] Michel 2001, 466–468.

[71] Michel 2001, 471.

[72] Michel 2001, 472–473. Note the simultaneous use of "master," and the commanding tone of the letter.

[73] Michel 2001, 474–475.

[74] Michel 2001, 473.

on credit. Give the gold to the son of Limiššar and send it to me."[75] This daughter, it seems, did not always 'obey' the commands of her male family members. Rather, by sliding deftly between 'public' and 'domestic/household' contexts, Ishtar-bašti eluded traditional patriarchal authority. Some women defied patriarchal rules within the broader context of the city of Ashur's legal authorities. An unnamed woman, the "wife of the Rabi Sisi'e", refused to settle a case with a debtor. A letter from Kanesh reads: "Her case concerning the 3½ minas of silver is settled, but she refuses to take the silver. She (now) says: 'Neither will I make Buzazu pay, nor will I drop the case against him!' You are my father why does she keep putting forward claims against me?"[76]

Problematizing Women's Textile Production in the Old Assyrian Period: Historiography

While the process of textile production is interesting in itself, and the letters do give some detail about it, the prominence of the women textile entrepreneurs in the entire business of textile commerce is perhaps most interesting, as it relates to the important topics of gender, agency and identity. In the case of the Assyrian women, we learn of their agency in economic matters not from how they use the textiles to dress themselves but from how they use their *labour* in producing the textiles to negotiate their financial and familial situations. In the past, studies of textile production in the Old Assyrian period have suggested that the women of Ashur and Kanesh, producing their textiles in the "privacy of their homes," were only slightly additive to the more public nature of their husbands' commercial endeavors.[77] Although they do not state so explicitly, the scholars of the Old Assyrian period were influenced by the first wave of feminist historical scholarship. Early historians of women desired to 'find' women in the written historical records. However, a second and even third wave of feminist historical scholarship has emerged, and drives my own historiographic analysis here.[78] In the second wave of feminist thought, scholars seek to expose the historical oppression of women in society and historiography in order to "form alternative methods of defining relations of gender and society."[79] In the third wave, feminist scholars are forming new methodologies and alternative ways of exploring gender difference in the historical record as it relates especially to power.[80] I suggest that many of the publications about the 'remarkable' women of Ashur and Kanesh have resulted in *minimising* the Assyrian textile producers' achievements. For until very recently, the modern scholars usually concluded that the women were the supporters of the family firms, and not driving the business decisions, much less independent or entrepreneurial in their own right. Early in the historiography of the archives, the leading scholar on the Old Assyrian period, Klaas Veenhof wrote, "Various merchants wives in the absence of their husbands, came to function as heads of households, acquiring a number of responsibilities as their correspondence with their husbands abroad shows."[81] Two years later, he reiterated this assumption: "All the women remain in Assyria keeping their husbands' affairs

[75] Michel 2001, 473–474.
[76] Farber 2001, 41.
[77] Veenhof 1972; Veenhof 1977; Garelli 1979; Larsen 1982; Barber 1994; Dercksen 2004; Veenhof 2008b.
[78] For discussion of feminist scholarship in Mesopotamian studies, see: Meyers 2001, 278–279; Asher-Greve 1997; Bahrani 2001.
[79] Bahrani 2001, 15.
[80] *Ibid.*
[81] Veenhof 1977, 113.

in order, producing textiles that they send and receiving gifts and money in return."[82] In 1992, Gunbatti suggested that the women "helped" their husbands and brothers and were "almost as active" as them in business affairs.[83]

Elizabeth Barber, the foremost authority on ancient weaving (if not on Mesopotamia), whose books from 1991, *Prehistoric Textiles: the Development of Cloth in the Neolithic and Bronze Ages* and from 1994, *Women's Work, the First 20,000 Years: Women, Cloth and Society in Early Times* are the most frequently cited works on the subject, falls squarely into this school of thought. Barber reiterates the surprise of Veenhof, whose work she cites for her own material. She writes:

> Unlike the women of later times who were strictly confined to the harems, these women were free to go out to the market places and buy textiles from other women or buy the wool to make more cloths. They also dealt directly with donkey drivers and sometimes were asked to attend legal matters for their absent men ... The women's rights were far from equal to those of their husbands.[84]

Barber and the Assyriologists were influenced by their own post-Industrial Revolution, twentieth-century model of women and work, which privileged the "stay-at-home" wife and mother.[85] This model, however, forces scholars to form a literal interpretation of the written record from Mesopotamia; it was inconceivable that women could have owned businesses outright or to have been the driving force behind them in the ancient world. Indeed, scholars concluded that the female textile entrepreneurs of Ashur were conducting business within the confines of their homes but only secondarily to other duties for which they were responsible – taking care of the household while their husbands were away in Anatolia. As recently as 2008, Veenhof has reinforced the image of the women stalwartly standing by their men: "thus women took part in and supported their husbands' and fathers businesses." Yet he also notes secondarily that, "[they] were also able to earn some silver for their own purses."[86]

From the modern Assyriologists' point of view, men were the central actors in the 'public' institutions of commerce and politics, whereas women were involved in the family's 'private' affairs (or daily life) such as raising the children and taking care of the household. In fact, a whole new body of scholarship devoted to understanding the difference between 'private' and 'public' enterprise in Mesopotamia has emerged in Assyriology in the last few decades.[87] Throughout these discussions, the central concern of the scholars has been to define the primary context in which individuals owned property, and their relationship to state economic institutions.[88] All of these discussions have been driven by a long-accepted view of labor and property in history forwarded by Jürgen Habermas, which distinguishes between two separate (and unequal) 'public' and 'private' spheres of social agency. Critiquing the unconditional acceptance of Habermas' description of history, Garfinkle has recently argued for a continued differentiation in the activities

[82] Original in French, my translation of Garelli 1979, 42.
[83] Gunbatti 1992.
[84] Barber 1994, 171. Barber has recently updated her interpretation, writing in 2008 that the "women were in business for themselves", Barber 2008, 174.
[85] Carol Meyers 1999, who influences my work here, has argued for a similar historiographic narrative for biblical scholarship of the 19th and 20th centuries.
[86] Veenhof 2008b, 285.
[87] Perhaps this arose as a response to Cold War politics and debates over socialism in modern government, a debate that continues with regard to the Mesopotamian economy well into the 21st century. For a recent contribution, see for example, Silver 2006.
[88] The literature on this subject is vast. See Garfinkle 2005 for further references.

of individuals, but he suggests using the terms 'institutional' and 'non-institutional' in the place of 'public' and 'private'; this terminology seems more descriptive and less anachronistic to him.[89]

However, the terms 'public' and 'private' continue to be used today without regard to their connotations or the role of gender in their conception and differentiation. For example, Larsen uses the term 'private' to describe the level of intimacy between the senders of letters at Ashur and Kanesh, and the restricted number of people who would have been privy to the information in them: "[The letters could] therefore be entirely private exchanges directly between a person and his or her close kin or friends and colleagues, a privacy ensured also by the practice of placing letters in sealed envelopes."[90] Private, in this context, describes interpersonal relationships – yet those 'private' exchanges often concerned very 'public' subjects, such as the collection of city taxes. Private, to other scholars and in other contexts, refers to the level of economic interaction, again, without regard to gender and the implications the modern term has in our own society. When Garfinkle writes: "It has become obvious that the ancient entrepreneur operated in an economic system that was not governed by the same mechanisms as the modern economy. At the same time, the entrepreneur of the Ancient Near East was interested in acquiring ever greater wealth, and as a result he sought opportunities to maximize his gain, and to do so on behalf of his household," he assumes that the generic entrepreneur was a male.[91] This sentiment is echoed by scholars interested in the Old Assyrian economy. Dercksen uses the terms private and institutional to differentiate between two modes of textile production, asserting that the male-dominated institutional mode was more important to profit-building. He writes, "the businessmen [at Kültepe were] *private* (italics orig.) entrepreneurs and the sole motivation of their undertaking was profit."[92] In a later article, he argues that

> Small-scale spinning and weaving was usually done by women and will have been performed largely within a domestic context. The 'local production' [of textiles at Ashur] was different from the home weaving performed within the context of the households of the traders...the quantity of textiles produced in that way, estimated at several hundred pieces, probably carried little weight in economic terms.[93]

While quantitatively we have far more textual evidence for male entrepreneurs than for females in Mesopotamia in general, such language is engrained in and contributes to a furthering of modern anachronistic stereotypes about women, men, work and agency. Feminist historians from other fields indeed have argued that the dichotomy that relegates female labor to the private sphere and male commercial activities to the public sphere was constructed in the eighteenth century (AD) in Europe in response to the Industrial Revolution and the concurrent Cult of Women's Domesticity that built an emerging middle class identity.[94] The 18th and 19th centuries' model of women's status and roles in society subordinated women legally and relegated them to the 'private' sphere in order to 'liberate' them from the toil of work. This ideological insistence and naturalisation of the "bourgeois domesticity" of separate spheres created a social space where middle class males could distinguish themselves from the working classes.[95]

[89] *Ibid.* See also Dercksen 2000.
[90] Larsen 2001, 277.
[91] *op. cit.*, 408
[92] Dercksen and Lamberg-Karlovsky 1996, 168.
[93] Dercksen 2004, 15.
[94] Riverby and Helly 1992, 8–9.
[95] For a concise discussion of the historical contingency of the notion of "separate spheres", see Katz 1999, 295–300.

Cécile Michel, on the contrary, argues that our ancient businesswomen were as equally attentive to their own capital and profits as were their husbands. She writes, "they stridently defend their interests and [the women] guard against any use of their capital by their husbands or their representatives."[96] The un-self-conscious use of public and private to differentiate between women's and men's (unequal) spheres of labor begs further consideration, especially when Assyriologists wish to discuss the household and 'domestic economy.' The feminist Biblical historian and archaeologist, Carol Meyers, has argued for such a gendered interrogation of the division of labor, observing that modern biases will lead to inappropriate archaeological analogies.[97] As for the 'household', Garfinkle suggests that "the ordinary urban household...was usually a patriarchal household and the head of the family controlled all of the household's material wealth."[98] Such assumptions and their constant reiteration therefore lead to "surprise" when a female "head of household" or entrepreneur is encountered, as in the case of the women textile entrepreneurs at Ashur and Kanesh. As Meyers has argued, they also "subtly reinforce essentialist notions about female (and male) behavior."[99] I offer here an alternative to analyses of the Old Assyrian material that have naturalized a model based exclusively on the public/private dichotomy, when in fact we have many other models that undermine such an interpretation. For if we do not question such a model, and we portray such texts as "hopelessly patriarchal, [such a portrayal] risks being an act of cultural hubris, if not academic orientalism."[100]

Studies of textiles and their production, in particular, can serve centrally in feminist historians' desire to de-naturalize this private/public dichotomy since, as Schneider has argued:

> The study of cloth can illuminate women's contributions to social and political organization that are otherwise over looked ... women's involvement with cloth production exposes in complex ways the complementarity, the domination and the subversive tactics that together comprise gender relations, forcing us to rethink women's roles in kinship, economic, and political domains ... cloth gives women a measure of economic autonomy.[101]

It is the task of the ancient historian of Mesopotamia, therefore, not only to make the invisible visible, but also to find the spaces in which the women of Ashur maneuvered, while recognizing that such spaces are not necessarily always 'private' or never 'public'. In fact we have in the Old Assyrian tablets a rare occurrence of the *obvious visibility* of women in an arena – written records about public or private commerce – in which males are typically more visible, especially in southern Mesopotamia. The archives demonstrate that despite frequent assertions by modern scholars to the contrary, the women of the Old Assyrian period were not always dependent upon and unequal to their male relatives.

I suggest that the Ashur-Kanesh culture was a frontier society with an entrepreneurially minded population in which traditional societal practices might have been altered or disregarded entirely. Indeed, Steven Lumsden has noted that the Old Assyrian colony period should "be understood as one of dramatic change ... that was extraordinarily transformative for local Anatolian societies."

[96] Michel 2001, 423.
[97] Meyers 2001, 279.
[98] Garfinkle 2005, 409.
[99] Meyers, *op. cit.*
[100] *Ibid.*
[101] Schneider and Weiner 1989, 4, 25. This idea is reiterated in an article about female tailors in Renaissance Florence by my colleague at Southern Illinois University Edwardsville, Carole Frick 2005.

Therefore, the period led to the formation of "new social realities, new institutional practices, new identities and new ways of thinking," [102] especially in Anatolian societies, but also likely in Assyrian society. Borrowing a concept that Richard White framed for the French and Algonquian Indians in North America during the pre-modern period, Lumsden describes the encounter between Anatolians and Assyrians as a "Middle Ground ... an ambivalent place 'in-between' cultures and peoples in social encounters, where accommodation and invention takes place, and social identities are negotiated."[103] For the Algonquian Indians and the French, Indian women played a crucial role in this Middle Ground for a variety of reasons that I do not have space to reiterate here.

While I am not directly comparing the Old Assyrian colony period with the North American fur trade, I do think that we can frame similar questions about our respective materials. One historical contingency of the period is the fact that traders were often traveling and not able to be present in person when legal matters arose.[104] Therefore, the Old Assyrians were forced to be original and creative in their legal practices, which led in part to a situation in which "women in many respects were equal to men in law," a condition not always present in other parts of Mesopotamia or in other time periods.[105] Furthermore, individuals within merchant firms were linked together by movable property and loose business connections and not by common land ownership and inheritance.[106] The Assyrians of this time determined that wives and daughters could serve this linking function as well as male relatives.

In a society that valued *movable* over landed property, it is not surprising that women would play an equally important role in the ownership and management of such property, since the women were largely in charge of manufacturing and/or procuring such movable capital, mainly in the form of textiles. However, exchanges of other material culture must have led to the prominence of women in this period. Lumsden notes that luxury items and votive objects were often discussed in the tablets as traveling between Assyria and Anatolia and intended for family members of traders, along with the more commercially-intended trade items of bulk silver and other goods. We have seen this transference of property in some of the women's correspondence. Moreover, he argues that the intermarriage of Assyrians and Anatolians contributed to this exchange of material culture, and furthered the unique 'hybridity' of this Middle Ground situation.[107] In sum, the general historical contingencies of the Old Assyrian colony are unique in Mesopotamian history. However, the prominence of women in the business affairs of the trading firms was not the *cause* of the unique and surprising nature of the correspondence, but rather a *result* of the historical context of a unique frontier society. This example demonstrates the importance of assessing scholarly models and de-naturalizing the public/private dichotomy in studies of the ancient world.

[102] Lumsden 2008, 24.

[103] *Ibid.*, citing White 1991, x.

[104] Veenhof, Eidem and Wäfler 2008, 95.

[105] There are, of course, many exceptions to this rule. Queens (royal wives) certainly had higher legal status than others, even males. Or, certain priestesses of a particular class enjoyed such (near) equality during the Old Babylonian period in the south. For discussion of *naditu*-priestesses, see Harris 1987. The *ugbabtu*-priestesses from Ashur, well-known from the Kanesh archives, might have also enjoyed such status. However, the difference during the Old Assyrian period is that women did not *have* to belong to such priestly classes to garner legal equality and economic independence.

[106] As noted by Lumsden 2008, 37; Larsen 2007.

[107] Lumsden 2008, 37.

Conclusion

Textiles were the form of material culture that played perhaps a primary role in the hybridization of the community at Kanesh. While we do not have any actual representations of the textiles or fragments of cloth from this period and place in Mesopotamia, the phantom trails left in the letters from the trading families of Ashur allow us to follow the lives of female textile entrepreneurs. Without the textiles, and the importance of their trade within the Old Assyrian *kārum* system, we might not have known about the shrewdly resourceful businesswomen of the period. It is through their ability to produce and trade textiles that the woman used their voices, and in a rhetorically creative and effective manner, shaped their identities as actively agent participants in all spaces – 'public' or 'private', 'institutional' or 'individual' – of their society.

Acknowledgements

I would like to thank Henriette Koefoed and Marie-Louise Nosch for their encouragement and the editorial committee of this volume for their astute reading and constructive responses to this study.

Bibliography

Asher-Greve, J. 1997. Feminist Research and Ancient Mesopotamia: Problems and Prospects. *In* A. and C. Fontaine Brenner (eds) *A Feminist Companion to Reading the Bible: Approaches, Methods and Strategies*, Sheffield, 218–37.

Bahrani, Z. 2001. *Women of Babylon: Gender and Representation in Mesopotamia*. New York.

Barber, E. J. W. 1994. *Women's Work: The First 20,000 Years. Women, Cloth, and Society in Early Times*, New York, Norton.

Barber, E. J. W. 2008. Weaving the Social Fabric. In C. Gillis and M.-L. Nosch (eds) *Ancient Textiles. Production, Craft and Society*, Oxford, 174–179.

Dercksen, J. 2000. Institutional and Private in the Old Assyrian Period *In* A. Bognaar (ed.) *Interdependency of Institutions and Private Entrepreneurs*, Istanbul, 135–52.

Dercksen. J. 2004. *Old Assyrian Institutions*. Vol. 4. PIHANS 98, Leiden.

Dercksen, J. and Lamberg-Karlovsky, C. C. (eds) 1996. *Beyond the Tigris and Euphrates: Bronze Age Civilizations*. Beer Sheva, vol. 9, Negev.

Donbaz, V. 1989. Some Remarkable Contracts of the I-B Period Kultepe Tablets. *In* K. Emre, M. Mellink, B. Hrouda and N. Özgüç (eds) *Anatolian and Ancient Near Eastern Studies in Honor of Tahsin Özgüç*, Ankara, 75–90.

Emre, K. 1993. New Lead Figurines and Moulds from Kultepe and Kizilhamza. *In* M. Mellink, E. Porada and T. Özgüç (eds) *Aspects of Art and Iconography: Anatolia and Its Neighbors: Studies in Honor of Nimet Özgüç*, Ankara, 169–77.

Farber, W. 2001. '... But She Refuses to Take the Silver!' the Strange Case of the Aššat Rabi Sisi'e." *In* W. van Soldt, J. G. Derckse, N. J. Kouwenberg and Th. J. Krispijn (eds) *Veenhof Anniversary Volume: Studies Presented to Klaas R. Veenhof on the Occasion of his Sixty-Fifth Birthday*, Leiden, 137–43.

Frick, C. 2005. Gendered Space in Renaissance Florence: Theorizing Public and Private in the 'Rag Trade'. *Fashion Theory* 9, 127–45.

Garfinkle, S. 2005 Public and Private in the Ancient Near East. *In* D. C. Snell (ed.) *A Companion to the Ancient Near East*, Oxford, 384–96.

Garelli, P. 1979. Femmes d'affaires en Assyrie. *Archiv Orientalni* 47, 42–8.

Gunbatti, C. 1992. Some Observations About the Commerical Activities of Women in Light of the Kültepe Tablets. *In* H. Otten, H. Ertem, E. Akurgal and A. Süel (eds) *Sedat Alp Festschrift: Hittite and Other Anatolian and Near Eastern Stuides in Honour of Sedat Alp*, Ankara, 229–34.

Harris, R. 1987. Independent Women in Ancient Mesopotamia? *In* B. S. Lesko (ed.) *Women's Earliest Records from Ancient Egypt and Western Asia*, Atlanta, 145–65.

Ichisar, M. 1981. *Les archives Cappadociennes du marchand Imdilum*, Paris.

Katz, M. 1999. Women and Democracy in Ancient Greece, 41–68. *In* M. Falkner, N. Felson, and D. Konstan (eds) *Contextualizing Classics: Ideology, Performance, Dialogue*, Rowan and Littlefield.

Lamberg-Karlovsky, C. C. 1996. The Archaeological Evidence for International Commerce: public and/or private enterprise in Mesopotamia. In M. Hudson and B. Levine (eds) *Privatization in the Ancient Near East and Classical World*, Cambridge (MA), 73–108.

Larsen, M. T. 1967. *Old Assyrian Caravan Procedures*. Nederlands Historisch-Archaeologisch Instituut in het Nabije Oosten, Istanbul

Larsen, M. T. 1982. Your Money or Your Life! A Portrait of an Assyrian Businessman. *In* J. N. Postgate (ed.) *Societies and Languages of the Ancient Near East: Studies in Honour of I.M. Diakonoff*, Warminster, 214–45.

Larsen, M. T. 2001. Affect and Emotion. *In* W. von Soldt *K. R.* (ed.) *Veenhof Anniversary Volume*, l'Institute historique-archeologique neerlandais de Stambou, Leiden, 275–86.

Larsen, M. T. 2002. *The Aššur-nādā Archive*, Nederlands Instituut voor het Nabije Oosten. Leiden.

Larsen, M. T. 2007. Individual and Family in Old Assyrian Society. *Journal of Cuneiform Studies* 59, 93–106.

Larsen, M. T. 2008. Archives and Filing Systems at Kultepe. *In* C. Michel (ed.) *Old Assyrian Studies in Memory of Paul Garelli*, PIHANS 122, Leiden, 77–88.

Larsen, M. T. 2010. *The Archive of the Shalim-Ashur Famiily, Vol. 1: The First Two Generations*, Ankara.

Lumsden, S. 2008. Material Culture and the Middle Ground in the Old Assyrian Colony. *In* C. Michel (ed.) *Old Assyrian Studies in Memory of Paul Garelli*, PIHANS 112, Leiden, 21–43.

Meyers, C. 1999. 'Women of the Neighborhood' (Ruth 4.17): Informal Female Networks in Ancient Israel. *In* A Brenner (ed.) *Ruth and Esther: A Feminist Companion to the Bible*, edited by, Sheffield, 110–27.

Meyers, C. 2001. Recovering Objects, Re-Visioning Subjects: Archaeology and Feminist Biblical Study *In* A. Brenner and C. Fontaine (eds) *A Feminist Companion to Reading the Bible: Approaches, Methods, and Strategies*, London, 270–84.

Michel, C. 1991. *Innaya dans les tablettes paléo-assyriennes, analyse et textes*. Editions Recherche sur les Civilisations, Paris.

Michel, C. 1997. Les malheurs de Kunnanīya, femme de marchand. *Archivium Anatolicum*, 239–53.

Michel, C. 2001. *Correspondance des marchands de Kanish au début du IIe millenaire avant J.-C.*, Les Editions du CERF Paris.

Michel, C. 2006a. Femmes et production textile à Aššur au début du IIe millénaire avant J.-C. *Techniques et culture* 46, 281–97.

Michel, C. 2006b. Bigamie chez les Assyriens au début du IIe millénaire. *Revue historique de droit français et étranger* 84, 155–76.

Michel, C. 2008, The Alahum and Assur-Taklalu Archives Found in 1993 at Kultepe Kanish. *In* G. Kryszat (ed.) *Festschrift Karl Hecker zum 75. Geburtstag am 25. Juli 2008*, AoF 35, 53–67.

Michel, C. 2009, Les femmes et l'écrit dans les archives paléo-assyriennes. *In* F. Briquel-Chatonnet, S. Fres, B. Lion and C. Michel (eds) *Femmes, cultures et sociétés dans les civilisations Mediterranéennes et Proche-Orientales de l'antiquité*, Lyon, 253–72.

Michel, C. and Veenhof, K. 2010, The Textiles Traded by the Assyrians in Anatolia (19th–18th centuries BC) *In* C. Michel and M.-L. Nosch (eds) *Textile Terminologies in the Ancient Near East and Mediterranean from the Third to the First Millennia BC*, Oxford, 211–71.

Özgüç, T. 2003. *Kultepe Kanish/Nesha: The Earliest International Trade Center and the Oldest Capital City of the Hittites*, Middle Eastern Cutlure Center in Japan, Istanbul.

Riverby, S. and Helly, D. (eds) 1992 *Gendered Domains: Rethinking Public and Private in Women's History*, New York.

Schneider, J. and Weiner, A. B. (eds) 1989. *Cloth and Human Experience*, Washington.

Silver, M. 2006. Public, Palace and Profit in the Ancient Near East. *Akkadia* 127, 5–12.

Teissier, B. 1994. *Sealing and Seals on Texts from Kültepe Karum Level 2*, Uitgaven Van Het Nederlands Historisch-Archaeologisch Instituut Te Istanbul, Leiden.

Veenhof, K. 1972. *Aspects of Old Assyrian Trade and Its Terminology*, Leiden.

Veenhof, K. 1977. Social Aspects of Old Assyrian Trade. *Iraq* 39, 109–18.

Veenhof, K. 1978. 'Modern' Features in Old Assyrian Trade. *Journal of the Economic and Social History of the Orient* 40, no. 4, 336–66.

Veenhof, K. 2003a. The Old Assyrian List of Year Eponyms from Karum Kanish and Its Chronological Implications. *Publications of the Turkish Historical Society.*

Veenhof, K. 2003b. Old Assyrian Period. *In* R. Westbrook (ed.) *A History of Ancient Near Eastern Law*, Leiden Boston, 431–83.

Veenhof, K. 2003c. Archives of Old Assyrian Traders. *In* M. Brosius (ed.) *Ancient Archives and Archival Traditions: Concepts of Record-Keeping in the Ancient World*, Oxford, 78–123.

Veenhof, K. 2008a. The Death and Burial of Ishtar-Lamassi in Karum Kanish. *In* R.J. van der Spek (ed.) *Studies in Ancient Near Eastern World View and Society. Presented to Marten Stol on the Occasion of his 65th Birthday, 10 November 2005*, Amsterdam, 97–119.

Veenhof, K. 2008b. Sisterly Advice on an Endangered Marriage in an Old Assyrian Letter. *In* M. T. Roth *et al.* (eds) *Studies Presented to Robert D. Biggs, June 4, 2004 from the Workshop of the Chicago Assyrian Dictionary, Vol. 2*, Chicago, 285–303.

Veenhof, K., Eidem, J. and Wafler, M. 2008. *Mesopotamia: The Old Assyrian Period*. Orbis Biblicus et Orient, vol. 160, Fribourg.

Waerzeggers, C. 2006. Neo-Babylonian Laundry. *Revue d'assyriologie et d'archéologie orientale* 100, 83–96.

Waetzoldt, H. 1972. *Untersuchungen zur Neusumerischen Textilindustrie*. Vol. 1, Rome.

White, Richard. 1991. *The Middle Ground: Indians, Empires, and Republics in the Great Lakes Region,* Cambridge Studies in North American Indian History. Cambridge.

7. Visualising Ancient Textiles – how to make a Textile Visible on the Basis of an Interpretation of an Ur III Text

Eva Andersson Strand and Maria Cybulska

Ancient textiles are often only preserved as fragments and even if some textile tools, or rather parts of these tools, like spindle whorls and loom weights, are frequently found, it is clear that the picture will never be complete. However, by combining different sources, such as iconography and textual evidence as well as ethnographic textile craft knowledge and experimental textile archaeology, is it possible to give a more detailed and complete interpretation of ancient textile craft.

In this article the focus is on how such a combination of knowledge and sources can make textile production more visible in relation to a translated Mesopotamian Ur III text (Fig. 1) dated to *c*. 2050 BC. A translation of the text was published in 1972 but was also presented by Professor Hartmut Waetzoldt, Universität Heidelberg, at the international exploratory seminar Textile Terminology in the 3rd and 2nd millennia BC in Copenhagen in 2009.[1] At this seminar, questions were raised regarding *what this text tells us about the textile production* and *what type of textile was produced*. Furthermore, does this text give a *"true" description of a textile production process* and did the *original author know what he/she was describing*? In the following, the text will be interpreted and discussed from *a textile technology perspective*. It is important to note that the aim is *not* to discuss the context in which it was found or indeed the context in which it was recorded. The aim is instead to discuss if, and demonstrate how, this specific text can be combined with textile craft knowledge, strictly from a textile technical perspective.

Producing a textile includes many steps: fibre preparation, spinning, loom setup, weaving and finishing. Furthermore, many decisions have to be made: what type of fibres to use, what type of yarn and of what quality, what type of weaving and technique, *etc*. The choices are myriad and depend on the result you wish to obtain and what the finished product will be used for. Moreover, several types of textile tools are necessary for this *chaîne opératoire* (see Figure 7.1).[2]

In the text, the first sentence *1 guz-za-fabric of fourth-class wool* gives the name of the textile and, furthermore, information on wool type and demonstrates that a structured wool sorting system existed (Fig. 7.1).

[1] Waetzoldt 1972, T.32 Rs. I 6–14, 233; 2010, 205; Michel and Nosch 2010.
[2] *E.g.* Barber 1992; Breniquet 2008; Völling 2008.

1 guz-za-fabric of fourth-class wool,

the mixed wool for it (weighs) 4kg

1 woman cleans and combs 125g in a day and 1 woman 'mingles' (HI.HI.) in a day 1kg (possibly production of roving/slubbing/Vorgarn)

The warp threads for it (weigh) 333g (and) 1 woman yarns 8.3g strongly twisted threads; the weft threads for it (weigh) 1.66kg (and) 1 woman produces (of them) 61g on a day

(the) length (of the guz-za-fabric is) 3.5m (and the) width (is) 3.5m;

3 women fasten the warp in 3 days

(and) 2 women weave 50cm on a day.

Figure 7.1. Translation of T.32 Rs. I 6-14 Ur III text, Prof. Hartmut Waetzoldt, Universität Heidelberg. Waetzoldt 1972, 2010.

Figure 7.2. Different wool sorting categories on one merino sheep (after Kriger 1969).

According to Ur III texts the wool was sorted into no less than five categories/groups: royal quality, next quality (after royal), 3rd quality, 4th quality and poor quality.[3] It is clear that the more homogeneous wool fibres are the easier it is spin a homogenous and evenly spun thread. Different fibre qualities are needed for different types of textiles. This is also the reason that even today many different sheep breeds exist and depending on where the sheep are from and what the wool is used for the wool fibres varies. In order to get the desired wool type selected breeding is commonly used. Furthermore, the wool from the sheep is also today sorted in different categories since the wool quality of fibres vary depending on what part of the sheep the wool is taken from. For example fibres from the neck and belly are in general coarser than the wool from the sides and back. Also today, in the wool industry, the wool quality is often defined by the fineness of the fibres (Fig. 7.2).[4]

From different Ur III texts it has been calculated that the royal quality is 2,74–5,26% of the

[3] Waetzold 1972, 47–48.

[4] Kriger 1969, 31–32.

total amount of one fleece while the 4th quality is as much as 63,21% to 70,48% of the total weight.[5] A fourth class wool is, according to modern wool sorting qualities, quite coarse while it is likely that the royal quality had very thin fibres.[6]

The sentence continues *the mixed wool for it (weighs) 4kg.*

How much wool one sheep can yield depends on the breed of sheep, but also on whether it is a lamb, ewe, ram or wether. Differences can also be due to the food available to the sheep and also to the type of climate. However, based on calculations on different Ur III texts it has been suggested that the annual raw wool yield on average would have been approximately 0.7 to 1.12kg.[7] If these suggestions are correct and taking into account that only 70% of the fleece from a sheep is used (fourth class wool), it can be estimated that wool from at least five, maybe eight, sheep were used to produce this textile.

Furthermore, the wool, used for textiles, on each sheep contains different parts: hair and underwool (Fig. 7.3). The hair is in general coarser and longer than the underwool and ranges in

Figure 7.3. Underwool and hair fibres. Photo CTR.

diameter from *c.* 50 to 100 microns (µ) and can either be spun on its own into a hard and strong yarn, or can be spun with the underwool. The underwool fibres are thinner; they can be less than 30 µ in diameter, but between 30–35 and *c.* 60 µ is classed as medium.[8] The underwool tends to be shorter than the hair, but can be spun separately from it. Yarn spun partly or entirely from underwool will be softer than a yarn spun with only hair. In this case the wool is *mixed* and it could therefore be suggested that both hair and underwool were used.

Next it is written that *1 woman cleans and combs 125g on a day.*

The quality of the spun thread partly depends on how carefully the wool is prepared. The wool could of course have been washed but since it is written that the wool is 'cleaned' this might not have been the case. It is likely that the combs, used to prepare the fibres for spinning, were made of perishable material like wood and unfortunately no combs from this area have been preserved. However, there are finds of wool combs dating to the Bronze Age from the Caspian Sea Maritime Steppes.[9] It is possible that a similar comb could have been used in the Mesopotamian region during this period (Fig. 7.4a and b).

At the Danish National Research Foundation's Centre for Textile Research (CTR), several wool

[5] Waetzold 1972 in Wisti Lassen 2008, 46–47.
[6] Kriger 1969, 31.
[7] Waedzoldt 1972, 17–23; Potts 1997, 92–93.
[8] *E.g.* Barber 1992, 20–21.
[9] Shislina *et al.* 2000, 111; Olofsson *et al.* forthcoming.

a b

Figure 7.4. a. A reconstructed wool comb. Photo by CTR; b. Woolcombing. Drawing by Annika Jeppsson © Annika Jeppsson and CTR.

sorting and combing tests have been made by highly skilled craftspeople (Figs 7.4a and 7.4b).[10] The tests demonstrated that each craftsperson prepared *c.* 14.16g an hour; if working 8 hours, each craftsperson would have prepared and combed *c.* 114g a day. It is of course not possible to know how many hours the woman worked but 125g corresponds well with the estimated daily amount of prepared wool determined from the experimental tests.

The sentence continues *and 1 woman 'mingles' (HI.HI.) on a day 1 kg (possibly production of roving/ slubbing/Vorgarn)*. When combing the wool is drawn out from the combs in bands, these bands are then put together and formed into balls that can then be put onto a distaff (Fig. 7.5). This process does not, according to the time it took the CTR textile technicians, take a great deal of time, so it is reasonable that an individual could prepare 1kg a day.

Next it is written *The warp threads for it (weigh) 333g (and) 1 woman yarns 8.3g strongly twisted threads; the weft threads for it (weigh) 1.66kg (and) 1 woman produces (of them) 61 g on a day.*

This sentence gives a lot of information. First, the warp weighs 333g and the weft 1660g: altogether, 2kg. Has only 2kg of the 4kg wool been used? Or is it actually two fabrics that have been produced? The first question to ask is, does the text refer to 4kg of raw wool or wool already sorted? For the CTR experiments a fleece weighing 2.7kg was selected, after sorting the wool 1.1kg was used for spinning: that is, 41% wool for spinning and 59% discarded. However, this was a choice that the CTR spinners made, they wanted a specific wool quality and it is clear that some parts of the discarded wool could have been used. If the UR III text refers to raw wool it is reasonable to believe that 50%, that is 2kg, was discarded. However, it is also important to note that during the preparation and spinning process some wool is always discarded. During the experiments at CTR approximately 22% was discarded during the preparation process and 26–40% during the spinning process = 48–62% of the total amount of wool.[11] Again this was a

[10] Mårtensson *et. al.* 2006a; Mårtensson *et. al.* 2006b; Andersson *et. al.* 2008.
[11] Olofsson *et al.* forthcoming.

choice of the spinners and much of the discarded wool could have been used for spinning other qualities for other types of textiles.

To conclude the knowledge obtained at the CTR tests suggests, according to our opinion, that it is likely that the UR III text refers to wool that has already been sorted and that 2kg of wool were discarded during the different preparation processes.[12] Furthermore, it is plausible that also the discarded wool could have been used in the production of another type of textile. If the text refers to the production of two different fabrics there is no discarding and loss of wool fibres during the fibre preparation processes, which would be highly unlikely.

It is clear that the warp and weft yarn were

Figure 7.5. Balls made of combed wool. Photo CTR.

of different types. The thread could have been spun with spindles with or without a whorl. Testing spindle whorls of different sizes clearly confirms that with a light spindle one spins a thin thread and with a heavier whorl one spins a thick thread.[13] If using a spindle with a whorl it is therefore likely that the spinners used different types of spindles for spinning the warp and weft yarn. According to different spinning tests it is clear that it takes a longer time to spin a very thin thread than a coarser thread.

Comparing the amounts given in the text with the CTR spinning tests, the textile technicians spun an average of 35m of yarn an hour using a spindle with a spindle whorl weighing 4g, and 50m an hour if using a spindle with a spindle whorl weighing 18g. The 35m of thread spun in an hour with the light spindle weighed 2.11g, and in eight hours the CTR spinners could therefore spin a yarn weighing *c.* 17g.[14] This is twice the weight of yarn that the Mesopotamian women spun in a day. The 50m of CTR yarn spun in an hour with the heavier spindle weighed 8.0795g and if spinning eight hours the yarn would weigh *c.* 65g, which is similar to the amount of yarn the Mesopotamian women spun a day. However, it is important to note that the CTR spinning time does not include winding up the yarn when the spindle was spun full (*i.e.*, the amount of yarn that can be spun on one spindle) while it is plausible that the time mentioned includes time for winding up the thread when a spindle was spun full. With this time included, the CTR spinners spun *c.* 10g in eight hours with the light spindle and *c.* 50g in eight hours with the heavier spindle. The reason for the difference is that the very thin thread spun with the light spindle takes a longer time to wind up because one has to be more careful; if not, this fine thread would break. As mentioned above, it is not possible to evaluate how many hours the Mesopotamian craftspeople worked a day, but it is clear that the spinning time mentioned in the text corresponds to one very thin thread and one thicker.

[12] Mårtensson *et al.* 2006a; Mårtensson *et. al* 2006b; Andersson *et al.* 2008; Olofsson *et al.* forthcoming.
[13] Andersson Strand *et al.* 2008; Andersson Strand and Nosch forthcoming.
[14] Andersson *et al.* 2008.

It should also be noted that the "warp was strongly twisted". When spinning, one can spin a loose thread or a hard spun thread. Under the condition that yarn has the same thread diameter and the same amounts of fibres are spun, a loosely spun thread contains fewer fibres than a hard spun thread. The loosely spun yarn will therefore be lighter and the spinner will get more meters than if the yarn was hard spun. The latter would be heavier per meter *i.e.* the spinner would get less meters of threads. In this specific case, one can assume that the warp yarn was hard spun, resulting in less meters of yarn than if the yarn had been loosely twisted. Furthermore, regardless of the type of loom, the warp yarn has to be strong enough so it can be kept taught, if not the thread will break.[15]

To conclude, the different amount of wool used for the warp and the weft yarn suggests that the spinners where spinning two different yarn qualities. Additionally, this is supported by the time it took to spin the yarn. According to spinning tests, even for an experienced spinner, it takes more time to spin a hard spun thin yarn than it takes to spin a thicker more loosely spun yarn.

A fabric is created by weaving together two thread systems. One of these systems, the warp, runs parallel to the side of the loom and is kept stretched during weaving. The other system, the weft, lies at right angles to the warp and runs alternately over and under the warp threads. Since both the length and the width of the textile is given in the next sentence, *(the) length (of the guz-za-fabric is) 3.5m (and the) width (is) 3.5m,* it is not only possible to suggest what types of thread could have been used but also what type of fabric could have been produced. Again, the calculations are based on the CTR spinning experiments and the relationships between the structural parameters of thread and fabric used in contemporary textile science and engineering.

The areal mass of the fabric can be calculated as 2000g/(3.5m × 3.5m) = 163g/m². However, when setting up a weave and also during weaving some yarn will always be wasted. Assuming 3% of waste, the areal mass equals 158g/m². The areal mass of the fabric can also be calculated as the sum of the mass of the constituting warp and weft. Because from the text it can be determined that the ratio between the weight of the warp and the weft equals 1/5 (0.333/1.66) the weight (including waste) of warp in 1m² equals 26.3g and the weft in 1m² of fabric equals 131.7g.

The relation between the weight of warp and weft is consistent with gauze weave with thin warp threads and thicker weft threads. In a gauze weave the warp threads run in pairs and are not evenly spread in the fabric, as they are, for example, in a balanced tabby (Figs 7.6a and 7.6b). This type of weave would make the structure stable in a set-up with a width of 3.5 m. However one of course cannot exclude an ordinary tabby fabric in which the warp threads are evenly placed and in this case the weave would get a weft-faced structure *i.e.* the thicker weft thread would cover the thinner warp threads (Fig. 7.7).

It should also be noted that different weaving techniques are used when producing a gauze fabric and a tabby weave. When producing gauze, the two successive warps are twisted together after each weft insertion, while the weft is relatively straight. In a tabby the warp threads are divided into two layers, so that the weft runs alternately over one warp thread and under the next.

Textile finds are very rare from the area and period under study but it is interesting that gauze like textiles were already produced in wool in the Early Bronze Age in the North Caucasus.[16]

Furthermore, based on

[15] Mårtensson *et al.* 2009.
[16] Shishlina *et al.* 2003.

Figure 7.6. The structure of: a. A gauze fabric; b. A tabby weave.

Figure 7.7. An example of a weft faced fabric. Photo CTR.

- warp and weft crimp;[17]
- twist factor;
- efficiency of spinning/ meters of spun yarn per hour;
- hours of spinning a day,

one can suggest the thread diameter and the number of thread per centimetre for this specific *guz-za* textile (for more information on the calculations please see Appendix 1). In this case the most likely calculations, based on assumptions from experiments and textile science, suggests that the warp threads have a diameter of *c.* 0.31 mm and the weft thread a diameter of 0.8 mm with 3.66 warp threads and 6.17 weft threads per cm (Appendix 1). However, it is very important to understand that if the given parameters change the calculations will change and consequently that is the given thread diameter and threads per centimetre will be different. Nevertheless, it is clear that the warp thread will be much thinner than the weft thread and that this fabric will have a special structure either as a gauze textile or a weft-faced tabby.

The text continues

> 3 women fasten the warp in 3 days
> (and) 2 women weave 50 cm on a day.

It is not surprising that it takes three women three days to fasten the warp; actually this is, according to the CTR experiments, quite quick and indicates that these women had a lot of experience. Before weaving the setup had to been done, in which the warp threads have to be pre-arranged in a more or less fixed set. The setup is done in slightly different ways depending on which loom type is used, but the principles for different loom types are mainly the same. The first step is to warp the warp threads (Fig. 7.8). Each warp thread has to be the length of the decided length of the fabric. In order to make the warping easier, one can warp several threads together. One warping method known from Middle Bronze Age Egypt (but also from ethnographic sources), is to wind the yarn between pegs fastened on a wall (Fig. 7.8a). Another method known from the same area and time period is to wind the warp yarn on supported uprights (Fig. 7.8b).[18] The length between the first and the last peg/upright is the length of the warp threads.

The prepared warp is then stretched between two beams (horizontal and vertical two-beam looms) (Figs 7.9 and 7.10). It is important that the warp threads are held taut; if the threads are too loose it will not be possible to change the shed (the space through which the weft is passed) when weaving, and if they are too taut they will break. Another important factor is that the warp threads lie straight or slightly outwards, otherwise the width of the fabric will vary and/or the weaving process will become unnecessarily complicated. This is generally demonstrated on depictions of looms, regardless of which type of loom is represented.[19]

In the process of weaving, the weft is inserted between the warp threads; to facilitate this, the warp threads are first divided into different layers so that sheds can be created. The next step in the setup is therefore to heddle the warp threads to heddle rods. The heddles, usually made

[17] Crimp: in a weave the weft threads run alternatively over and under the warp threads and thus they are not straight but follow a wave-like line. The same concerns warp threads. It means that a real length of thread in the fabric is longer then a fabric itself. The difference between this real length of thread and the length of the fabric, expressed in percents, in textile engineering is called the crimp and can be calculated for different fabrics (see also Appendix 1).
[18] Vogelsang-Eastwood 1992, 23.
[19] *E.g.* Barber 1992, 81–115.

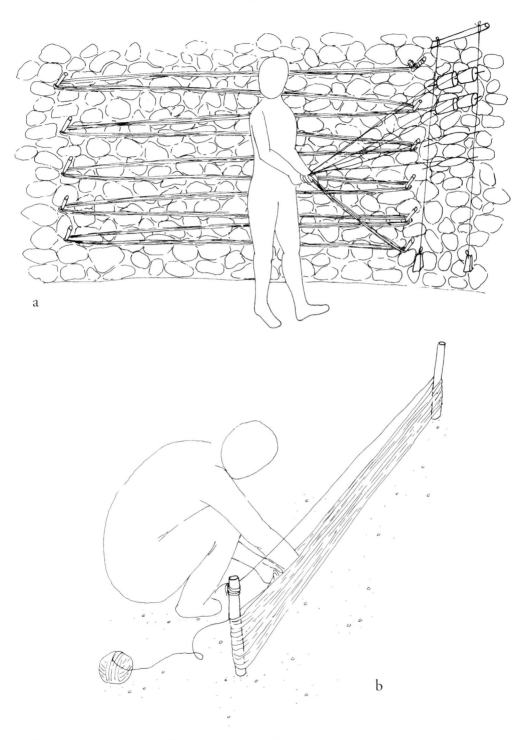

Figure 7.8. Warping. a. warping on pegs fasten in the wall. b. Warping on supported uprights. Drawing Annika Jeppsson.
© Annika Jeppsson and CTR.

of strings, are used to attach each individual warp thread to the heddle rods. When weaving tabby on a two-beam loom or a horizontal ground loom, warp threads number 1, 3 ,5 7, 9, *etc.* are attached to one heddle bar while warp threads 2, 4, 6, 8, 10 *etc.* are attached to the other bar. The heddle bars can then be used to lift all of the warp threads in a given layer at the same time, thus creating different sheds Finally, when the setup was completed, the weaver could start weaving.

The length and the width of the fabric are quite substantial and again one can discuss if it is woven in one or two pieces. However these types of fabric, gauze or tabby, could hypothetically be woven without any problems in both a vertical loom with two or more beams (Fig. 7.9) or a horizontal ground loom (Fig. 7.10). Finally the texts tell us that two women weave 50cm in a day and because of the width of the fabric it is likely that two weavers would have worked together Unfortunately, no weaving tests have been done on a loom with this width and this type of fabric, so it is not possible to evaluate if this time consumption could be considered as reasonable.

In this paper the aim was to present how different types of sources can be combined in order to give more detailed information and to make an invisible textile visible by combining textual evidence with textile knowledge. It is clear that all the information given in the text is very reasonable: it could actually be a description of how this textile was produced, how long it took to make and finally how much raw material was used. Whether the woven fabric actually was a gauze-like fabric can of course be discussed, but according to calculations it is likely even if another type of weaving technique *e.g.* a weft-faced tabby with thicker weft threads than warp threads cannot be excluded. The definition of quality is highly subjective and it is of course very difficult to know if the people in this area and period considered this guz-za textile as fine, coarse, of high quality, something for everyday use *etc.* To discuss this perspective a more detailed study and comparisons are necessary. [20]

However, it is, according to the authors, clear that the person who wrote the texts had knowledge about textile craft or at least recorded more or less correct information. Thus even if we do not have all the information it is possible, by combining approaches, to provide a more detailed picture of ancient textile production.

Acknowledgements
We kindly thank Hartmut Waetzoldt for the inspiring question. We would also like to thank Joanne Cutler, Agnete Wisti Lassen and Marie-Louise Nosch for help and constructive criticism.

[20] *E.g.* Firth and Nosch 2012.

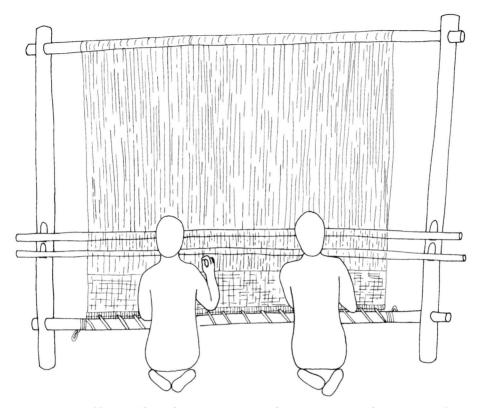

Figure 7.9. Vertical loom, with two beams. Drawing Annika Jeppsson. © Annika Jeppsson and CTR.

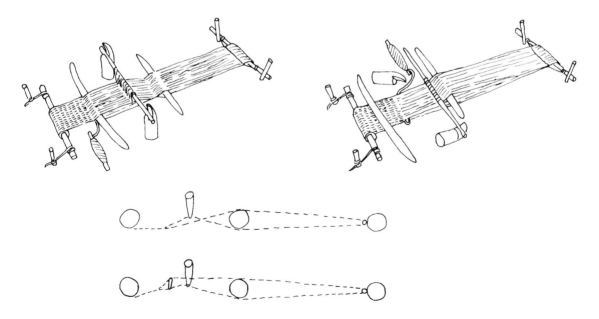

Figure 7.10. Horizontal ground loom. Drawing by Annika Jeppsson after Broudy 1979. © Annika Jeppsson and CTR.

Appendix 1

Calculations based on the CTR spinning experiments and the relationships between the structural parameters of thread and fabric used in contemporary textile science and engineering

Maria Cybulska

Most fabrics can be characterised by a weft crimp higher than the warp crimp. However, there are some exceptions. In the case of gauze weave due to its structure (two successive warps are twisted together after each weft insertion, while the weft is relatively straight) the warp yarn crimp is much higher than the weft crimp. Additionally the warp was strongly twisted and thus stiffer, which could make the crimp even higher. The weft in the fabric is almost straight. In this case the fabric cross-section would look like the one shown in Fig. 7.A1.

One can assume a very low weft crimp of 5%, and a higher warp crimp of 35% caused by the gauze-like structure. Values of crimp can be verified experimentally – this is an initial calculation only. From the equations written above the number of threads per cm can be calculated for any assumed linear density of yarn Tt, tex. (weight in g of 1km of thread)

$$\text{No. of warps per cm} = 26.3*1000/[Tt1*130]$$
$$\text{No. of wefts per cm} = 131.7*1000/[Tt2*105]$$

Then the spacing of warp and weft threads is calculated (distance between the axes of successive threads) as an inverse of the number of threads per cm.

It is also possible to estimate the diameter of threads on the basis of linear density Tt using the formula

$$d\,[m] = \frac{c}{\sqrt{1000}} \cdot \sqrt{Tt}$$

(C for wool equals 1.32)

Also the linear density in tex [g/km] can be estimated on the basis of the weight of the warp and weft spun during one day by one woman W, assuming spinning efficiency per hour E and number of hours of daily spinning H

$$Tt = 1000* W / (E*H)$$

The number of twists per 1m can be calculated on the basis of twist factor and linear density of thread using the formula

$$\text{No. of twists} = t_f^* \sqrt{\frac{1000}{Tt}}$$

Then we can recalculate the thread diameter using the empirical relationship for wool by van Issum and Chamberlain

$$d\,[m] = 0{,}0532^* \sqrt{Tt} + 0{,}0683 - 0{,}245^* \frac{\text{(twists per metre)}}{1000}$$

For the calculations it has been assumed that the twist factor for the warp is 150 and is three times lower = 50, for the weft. The results of the calculations are presented in Tables 7.A1 and 7.A2 below.

The efficiency of spinning and the number of working hours in a day have to be chosen on the basis of textile experience and knowledge. It also needs to be taken into account that the warps in gauze fabric run in pairs, so distance between pairs equals doubled spacing.

1. warp and weft crimp
2. twist factor
3. efficiency of spinning
4. hours of spinning a day

On the basis of experiments the assumed data can easily be corrected and it would also be easy to recalculate the fabric structure.

The fabric could be made on the simple frame where after each weft insertion two successive warp threads are twisted in the same direction. However, more probably the fabric was made on a horizontal or vertical loom. In this case two successive warp threads have to be turned alternatively in Z and S direction. Figure 7.A2 shows both structures.

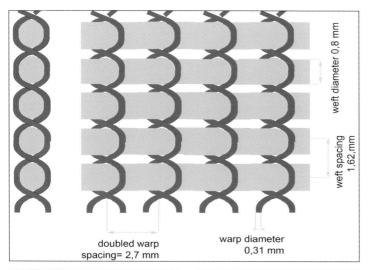

Figure 7.A1. The suggested gauze weave.

a b

Figure 7.A2. Visualisation of the suggested fabric woven on:
a. simple frame; b. horizontal or vertical loom.

Efficiency m/hour	hours of spinning	m/day	linear density of warp, tex	threads per cm	Diameter	twists per m	spacing	diameter based on twist
25	5	125	66	3,05	0,34	582	3,28	0,36
25	6	150	55	3,66	0,31	638	2,74	0,31
25	7	175	47	4,27	0,29	689	2,34	0,27
25	8	200	42	4,87	0,27	736	2,05	0,23
25	9	225	37	5,48	0,25	781	1,82	0,20
25	10	250	33	6,09	0,24	823	1,64	0,17
30	5	150	55	3,66	0,31	638	2,74	0,31
30	6	180	46	4,39	0,28	699	2,28	0,26
30	7	210	40	5,12	0,26	755	1,95	0,22
30	8	240	35	5,85	0,25	807	1,71	0,18
30	9	270	31	6,58	0,23	856	1,52	0,15
30	10	300	28	7,31	0,22	902	1,37	0,13
35	5	175	47	4,27	0,29	689	2,34	0,27
35	6	210	40	5,12	0,26	755	1,95	0,22
35	7	245	34	5,97	0,24	815	1,67	0,18
35	8	280	30	6,82	0,23	871	1,47	0,14
35	9	315	26	7,68	0,21	924	1,30	0,11
35	10	350	24	8,53	0,20	974	1,17	0,09

Table 7.A1. Results of calculations for warp threads.

Efficiency m/hour	hours of spinning	m/day	linear density of weft, tex	threads per cm	diameter	twists per m	spacing	diameter based on twist
45	5	225	271	4,63	0,69	96	2,16	0,92
45	6	270	226	5,55	0,63	105	1,80	0,84
45	7	315	194	6,48	0,58	114	1,54	0,78
45	8	360	169	7,40	0,54	121	1,35	0,73
45	9	405	151	8,33	0,51	129	1,20	0,69
45	10	450	136	9,25	0,49	136	1,08	0,65
50	5	250	244	5,14	0,65	101	1,95	0,87
50	6	300	203	6,17	0,60	111	1,62	0,80
50	7	350	174	7,20	0,55	120	1,39	0,74
50	8	400	153	8,22	0,52	128	1,22	0,69
50	9	450	136	9,25	0,49	136	1,08	0,65
50	10	500	122	10,28	0,46	143	0,97	0,62
55	5	275	222	5,65	0,62	106	1,77	0,83
55	6	330	185	6,79	0,57	116	1,47	0,76
55	7	385	158	7,92	0,53	126	1,26	0,71
55	8	440	139	9,05	0,49	134	1,11	0,66
55	9	495	123	10,18	0,46	142	0,98	0,62
55	10	550	111	11,31	0,44	150	0,88	0,59

Table 7.A2. Results of calculations for weft threads.

Bibliography

Andersson, E. B., Mårtensson, L., Nosch, M.-L. B., and Rahmstorf, L. 2008. New Research on Bronze Age Textile Production. *Bulletin of the Institute of Classical Studies* 51, 171–174.

Andersson Strand, E. and Nosch, M.-L. B. (eds) forthcoming. *Tools, Textiles and Contexts. Investigating Textile Production in the Aegean and Eastern Mediterranean Bronze Age,* Ancient Textiles Series. Oxbow, Oxford.

Barber, E. J. W. 1992 (1991). *Prehistoric Textiles. The Development of Cloth in the Neolithic and Bronze Ages with Special Reference to the Aegean*, Princeton.

Breniquet, C. 2008. *Essai sur le tissage en Mésopotamie, des premières communautés sédentaires au milieu du IIIe millénaire avant J.-C.*, Paris.

Broudy, E. 1979. *The Book of Looms, A history of the handloom from Ancient Times to Present*, London.

Firth, R. and Nosch, M.-L. B. 2012. Spinning and Weaving Wool in Ur III Administrative Texts. *Journal of Cuneiform Studies* 64, 53-70.

Geijer, A. 1979. *A history of textile art*, London.

Kriger, M. 1969 (1963). *Wool in pictures.* Visual Industry Series, London.

Mårtensson, L., Andersson, E., Nosch, M.-L. and Batzer, A. 2006a. *Technical Report, Experimental Archaeology, Part 1, 2005-2006.* Tools and Textiles – Texts and Contexts Research Program. The Danish National Research Foundation's Centre for Textile Research, University of Copenhagen. http://ctr.hum.ku.dk/research/tools_and_textiles_/.

Mårtensson, L., Andersson, E., Nosch, M.-L. and Batzer, A. 2006b. *Technical Report Experimental Archaeology, Part 2:2 Whorl or bead? 2006.* Tools and Textiles – Texts and Contexts Research Program. The Danish National Research Foundation's Centre for Textile Research, University of Copenhagen. http://ctr.hum.ku.dk/research/tools_and_textiles_/.

Michel, C and Nosch, M.-L. 2010. *Textile Terminologies in the Eastern Mediterranean and Mediterranean from the Third to the First Millennnia BC*, Ancient Textiles Series 8. Oxford. Oxbow.

Olofsson, L., Andersson Strand, E. and Nosch M.-L. B. (forthcoming). Chapter 4.1. *In* E. Andersson Strand and M.-L. Nosch (eds), *Tools, Textiles and Contexts. Investigations of textile production in the Bronze Age Eastern Mediterranean.* Ancient Textile Series. Oxbow, Oxford.

Petruso, M. K. 1986. Wool-evaluation at Knossos and Nuzi. *KADMOS Zeitschrift für Vor-und Frügriechishce Epigraphik.* 26–37.

Potts, D.T. 1997. *Mesopotamian Civilization: The material Foundations.* Cornell University Press. London

Shishlina, N. I., Orfinskaya, O. V. and Golikov, V. P. 2000. Bronze Age textiles of the Caspian Sea Martime Steppes. *In* J. Davis-Kimball, E. E. Murphy, L. Koryakova and L. T. Yablonksy (eds), *Kurgan Ritual Sites, and Settlements: Eurasian Bronze and Iron Age.* BAR International Series 890, 109–125.

Waetzoldt, H. 1972. Untersuchungen zur Neusumerischen Textilindustrie. *Studi Economici e technologici* 1. Roma.

Waetzoldt, H. 2010. The Colours of Textiles and Variety of Fabrics from Mesopotamia during the Ur III Period (2050 BC). *In* C. Michel and M.-L. Nosch (eds), *Textile Terminologies in the Ancient Near East and the Mediterranean Area from the 3rd to the 1st millennium BC.* Ancient Textiles Series 8, Oxbow, Oxford, 201–209.

Wisti Lassen, A. 2008. *Textile and Traders, a study of technology, organization and socioeconomics of textiles production in Anatolia in the Middle Bronze Age c. 2000-1700 BC.* MA thesis in Assyriology, University of Copenhagen.

Völling, E. 2008 *Textiltechnik im Alten Orient : Rohstoffe und Herstellung*, Würzburg.

Vogelsang-Eastwood, G. 1992. *The Production of Linen in Pharaonic Egypt*, Leiden.

8. The Costumes of Inanna/Ishtar

Bernice Jones

Among the pantheon of Mesopotamian goddesses, Ishtar (Inanna in Sumerian), goddess of love and war, is clearly the most significant and intriguing, not least of all, in terms of her garments. In her poem, *Inanna and Ebih*, dating to the Akkadian period, *c.* 2300 BC, Enheduanna, daughter of Sargon, King of Akkad, described Inanna (translated variously) as "clad in terror"[1] or with "terror folds in her robes."[2] In *Inanna and Enki*, and a *Balag* hymn, Inanna is the "Queen of the multi-coloured robe," and she also wears a black garment.[3] In *The Courtship of Inanna and Dumuzi*, she preferred fine linen over coarse wool, and her bridegroom "Dumuzi waited expectantly" while "she covered her body with the royal white robe."[4]

In order to explore these important statements, this paper shall focus on various aspects of the costumes of Ishtar, and related ones. Because no garments from the ancient Near East have survived in the archaeological record, the paper evaluates and identifies their construction through a detailed analysis of their representations in art and comparisons with actual clothes preserved from Egypt, and representations of garments from the Aegean. It incorporates experiments in reproducing the garments,[5] and arranges them on live models positioned as in art to determine which constructions best reflect the art, and how the garments were arranged on the body.

At the beginning of the Akkadian period, Ishtar is portrayed wearing the new style of flounced garment as illustrated on a seal in the Oriental Institute (Fig. 8.1).[6] The style is also worn by

[1] Black 1998, lines 1–6. Also see Verderame 2009, 63–73.

[2] Meador 2000, 90–92. Meador's translation that she "wear[s] the robes of the old, old gods," although intriguing, appears misunderstood since the passage is translated differently by others, particularly Attinger 2011, 2, lines 15–20, and Attinger 1998, 164–195.

[3] Kramer 1981, 4, line 11; Kramer 1989, 61, 223, and Wolkstein and Kramer 1983, 16. There is also a reference to multicoloured strands of Ishtar's skipping rope, see Sjöberg 1976, 212.

[4] Wolkstein and Kramer 1983, 30–31, 33, 35.

[5] My experimental garment reconstructions, like those of Bieber 1918, 62; Goldman 1994, 213–37, esp. 213–16, utilize modern commercial cloth. Although experiments with recreating ancient textiles are outside the scope of this paper, we know from texts that linen and wool were used to make clothes (see Wolkstein and Kramer 1983, 30–31, 33, 35), and perhaps even cotton since during the Harappan civilization, *c.* 2600–1900 BC, Indus cities cultivated cotton, produced cotton cloth, and traded with the Mesopotamian cities of Susa and Ur (Kenoyer 2003, 377–381). This is especially intriguing since Ur was the home of Enheduanna during this period.

[6] Black stone Mesopotamian seal, Akkadian period, *c.* 2334–2154 BC. Oriental Institute, University of Chicago inventory

Enheduanna, daughter of King Sargon of Akkad and priestess of Nanna, the Moon God of Ur, on the Disc of Enheduanna.[7] The style, which will be considered in detail below, replaces an older design that was either made of bulky fleece or made to look like it.[8] The old flounced garment design is portrayed on both men and women on the plaque of Ur-Nanshe, ruler of Lagash in ED IIIa (*c.* 2520 BC).[9] Fine examples of this garment dated to ED III are preserved in sculpture from both Mesopotamia and Syria. A sealing from royal palace G at Ebla (*c.* 2400–2250 BC), illustrates Syrian male and female figures wearing such flounced skirts, which, according to Porada, were of fleece, made of tufts of wool shaped like large leaves and arranged in flounces.[10] Similar interpretations of the garment have been suggested by Strommenger, who called it "Zottenstoff" (tufted material), and by Kohlmeyer, "so-called *Kaunakes* ... styled from a woven material which was tufted and/or

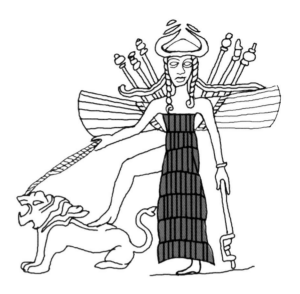

Figure 8.1. Ishtar on seal in the Oriental Institute, University of Chicago A27903 (drawing by S. White after Wolkstein and Kramer 1983, 92).

tasseled to resemble a sheep's fleece."[11] The costume on an alabaster seated priestess from the ED III Temple of Ishtarat at Mari seems to support Kohlmeyer's theory.[12] A fringed border is revealed at the lower part of her mantle which may indicate the warp fringes at the edge of a cloth onto which rows of tufted or tasselled fleece appear to be applied. A comparison of the tufted garments on the Mari priestess and on Ur Nanshe and his wife with the contemporary representation of fleece on the ram from the Royal Cemetery of Ur, ED IIIa (*c.* 2550 BC), reveals that its' fleece, carved from shell and set into bitumen, is identical in style to them.[13] Just how severely stylized the artist's rendering of the fleece was is immediately apparent when comparing natural fleece from actual rams.[14]

The subsequent flounced style as seen on Ishtar on the Oriental Institute's seal (Fig. 8.1),[15] and

number A 27903 (after Wolkstein and Kramer 1983, 92). Also see Ishtar on the seal of the scribe Adad from the Akkadian period, British Museum 89 115, in Collon 1987, 164, no. 761; Moortgat 1969, 54, 333, pl. F, no. 5; and Parrot 1961, 193, fig. 237.

[7] Amiet 1975, 193–196, Abb. 101.

[8] Jones 1998, 127–137.

[9] Here, the king and his wife, i.e. men and women of the highest rank, wear the garment. See Frankfort 1970, 70, fig. 73. For further discussion and bibliography see Hansen 1975, 179–181, 188, Abb. 85.

[10] Porada 1985, 92, fig. 14.

[11] Strommenger 1971, 48; Kohlmeyer 1985, 157.

[12] Kohlmeyer 1985, 130–133, 158–161, cat. no. 64.

[13] Woolley 1939, 121 and 264. For further discussion see Hansen 1975, 158–161, 170, Abb. 41.

[14] Mazar 1959, 182.

[15] Seal from the Oriental Institute, University of Chicago A 27903 (after Wolkstein and Kramer 1983, 92).

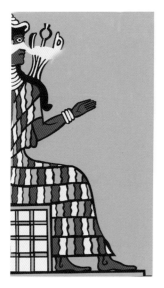

Figure 8.2. Ishtar from Audience Hall, Mari (drawing by S. White after Parrot 1961, 283, fig. 348b).

Enheduanna on her disc,[16] has received various interpretations. Moortgat describes Enheduanna's robe as: "a flounced garment of several layers of ruches (strips of pleated material] which are cut off horizontally, while the tufts on the layers are vertical and wavy ... and they are of equal length throughout.[17] In her study of Mesopotamian dress, Strommenger described the material as organized in pleated flounces in steps one above the other but lamented being unable to reach a clear reconstruction because of the lack of representations in sculpture in the round.[18] Indeed, even when all views are represented as on the Old Babylonian copper or bronze statuettes from Ur, still little information as to the manufacture of the tiered garment is provided.[19] The rear view, however, shows the necklace counterweight which hangs down the centre of the back. Collon thought that the tiered garment was made either of a pleated or fringed fabric, the latter possibility in imitation of the earlier sheepskin garment.[20]

Painted depictions of the wavy, tiered garment, worn by Ishtar, from the Audience Hall of the palace of King Zimri-Lim of Mari, who reigned *c.* 1781–1758 BC, show that it is comprised of a variety of colours: black, bluish grey, ochre, and dark brown (Fig. 8.2).[21] This must be the multi-coloured robe described in *Inanna and Enki* and the *Balag*.[22] Whether the art portrays the actual colours of the textile or the palette available to the painter is an open question. If pleats are meant, as the above scholars suggested, they appear to be striped and multicoloured. If fringes, as Collon has proposed, the variations in colour may indicate either the subtleties of hues inherent in natural wool or dyed strands, especially since wool takes dyes easily. Donald Hansen believed that the wavy lines of colour likely were a painterly convention for fringes.[23]

In terms of the alternative, pleating with wool is difficult to achieve and hard to retain.[24] Linen, on the other hand, is easy to pleat. Although climatic conditions in the Near East prevent the preservation of textiles, the situation is different in Egypt where actual pleated linen garments are not only preserved but are favoured from as early as the 1st Dynasty, *c.* 2800 BC as the linen dress from Tarkhan indicates.[25] A 6th Dynasty example is the linen dress with pleats arranged horizontally from an adult female burial at Naga ed-Der.[26] A 12th Dynasty painted example is the horizontally pleated cattle driver's tunic from the Tomb of Amenemhet at Beni Hasan.[27] They

[16] Amiet 1975, 193–196, Abb. 101.
[17] Moortgat 1969, 48.
[18] Strommenger 1971, 52–3.
[19] Collon, 1995, 101, fig. 80.
[20] Collon 1995, 101.
[21] For colour image, see Parrot 1961, 282–283, figs 348a, b.
[22] Kramer 1981, 4, line 11; Kramer 1989, 61, 223; Wolkstein and Kramer 1983, 16.
[23] Personal correspondence, 1998.
[24] Hyde 1988, 561; Austin, 1944.
[25] Hall 1986, 27–28, figs 15–16.
[26] Hall 1986, 31, fig. 20.
[27] Hall 1986, 32, fig. 21.

are, however, nowhere more finely represented then in the 18th Dynasty, *c.* 1361–1352 BC, in the vertically pleated garments of Tutankhamun and his queen, rendered in silver-plate on his throne.[28] According to Hall, the pleats were achieved by placing the wet fabric into wooden crimping boards such as the one preserved in the British Museum. Boards with straight grooves yielded straight pleats, and curved or serrated grooves yielded wavy pleats.[29]

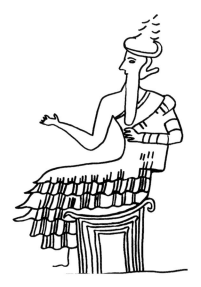

Lacking the actual garments and textiles, we are left without real evidence for the construction of the Near Eastern flounced garments. Although lines mark linen pleats in Egypt, they alternatively, as Hansen suggested, may be a painterly convention for fringes in the Near East, especially since there they are differentiated by colour. And if, as Collon suggested, the intent was to imitate fleece, wool fringes seem a likely choice. On the other hand, the colour differentiation, and the ubiquitous presence of ground lines at the flounces' hems, could well argue for striped or pleated cloth.

Figure 8.3. God on Old Syrian Seal (Drawing by S. White after Porada, 1948, pl. CXXXVII, fig. 910).

The flounced garments and skirts, with striated tiers as traditionally worn by deities and priestesses, lasted through the Kassite and Mitannian periods as indicated on the Kassite seal of Narubtum, dated *c.* 1400–1350 BC.[30]

In contrast to the elaborate flounced costumes of Near Eastern deities and priestesses, much simpler flounced versions, not striated, but of solid fabric, are worn by Syrian women of the 15th to 13th centuries as recorded both in the Near East on a fragment of an alabaster jar found in the stone foundations of the Middle Assyrian palace of Adad-nirari I (1307–1275 BC) at Assur, illustrating, albeit in an abbreviated manner, a seated woman wearing a Syrian flounced skirt,[31] as well as in Egyptian tombs of the 18th Dynasty, for example, the captive Syrian women in the tomb of Rekhmire, *c.* 1450 BC,[32] and the wife of a Syrian prince from the tomb of Nebamon, *c.* 1411–1397 BC.[33] As clearly as the Egyptians in their tombs distinguish the flounced garments of the Syrian women from their own female attire, so the solid white, flounced garments of the Syrian woman are distinguished from the striated, multi-coloured, flounced attire of the Syrian and Mesopotamian goddesses and priestesses.

A seated god on an Old Syrian seal, *c.* 1750 BC, wears one of the fanciest representations of the flounced garment (Fig. 8.3).[34] Like Ishtar on the Audience Hall painting (Fig. 8.2), a flounced diagonally wrapped mantle covers his torso. The ankle length garments' six, or possibly seven

[28] Donadoni 1969, 128–129.
[29] Hall 1986, 52, fig. 40.
[30] Kassite seal inscribed "Narubtum, daughter of Bazi, sister of Nabu-dayan, servant girl of gods Shamash and Amurru." See Collon 1987, 150, fig. 653.
[31] Smith 1965, 29, fig. 42.
[32] Wachsmann 1987, detail, pl. XLI; Mazar 1959, 276.
[33] Smith 1965, 29, fig. 41; Bossert 1923, 245, fig. 339.
[34] Porada 1948, 118–119, pl. CXXXVII, fig. 910.

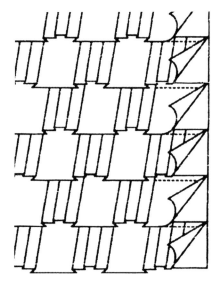

Figure 8.4. Diagram of construction of experimental striped and pleated flounced garment (drawing by M. Carvalho and L. Grisafi).

tiers are made up of groups of three to four closely arranged striations alternating with a wide space, somewhat like metopes and triglyphs. Although the ancient Near Eastern flounced skirt is adopted by the Minoans and Mycenaeans for their goddesses and priestesses in general, this elaborate design appears on the most important Aegean examples: the faience "snake goddess" from Knossos and the goddess on the gold pin finial from the Shaft Graves at Mycenae, both dated to *c.* 1600 BC.[35]

Since I experimented with its construction for the Aegean models, it is appropriate that I apply it to its Near Eastern prototypes. Based on the multicoloured stripes on the presentation goddesses and Ishtar on the Audience Hall and Investiture paintings from the palace of King Zimri-Lim of Mari, *c.* 1781–1758 BC (and the Knossos "snake goddess"), I constructed two versions. The split robe shown by the raised leg of Ishtar on the Chicago seal (Fig. 8.1), and a split skirt illustrated on the raised leg of the god in ascending posture at the right on a provincial Old Babylonian seal, *c.* 18th century BC, in the Yale Babylonian collection, suggest that the garments were rectangles of cloth, open at one side and wrapped around the body.[36] Therefore, one garment is made of striped and pleated flounces, diagram of construction in Fig. 8.4, to satisfy the "metope and triglyph" design of the skirt of the god on the Old Syrian seal (Fig. 8.3), where the hemlines undulate, arching below the striations ("triglyphs"), as if marking pleats, and, alternatively, curving downward below the blank spaces ("metopes"), as if marking plain fabric. Seven flounces (L: 7"), were stacked one above the other and sewn onto a white piece of cloth (W: 54", L: 38"). Strings were sewn onto the top corners for tying the garment around the body as was done with Egyptian loincloths.[37] The second garment was constructed in the same way, but with seven multicoloured fringed flounces (L: 6 ½"), sewn one above the other onto a white cloth (W: 50"; L: 38"), to test the cited theories and possibly satisfy such images as the wavy stripes on Ishtar's skirt on the Audience Hall painting (Fig. 8.2).[38] The experimental striped and pleated (Fig. 8.5), and fringed (Fig. 8.6), skirts, arranged on the author, seated in imitation of the god on the Old Syrian seal (Fig. 8.3), and Ishtar from the Audience Hall (Fig. 8.2, although reversed), informs us of the enormous artistic license of the ancient artist. On the garments on the seal (Fig. 8.3), and on Ishtar from the Audience Hall painting (Fig. 8.2), the flounces run in length from waist to knee with the striations/stripes represented vertically on both lap and legs, whereas in reality,

[35] For a full discussion of the Minoan adaptation of the ancient Near Eastern flounced skirt along with aspects of its religion, and an experimental replication of the costume of the Knossos snake goddess see Jones 2001, 262–263; Jones 1998, 127–157; Jones 2000, 39.

[36] Buchanan 1981, 294–5, fig. 1137. The garments' colours were dyed by Valerie Bealle.

[37] Vogelsang-Eastwood 1993, 10–11, pl. 1.

[38] For diagrams depicting the same technique for my experimental pleated and fringed Aegean flounced skirt reconstructions see Jones 2001, 263, pl. LXXXVIIb.

on the experimental garments, the flounces run around the waist and both stripes and fringes respond naturally, running horizontally at the lap and vertically at the legs. Visually, the pleated striped garment (Fig. 8.5), seems the best match for the skirt on the seal (Fig. 8.3), and, if we can judge by fragment 13 from a fresco from Mycenae, which clearly illustrates stacked striped cloth flounces on the kilt of the Mykenaia,[39] stripes, probably pleated, may be the likelier solution. The experimental fringed flounces (Fig. 8.6), may explain the wavy stripes on the skirt of Ishtar from the Audience Hall (Fig. 8.2), although all the flounces there too, have clear horizontal ground lines that appear to mark woven cloth hems.

When the model assumed the standing position of Ishtar on the Chicago seal (Fig. 8.1), wearing the same experimental garments (Fig. 8.7 fringed version; Fig. 8.8 striped/pleated version), wrapped around her as robes tied at her right side above the chest and reaching to the ankles, the seven tiered robes draped exactly as depicted on the seal. Here the artist did not alter reality. Since both versions agree well with the art, it is difficult to determine whether the artist's striations on the seal marked striped pleats, simple stripes, or fringes. And though all possibilities should still be considered, the modern experimental garments take the theories out of the abstract and into the realm of material reality. Thus, they provide the reader with more concrete evidence to reach a conclusion.

Another garment worn by Ishtar that is worthy of consideration for our subject is a tunic portrayed in the Old Babylonian period.

The tunic is depicted in two ways. One, on Ishtar in the Investiture painting from the palace of King Zimri-Lim at Mari, *c.* 1781–1758 BC (Fig. 8.9),[40] illustrates a white garment with a V-neckline that appears to be thigh-length, decorated at the hem by a border of triple horizontal dark stripes.[41] Here we recall the royal white robe that Ishtar covered her body with in *The Courtship of Inanna and Dumuzi.*[42] A tabbed band also edges the cloth at Ishtar's right arm-hole, whereas a dark band edges the border at her left side. Worn over the tunic is a long, white, red, and yellow, vertically striped skirt, portrayed as wrapped around the body and open at Ishtar's right side

Diagrams of a possible construction method of the tunic of Ishtar's costume are illustrated in Fig. 8.10A–B. The experimental tunic is constructed from a rectangular piece of cloth (Fig. 8.10A), folded in half with a V-shaped opening for the head, cut in the center of the fold (Fig. 8.10B). This design is based on the image and the contemporary Egyptian bag tunic which was constructed in a similar manner except for a round opening for the head, cut in the centre of the fold.[43] The right side of Ishtar's tunic is seamed except for an arm-hole opening which was bordered with a tab-fringe; the left side of the tunic, bordered with a plain narrow band, remained open as it is exhibited in the other version. Three blue bands were sewn at the hem of the tunic, which were probably woven stripes in the original.[44]

[39] Jones 2009, 333, figs 9, 20, 28.

[40] Kohlmeyer 1985, 197, fig. 42; Parrot 1961, 279, fig. 346.

[41] The wide red stripe above the dark ones reconstructed by Parrot 1961, 279, fig. 346, is omitted on my experimental tunic.

[42] Wolkstein and Kramer 1983, 35.

[43] See the chapter on Egyptian bag tunics, Vogelsang-Eastwood 1993, 130–154, esp. 135, fig. 8.2.

[44] Parrot's (1961, 279, fig. 346), wide red stripe, omitted in my experimental tunic, was probably also woven in, in the original. Stieglitz 1994, 48, discusses the religious rulings concerning the use of murex to colour blue stripes on the ceremonial Jewish tallit or prayer shawl. The tunic of Ishtar may illustrate an earlier example of a similar practice.

Figure 8.5. Experimental striped and pleated flounced skirt (modelled by author, photo by N. Miller).

Figure 8.6. Experimental fringed flounced skirt (modelled by author, photo by N. Miller).

Figure 8.7. Experimental striped and pleated flounced skirt (modelled by author, photo by R. Jones).

Figure 8.8. Experimental fringed flounced skirt (modelled by author, photo by R. Jones).

The skirt appears as a striped length of cloth, wrapped around the waist and secured by a separate belt.[45] The replicated skirt is 55" wide and 37" long; the belt is 37" wide and 1 1/5" long. Fig. 8.11 illustrates a model clad in the replicated tunic and skirt and posed as Ishtar in the Investiture

[45] One wonders why the vertical red band in the front and another at the back hang lower than the remaining hem. Are they streamers, and if so, prototypes for those on the wounded woman from Xeste 3, Thera (Doumas 1992, 142, pl. 105)?

Figure 8.10. Diagram of suggested construction of tunic of Ishtar from the Investiture painting, Mari (drawing by R. Ruppert).

Figure 8.9. Detail of the "Investiture" painting, Palace of Zimrilim, Mari (drawing, courtesy of Kohlmeyer 1985, 197, fig. 42).

Figure 8.11. Experimental tunic and skirt of Ishtar from the Investiture painting (modelled by D. Oktay, photo by M. Gammacurta).

painting. The crossed breast-bands probably were added separately and placed on top of the tunic as they were on a silver statuette with attached gold cross-bands from Hasanoglan, c. 2000 BC.[46] In her role as the goddess of love *and war* on the Investiture painting, Ishtar's weapons must have projected from a quiver attached to the cross bands in the back, similar to the one worn by the Asiatic archer from the Middle Kingdom tomb of Knum-Hotep at Beni Hasan.[47]

A different arrangement of what appears to be the same style tunic appears on the Syrian goddess who reveals her nudity. A particularly good engraving of the garment exists on a goddess, identified by Porada as Ishtar, on the seal of Ana-sin-taklaku, also dated to the reign of king Zimri-Lim of Mari, c. 1781–1758 BC (Fig. 8.12).[48]

[46] Akurgal 1962, 41, pls VIII and XXII. It is possible that the figurine was once fitted with clothing, now perished, in addition to the metal breast-band and ankle bracelets.

[47] Mazar 1958, 114, archer at the bottom left.

[48] Porada 1985, fig. 19. For another good example of this

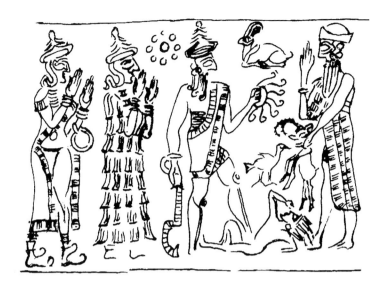

Figure 8.12. Seal of Ana-sin-taklaku from Mari (after Porada 1985, fig. 19).

As illustrated in my diagram (Fig. 8.13), the tunic probably is a full length version of the one worn by Ishtar in the Investiture painting (Figs 8.9–8.10). In both tunics, the right side is seamed except for the armhole area which is bordered with a tabbed fringe and the un-seamed side is banded, likely to reinforce the edge. The un-seamed left side and the hem were bordered with what appears to be a striped band. In the replicated tunic, a striped band was substituted for the band at the side and at the hem as well as for the tabbed fringe that borders the armhole. With the tunic placed on the model, its open left side was brought across to her right hip, in an imitation of that of the goddess revealing her nudity on the seal of Ana-sin-taklaku (Fig. 8.14).

In conclusion, we return to Enheduanna (*c.* 2300 BC), en-priestess of the moon god Nanna at Ur, and daughter of King Sargon of Akkad who's patron diety was Ishtar.[49] In Enheduanna's *Exaltaltation of Inanna*, Hallo remarked that the fates of Enheduanna and Ishtar are so closely linked that it is difficult to know which one the narrator is speaking about. [50] As Enheduanna linked her fate with that of Inanna, so she also fashioned herself after the goddess. Performing a ritual on the Disk of Enheduanna from the *giparu* at Ur,[51] Enheduanna has spiral-curled hair locks similar to Ishtar's on the Chicago seal (Fig. 8.1), and she wears a flounced costume analagous, except for the mantle, to those of Ishtar on the contemporary Chicago seal (Fig. 8.1) and the seal of Adad.[52] The flounces' wavy, vertical striations find later parallels on Ishtar and other deities on the Audience Hall painting (Fig. 8.2), and the suppliant goddesses on the Investiture painting.[53] Although, in both paintings, Ishtar wears multi-coloured garments: (Figs 8.2 and 8.9), she best

tunic see Porada 1957, 193, fig. 1.
[49] Winter 1987, 200.
[50] Hallo 1968, 62.
[51] Winter 1987, 190–201, fig. 1; Amiet 1975, 193–196, Abb. 101.
[52] Collon, 1987 164, no.761; Moortgat 1969, 54, 333, pl. F, no. 5; and Parrot 1961, 193, fig. 237.
[53] Parrot 1961, figs 346 and 348.

Figure 8.13. Diagram of suggested construction of tunic of Ishtar from the seal of Ana-sin-taklaku, Mari (drawing by R. Ruppert).

Figure 8.14. Experimental tunic of Ishtar modelled in position on seal of Ana-sin-taklaku (modelled by D. Oktay, photo by M. Gammacurta).

depicts the epithet "Queen of the multi-coloured robe,"[54] enthroned in her flounced costume in the Audience Hall painting (Fig. 8.2).

Although purely hypothetical, can we consider the possibility that the multi-coloured and flounced garments symbolize "terror" and thus visualize the descriptions, "clad in terror," or having "terror folds in her robes,"[55] especially when she wears them along with her weapons in her warlike role (Figs 8.1, 8.2)?

In addition, despite the problems with Meador's translation,[56] it is worth pursuing the idea of whether or not, in the Akkadian period of Enheduanna, Ishtar wears the robes of the old gods. In the case of the multi-coloured flounced garment, the answer is clearly no, since the style originated with Enheduanna at that time.

On the other hand, the design of the tunics of Ishtar from Mari (Figs 8.9 and 8.12), originated as far back as the Uruk period, *c.* 3300–3000 BC. On the representation of Sumerian Inanna on the alabaster vase from Uruk (Fig. 8.15), we see that she is wearing the identical tunic design that is represented on Ishtar from Mari (Figs 8.9 and 8.12), especially the long version on the seal of Ana-sin-taklaku (Fig. 8.12). The same banding appears on the open side and on the hem (compare Inanna's tunic (Fig. 8.15) with the diagrams of construction (Fig. 8.13) and the modeled tunic (Fig. 8.14). On the seal (Fig. 8.12), the open side is pulled to Ishtar's right hip to reveal her

54 In Inanna and Enki, and a Balag hymn, see Kramer 1981, 4, line 11; Kramer 1989, 61, 223, and Wolkstein and Kramer 1983, 16.

55 Black 1998, lines 1–6; Meador 2000, 91.

56 Meador 2000, 92: "[Inanna] wear[s] the robes of the old, old gods."

body; on the vase (Fig. 8.15), Inanna pulls the open side of the tunic slightly to her left with her left hand. On the seal, she is clearly the goddess of sexuality and fertility; on the vase, at the gates of her storehouse, she embodies the same role as she greets her consort Dumuzi and begins to open her robe to expose herself at the advent of their sacred marriage.[57] On both seal and vase she wears the long tunic, which, like the shorter version on the Investiture painting,[58] was presumably white. Thus, the scene on the vase seems to be the pictorial equivalent of the passage from the text of *The Courtship of Inanna and Dumuzi*:

> "Dumuzi went to the royal house with milk.
> Before the door, he called out:
> 'Open the house, My Lady, open the house!'...
> Inanna ... bathed and anointed herself with scented oil.
> She covered her body with the *royal white robe* [italics mine]...
> She readied her dowry...
> Dumuzi waited expectantly."[59]

Figure 8.15. Inanna on the Alabaster Vase from Uruk (drawing by S. White after Parrot 1961, 72, fig. 89 and Frankfort 1970, 26, fig. 10).

Bibliography

Akurgal, E. 1962. *The Art of the Hittites*, London.

Amiet, P. 1975. Altakkadische Flachbildkunst. *In* W. Orthmann (ed.) *Der alte Orient*, Propyläen Kunstgeschichte, Band 14 Abb. 101. Berlin, 193–196.

Attinger, P. 1998. Inana et Ebih. *Zeitschrift für Assyriologie*, 88, 164–195.

Attinger, P. 2011. *Innana et EbiḪ (1.3.2)* http://www.arch.unibe.ch/content/ueber_uns/pascal_attinger/traductions/index_ger.html

Austin, H. B. 1944. *The Merino: Past, Present and Probable*. Sydney.

Black, J. A., Cunningham, G., Robson, E. and Zólyomi, G. 1998. *The Electronic Text Corpus of Sumerian Literature*. Oxford.

Bossert, H. 1923. *Altkreta*, Berlin.

Buchanan, B. 1981. *Early Near Eastern Seals in the Yale Babylonian Collection*. New Haven.

Collon, D. 1987. *First Impressions: Cylinder Seals in the Ancient Near East*. Chicago.

Collon, D. 1995. *Ancient Near Eastern Art*. Berkeley.

Doumas, C. 1992. *The Wall Paintings of Thera*. Athens.

Donadoni. S. 1969. *Treasures of the Egyptian Museum*. Cairo, Verona.

Frankfort, H. 1970. *The Art and Architecture of the Ancient Orient*. New Haven/London.

Hall, R. 1986. *Egyptian Textiles*. Aylesbury.

Hallo, W. W. and J. J. A. Van Dijk 1968. *The Exaltation of Inanna*. New Haven/London.

Hansen, D. P. 1975. Frühsumerische und frühdynastische Flachbildkunst. *In* W. Orthmann (ed.) *Der alte Orient*, Propyläen Kunstgeschichte, Band 14. Berlin, 158–161, 179–193.

Hansen, D. P. 2003. Art of the Early City-States. *In* J. Aruz and R. Wallenfels, *Art of the First Cities: The Third Millennium B.C. from the Mediterranean to the Indus*. New York, 21–37.

Hyde, N. 1988. Fabric of History: Wool. *National Geographic* 173.5, 552–591.

Jones, B. R. 1998. *Minoan Women's Clothes: An Investigation of their Construction from the Depictions in Aegean Art*. PhD dissertation, New York University.

[57] Hansen 2003, 23–25, figs 9–10.

[58] For the Investiture Painting in colour see Parrot 1961, pl. 346.

[59] Wolkstein and Kramer 1983, 35.

Jones, B. R. 2000. Revealing Minoan Fashions. *Archaeology* 53.3, 36–41.

Jones, B. R. 2001. The Minoan Snake Goddess: New Interpretations of her Costume and Identity. *In* R. Laffineur and R. Hägg, *POTNIA: Deities and Religion in the Aegean Bronze Age. Aegaeum* 22, Liège/Austin, 259–269.

Jones, B. R. 2009. New Reconstructions of the 'Mykenaia' and a Seated Woman from Mycenae, *American Journal of Archaeology*, 113.3, 309–338.

Kohlmeyer, K. 1985. Mari: Tell Hariri. In H. Weiss (ed.) *Ebla to Damascus: Art and Archaeology of Ancient Syria*. Washington DC, 130–133, 149–168.

Kramer, S. N. 1981. BM 29616: The Fashioning of the gala. *Acta Sumerologica* 3, 1–9.

Kramer, S. N. and Maier, J. 1989. *Myths of Enki, The Crafty God*. Oxford.

Kenoyer, J. M. 2003. The Indus Civilization. *In* J. Aruz and R. Wallenfels, *Art of the First Cities*. New York, 376–381.

Mazar, B. 1958. *Views of the Biblical World*. Vol. 1. Jerusalem.

Meador, B. De Shong, 2000. *Inanna: Lady of Largest Heart*. Austin.

Moortgat, A. 1969. *The Art of Ancient Mesopotamia*. London.

Parrot, A. 1961. *Sumer*. Paris.

Porada, E. 1948. *Corpus of Ancient Near Eastern Seals in North American Collections*, vol. I. The Pierpont Morgan Library Collection, The Bollingen Series 74.

Porada, E. 1957. Syrian Seal Impressions on Tablets dated in the Time of Hammurabi and Samsu-iluna. *JNES* 16, 192–197.

Porada, E. 1985. Syrian Seals from the Late Fourth to the Late Second Millennium. In H. Weiss (ed.) *Ebla to Damascus*, 92. Washington DC.

Sjöberg, Å. W. 1976. innin šà-gur$_4$-ra: A Hymn to the Goddess Inanna by the en-Priestess Enheduanna. *Zeitschrift für Assyriologie und vorderasiatische Archäologie* 65.11, 161–253.

Smith, W. S. 1965. *Interconnections in the Ancient Near East*. New Haven/London.

Stieglitz, R. 1994. The Minoan Origin of Tyrian Purple. *BiblArch* 57.1, 46–54.

Strommenger, E. 1971. Mesopotamische Gewandtypen von der Frühsumerischen bis zur Larsa-Zeit. *Acta praehistorica et archaeologica* 2, 37–55.

Verderame, L. 2009. La vestizione di Inanna. *In* S. Botta (ed.) *Abiti, corpi, identità. Significati e valenze profonde del vestire*. Firenze, 63–73.

Vogelsang-Eastwood, G. 1993. *Pharaonic Egyptian Clothing*. Leiden.

Wachsmann, S. 1987. *Aegeans in the Theban Tombs*. Leuven.

Winter, I. J. 1987. Women in Public: The Disk of Enheduanna, the Beginning of the Office of En-Priestess, and the Weight of Visual Evidence. In J.-M. Durand (ed.) *La Femme dans le Proche-Orient Antique, XXXIII Rencontre Assyriologique Internationale (Paris, 7-10 Juillet 1986)*. Paris, 189–201.

Wolkstein, D. and Kramer, S. N. 1983. *Inanna, Queen of Heaven and Earth: Her Stories and Hymns from Sumer*. New York.

Woolley, C. L. 1939. *Ur Excavations II*. London/Philadelphia.

9. Considering the Finishing of Textiles based on Neo-Sumerian Inscriptions from Girsu

Richard Firth

Introduction

Waetzoldt has presented a detailed analysis of the Neo-Sumerian texts relating to the finishing of textiles.[1] The purpose of this paper is to reconsider some of his findings and try to relate them to the practicalities of fulling textiles.[2]

In this paper we will primarily concentrate on the Girsu tablets as these provide the most detailed quantitative information for the man-power required and the amounts of material used for fulling textiles.

The Fulling Processes

Waetzoldt suggests that fulling was subdivided into three separate steps:

Process	Girsu	Ur
Preliminary washing	túg šà-ha	túg šà-ha
Fulling	túg kin-DI-a	kin-gi$_4$-a-aš gi$_4$-a
Final washing	túg sur-ra	túg-ga-DU-a-aš

On the Girsu tablets, the three processes are usually listed in the order túg sur-ra, túg kin-DI-a, túg šà-ha. Waetzoldt argued that, "Gemäß der Schreibertradition der Ur III-Zeit werden in diesen Urkunden die besten Qualitäten bzw. die schon fertig behandelten Gewebe an erster Stelle genannt, während alle 'minderen' Qualitäten folgen. Aus diesem Grunde sind die Texte der 'Walker' – will man den Arbeitsgang rekonstruieren – rückwärts zu lesen, in unserem Fall beginnt der Behandlungsprozess bei (túg)-šà-ha."[3] However, the logic of this argument appears to be open to question. It seems quite reasonable to put the most valuable items at the top and then list the remainder in order of descending value. It also seems reasonable to list a series of tasks in the order in which they occur. The logic underlying the suggestion that the tasks should be listed

[1] Waetzoldt 1972, 153–174. It is convenient to abbreviate Waetzoldt 1972, *Untersuchungen zur Neusumerischen Textilindustrie* as UNT.
[2] See Gordon 1982 (and its references) for a general discussion of the work of the fuller.
[3] Waetzoldt 1972, 156.

in the reverse order, because the most valuable items are those which have had the most fulling treatment, seems rather tenuous.

However, there is a more fundamental question about whether túg sur-ra, túg kin-DI-a and túg šà-ha are three consecutive steps within the overall fulling process. The alternative suggested here is that they could be terms used to describe three separate processes which the fuller offers.

This question arises because the tablets that list the textiles, man-power and materials for the three processes do not appear to be internal documents of the fulling workshop. For example, MVN 22, 188 and ITT 2, 902 + ITT 5, 6850 are describing textiles and materials that were sent from the warehouse (é-šu-sum-ma). The textiles and materials are neatly set out in the categories túg sur-ra, túg kin-DI-a and túg šà-ha. The obvious interpretation is that there is a requirement for the textiles listed within the túg sur-ra category to have the túg sur-ra treatment and so on. The textiles listed within each category differ, so there is no implication that all the textiles should undergo each of the three processes. However, it would seem nonsensical for the textiles to undergo one process, and then be sent back to the warehouse, only to be returned to the fuller for a second and then a third process.

Thus, it is suggested that túg sur-ra, túg kin-DI-a and túg šà-ha are three separate processes and the 'customers' of the fuller can chose which one of these three processes is required for each of the textiles sent to the fuller. It seems reasonable to presume that the process chosen will be dependent on the state of the textiles. As an example, textiles which are new might require the complete fulling and washing treatment, textiles which have been worn and are heavily soiled would require to be thoroughly washed and restored, and textiles which have been worn and lightly soiled might require a normal wash.

In the four Girsu tablets, which are discussed at length in Section 4, túg šà-ha differs from túg sur-ra and túg kin-DI-a because it is not associated with specific allocations of man-power. The implication is that this task was a less time consuming. The most likely suggestion is that túg šà-ha is a simple washing process.

Allocations of oil for túg šà-ha, túg sa-gi₄-a and túg-ge ak(-dè) on a series of tablets frim Girsu

There are a series of tablets from Girsu where a distinction is drawn between oils and fats for túg šà-ha and for túg sa-gi$_4$-a (Appendix B).

Waetzoldt[4] interprets túg-sa-gi$_4$-a as denoting the complete fulling and washing process. He notes that the sa-gi$_4$-a can also be applied to linen fabrics and sa-gi$_4$ is used for victuals, wooden equipment and ships. For textiles, this is translated as 'finished',[5] referring to the discussion given by Jacobsen[6]. However, as Jacobsen notes, this interpretation does not give us any specific insights into the nature of the work of the fuller.

In the same series, there is also a third classification of oil, túg-ge ak(-dè), which Waetzoldt translates as "Öl, um an Stoffen zu 'arbeiten'",[7] *i.e.* it is not specific whether it is for šà-ha or sa-gi$_4$-a. There are examples of royal quality (lugal) oils being specified for all three processes and so it is not clear what determined why oils and fats were being specifically given one of these three labels.[8]

[4] Waetzoldt 1972, 155.
[5] CAD E, 307–308.
[6] Jacobsen 1953, 184.
[7] Waetzoldt 1972, 170.
[8] Following Levey 1959, 125-129 and Waetzoldt 1972, 159, it is assumed that the oils and fat were mixed in water with

This series are mostly oils and fats being expended by one man, Ur-ab-ba, and the distinction between oils and fats for túg ša-ha and túg sa-gi$_4$-a has not been found elsewhere (although túg-ge ak-dè is also noted at Umma, on SNAT 532 & BPOA 1, 1442). The totals of all the oils and fats listed in Appendix B are 1701.5 litres of oil, 2189.3 litres of sesame oil and 31.3 litres of pig fat and, of these totals, 15.5 litres of oil, 1459.2 litres of sesame oil and 20 litres of pig fat were royal quality. Thus, on the basis of the evidence from Appendix B, it would seem reasonable to assume that a very large proportion of the oil supplied to fullers was sesame oil and a substantial proportion of that oil was royal quality. Furthermore, the bulk of the royal quality oil and fat for textiles, listed in Appendix B, was issued during the years on or before AS 8, which might be significant.

It is worth noting that, in total, these quantities of oil for túg šà-ha are much smaller than those allocated for túg sa-gi$_4$-a and túg-ge ak in the same series. This could be regarded as supportive of the suggestion that túg šà-ha was a less intensive process.

Allocations of man-power and materials allocated for fulling on four tablets from Girsu

There are four tablets from Girsu that are particularly interesting because they list the quantities of man-power and materials for specific batches of woollen textiles.[9] These tablets list textiles that are being sent to the fuller for the túg sur-ra, túg kin-DI-a and túg šà-ha processes. They also state the man-power and materials required for the túg sur-ra and túg kin-DI-a processes (although not for the túg šà-ha process). The aim of this section is to consider the details of these allocations of man-power and materials and show that, through them, it is possible to get a better understanding of the fulling processes of Ur III.[10]

In his analysis, Waetzoldt[11] considers the amounts of man-power and materials required per kilo of textile. Such calculations are useful for giving a broad indication of which factors were being taken into account. However, in practice, it is unlikely that the accounting would have been done by literally weighing the fabrics and applying multipliers to assess the man-power and materials required for each batch of textiles. There are two reasons for suggesting this. Firstly, it would have been cumbersome to include a series of elaborate multiplication calculations in the assessment of the finishing requirements for each batch of textiles. Secondly, textile finishing was being done on an industrial scale and the work was repetitive. Therefore, it is more likely that there would have been simple 'rules of thumb' to estimate the man-power and materials required for each type of fabric. In this case, the scribe simply had to add up the quantities of man-power and materials required for each textile in the batch.

It is possible to support the hypothesis of such simple 'rules of thumb' in two ways. Firstly, by noting the Ur tablets, UET 3, 87:3 and 98:1, where a number of textiles of specific types are listed and the man-power required for a fulling process (túg-sa-gi$_4$-a) is quoted per textile (see Table 9.6 below). There is no indication that these figures are based on the weight for that particular batch of textiles. It is much more likely that these figures are based on a requirement for all

alkali to make the water soapy. However, Durand 2009, 43, makes the alternative suggestion that the oils, ì túg-šà-ha and ì túg-sa-gi$_4$-a, were used to make the textiles shine.

[9] ITT 2 902+ITT 5 6850 (= UNT 37); MVN 6, 291 (= ITT 4 7300+9151 = UNT 38); UNT 39 (= ITT 5 9661) and MVN 22, 188. The latter was published in 2003 and so was not considered by Waetzoldt in 1972.

[10] See Englund 1991 for a more general discussion of the administration of workmen during Ur III by the monitoring of man-power and materials required for specific tasks.

[11] Waetzoldt 1972, 155–166.

textiles of that type. Secondly, by demonstrating that it is possible to deconstruct some apparently 'complicated' series of figures given in the Girsu tablets and show that they are made up from the combination of 'simpler' numbers. This demonstration is given in Appendix A, where each of the four individual tablets is analysed.

Man-power and materials for túg sur-ra

The data for the túg sur-ra process are set out below. These are either taken directly from the tablets or from the results of the analysis described in Appendix A.[12]

Textiles	man-power	oil	alkali	thread	tablet
1 guz-za (4th quality)	20 days	1/3 sìla	3 sìla	-	UNT 39
1 guz-za (5th quality)	10 days	1/6 sìla	3 sìla	-	UNT 39
1 pair MA-fabrics (1st quality)	10 days	-	20 gín	-	ITT 2, 902 + ITT 5, 6850
1 bar-si (5th quality)	1 day	-	2 gín	-	ITT 2, 902 + ITT 5, 6850
4 nì-lám (3rd quality) 2 guz-za (3rd quality) 6 guz-za (4th quality) 1 ZU.BU 2 uš-bar	367 days	6 sìla 14 gín	51 sìla	-	MVN 6, 291
4 nì-lám (3rd quality) 4 guz-za (3rd quality) 3 nì-lám (4th quality) 22 guz-za (4th quality) 4 guz-za (5th quality) 1 ZU.BU 8 sag-uš-bar 10 uš-bar 4 uš-bar siki mug 16 bar-si nì-lá	1023 days	16 sìla 5 gín	142 sìla	-	MVN 6, 291
18 guz-za (2nd quality) 1 túg aktum (3rd quality) 90 guz-za (4th quality) 12 guz-za (5th quality) 228 túgsa-sa	4326 days	11 units (royal quality)	712 sìla	6 mana	MVN 22, 188

Table 9.1.

It is immediately evident, for the guz-za fabrics from UNT 39, that the allocation of man-power and materials is a function of the quality of the textiles. Thus, the 4th quality guz-za fabric requires twice as much man-power and oil as the 5th quality guz-za fabric. This would imply that the túg sur-ra process given to the 4th quality guz-za fabric is twice as intensive as that for the 5th quality guz-za fabric. This is interesting because it begins to give us a little insight

[12] It is convenient in these tables and the following discussion to abbreviate túgnì-lám to nì-lám, túgguz-za to guz-za, túguš-bar to uš-bar and so on.

Textiles	man-power/oil (days/sìla)	man-power/alkali (days/sìla)	alkali/oil (sìla/sìla)	tablet
1 guz-za (4th quality)	60	6.7	9	UNT 39
1 guz-za (5th quality)	60	3.3	18	UNT 39
4 nì-lám (3rd quality) 2 guz-za (3rd quality) 6 guz-za (4th quality) 1 ZU.BU 2 uš-bar	58.9	7.2	8.2	MVN 6, 291
4 nì-lám (3rd quality) 4 guz-za (3rd quality) 3 nì-lám (4th quality) 22 guz-za (4th quality) 4 guz-za (5th quality) 1 ZU.BU 8 sag-uš-bar 10 uš-bar 4 uš-bar-sig-mug 16 bar-si nì-lá	63.6	7.2	8.8	MVN 6, 291
18 guz-za (2nd quality) 1 túg aktum (3rd quality) 90 guz-za (4th quality) 12 guz-za (5th quality) 228 ᵗúᵍsa-sa		6.07		MVN 22, 188

Table 9.2.

into the fulling processes being considered. However, it does have the unfortunate consequence that we are unable to break the contents of Table 9.1 down and give the amount of man-power and materials required for each textile because there are too many different textiles (and textile qualities) for the amount of data available.[13]

The pair of MA-fabrics and bar-si are small items, both having an estimated weight of only ⅙ kg (⅓ mina).[14] At this stage, we will set these small items to one side and concentrate on the remaining textiles. Table 9.2 presents ratios of the man-power, oil and alkali given in Table 9.1.

If we consider the ratios of man-days to the volume of oil in Table 9.2,[15] it is evident that each of these ratios is 60 or quite close to 60. This means that if the scribe calculated the number of days required to perform the túg sur-ra process on a quantity of textiles then he could calculate the amount of oil by dividing the number of days by 60. This is significant because the Sumerian counting system was based on 60, so that multiplying or dividing by 60 would be relatively easy for Sumerian scribes.[16]

[13] Waetzoldt 1972, 162, suggested that the number of working days per kilo of cloth for the túg sur-ra process is almost constant for groups of textiles of varying quality. However, there appears to have been an error in those calculations (for batch b).

[14] Waetzoldt 1972, 165 note 76.

[15] As the amount oil specified for túg sur-ra on MVN 22, 188 does not specify the units being used the corresponding entries have been left blank. See the discussion in Appendix A.

[16] Alternatively, the number of man-days is equal to the amount of oil measured in gín.

In the examples given, the ratio of alkali to oil ranges from 8.2 to 9, with one example that appears much higher. Similarly, for the ratios of man-power to volume of alkali the values are in the range 6.07 to 7.2 except for one value that is considerably lower. It is tempting to suggest that the anomalous value in both cases arose because of a scribal miscalculation in the amount of alkali allocated for the 5th quality guz-za fabric.

There is only one example where there is an allocation of thread but in that case the allocation was a generous amount of 6 mana (3kg). This is far in excess of the amount of thread required for sewing up or small repairs, suggesting that it was used for edgings or other decorations.

Man-power and materials for túg kin-DI-a

The data that we have from the tablets (and from Appendix A) for the túg kin-DI-a process are set out below.

Textiles	man-power	Oil	alkali	thread	tablet
1 nì-lám-tab-ba (3rd quality)	30 days	35 gín	5 sìla	5 gín	ITT 2, 902 + ITT 5, 6850
1 nì-lám (of 1st or 2nd quality)	90 days	½ sìla	2½ sìla	5 gín	ITT 2, 902 + ITT 5, 6850
1 nì-lám (3rd quality)	15 days	17½ gín	2½ sìla	2½ gín	ITT 2, 902 + ITT 5, 6850
1 guz-za (3rd quality) 3 guz-za (4th quality)	60 days	1 sìla	4 sìla	-	MVN 6, 291
1 guz-za (4th quality)	10 days	1/6 sìla	1½ sìla	-	UNT 39
1 pair MA-fabrics (1st quality)	5 days	-	10 gín	-	ITT 2, 902 + ITT 5, 6850
2 túg nì-bàra (2nd quality) 1 túg aktum (2nd quality) 6 guz-za (2nd quality) 1 guz-za (3rd quality)	530 days	5 sìla 45 gín	42½ sìla	1 mana 55 gín	MVN 22, 188

Table 9.3.

It is evident, from the comparison of man-power and materials required for the túg kin-DI-a process for nì-lám, that substantially more are required for 1st and 2nd quality fabrics than for a 3rd quality nì-lám textile. This is analogous to the finding noted for guz-za fabrics for the túg sur-ra process.

It is also evident, from considering the guz-za fabrics on UNT 39 and MVN 6, 291, that there can be differences in the allocations between different tablets. Thus, whilst there might be the same allocation of man-days and oil for the 4th quality guz-za tablets on MVN 6, 291 as derived from the data on UNT 39, it would not be possible to allocate the same quantity of alkali (see Appendix A).[17]

[17] Waetzoldt considered the allocation of man-power and materials per kilogram of textiles. There is some evidence that the number of days required for the túg kin-DI-a process takes some account of the weight of the textile, although this is not a simple proportionality. If we accept the analysis shown in Table 9.A6b, the allocation of man-power for

Textiles	man-power/ oil (days/sìla)	man-power/ alkali (days/sìla)	alkali/oil (sìla/sìla)	oil/thread (sìla/mana)	tablet
1 nì-lám-tab-ba (3rd quality)	51.4	6	8.6	7	ITT 2, 902 + ITT 5, 6850
1 nì-lám (of 1st or 2nd quality)	180	36	5	6	ITT 2, 902 + ITT 5, 6850
1 nì-lám (3rd quality)	51.4	6	8.6	7	ITT 2, 902 + ITT 5, 6850
1 guz-za (3rd quality) 3 guz-za (4th quality)	60	15	4		MVN 6, 291
1 guz-za (4th quality)	60	6.7	9		UNT 39
2 túg nì-bàra (2nd quality) 1 túg aktum (2nd quality) 6 guz-za (2nd quality) 1 guz-za (3rd quality)	92.2	12.5	7.4	3	MVN 22, 188

Table 9.4.

Setting aside consideration of the pair of MA-fabrics, as before, Table 9.4 gives the ratios for the remaining textiles (*cf.* Table 9.2).

Once again, the ratios of man-days to sìla of oil are roughly 60, except for the two instances where there are fabrics of 1st and 2nd quality. The implication is that, for these high quality fabrics, there were additional stages in the process that were labour intensive and did not use oil. The obvious suggestion is that this man-power was spent improving the finish of the surface of the textile, perhaps by napping or some similar treatment. We can estimate that, for the 1st and 2nd quality nì-lám fabrics listed on ITT 2, 902 + ITT 5, 6850, the amount of man-power allowed for this surface finishing was 60 days.

For the túg kin-DI-a textiles on MVN 22, 188, there is some uncertainty in the reading of the numbers. However, if we were to assume that the total number of man-days is 530 and there are a total of nine fabrics of 2nd quality, then it would imply that each of these fabrics had 20 days of surface finishing. (Alternatively if, for example, the guz-za fabrics did not require surface finishing, then the remaining three fabrics would each have 60 days of surface finishing.)

The ratio of alkali to oil is more variable, ranging from 4 to 9 (cf. the range 8.2 to 9 for the túg sur-ra process).[18]

Allocations of thread appear to be restricted to nì-lám fabrics. Whenever thread is allocated, the quantity of oil (in sìla) is always an integral multiple of the quantity of thread (in mana). These integral multiples vary from 3 to 7, with no thread allocated for the túg kin-DI-a of guz-za fabrics. If we assume that no allowance of thread had been made for the guz-za included within the textiles listed for túg kin-DI-a on MVN 22, 188 then the multiple there would increase from 3 to something closer to 6 or 7 for the remaining fabrics. The allocation of thread is small compared to the weight of the textile, therefore the thread is for small-scale improvements, rather than extensive work on edgings or other decorations.

a 3rd quality guz-za fabric is twice that of a 3rd quality nì-lám fabric whereas the weight is approximately threefold (based on weights assessed by Firth and Nosch 2012).

[18] The ratio of ~5 found by Waetzoldt 1972, 159 was based on a more limited data set.

The smaller bar-si and MA-fabrics do not have separate oil allocations and were presumably washed and fulled in the same soapy solution as the larger fabrics.[19] However, they are allocated man-power which, for the túg sur-ra process of 1st quality MA-fabrics, can be as much as 10 days. In this latter case, we might reasonably assume that this included an allowance for surface finishing. On the other hand, for the bar-si, the one day allocated is more probably just recognising that some extra man-power has to be allocated for these additional textiles. The allocation of alkali in each of these cases is consistently 2 gín for each day.

Comparison of *túg sur-ra*, *túg kin-DI-a* and *túg šà-ha*

Within the available data, the point of comparison between the túg sur-ra and túg kin-DI-a processes is 4th quality guz-za fabrics. These data are both obtained from UNT 39 and so allow a simple comparison. This shows that the túg sur-ra process requires literally twice as much man-power, oil and alkali as the túg kin-DI-a process. This finding is supported by the results for the MA-fabrics. The obvious conclusion is that túg sur-ra is a more intensive fulling process than túg kin-DI-a.

We have shown that the amount of man-power and materials given to higher quality textiles can be greater than for lower quality textiles for both the túg sur-ra and túg kin-DI-a processes. Thus, we can conclude that, although the quality of the textiles was initially determined by the quality of wool that was used, these differences between qualities were increased by differences in the finishing treatments given to the textiles.

The three processes are usually listed in the order túg sur-ra, túg kin-DI-a, túg šà-ha. We have shown that túg kin-DI-a is less intensive then túg sur-ra. Thus, the obvious suggestion is that túg šà-ha is the least intensive of the three processes. Thus it would follow that túg sur-ra is the complete fulling process for newly manufactured fabrics and túg kin-DI-a is a lesser fulling process (perhaps for restoring clothes that had been worn). Then, by extrapolation, túg šà-ha would probably be a simple washing process, which would take much less man-power and materials than the other two processes.

As already noted, this conclusion differs from that of Waetzoldt.[20] He found that the alkali to oil ratio was higher for the túg sur-ra process than the túg kin-DI-a process. He argues that a smaller alkali to oil ratio would have been required for the finishing process than the washing process (although the underlying reason for this is not made clear). Following this logic, he concluded that túg kin-DI-a was a finishing process and túg sur-ra was a washing process. When we re-examine his findings using our more detailed analysis, we find that the alkali to oil ratios for túg sur-ra range from 8.2 to 9 (with one out-lying ratio of 18) and ratios for túg kin-DI-a range from 4 to 9. In other words, whilst the average ratio for túg sur-ra is higher, there is some overlap of these ranges and the distinction between the ratios for these two processes is not so clear.

There are two additional factors which should be taken into account in a discussion of the alkali to oil ratios.

Firstly, a newly woven fabric would contain more oil than a finished fabric. Although the wool would have been washed before it was spun, there would have some residual natural oils in the wool. In addition, oil may have been used to lubricate the threads during weaving. Thus, it would

[19] The reason for not providing additional oil might be that the quantities involved would usually be too small to be considered significant.

[20] Waetzoldt 1972, 159, 162.

have been appropriate to use a higher alkali to oil ratio for the finishing process (than for the washing process) to compensate for the oil that was held by the newly woven fabric.

Secondly, the alkali may have been supplied to the fuller as vegetable matter, which the fuller had to burn, and then the alkaline ash would have been combined with the oil in water to produce a soapy solution. Thus, whereas there would have been a direct relationship between the quantity of oil supplied and the quantity used, that relationship would have been less exact between the quantity of vegetable matter supplied and the quantity of ash used.

For these reasons, it seems reasonable to assume that the fuller would not have relied on the calculations of the scribe in the warehouse who supplied the materials. Instead, he would have used his expertise to gauge the quantity of alkaline ash that was required for each of the processes. In other words, we should not place too much emphasis on the precise quantities of alkali issued by the central warehouse because that would risk forgetting the judgement that the fuller would have exercised in determining the exact quantities of materials used for each particular process.

It should be noted that in the detailed listings of materials for the túg sur-ra, túg kin-DI-a and túg šà-ha processes, there is no mention of 'white earth' (*i.e.* gypsum) that was used in the fulling process as an abrasive (Firth 2011). However, on MVN 6, 291 REV. III 9, amongst the totals of man-power and the other materials, a large quantity of 'white earth' is included. This is listed as 2 gu 55 mana, *i.e.* 175 mana (= 87.5kg). At first sight it seems surprising that, whilst there are detailed records of the amount of oil and alkali required for small batches of textiles, there is no similar detailed assessment for the 'white earth'. From practical considerations, the most likely reason for this is that the quantity of 'white earth' required was proportional to the amount of oil or alkali so that separate scribal accounting of its details was unnecessary. In the case of MVN 6, 291, there are 'traces' of the scribal calculation because, whilst the exact quantity of oil required is 23 sìla 19 gín, the scribe has rounded this to 23⅓ sìla (less 1 gín, which was noted in col. 3 l. 8 and then apparently ignored in the subsequent calculation). The quantity of 'white earth' (measured in mana) is then precisely 7.5 times the quantity of oil (measured in sìla), *i.e.* 175 = 7.5 × 23⅓.

Before concluding this discussion, we will consider the small group of tablets that include man-power and materials but do not give an indication of which process is required.[21] Unfortunately, the state of preservation of these tablets is poor. In his discussion, Waetzoldt[22] effectively uses the findings from his earlier discussion to help to fill the gaps caused by poor preservation. For completeness, we will include the data based on this reading of these tablets.

It is worth noting that, for the high quality textiles listed on these tablets, the amount of man-power allocated to the fullers varies from 90 to 300 days.

Another point worth noting is that on ITT 3, 6606 thread is allocated for 2nd quality guz-za, though not for 1st quality guz-za. The amount of thread listed here is ⅔ mana (*i.e.* ~333g), which compares to the weight of the textile of ~3.0kg. Thus, the quantity of thread is more than would be necessary for small repairs and it is likely to have been used for decoration of the fabric, possibly with edgings.

These tablets include time by women and time taken by the fullers. The time taken by women is several times larger than that taken by the men. In view of the very large amounts of time

[21] ITT III 6606 and ITT V 6855, 6858.
[22] Waetzoldt 1972, 163.

Textiles	man-power		oil	alkali	thread	tablet
	women	fulling men				
[1] guz-za (1st quality)	1200	90	1 sìla (!)	10 (sìla)	-	ITT III 6606 i 3–7
1 guz-za (2nd quality)	[]	240?	2⅔ sìla‡	20 (sìla)	⅔ mana	ITT III 6606 ii 2–8
1 nì-lám-GUG₄ (2nd quality)	300	90	½ sìla	5 sìla	-	ITT V 6855 iii 4–8
1 ba-tab *du₈-hu-um-us*	240	40	<½ sìla> 2 gín good oil	5 sìla	-	ITT V 6858 ii 3–7
1 nì-lám-tab-ba-ús-AB-Šūsîn (2nd quality)	960	300	1 sìla sesame oil	10 (sìla)	⅓ mana	ITT V 6858 ii 8–13

‡ 2 sìla sesame oil and ⅔ sìla of good oil.

Table 9.5.

quoted, Waetzoldt[23] is almost certainly correct in suggesting that the time taken by the women is the time taken to manufacture the fabric before it is passed to the fuller. The fact that this was known at the time that the tablet was written demonstrates that the fabric had just been made. This is consistent with the suggestion that a complete fulling process required, *i.e.* túg sur-ra.

It is evident that the textiles listed in Table 9.5 are higher quality textiles and they are listed individually rather than being included within a batch. It is possible that in each case the level of finishing required was set down specifically for that textile (rather than by being set on the basis of a simple 'rule of thumb'). If the assumption is correct and the times are indeed set in days and the women's times are spent weaving rather than fulling, then it seems possible that these weavers' times are included in order to show that a proportionate amount of time is spent on fulling relative to the time taken to weave the fabric.

Considering túg-sa-gi₄-a and túg kin-gi₄-a-aš gi₄-a at UR

For completeness, we will include a brief discussion of the tablets from Ur that quote the levels of man-power required for textiles undergoing the túg-sa-gi₄-a and túg kin-gi₄-a-aš gi₄-a fulling processes.

UET 3, 1432 Obv I 1- II 6 lists the man-power required for the túg-sa-gi₄-a process from which we can deduce that:[24]

bar-dul₅ (3rd quality)	30 days each (based on 1 piece)
bar-dul₅ (4th quality)	20 days each (based on 1 piece)
nì-lám (3rd quality)	30 days each (based on 25 pieces)
nì-lám (4th quality)	15 days each (based on 25 pieces)

23 Waetzoldt 1972, 164.
24 Waetzoldt 1972, 155. Waetzoldt also includes discussion of UET 3 1607, which does not explicitly include the word túg-sa-gi₄-a. This lists types of fabrics that are not present on the Girsu tablets and so gives little basis for comparison for present purposes.

Thus the man-power required is a function of the type and quality of the textile, as on the Girsu tablets. By extrapolation of the Girsu data, it seems likely that the time required here for the 3rd quality nì-lám fabric for the túg-sa-gi$_4$-a process is similar to that might have been required for the túg sur-ra process at Girsu.

There are three tablets from Ur that explicitly give details of the túg kin-gi$_4$-a-aš gi$_4$-a process.

Inscription	Textiles	Man-power
UET 3, 87:3ff	nì-lám (5th quality)	1 day each (for 8 pieces)
	guz-za (5th quality)	1 day each (for 15 pieces)
UET 3, 98:1ff	nì-lám (4th quality)	17 days each (for 3 pieces)
	guz-za (4th quality)	28 days each (for 3 pieces)
	nì-lám (5th quality)	5 days each (for 3 pieces)
	guz-za (5th quality)	11 days each (for 6 pieces)
	guz-za (5th quality)	5 days each (for 18 pieces)
	sag-uš-bar	4 days each (for 11 pieces)
	uš-bar	1 day each (for 38 pieces)
	uš-bar (dark, black)	½ day each (for 21 pieces)
UET 3 1616: 3ff	nì-lám (3rd quality)	20 days for 2 pieces

Table 9.6.

Finally, on UET 3 1731, thirteen 3rd quality nì-lám fabrics and one 4th quality guz-za fabric are allocated 5 days each and eleven 3rd quality nì-lám fabrics are allowed a total of 103 days, although the fulling process is not specified.

The times allocated are very variable. In some cases, the amounts of man-power seem generous compared to those allowed for túg kin-DI-a at Girsu. However, as already noted, such times are not intrinsically determined, and we might presume that the textiles underwent fulling processes commensurate with the times allowed. At the other end of the scale the time allowed is only one day (or even ½ a day) per textile. The most straightforward way to interpret this is to suggest that these textiles were simply washed, since the time allocated does not allow scope for an elaborate fulling process.

Acknowledgements
I would like to thank Hartmut Waetzoldt for drawing my attention to the inscription, MVN 22, 188. I also wish to thank Marie-Louise Nosch for reading an early draft of this paper and more generally for giving the support of the Danish National Research Foundation's Centre for Textile Research to this work. Thanks are also due for the comments of the anonymous reviewer.

Bibliography

Chicago Assyrian Dictionary, Oriental Institute of Chicago (= CAD)
Durand, J.-M. 2009. *La Nomenclature des Habits et des Textiles dans les textes de Mari: Matériaux pour le Dictionnaire de Babylonien de Paris Tome 1*, Paris.

Englund, R. K. 1991. Hard Work – Where will it get you? Labour Management in Ur III Mesopotamia, *JNES* 50, 255–280.

Firth, R. J. 2011. A Discussion of the use of *im-babbar₂* by the Craft Workers of Ancient Mesopotamia, *CDLJ* 2011:2.

Firth, R. J. and Nosch, M.-L. 2012. Spinning and Weaving Wool in Ur III Administrative Texts, *JCS* 64, 65–82.

Forbes, R. J. 1964. *Studies in Ancient Technology. Vol. IV*, Leiden.

Gordon, B. 1982. *The Final Steps: Traditional Methods and Contemporary Applications for Finishing Cloth by Hand*, Loveland.

Jacobsen, T. 1953. On the Textile Industry at Ur under Ibbi-Sîn, *Studia Orientalia Ioanni Pedersen*, Hauniae, 172–187.

Levey, M. 1959. *Chemistry and Chemical Technology in ancient Mesopotamia*. Amsterdam/London.

Pomponio, F. 2010. New Texts Regarding the Neo-Sumerian Textiles. *In* C. Michel and M.-L. Nosch (eds) *Textile Terminologies in the Ancient Near East and Mediterranean from the Third to the First Millennia BC*, Oxford, 186–200.

Waetzoldt, H. 1972. *Untersuchungen zur Neusumerischen Textilindustrie*, Studi Economici e Tecnologici I, Rome (= UNT).

Appendix A: Mathematical analysis of the Girsu fulling tablets

Considering UNT 39 (= ITT 5, 9661)

UNT 39, I 1–5 and II 2–6, presents us with the information given in Table 9.A1a concerning the túg sur-ra and túg kin-DI-a finishing processes on guz-za fabrics of 4th quality.

Text	Textiles (4th quality)	Process	man-power	oil	alkali
UNT 39 I 1-5	6 guz-za	túg sur-ra	130 days	2 sìla	19½ sìla
	1 guz-za	túg kin-DI-a		10 gín	
UNT 39 II 2-6	12 guz-za	túg sur-ra	250 days	4 sìla	37½ sìla
	1 guz-za	túg kin-DI-a		10 gín	

Table 9.A1a.

We can solve the information in Table 9.A1a mathematically (as a pair of simultaneous equations) and show that the man-power and materials required to túg sur-ra and túg kin-DI-a each item of 4th quality guz-za fabric are as given in Table 9.A1b.

Textiles (4th quality)	Process	man-power	oil	alkali
1 guz-za	túg sur-ra	20 days	⅓ sìla	3 sìla
1 guz-za	túg kin-DI-a	10 days	⅙ sìla	1½ sìla

Table 9.A1b.

In this way we have shown that the rather complex series of numbers in Table 9.A1a are made up from a summation of differing combinations of the simpler series of numbers in Table 9.A1b.

We can take this a step further by considering UNT 39 I 8-13,

Textiles	Process	man-power	oil	alkali
5 guz-za (4th quality) 2 guz-za (5th quality)	túg sur-ra	120 days	2 sìla	21 sìla

Table 9.A2a.

Since these data are from the same tablet as those considered in Table 9.A1a, then it is reasonable to assume that the calculations have been done on the same basis. Thus we can substitute the results for applying the túg sur-ra process to a 4th quality guz-za fabric into the data in Table 9.A2a and in this way calculate the man-power and materials required for applying the túg sur-ra process to a 5th quality guz-za fabric. The results for this are given in Table 9.A2b.

Textile	Process	man-power	oil	alkali
1 guz-za (5th quality)	túg sur-ra	10 days	⅙ sìla	3 sìla

Table 9.A2b.

This suggests that the man-power taken for the túg sur-ra process on the 5th quality guz-za fabric was half that taken for the 4th quality guz-za fabric although the same quantity of alkali was required.

Considering ITT 2, 902 + ITT 5, 6850 (= UNT 37)

We will begin this section by considering the textiles listed in the texts ITT 2, 902 + ITT 5, 6850 I 1-7 and II 3-10 (see Table 9.A3a).

Textiles	Process	man-power	oil	alkali	thread
2 nì-lám Šūsîn-quality 3 pairs MA-fabrics (1st quality)	túg kin-DI-a	195 days	1 sìla	5½ sìla	10 gín
1 nì-lám Šūsîn-quality 1 nì-lám (2nd quality) 1 pair MA-fabrics (1st quality)	túg kin-DI-a	185 days	1 sìla	5 sìla 10 gín	10 gín

Table 9.A3a

We know that the Šūsîn-quality textile is royal quality, *i.e.* first quality.[25] Therefore, the first row in the table is concerned with 2 nì-lám fabrics (both first-quality) and 3 pairs of MA-fabrics and the second row is concerned with 2 nì-lám fabrics (one first quality and one second quality) and one pair of MA-fabrics. These two rows require the same amount of oil and thread and almost the same amount of alkali and man-power. Therefore, the obvious assumption is the amount of man-power and materials required for a nì-lám of Šūsîn-quality is the same as that for a nì-lám of 2nd quality. With this assumption, we are able to solve the information given in Table 9.A3a (again as a pair of simultaneous equations) to obtain the solutions given in Table 9.A3b.[26]

Textile	Process	man-power	oil	alkali	thread
1 nì-lám (of either Šūsîn or 2nd quality)	túg kin-DI-a	90 days	½ sìla	2½ sìla	5 gín
1 pair MA-fabrics (1st quality)	túg kin-DI-a	5 days	-	10 gín	-

Table 9.A3b.

The fact that the contents of Table 9.A3b are a series of 'simple' numbers should be taken as highly supportive of the assumption that the man-power and materials required for a nì-lám of Šūsîn quality are the same as that for a nì-lám of 2nd quality. The absence of additional oil and thread for the MA fabrics can be understood because these are light textiles (~⅙ kg) compared to the nì-lám fabrics which are each ~1.1kg.[27] Thus, in practice, we might suggest that the MA-fabrics would have been included as incidental items in the fulling and cleansing processes and therefore did not require additional allocations of oil and thread.

We can take this a step further by considering ITT 2, 902 + ITT 5, 6850 I 12-20, which give the following information (Table 9.A4a).

[25] Following Pomponio 2010, 192.
[26] Cf. Waetzoldt 1972, 161, note 61, where 5 days was assumed for each pair of MA fabrics.
[27] See Waetzoldt 1972, 159, note 50.

Textiles	Process	man-power	oil	alkali	thread
1 pair MA-fabrics (1st quality) 16 bar-si (5th quality)	túg sur-ra	116 days	½ sìla	3⅓ sìla 2 gín	5 gín
1 nì-lám Šūsîn-quality	túg kin-DI-a				

Table 9.A4a.

We can subtract the man-power and materials required to treat the nì-lám Šūsîn-quality fabric with the túg kin-DI-a process to obtain the information given in Table 9.A4b.

Textiles	Process	man-power	oil	alkali	thread
1 pair MA-fabrics (1st quality) 16 bar-si (5th quality)	túg sur-ra	26 days	-	52 gín	-

Table 9.A4b.

We can see the simple relationship that the number of gín of alkali is precisely double the number of days (cf. the túg kin-DI-a process for the MA fabric in Table 9.3b). This clearly gives confidence that our calculations (and underlying assumptions) are correct. Waetzoldt estimates that weight of both the pair of MA fabrics and the bar-si textile is ⅓ mina.[28] However, the MA-fabrics are first quality and the bar-si textile is 5th quality. We have noted above that the amount of man-power taken for finishing processes is a function of the quality of the textile. On this basis, guided by the figures, we might suggest that the man-power required for the túg sur-ra processes on the 1st quality MA textile was 10 days and with 1 day each for the 5th quality bar-si textiles, with proportionate quantities of alkali (see Table 9.A4c).

Textiles	Process	man-power	oil	alkali	thread
1 pair MA-fabrics (1st quality)	túg sur-ra	10 days	-	20 gín	-
1 bar-si (5th quality)	túg sur-ra	1 day	-	2 gín	-

Table 9.A4c.

The absence of oil and thread makes the túg sur-ra process on these textiles analogous to the túg kin-DI-a process for the MA fabric and we might assume that the oil and thread required for these smaller textiles would have been provided from the allocation for the processing of the more substantial nì-lám textile that is listed with them.

There is a further step we can take here by examining the larger list of items on this tablet, ITT 2, 902 + ITT 5, 6850 III 12-IV 3 (Table 9.A5a).

[28] Waetzoldt 1972, 165 note 76.

Textiles	Process	man-power	oil	alkali	thread
1 pair MA-fabrics (1st quality) 16 bar-si (5th quality)	túg sur-ra				
5 nì-lám Šūsîn-quality 1 nì-lám (2nd quality) 1 nì-lám-tab-ba (3rd quality) 15 nì-lám (3rd quality) 5 pair MA-fabrics (1st quality)	túg kin-DI-a	846 days	7⅚ sìla 7½ gín	59 sìla 11 gín	1 mana 12½ gín

Table 9.A5a.

This is a summation of all the túg kin-DI-a and túg sur-ra processes on this tablet and so it is referring, in part, to the textiles already considered above. However, it is also including other textiles for which the data are now lost to us, because the tablet has not been preserved. Therefore, by analysis, we can recover the information in the missing text, as shown in Table 9.A5b.

Textiles	Process	man-power	oil	alkali	thread
1 nì-lám Šūsîn-quality 1 nì-lám-tab-ba (3rd quality) 15 nì-lám (3rd quality) 1 pair MA-fabrics (1st quality)	túg kin-DI-a	350 days	5 sìla 27½ gín	45 sìla 9 gín	47½ gín

Table 9.A5b.

We can now subtract the man-power and materials required for processing the nì-lám Šūsîn-quality and MA fabrics (Table 9.A5c).

Textiles	Process	man-power	oil	alkali	thread
1 nì-lám-tab-ba (3rd quality) 15 nì-lám (3rd quality)	túg kin-DI-a	255 days	4 sìla 57½ gín	42 sìla 29 gín	42½ gín

Table 9.A5c.

If we suggested that the 3rd quality nì-lám-tab-ba fabric required the same man-power and materials as a 3rd quality nì-lám then we would divide each of the figures in Table 9.A5c by sixteen which would not give us a 'simple' series of numbers. However, Waetzoldt interprets 'tab' as 'doubles'.[29] If we apply this interpretation literally and assume that the 3rd quality nì-lám-tab-ba is a special type of fabric that required double the amount of man-power and materials as a 3rd quality nì-lám fabric, then (with a single minor exception)[30] we are led directly to a 'simple' series of numbers (Table 9.A5d).

[29] Waetzoldt 1972, 291.
[30] The single exception is that we have assumed that the 42 sìla 29 gín of alkali should actually be 42 sìla 30 gín.

Textiles	Process	man-power	oil	alkali	thread
1 nì-lám-tab-ba 3rd quality	túg kin-DI-a	30 days	35 gín	5 sìla	5 gín
1 nì-lám 3rd quality	túg kin-DI-a	15 days	17½ gín	2½ sìla	2½ gín

Table 9.A5d.

Considering MVN 6, 291 (= UNT 38)

We can make less progress with MVN 6, 291 because it introduces too many new fabrics and there is not sufficient information to allow us to calculate the amount of man-power and materials required for each of them. Nevertheless, it is worthwhile considering REV. I 16–21 (Table 9.A6a).

Textiles	Process	man-power	oil	alkali
1 guz-za (3rd quality) 3 guz-za (4th quality)	túg kin-DI-a	60 days	1 sìla	4 sìla

Table 9.A6a.

In principle, we should be able to apply the data from Table 9.A1b for 4th quality guz-za textiles and derive the man-power and materials required for 3rd quality guz-za textiles. However, this would result in a ratio of oil to alkali of 1:1. This is clearly incorrect as the oil and alkali combine by a chemical process to form a soap solution and the usual ratios for finishing processes are in the range 1:4 to 1:10.[31]

The most likely way to separate the man-power and materials required for these two textiles is as given in Table 9.A6b. This would require the same amount of man-power and oil as in Table 9.A1b for the 4th quality guz-za textiles and then the alkali would be divided pro rata. However, because there is a speculative element here, this has not been included in Table 9.3 of the main text.

Textiles	Process	man-power	oil	alkali
1 guz-za (3rd quality)	túg kin-DI-a	30 days	½ sìla	2 sìla
1 guz-za (4th quality)	túg kin-DI-a	10 days	10 gín	40 gín

Table 9.A6b.

There is an important point here that, whilst it is reasonable to assume that the scribe consistently used comparable data for each tablet that he wrote relating to a particular fuller's workshop, this does not imply that all scribes used the same 'rules' to estimate man-power and materials, particularly if their texts related to different workshops. In other words, the finishing processes are not closely adhering to physical laws, so they do not require a fixed set of man-power and materials. There is clearly a range of discretion, so that for example, more man-power could be allocated to higher quality materials. The Girsu tablets that we are considering here show a relatively high degree of consistency but when we compare data from Ur there are marked variations (see above).

[31] Waetzoldt 1972, 159, 162.

Using this tablet to derive new information becomes more difficult when we look at other examples of lists of textiles with their requirements of man-power and materials. There are two further complete examples II 5–18, REV. I 7–15 (see Table 9.A7).

Texts	Textiles	Process	man-power	oil	alkali
REV. I 7–15	4 nì-lám (3rd quality) 2 guz-za (3rd quality) 6 guz-za (4th quality) 1 ZU.BU 2 uš-bar	túg sur-ra	367 days	6 sìla 14 gín	51 sìla
II 5–17	4 nì-lám (3rd quality) 4 guz-za (3rd quality) 3 nì-lám (4th quality) 22 guz-za (4th quality) 4 guz-za (5th quality) 1 ZU.BU 8 sag-uš-bar 10 uš-bar 4 uš-bar siki mug 16 bar-si nì-lá	túg sur-ra[32]	1023 days	16 sìla 5 gín	142 sìla

Table 9.A7.

These introduce too many new textiles to proceed further with the analysis at this stage.[33]

MVN 6, 291 is particularly interesting because, although the tablet is not complete, we have both a reasonable amount of detailed information and a summary. In particular, we find that the sum of man-days for the túg sur-ra and kin-DI-a processes is (1023+367+60=) 1450 days. However, on lines REV. III 5–6, which appear to be part of the summing up on the tablet, there are 543.5 man-days listed and 1285 woman-days. In other words, whilst the tablet seems to specifically refer to man-days, it would appear that these are intended to be person-days and may be undertaken by women. This suggests that women worked in some fulling workshops.

A further point of interest on this tablet is that the summation of the oil and alkali for the túg sur-ra and kin-DI-a processes is equal to the amounts listed on REV. III 7–8. This would imply that we have a complete knowledge of the túg sur-ra and kin-DI-a work that was being recorded on this tablet. However, the list of textiles in the summary, REV. II 8–17 exceeds the list of textiles that underwent the túg sur-ra and kin-DI-a processes. We might presume that the other textiles required túg šà-ha.

[32] Here we are accepting Waetzoldt's 1972, 239 suggestion that the túg sur-ra process is intended, although the text is missing.

[33] We could can make some attempt to simplify the information by substituting into the information from lines II 5–17 from IV 7–15 and for 4th and 5th quality guz-za from UNT 39 and similarly for IV 7–15 using the information for 4th quality guz-za derived from UNT 39. However, it becomes clear that the allocations of materials on different tablets are not entirely consistent between these two tablets and so it is preferable not to make these substitutions.

Considering MVN 22, 188

The relevant information from this tablet is summarised in Table 9.A8.

Textiles	Process	man-power	oil	alkali	thread
18 guz-za (2nd quality) 1 túg aktum (3rd quality) 90 guz-za (4th quality) 12 guz-za (5th quality) 228 ^{túg}sa-sa	túg-sur-ra	4326 days	11 units (royal quality)	712 sìla	6 mana
2 túg nì-bàra (2nd quality) 1 túg aktum (2nd quality) 6 guz-za (2nd quality) 1 guz-za (3rd quality)	túg kin-DI-a	530 days	5 sìla 45 gín	42½ sìla	1 mana 55 gín

Table 9.A8.

The inscription also gives the additional information that the two túg aktum each weigh 10 mana.

The amount oil specified for túg sur-ra does not specify the units being used. The reading given in MVN 6 suggests that these units are in gur. If this were correct, then the amount of oil would be 3300 sìla however this would be grossly in excess of the amount of oil needed. A supply of oil of, say, 66 sìla would be more appropriate, although it is not possible to obtain such a value from the text without assuming that there is a scribal error. Therefore, the main text does not include ratios based on this value.

Unfortunately, Table 9.A8 introduces too many new types of textiles and provides too little basis for us to attempt any mathematical analysis to separate the terms.

Appendix B: The ì túg šà-ha, ì túg sa-gi$_4$-a and ì túg-ge ak oil tablets of Girsu

Tablet	Date	Materials	Expended by	Received by
BAOM 2, 24 10	SH 37 III	20 [litres] pig fat (royal quality) ì túg-ge ak-dè	ki inim-dba-ba$_6$ ì-dab$_5$-ta	lú-uru$_{11}$ki šu ba-ti
DAS 359	SH 40 V	150 litres sesame oil ì túg-ge ak-dè	ki ur-ab-ba-ta gìri nam-zi-tar-ra	ì-lí-NE dumu ur-diškur šu ba#-ti
MVN 9, 67	AS 4 VII	325 litres sesame oil (royal quality) 4⅓ litres pig fat 91 litres sesame oil ì túg-ge ak-dè #	ki ur-ab-ba-[ta] gìri lugal-iri-da gìri ur-diškur	lugal-iri-da šu ba-ti
Amherst 75	AS 4 X	180 litres sesme oil (royal quality) túg-ge ak-dè	ki ur-ab-ba-ta mu lú -dba-ba$_6$-šè	ur-nigargar šu ba-ti ba-geš-eb
MVN 9, 69	AS 4 XI	15 litres sesame oil (royal quality) ì túg-ge ak	ki ur-ab-ba-ta	ur-dnin-marki šu ba-ti
ITT 3, 5541	AS 7 I	591 litres sesame oil (royal quality) ì túg-ge ak-dè	ki ur-ab-ba-ta	ur-sa$_6$-ga mu [...] šu ba-ti
BPOA 1, 141	AS 7 V	11 litres sesame oil (royal quality) ì túg šà-ha		ur-mes dumu šu-na šu ba-ti
RA 58, 104, 73	AS 7 VII	5 litres [...] oil [...] ì túg sa-gi$_4$? [šà] gír-suki	ki ur-ab-ba-ta	ur-mes dumu ur-sa$_6$-ga šu ba-ti
RA 58, 104, 74	AS 7 IX	[x] litres oil ì túg šà-ha# [...]	gìri lugal-siki-sùl	ur-ab-ba šu ba-ti
ITT 3 5560	AS 7 X	177 litres sesame oil (royal quality) ì túg-ge ak	ki ur-ab-ba-ta	lugal-sukkal šu ba-ti
RA 58, 104, 75	AS 7 XI	5 litres pig fat ì túg šà-ha	ki ur-ab-ba-ta	ur-dig-alim šu ba-ti
MVN 22, 281	AS 7 XII	5 litres sesame oil ì túg šà-ha		ur-sa$_6$-ga šu ba-ti
Nisaba 13, 51	AS 8 I	29 litres of sesame oil ì túg sa-gi$_4$-a		issued to 21 named men
RA 58, 104, 76	AS 8 IV	5½ litres sesame oil ì túg sa-gi$_4$-a	ki ur-ab-ba-ta	sá-ge$_6$ šu ba-ti šà gír-suki
TCTI 2, 3633	AS 8 IV	140 litres sesame oil (royal quality) ì túg-gé ak-dè	ki ur-ab-ba-ta	lugal-sukkal šu ba-ti
MVN 13, 372	AS 8 XII	7 litres sesame oil ì túg šà-ha	ki ur-ab-ba-ta é úr-mah-BI?	lú-na šu ba-ti
RA 58, 104, 77	AS 8 XII	3½ litres sesame oil ì túg# [šà]-HA#	ki ur-ab-ba-ta é sa$_6$-[...]	ur-mes dumu ur-sa$_6$-ga šu ba-ti
MVN 22, 282	AS 9 XI	⅙ litre sesame oil (royal quality) ì túg sa-gi$_4$-a šà kar-lugal-ka	gìri ur-sa$_6$-ga-mu	ur-mes dumu ba-na šu ba-ti
RA 58, 104, 78	AS 9 XII	1½ litres sesame oil ì túg sa-gi$_4$-a	ki ur-ab-ba-ta	ur-mes dumu ur-sa$_6$-[ga] šu ba-ti
MVN 13, 373	ŠS 1 II	5 litres sesame oil ì túg šà-ha má x?		ur-dig-alim šu ba-ti
RA 58, 104, 79	ŠS 1 IV	20 litres sesame oil (royal quality) ì túg šà-ha	ki ur-ab-ba-ta gìri šeš-du$_{10}$-ga	lú-dnin-marki šu ba-ti šà# gír-suki
RA 58, 104, 80	ŠS 1 IV	27 [litres] sesame oil ì túg šà-ha	ki lu?-lu-di-ta gìri [...]	ur-dlamma dumu ur-ab-ba šu ba-ti
BPOA 1, 130	ŠS 1 V	4 litres sesame oil ì túg sa-gi$_4$-a 12 litres ì túg šà-ha	gìri šeš-du$_{10}$-ga	šà gír-suki ur-dig-alim šu ba-ti

Tablet	Date	Materials	Expended by	Received by
MVN 22, 192	[...] V	105⅚ litres sesame oil ì túg sa-gi₄-a šà gír-su^ki	gìri šeš-du₁₀-ga	issued to 24 named men
MVN 22, 193	ŠS 1 VII	295⅚ litres sesame oil ì túg sa-gi₄-a	ki# ur-ab-ba-ta gìri # šeš-du₁₀-ga	issued to 23 named men lú azlag#-e šu-ti-a
RA 58, 104, 81	ŠS 1 VII	29 litres ì túg sa-gi₄	ki ur-ab-ba-ta	ú-^dnin-mar^ki šu ba-ti
MVN 22, 263	ŠS 1 VIII	2 [litres?] pig fat [x] ^túgšà-ha	gìri lugal-sukkal	lú#-na šu# ba-ti
AAS 193	ŠS 5 II	15½ [litres] oil (royal quality) ì túg sa-gi₄-a šà gír-su^ki	ki# ur-ab-ba-ta	lugal-ezem šu ba-ti
MVN 7, 535	ŠS 8 VIII	1640 litres ì túg-ge ak-dè	ki ur-ab-ba-ta	lugal-amar-kù šu ba-ti

10. Tapestries in the Bronze and Early Iron Ages of the Ancient Near East

Joanna S. Smith

The broad category of textiles encompasses a diverse group of artistic techniques and finished products. The narrower category of multicoloured textiles includes decorated cloth created by weaving, braiding, sewing, embroidery, painting, and dyeing. This paper explores the multicoloured weaving technique of tapestry used to make cloth for clothing, furniture covers, wall hangings, and other objects. In the Bronze and early Iron Ages of the ancient Near East, tapestry woven cloth was nearly synonymous with royalty. With their potential to be large and elaborately decorated, not only did tapestries form parts of clothing, but also tapestry cloths became portable elements of interior design that could create spaces of prestige wherever their owners might have needed them.

Still, even though most consumers of tapestry were rulers or those closely associated with them, tapestry weaving did not necessarily take place in a royal context. Furthermore, evidence for several approaches to the manufacture, design, and use of tapestry-woven cloth suggests that tapestry weaving did not follow one unbroken tradition, passed down from weaver to weaver, generation after generation, and across the Near East, Egypt, and the eastern Mediterranean. For example, tapestry in antiquity was often made with colourful woollen fibres, wool being a fibre that held dye well. However, all surviving tapestry woven textiles for the period under study were found in Egypt and were created with coloured linen fibres, sometimes touched up with paint. The multiple forms of tapestry production are best understood with respect to the power that their consumers wished to convey, especially the kings of northern Mesopotamia and Egypt.

Tapestry in the Bronze and early Iron Ages

The word tapestry brings to mind the large full field designs of Europe in the Middle Ages and the Renaissance.[1] The tapestry technique involves weaving patterns and figural designs to create solid fields of colour on both sides of the fabric. The finished product is flat and double-sided; asymmetrical designs will appear in reverse on the opposite side. The weft strands in tapestry outnumber the warp fibres. Typically the wefts are beaten in so that they are closely set; the

[1] Campbell 2002; Phillips 1994; Cavallo 1998.

surface is described as weft-faced and the warp strands do not show through.[2] A similar effect may be achieved in the more unusual warp-faced weave, sometimes termed warp tapestry, in which the warp strands outnumber and entirely cover the wefts.[3] Because of the discontinuous warp fibres, this approach was often used for narrow bands rather than wider textiles. Usually in making a weft-faced tapestry, one thinks of the drawn or painted cartoons that guided European weavers.[4] However, a weaver can also achieve a consistent pattern through counting, story telling, or singing, as is known, for example, from Homeric epics[5] and Andean weavers in Peru.[6]

This study makes use of the evidence derived from surviving cloth, all of which comes from Egypt; and texts, nearly all of which come from the Near East; as well as parts of looms, hand held weaving tools, and contexts of production. Tapestries in the ancient Near East and Egypt could comprise a large design filling the warp and weft grid of a textile; however, other examples featured a larger plain field with tapestry-woven details, some were made up of bands of tapestry-woven decoration, and some were altered with other techniques such as sewing or painting. The Egyptian evidence shows that several approaches to the delineation of fields of colour in tapestry weave were used, especially slit, dovetail, and eccentric (bent) techniques.[7] Woven tapestry designs and the purposes of the woven products varied with their places of manufacture and their intended users.

The evidence for tapestries and tapestry weaving may be as early as the last century of the third millennium BC in the Ur III period,[8] but more certain evidence begins in the 19th century BC and can be traced first in Syria (including the Lebanon) and northern Mesopotamia, then in Egypt by the 18th Dynasty, and eventually in the southern Levant, Cyprus, Cilicia, and the Aegean. The earliest evidence relies on the meaning of the Akkadian word, *mardatum*. The first use of that word is a single reference to a textile among the Old Assyrian documents at Kanesh from the 19th century BC.[9] The word *mardatum* (Ugaritic *mrdt*) continues to appear in second millennium BC texts, most frequently at Mari and later at Nuzi, but also at Alalakh, Ugarit, and Kār-Tikulti-Ninurta. The term is rarely used in the first millennium BC.[10]

The precise definition of *mardatum* varies somewhat through time, but in all references it seems to be a multicoloured cloth made with a special technique.[11] It is thought to reference tapestry not just because it was multicoloured, but also because at its root, *mrd*, it appears to reference both authority and protection in that it was unyielding and impervious.[12] Possibly this root meaning references both the closely packed weave used to create the unbroken fields of colour in the designs and the significance of these textiles as symbolic of kingly power.

[2] Emery 1966, 76–78.

[3] Emery 1966, 76, 88–89,

[4] Campbell 2002, 41–49.

[5] Tuck 2006.

[6] Urton 1997, 96–137.

[7] On the different techniques used to delineate fields of colour in tapestries see Emery 1966, 79–84.

[8] Waetzoldt 2010, 208 notes that texts from this period indicate that several fabrics were woven with a higher weft than warp count and that the weft threads were of a heavier wool. This could indicate that weft-faced fabrics were the woven products.

[9] Smith 1921, 9, 16, no. 113319; Veenhof 1972, 160, 179; Michel and Veenhof 2010, 235-236.

[10] Oppenheim and Reiner (eds) 1977, 278; Mayer 1977, 186–188.

[11] Oppenheim and Reiner (eds) 1977, 277–278.

[12] Durand 2009, 64. Durand also notes that the term may simply mean, "(fabric) that descends" as a wall covering or hanging of some sort.

Elizabeth Riefstahl first suggested that Egyptian weavers learned techniques for weaving patterned cloth from Syrians who were brought to Egypt as captives during reign of Thutmose III.[13] While there is no doubt that cloth from Syria was brought into Egypt by the 18th Dynasty[14] and that hundreds of Syrian slaves were at work in Egypt by the same period,[15] the ways in which the technique of tapestry weaving came to be known outside of Syria remain to be demonstrated. Consideration of the materials used and the contexts of production in relationship to textual descriptions and the existing designs of tapestries begin to suggest how the techniques were learned by weavers of the Near East, Egypt, and the Mediterranean and why there were differences in the approaches taken as well as the resulting tapestry woven products.

Tapestry Weavers and their Tools

References to the *mardatum* begin to reveal where in the ancient Near East there were tapestry weavers. The *mardatum* listed at Kanesh probably came from Aššur, but whether it was made there is not known because those who conducted the trade during this period acquired textiles from several places.[16] Textiles designated as *mardatum* at Mari in the 18th century BC are described as Yamhad- and Byblos-type,[17] suggesting that those who wove in the tapestry technique were from Syria. The word *mardatum* and another possible word for a kind of tapestry, *massilâtum*, both come into the Akkadian used at Mari from the west.[18] Both were the products of specialized weavers. At Alalakh and Nuzi, *mardatuhuli* (*mardatum*-makers) are mentioned by the 15th century BC,[19] indicating the wider geographical spread in which such textiles may have been manufactured. At Alalakh *mardatuhuli* appear in census lists and a document listing families of *mardatuhuli*, which suggest that *mardatum* production was the specialty of certain families, possibly made in household contexts. The single occurrence at Nuzi is a *mardatuhuli* who served as a witness; it is unclear to what extent *mardatum* making took place in that city.

The use of the Hurrian ending, *-huli*,[20] for the term *mardatuhuli* is reflective of the Mitannian cultural sphere in which tapestries would have been made during the 15th into the 14th centuries

[13] Riefstahl 1944, 31–32. Scholarship continues to adopt this model for the transmission of the tapestry technique, see Barber 1991, 157–158, 161–162; Vogelsang-Eastwood 1993, 7. Kantor 1947, 59, noted that the patterning of imported cloth, seemingly as opposed to weavers demonstrating how to make new designs in new techniques, would have led to new designs found in Egypt.

[14] Breasted 1906, 187–188, no. 436 lists "much clothing of that foe" at the end of a section in the Annals of Thutmose III that describes plunder from the Lebanon and Megiddo.

[15] Breasted 1906, 222, no. 555; Riefstahl 1944, 31 notes that these slaves made cloth based on Henry Lutz's assertion (1923, 58) that "these Syrians, no doubt, were expert weavers and the word 'Syrian', became in time a synonym of 'weaver'," for which he cites a Coptic parallel. Also for the identification of these slaves as weavers, see Kemp and Vogelsang-Eastwood 2001, 433 for further clarifications.

[16] At Kanesh the *mardatum* is a gift to a palace authority, *1 TÚG ku-sí-tám ma-ar-da-a-tám*. The *kusítum* is not a frequent textile product and was probably an untailored wrap of some sort. *Kusítum* textiles are among the imports from Aššur, see Veenhof 1972, 159, but where the *mardatum* example was made is not clear from the text. Veenhof 1972, 98 discusses the acquisition of textiles by the traders.

[17] Durand 2009, 63.

[18] Durand 2009, 63, 66.

[19] Wiseman 1953, 65, 67, 79, nos. 136, 148, 227; Oppenheim and Reiner (eds) 1977, 278, original text in Lacheman 1955, no. 65 line 12.

[20] Dietrich and Loretz 1966, 192.

BC. It is from the period of Mitannian power that the earliest known tapestry woven products[21] are preserved in the 18th Dynasty tombs of Egypt. However, no word for tapestry has yet been found among Hurrian and Hittite texts, suggesting that the *mardatum* may not have been a specifically Mitannian product.[22] Most surviving tapestry woven textiles were found in the tomb of Tutankhamun[23] whose rule coincided with the last years of the Mitanni kingdom that was defeated by the Hittites.

Because of the use of coloured linen threads in all examples of tapestry found in Egypt,[24] the many designs incorporating Egyptian hieroglyphs, and the typically Egyptian forms of attire made with tapestry woven cloth, it seems that most of the tapestries in Egypt were made there rather than imported. The few items thought to be imported, whether as greeting gifts or parts of dowries, are gloves and gauntlets for horse and chariot riding,[25] both activities that were strongly associated with the Mitannian cultural sphere. These, like the Egyptian products, however, were made with linen threads. If the Mitanni were purveyors of tapestry products, it is of interest that there are fewer uses of the word *mardatum* after the Nuzi texts and weft-faced tapestry woven cloth is not found among the textiles in 19th and 20th Dynasty Egyptian contexts.

During the 18th Dynasty there is pictorial and physical evidence[26] in Egypt for the vertical loom. Pictorial evidence for that loom continues in the 19th Dynasty.[27] The vertical loom is commonly associated with tapestry weaving, although it can be used to weave other kinds of cloth. Representations in Egypt of the textiles woven on these looms[28] lack any colour or pattern; thus, it can not be said that these representations may show tapestry cloth being woven, only that such looms would have been appropriate for weaving tapestry based on parallels with later period tapestry looms.

It is possible that the vertical loom originated in Egypt, but most scholars posit that it was used earlier in Mesopotamia and/or the Levant.[29] It might have come into use in Egypt during the Second Intermediate period when the Hyksos kings ruled from the Nile Delta.[30] However, most place its first use in Egypt in the 18th Dynasty. Evidence for connections between the Near East and Egypt during the 18th Dynasty can be found among the texts and art forms in Egypt, including material remains that suggest that Asiatics continued to live and die in Egypt after the end of the Hyksos period.[31] Eighteenth Dynasty representations of the vertical loom show that it

[21] Thomson 1904.

[22] Durand 2009, 63. Vogelsang-Eastwood 1999, 84–86, however, has suggested that some of the textiles in Tutankhamun's tomb might have been Mitannian products. It is possible that the gloves and gauntlets might have come from there due to their uses in horse and chariot riding.

[23] Pfister 1937; Vogelsang-Eastwood 1999.

[24] Vogelsang-Eastwood 2000, 278–279; I thank Gillian Vogelsang-Eastwood for confirming that all tapestry woven cloth found in Egypt was made with coloured linen thread rather than wool (November 1, 2010). A discussion of the fibres found at Tell el-Amarna includes comments about the rare examples of woollen fibres found in Egypt overall as opposed to the more common linen fibres, see Kemp and Vogelsang-Eastwood 2001, 13–55.

[25] Vogelsang-Eastwood 1999, 88.

[26] Kemp and Vogelsang-Eastwood 2001, 335–356, 373–404, especially figs 9.19, 9.20, and a reconstruction of a loom 405–426.

[27] Kemp and Vogelsang-Eastwood 2001, 337, fig. 9.21.

[28] For a summary of these images see Kemp and Vogelsang-Eastwood 2001, 334–338.

[29] Ellis 1976, 77.

[30] Hall 1986, 15; but see Vogelsang-Eastwood 2000, 278 for a cautionary note.

[31] Lilyquist 2005.

was used in Egypt mainly by male rather than female weavers, suggesting that it was a new and innovative technology when it first was included as a subject in tomb decorations.[32] It is possible that this loom type and the technique for tapestry weaving were first used in Egypt at the same time.[33]

Cloth with the weft beaten in for fields of solid colour can be created, however, using other loom types such as the horizontal[34] and the warp-weighted looms. The warping and weighting of the loom will determine the width and length of the cloth, not whether a weaver could pack in the weft. Fragments of tapestries from contexts associated with nomadic cultures in Asia lend support to the portable nature of these products and at least some kinds of weaving technology used to make them.[35] In the Middle Ages it is thought that a horizontal rather than a vertical loom was used to weave large tapestries, such as the well known unicorn series.[36] There is limited evidence for the warp-weighted loom in Egypt.[37] It was characteristic of weaving in Anatolia, the Levant, Cyprus, and the Aegean. Unlike the vertical two-beam loom that would have held the warp in a fixed position, the warp-weighted loom is more flexible and may thus have been more appropriate for weaving some of the tapestry fabrics.[38] The bent weft technique was used especially to create hieroglyphic characters, which suggests strongly that at least these examples in Egypt must have been woven on a loom with some flexibility in the warp, as on a warp-weighted loom.[39]

Weaving on the vertical loom works from the bottom up, whereas weaving on the warp-weighted loom works from the top down. If both loom types were used, it is important to note that pointed bone tools suitable for beating in the weft come in two varieties, pierced and unpierced. The pierced tools are generally larger, appear to have been used singly, and would have been better suited for pushing up the solid fields of weft patterning in the flexible warp of a warp-weighted loom. Such tools could also, of course, have been used singly to compact the weft on a vertical or horizontal loom. Multiple examples of the unpierced and often smaller tool could have been used together, each for beating in a different colour area downward on a vertical loom or across on a horizontal loom with a fixed warp. When colour areas were left temporarily in order to fill in a different part of the design, the tightness of the warp fibres would have helped to hold the tools and their associated threads in place until they were needed again. This recalls much later tapestry weaving as in the large workshops of 19th century Europe.[40] These tools, of course, might also have been used singly on a warp-weighted or another type of loom.

Nearly all of these pointed bone beaters were made from cattle ribs. Unfortunately, none

[32] Barber 1991, 290–291 sees the introduction of men into a previously women's profession as evidence for innovation in the use of the vertical loom and hence in the art of tapestry weaving. A woman is shown at a vertical loom by the time of Ramses II, see Kemp and Vogelsang-Eastwood 2001, 336, fig. 9.21,

[33] Ellis 1976.

[34] Waedtzoldt 2010, 208 notes that Ur III period fabrics that might have been weft-faced would have been woven on horizontal looms, some more than five meters wide.

[35] Barber 1999, 62–64

[36] Cavallo 1998, 84–85.

[37] Kemp and Vogelsang-Eastwood 2001, 392–394 discuss the limited evidence for weights in connection with the vertical loom and the potential for more plentiful evidence for loom weights from El Lisht.

[38] Discussions were with Susan Edmunds during a series of four textile workshops that she ran for the Center for Archaeology at Columbia University in 2006–2007. See Edmunds *et al.*, 2004. See also Bellinger 1950 who mentions the warp-weighted loom in Greece as a tapestry loom.

[39] Thomson 1904, 143.

[40] See a photo from *c.* 1890 at the Merton Abbey Workshops in Phillips 1994, 118.

come from a context that includes a fragment of tapestry cloth or a text concerning the making of tapestries. However, several in Egypt, the Levant, and Cyprus have been found together with other weaving tools. In Egypt the evidence points to household workshop contexts, where weavers produced at least some textiles for customers outside the immediate household group, including royal customers.[41] At Gurob in Egypt many fibres and several wooden spinning and weaving tools were preserved that would not survive in most archaeological contexts.[42] The plentiful evidence at Amarna for weaving tools includes evidence for the vertical loom,[43] which may form a link between that loom type and bone beaters.[44] Among the textiles preserved at Amarna, none is a weft-faced tapestry, although fragments of warp-faced linen textiles were preserved there.[45] Strong contextual links between beaters and contexts with loom weights and other weaving-related tools come from Late Bronze Age and early Iron Age sites in the southern Levant and Cyprus.[46] Loom weights found in the same contexts as bone beaters at Kition on Cyprus were most suitable for weaving weft-faced cloth.[47]

While a full study of all potential bone beaters, their usewear and their contexts, remains to be undertaken, it is important to note that an example of such a tool has been found at Alalakh as early as Leonard Woolley's Level VII,[48] about a generation after references to tapestries of Syrian (Yamhad and Byblos)[49] type are mentioned in 18th century BC texts from Mari.[50] Furthermore, they come into use in settlements in Egypt such as at Gurob, first established by Thutmose III,[51] and Amarna, established during the reign of Akhenaten,[52] in the 18th Dynasty, the same period during which the earliest surviving tapestries have been found in tombs at Thebes.

The shape of these bone tools somewhat resembles an oversized fountain pen, which explains why several early 20th century archaeologists labelled some of them as styli for writing in clay.[53] The contexts of the tools and their wear marks strongly support their identification as weaving

[41] On the organization of the textile industry in Egypt, see Kemp and Vogelsang-Eastwood 2001, 427–476.

[42] Thomas 1981.

[43] Kemp and Vogelsang-Eastwood 2001, 358–373.

[44] Also see Giddy 1999, 162–163 for beaters from Kom Rabiʻa, contained within a survey of Memphis, and further references to such bone tools from Egypt.

[45] Kemp and Vogelsang-Eastwood 2001, 106–109.

[46] Smith 2001, 83–90. Ebla has provided detailed evidence for textile production over a long period of time; see Peyronel 2007, 27 n. 4 for a citation of a forthcoming article with evidence for such bone beating tools at Ebla from 1st millennium BC weaving contexts.

[47] Andersson, Cutler, Nosch and Smith in press.

[48] Woolley 1955, 402, no. AT/38/273, also note page 403, no. AT/38/296 (Level II), and fig. 77. This material requires study in order to determine whether they are similar in wear marks to similarly shaped tools from other sites. Woolley included them in his "residuary catalogue" calling them "objects of no intrinsic interest" but with "possible evidential value". A. Yener mentioned to me that there are other such tools from current excavations at the site.

[49] The stratigraphic problems at Byblos make it unclear to which periods potential bone beaters from those excavations might date. See *e.g.*, Dunand 1939, pls CXVII.5159, CXVIII.5158, CXIX.4078, 5215, 5218, 5331.

[50] Durand 2009, 63.

[51] Thomas 1981, 4.

[52] Kemp 1989, 266–273.

[53] Macalister 1912, 274; Schaeffer 1952, 28; 1954, 39; Van Beek and Van Beek 1990, 206; Smith 2001. Van Beek and Van Beek 1990 think that these sometimes wide and large hard pointed objects (much larger than the tweezers to which they compare them in their pointed shape) were used for removing chaff from the eye. In their article they reference the idea put forth by some that these tools were used for weaving, but they do not explain why that function is rejected except to say (1990, 206) that because they "respect ... Petrie's imagination, knowledge, and experience" they initially accepted his interpretation of these objects as netting tools (*e.g.*, Petrie 1928, 17) rather than weaving tools.

tools. Olga Tufnell used the term pattern sticks for them[54] and Grace Crowfoot equated them with the Greek κερκίς (*kerkis*) or pin beater.[55] In Homer's *Iliad*, Andromache used a single *kerkis* to weave a tapestry (δίπλακα, *diplaka*).[56] In the *Odyssey*, Calypso also used a single *kerkis* as she wove and sang.[57] The *kerkis* came to be associated with the weaving of the πέπλος (*peplos*) in Greece,[58] which was also made of tapestry weave. It is possible, thus, to begin to propose where the weavers of tapestries were through the contexts of these bone tools. It is also important to remember that a beater could be made of several materials including wood and some pointed bone tools may have served other purposes.

It is the use wear on these tools, especially the abrasion marks on the tips of these tools, that provides the strongest evidence that they were used for working with fibres. All pierced examples come from Cyprus.[59] Most come from 13th and 12th century BC contexts. These pierced tools were probably worn on a string around the neck, so that each weaver had one beater.[60] The piercing at the end of the handle has wear that shows it hung on a string and was tugged from one direction. On their pointed ends, the marks show that they rubbed against fibres. Their handles are generally highly polished but do not shown signs of abrasion by individual fibres.

These Cypriot tools come in several sizes. Some preserve nearly the full length of the bovine rib and would have been sturdy tools for working with thicker fibres. On most examples the full circumference of the rib is preserved except near the pointed end. Near the point, half of the rib's thickness was normally cut away to make for a finer tip. Some small examples, possibly for working smaller, finer fibres, are flat. On these examples the rib thickness was cut in half along the full length of each tool, removing most of the porous core of the bone. Possibly the beaters continued to be sharpened and cut back during their use lives as they became blunt or broken during the weaving work.

Unpierced examples come from Egypt, Syria, the southern Levant, and Cilicia. Some of the Syrian (including the Lebanon) and Cilician tools may be earlier in date than even the textual references to *mardatum* products.[61] The Egyptian examples may all date to the 18th Dynasty, but the chronological range of the tools found through survey at Memphis[62] and in the largely unstratified deposits at Gurob[63] make it impossible to determine the period of use more precisely. The southern Levantine pieces are roughly contemporary with and some are later than the pierced Cypriot tools. The Cilician examples appear to have a long period of use, down to the 6th century

[54] Tufnell 1953, 397.

[55] Crowfoot 1936–1937, 44–45.

[56] Smith 2012.

[57] *Iliad* 22.441, 448; *Odyssey* 5.62.

[58] Euripedes, *Electra*, 307. See also Crowfoot 1936–1937, 45–46 and Barber 1991, 360; 1992, 112.

[59] Smith 2001.

[60] I thank Susan Edmunds, a modern-day tapestry weaver, for her comment that these pierced bone tools would be ideal as single beaters for a weaver of tapestries.

[61] Several examples from Egypt, Syria, and the Levant have been cited above. In Cilicia several were found at Tarsus (Gözlü Kule), see Goldman 1956, 311–313, 315–316, figs 437, 439, especially nos 87–88 from the Late Bronze Age, and Goldman (ed.) 1963, 383–384, fig. 177, nos 3–13, Goldman dates these examples to the early Iron Age (no. 3), Middle Iron Age (nos 4–8), Assyrian period (nos 9–12), and the 6th century BC (no. 13). There are similar tools from Early Bronze Age contexts, Goldman 1956, 311–313, 315–316, figs 437, 439, especially nos 81–82, 84–86, that could be similar kinds of tools and would thus compare potentially with the early evidence from Byblos cited above (Dunand 1939).

[62] Giddy 1999, 162–163.

[63] Thomas 1981, 41–43.

BC, by which time there are even examples of such unpierced tools in Cypriot contexts at ancient Marion.[64]

The unpierced tools tend on average to be smaller than the pierced examples. The size difference is partly because the thickness of the bone was normally cut in half. Unlike the pierced tools, there is abrasion wear around the handles that is consistent with a tool with thread wrapped around it and rubbing across it as threads were pulled during weaving.[65] Often they are found in groups, suggesting that they served both to guide a particular colour of weft fibre and to beat it in. A detailed study of the wear marks on tools from Tell el-Amarna includes excellent photographs of the wear on the points as well as the handles of these tools.[66]

Tapestry woven cloth in the texts of Mesopotamia, Syria, Egypt, and the Aegean

No physical evidence for tapestry woven cloth survives outside of Egypt for the period under study. Nevertheless, study of how the term *mardatum* is used reveals the ways in which tapestry-woven products developed in Syria and northern Mesopotamia. It is generally thought that *mardatum* textiles were made of coloured wool because woollen fibres hold dye well and many Near Eastern textiles were made of wool. The fibres used for *mardatum* textiles are rarely specified; it may have been assumed that they were made of coloured wool. At Nuzi, when a fibre is specified it is wool rather than linen.[67] Those listed at Ugarit, however, are designated as linen products.[68] Because the fibres for each example are not made clear in each text from each site, it is difficult to be certain of the precise materials for different textiles described as *mardatum*. The use of wool as opposed to linen might have varied from site to site and from time period to time period. The surviving evidence does not make it clear whether there were some kinds of *mardatum* products that were always woollen and others that were always linen throughout the ancient Near East.

The *mardatum* differs from two other terms for colourful textiles that were made by specialized weavers, the *hayyû* and the *massilâtum*. Of these, only the term *hayyû* was already in use by the Ur III period.[69] Like the *mardatum*, the *hayyû* was used as a covering for a throne, but its decoration seems to have been made of metal and its use in chariots, boats, and a tomb suggest that it was more of a floor covering.[70] The *massilâtum* was also grouped with textiles for furnishings and Jean-Marie Durand thinks that it may also have been made of tapestry weave. It was stored in large numbers in the palace at Mari and was used during a festival concerning Ishtar. Unlike the *hayyû* and the *mardatum*, both of which appear in connection with the king, the *massilâtum* was delivered to women.[71] The use of the *hayyû* and *mardatum* to cover thrones may have included

[64] See further on for a discussion of the evidence from ancient Marion (modern-day Polis Chrysochous).

[65] Thomas 1981, 41.

[66] Kemp and Vogelsang-Eastwood 2001, 358–373.

[67] The fibres used are not always specified. Wool is listed as the material of some *mardatum* textiles at Nuzi, see Mayer 1977, 178–180; Pfeiffer and Lacheman 1942, no. 431 line 33 (*mardatum* of royal quality made of dyed wool); Lacheman 1950, no. 520 line 42 (wool for *mardatum* trim); Lacheman 1955, no. 220 (wool for *mardatum* loincloth, bedding, *etc.*), 221 line 5 (blue wool for *mardatum* sashes).

[68] Van Soldt 1990, 329.

[69] Durand 2009, 43.

[70] Durand 2009, 43–44.

[71] Durand 2009, 66. Durand also notes that the *massilâtum* may be equivalent to the *mšlt* at Ugarit (Ribichini and Xella 1985, 52 suggest that it a "veste", a cover or dress, suggesting that it might have had more of a purpose for covering the body).

some use in relationship to women, but no such specific mention exists in the surviving texts.

Cuneiform texts from the 19th through the early 13th century BC reveal that the *mardatum* textiles were often multi-coloured and could have figural designs. One example at Mari bore a figure of a *lammasatum*,[72] a protective goddess.[73] Another example described in a late 13th century BC text from Kār-Tikulti-Ninurta was decorated with figures of people, animals, fortified towns, and images of the king.[74] Durand's detailed study of the *mardatum* at Mari shows that the *mardatum*'s purpose was for covering, usually items of furniture, especially thrones. It was a wall hanging rather than a floor covering. Whether it was an item of clothing is difficult to understand, but it was associated with wardrobe of the king.[75] It was an appropriate gift for royalty and at the time of Zimri-Lim; *mardatum* cloths were among gifts to be sent to Babylonia.[76]

In the Old Assyrian period and at Mari the *mardatum* seems not to have been a tailored garment, but rather a draped cloth symbolizing authority.[77] That use continued into the 13th century BC[78] and possibly later in Assyria[79] where it remained closely associated with the throne.[80] It is only by the 15th century BC at Nuzi[81] that *mardatum* cloths seem to have had a slightly wider range of purposes, including some for at least parts of personal attire. Only a few *mardatum* textiles at Nuzi are described as of royal quality (*rabûtu*), a coloured cover and two dyed wool products, neither of which appears to be an item of clothing.[82] Among the textile products at Nuzi described as *mardatum* are blankets, cloths for beds, cushions, edgings, fastenings, Babylonian-style garments, headdresses, sashes, and loincloths.[83]

The *mardatum* often probably formed part of a larger whole; for some items the *mardatum* portion might only have been an edging or a section rather than the whole fabric. For example, among the texts at Nuzi one heavy cloth is listed[84] as one *and* in the plural form at the same time; possibly it and the two items that follow it, a dyed cloth described as *mardatum* that was sewn on[85] and a set of silver fasteners, formed part of a composite object. At Mari there are fractions

[72] Durand 1983, 410, 454–455, no. 342 line 3; 2009, 63.

[73] Oppenheim (ed.) 1973, 60.

[74] Köcher 1957–1958; Barrelet 1977; Lassen 2010, 278–280.

[75] Durand 2009, 63–65.

[76] Dossin 1939, 48; Durand 2009, 63.

[77] Durand 2009, 64.

[78] Müller 1937, 14–15, column II, lines 45–46.

[79] Oppenheim and Reiner (eds) 1977, 278; Mayer 1977, 186.

[80] Also see a patterned cloth draped over the throne of the king at Til Barsib (Thureau-Dangin and Dunand 1936, 52–53, pl. XLIX) that might have been meant to represent a tapestry, see Barrelet 1977, 85–86.

[81] See Mayer 1977, 178–185 for a summary of these textiles, including sections of the original texts in transliteration and his translations into German. For the full texts, only some transliterated, see especially Pfeiffer and Lacheman 1942, nos 13, 225, 431; Lacheman 1950, nos 247, 520, 550, 607; 1955, nos 130, 220, 221.

[82] Pfeiffer and Lacheman 1942, no. 431, reverse, lines 32–33: *mar-ta-du rabûtu$^{meš.tù}$ ša ku-li-na-aš / 2 mar-ta-du rabûtupl ša tam-ka₄ar-[hu] ša šu-h[u-un-ni-wa].*

[83] See especially Pfeiffer and Lacheman 1942, no. 431, lines 18, 27, 32–38, 40, 44–46 for the range of *mardatum* products at Nuzi.

[84] Pfeiffer and Lacheman 1942, no. 225, lines 18–19: *1 ṣubâtupl kab-ba-ru-tu₄ 1 ṣubâtu ba-aš-lu / ša mar-ta-ti ku-up-pu-ú il-te-nu-tu₄ du-ti-w[a-šu ša k]aspêpl ù 1 ṣubâtu: a-na[x xxx].*

[85] In line 19 of this text, *ku-up-pu-ú* could reference a patched (Oppenheim (ed.) 1971, 482–483) and hence old *mardatum* because in line 17 a different pair of textiles are described as *labīrūtum*, old or of old age, sometimes dilapidated, see Oppenheim (ed.) 1973, 33. Those textiles might, however, simply be of old age and the use of *ku-up-pu-ú* could simply mean that the *mardatum* was sewn on to form part of the composite cloth, see Oppenheim (ed.) 1971, 482–483.

of a *mardatum* listed.[86] Nothing in the texts is definitive evidence that the *mardatum* formed part of a tailored garment made with cut up pieces of tapestry-woven cloth. These fractions may reference smaller versions of *mardatum* weaves based on a standard woven size. That size could be adjusted by weaving a piece at a smaller size depending on the product needed. Alternatively these fractions may reference *mardatum* sections of a larger composite product.

The *mardatum* described in an inventory text found at Kār-Tikulti-Ninurta[87] may have consisted of more than one part. This *mardatum* is qualified as having five 'somethings', the missing portion of the text beginning with the syllable "*pi*". Given that the document is concerned with counting the parts that make up valuable composite objects such as furniture because items had been damaged[88] in the movement of precious objects from Aššur to Kār-Tikulti-Ninurta,[89] the five 'somethings' probably refer to parts of the *mardatum*. It is tempting to see this word as related to *pirsu* (*parāsu*) in the sense of divisions or sections. Some uses of the term show that it had meaning in connection with wool and threads.[90]

This *mardatum* of five somethings was the work of a weaver (*išparu*).[91] The *mardatum*'s description begins with its multicoloured trim, a *birmu*.[92] Because it is included in the description that follows the word *mardatum*, the trim might also have been of tapestry weave. Although the text is fragmentary, the description then appears to reference figural decorations that are not part of the *birmu* but that appear to make up the five woven somethings of the *mardatum*. The next five lines list (1) people and animals as part of a longer line of unreadable description, (2) fortified towns that again are part of a longer line of unreadable description, (3) a likeness of the king on or in something, (4) something not readable, and (5) another likeness of the king on or in something.[93]

A sectional approach to a larger textile recalls Stephanie Dalley's observation that the designs of pile carpets preserve evidence that they probably were originally made as sections sewn together rather than created as a single piece.[94] Both a fibre product and leatherwork, even entire hides, would have been set against a backing. While the *mardatum* appears not to be a knotted carpet or a piece of leatherwork, there might have been a similar approach to creating a large figural decorated cloth surface. The better-known tapestries of later periods in Europe often consisted of several thematically related but separate tapestries meant to be displayed together. On a much smaller scale, Bronze Age tapestry designs could have been made up of several sections that were pieced together so as to form a completed composition.

On the same text from Kār-Tikulti-Ninurta in the paragraph before the *mardatum* is another composite figural decorated object.[95] Unfortunately the beginning of the paragraph is missing, but

[86] Durand 2009, 63.

[87] Köcher 1957–1958, 306–307, column III, lines 32–38: *1 TÚG.mar-du-tu ša 5 pi-x-[/ ša ši-pár UŠ.BAR bir-mu-šu x-[/ ni-še ù ú-ma-ma-ni a-x-[/ ša URU.DIDLI du-un-nu [ù] [/ ṣa-lam LUGAL i-na GIŠ.ma-as-[/ GIŠ.x-a-[hu] [n]a-ha-x-[/ ṣa-lam LUGAL i-na x-x-x [.*

[88] Barrelet 1977, 56.

[89] Köcher 1957–1958, 300–301.

[90] See definitions in Roth (ed.) 2005, 165–178, 411–412.

[91] Oppenheim (ed.) 1960, 253–257.

[92] Oppenheim (ed.) 1965, 257–258.

[93] Barrelet 1977, 57.

[94] Dalley 1991, 127–134.

[95] Köcher 1957–1958, 306–307, column III, lines 27–31: *[1 TÚG.mar-du-tu] ša ši-pár ka-ṣi-ri [ú] / x [x x x] [lu]-ri-DU-e i-na*

the object is listed as the work of a *kāṣiru*. Some have taken the *kāṣiru* to be a knotter[96] and hence the object in this paragraph to be a pile carpet.[97] The reconstruction of the word *mardatum* at the beginning of the paragraph even led scholars to think of the *mardatum* as a word that means both tapestry and pile carpet.[98] However, it is important to note that there is no preserved word or even a fragment of a sign at the head of the paragraph.[99]

The word *kāṣiru* relates to the word *kaṣāru* and has the sense of tier, binder, or assembler[100] rather than a knotter of carpets. The same word, *kāṣiru,* also refers to a minor palace official who often organizes or assembles information, which is especially confusing when attempting to understand the craft of the *kāṣiru* because the *kāṣiru* as an official also occasionally appears in texts related to the handling of textiles and fibres.[101] Nevertheless, if the occurrences of the word are taken on a case-by-case basis, the craft of the *kāṣiru* as one featuring assembly, especially one related to but not creating the original woven portions of products, emerges. At Nuzi, for example, one text[102] lists an item of clothing (*nakbasu*)[103] specified as *mardatum* that is *ka-ṣí-ir-šu*. Such an item of clothing would not have been made as a knotted carpet. Instead it, as with the preceding item on the list, reconstructed as *labuštu*,[104] a wardrobe or assembly of clothing or even a cover,[105] also seemingly listed as *ka-ṣí-ir-šu*, are designated as textiles that were assembled or put together.

The wording of the object at Kār-Tikulti-Ninurta made by the *kāṣiru* shows clearly that this object was assembled from several parts. In the fourth line of the paragraph, the word *tēqītu* is used. This term refers to paint, slip, or salve,[106] being some kind of spreadable, viscous, or pastey substance that could have been used for inlay work. This suggests that the *ziqu*, an ornament in the shape of a crest of battlement,[107] and rosettes were inlaid. In the last line of the paragraph, the word *guḥaṣṣu* is used. It refers most often to a braided wire or cable made of metal, usually gold, or possibly of thread, even gold thread that held different pieces of a composite object together.[108] While it is unclear what this decoration was made of, the term usually refers to metal and the word that follows it, *ṣirpani* (*ṣirpu*), can mean strands of red-coloured wool, spots, or potentially even metal that might look like strands of red-coloured wool.[109]

The problem in the *kāṣiru* paragraph lies with the parts of the object described in the second and third lines. This section is very fragmentary, but some sort of figural decoration is mentioned

ša-x-x [/ ù ú-ma-am-tu tu-ra-ha ù x – [/ te-qi-a-tu-šu zi-qu ia-ú-r[u / gu-ha-ṣu-šu ša ṣir-pa-ni eš-r[u

[96] see Barrelet 1977, 58–60 who builds on von Soden's 1963, 458, definition of knüpfer (knotter); Mayer 1977, 179, 184–185; Dalley 1991, 118.

[97] Some such as Dalley 1991, 118 even take the word *mardatum* to be generally any kind of decorated covering.

[98] Mayer 1977.

[99] A point also made by Lassen 2010, 278–279, an article that became available to this author only after the present article was written.

[100] Oppenheim (ed.) 1971, 257–262.

[101] Oppenheim (ed.) 1971, 264–265; *e.g.,* Lacheman 1955, no. 220 line 10; Mayer 1977, 179.

[102] Lacheman 1950, no. 550 lines 10–13: *[x x] na-ak-ba-zu / mar-ta-te / ša ka-ṣí-ir-šu.*

[103] Reiner (ed.) 1980, 181.

[104] Lacheman 1950, no. 550 lines 8–9; *[lu-bu-ul-t[ù ša / [ka-ṣí-i]r-šu.*

[105] Oppenheim (ed.) 1973, 232–238.

[106] Reiner (ed.) 2006, 347–348.

[107] Oppenheim (ed.) 1961, 128–129.

[108] Oppenheim (ed.) 1956, 123–124.

[109] Oppenheim and Reiner (eds) 1962, 208–209.

that consists of a pomegranate tree on or in something, female mountain goats, and something else that is now broken off the tablet.[110] The *kāṣiru* does appear in contexts similar to weavers and it is possible that they worked with textiles in some fashion. Given that this paragraph immediately precedes that about the *mardatum*, possibly it describes a composite object seen near or in relationship to the *mardatum*. The product of the *kāṣiru* might not have involved weaving cloth, but instead the assembly of a framework for textiles, with paste or paintwork, inlays, and wiring to form a composite whole. It is unclear from the surviving text whether the section depicting the pomegranate tree and female mountain goats was made of fabric or of another material. It is possible that they were shown as part of a painted or inlaid section of the object.

Sectional tapestry, possibly set within larger composite frames, recall wall decorations at Mari, which predate the Kār-Tikulti-Ninurta text by more than half a millennium. Traces of a wooden framework, which measured 1.7m³ by 1.58m, were found in the soil on the floor of Room 46 at Mari.[111] The wooden framework was found face down on the floor of the room. Whether it was affixed to a wall or was a moveable form of wall hanging is unknown. Hollowed out sections and red paste preserved the details of figural designs and the edges were inlaid with rosettes and crescent-shaped pieces of white shell. While the panels that filled the framework had decayed, William Stevenson Smith suggested that they were filled with tapestry-woven sections.[112]

Possibly the inventory from Kār-Tikulti-Ninurta describes just such a framework that the assembler, binder, and tier, namely the *kāṣiru*, would have made. Such a wooden framework matches the kinds of composite and ornate furniture being inventoried overall in the Assyrian text. Related to this framework but made by the weaver were the sections of tapestry (*mardatum*) with figural scenes surrounded by multicoloured trim (*birmu*) that would have been set into the framework individually or possibly even sewn together and set into a framework. The end product would have hung on a wall in relationship to the throne described earlier on in the Assyrian tablet.

The better known wall decoration from Mari, which measures 1.75m × 2.5m in size, shows a scene of investiture set within a larger figural design. It was found on the wall of Room 106, 35cm above the level of the floor and just to the right of the entrance to the throne room.[113] It has often been connected with textiles, the white knobs at the top and bottom having been taken possibly to represent tassels.[114] These starkly white and rounded rather than fringed details might easily have been meant to recall inlay rather than the edges of a woven work. Possibly they were meant to represent shell inlays in a frame similar to that found in Room 46.

Trying to reconstruct wall hangings made of perishable materials through the potential evidence from wall paintings is difficult. Not all wall paintings necessarily stand in for other media and the media that they might replicate are numerous. Designs in leather work, wood work, and textiles may be preserved, but if they are, it is difficult to discern which parts of a painting stand in for which materials. Inspection of the surface of the Mari painting with the scene of investiture from Room 106 reveals that the different colours of paint stand out as distinct sections. For example, the robe of a goddess or the wings of an animal look almost as if they were inlay

[110] Barrelet 1977, 57.
[111] Parrot 1958, 5–7, figs 4–5, pl. III.
[112] Smith 1965, 114.
[113] Parrot 1958, 53–66, figs 46–53, pls VII–XIV, XXVII.1.
[114] See *e.g.* Moortgat 1952.

work or discrete areas of weft-beaten fabric. This feature of the surface of the painting differs from the smoother continuous surface of the later fragments[115] showing figures processing with sacrificial animals.[116] Furthermore, the subject matter of the investiture painting calls to mind the figures on *mardatum* textiles of a *lamassatum*, mentioned at Mari, and kings, mentioned at Kār-Tukulti-Ninurta. Its location to the immediate right of the entry into the throne room is also reminiscent of the uses and placement of *mardatum* textiles.

The sectional design of the investiture scene suggests that it could mimic or quote from tapestry woven rectangles of cloth set within an elaborately conceived wooden framework that set the scene for the king and the throne. Parallels between the subject matter, configuration, and form of the figures in the investiture scene and the surrounding trees, animals, and deities also find parallels among scenes and details typical of Old Babylonian and Old Syrian cylinder seals.[117] Indeed, the Old Babylonian format of the central investiture scene looks as if it has been placed into one of several registers of decoration similar to those that make up an Old Syrian design. It is tempting thus to see the register structure of Old Syrian seals as reflective of sectional tapestry design. Some motifs found in the registers of seals designs, such as the guilloche,[118] could be shorthand for the borders associated with larger textile designs or even a general reference to a larger scale figural textile.

Overlaps between words for woven and impressed designs offer some support for the crossovers between the miniature art of seal carving and the larger scale art of textile weaving.[119] For example the term *barāmu* as a verb can mean to seal or to engrave but also to be multicoloured or variegated or to colour or twine in several colours (*burrumu*).[120] The term *birmu* refers to trim woven of several colours but also, more rarely, a seal impression.[121] Just as different seal subjects and compositions could signify different social groups, certain types of trim by the Neo-Assyrian period appear to have been characteristic of different kinds of people or deities.[122]

From the earliest use of the term in the 19th century BC through its use in the 13th century, *mardatum* seems to have taken on, shed, and altered aspects of its meaning in different areas where they were used. It is at Nuzi that the *mardatum* appears to have its greatest range of meaning, being an expansion on the untailored cloth used for various coverings and hangings at Mari. Even at Nuzi, however, none of the *mardatum* products appear to have been cut to fit a shape and there is nothing to suggest that they were anything but rectangles and bands of woven fabric.

Possibly the Yamhad- or Byblos-types of textiles at Mari were known to be specific types of

[115] See Gates 1984, 78 for how these fragments, found on the floor of Room 106, were once painted over the scene of investiture.

[116] Parrot 1958, 19–52.

[117] See *e.g.* for details of the scenes as mentioned in Amiet 1960, 229–230; Collon 2000, 290–291, fig. 14; Winter 2000b, 752.

[118] Beyer 2001, 413–417 presents a wide array of guilloche bands on seals from Emar without suggesting what purpose they might serve on the seals. Collon 1975, 193–194 follows Seyrig's suggestion that the guilloche design represents water (1960, 240), both in seals and in larger representational art. In the context of Neo-Assyrian art, see Winter 2002, also considers the guilloche to be water, symbolic of fertility and abundance.

[119] See Winter 2000a for a similar relationship between Neo-Assyrian cylinder seals and the monumental art of palace wall reliefs.

[120] Oppenheim (ed.) 1965, 101–103.

[121] Oppenheim (ed.) 1965, 257–258.

[122] Dalley 1991, 125. Another term for trim, *sissiktu* (Reiner and Biggs (eds) 1984, 322–325), is used to reference the hem of a garment that could be substituted for a seal in a legal transaction, Renger 1977, 77.

clothing that included *mardatum* details or that were cut out of *mardatum* textiles. Among the 14th century BC Akkadian texts written on clay found at Amarna there are garments listed as city shirts, Tukris-style, and Hazor-style and there are numerous textiles with multi-coloured trim (*birmu*). The Assyrian king sends colourful garments, shoes, and blankets to the Egyptian pharaoh, whereas the pharaoh sends plain linen, the quality of which is differentiated by the fineness of the weave.[123] It is possible that these lists reference tunics with tapestry-woven trim and sashes of tapestry weave similar to those made of linen that have been found in Egypt. The lists of items sent to the pharaoh, however, specify when items such as shoes and sandals are made of linen and the remaining products may be assumed to be of wool. Even so, perhaps by this time *mardatum* weaves were so closely associated with specific styles of clothing that brief descriptions of them in lists no longer needed to include the word *mardatum*.

Tapestries at Ugarit continue to have royal assocations. These are specified as linen[124] rather than woollen products. There are is no mention of *mardatum* among the cuneiform tablets found at Tell el-Amarna or Pi-Ramesses. It has been suggested, however, that the 'obscure' New Kingdom Egyptian term, *mk*, may reference tapestry-woven linen cloth.[125] As with the *mardatum*, the Egyptian word *mk* seems also to have the meaning of "to protect."[126] Importantly it is used on tags that originally were meant as labels for textiles found in the 18th Dynasty tomb of Tutankhamun. The term is also found in 19th and 20th Dynasty documents.[127] The rare linen *mk* cloth is of high (even royal) quality and refers to shawls, tunics, loincloths, a cloak, and kerchiefs woven in the *mk* technique.[128]

Tapestry cloth seems also to have been known selectively in the Aegean Late Bronze Age. Terms beginning with the initial syllabic sequence *pa-ra-ku/* in Linear B reference tapestry-woven cloth through their common root *plak*[129] and relate to Homeric and later Greek *diplaka* and *peplos*.[130] It is curious that in the first millennium BC the term *mardatum* was rarely used. Yet elaborately decorated cloth seems to have defined Near Eastern dress. Greek texts of the Classical period repeatedly associate elaborately decorated cloth with the Near East.[131] The clothing of the Persians in the play of the same name is described as διπλάκεσσιν[132] from *diplaka*, a Homeric term for tapestry.

Just as certain types of dress during the Late Bronze Age may have no longer needed the

[123] For references to clothing in the Amarna texts, see Moran (ed.) 1992 for translations and commentaries and especially the original Akkadian in transliteration in Knudsen 1915, EA 14.III.11–13; EA 22.I.44–46, II.23–33, 36–42, III.24–28, IV.11–15; EA 25.IV.1–3, 45–50; EA 27.110–111; EA 29.182–189; EA 31.27–38; EA 34.16–25; EA 41.29–38; EA 120.21; EA 265.7–15; EA 266.32; EA 369.9–14.

[124] Nougayrol 1955, 206–207, R.S. 15.135 lists *[x m]ar(?)-de₄tu⁽²⁾ kitû 2 u[r-..*, which suggests that the possible *mardatum* there was made of linen. For the range of references see Ribichini and Xella 1985, 50–51 who note that the *mardatum* at Ugarit (Ugaritic *mrdt*) was made of linen and support its interpretation as a cover or hanging rather than a rug or similar item placed on the floor. Also see Van Soldt 1990, 329.

[125] Janssen and Janssen 2000; Kemp and Vogelsang-Eastwood 2001, 449.

[126] Janssen and Janssen 2000, 178.

[127] Janssen and Janssen 2000. In addition to the reasons cited in their article, the potential equation between *mk* and Akkadian *miku* (2000, 181) is problematic given the clear meaning of *mardatum* as tapestry-woven cloth.

[128] Janssen and Janssen 2000, esp. 179, 181.

[129] Smith 2012.

[130] Barber 1975, 314.

[131] Childs in press, chapter 7.

[132] Aeschylus, *Persians*, 277.

descriptor of *mardatum* to describe their elaborately decorated form, the term may also have become superfluous in describing the abundant and elaborate wall and furniture covers used during the Assyrian and Persian periods. Perhaps the increasing range in the purpose of *mardatum* textiles and their consequent non-exclusivity for royal personages led to an eventual cessation of the use of the term *mardatum* to refer to tapestry cloth.

Tapestry woven clothing and other tapestry woven objects in Egypt

The best sources of physical evidence for tapestry-woven cloth are to be found in 18th Dynasty tomb contexts at Thebes. These preserve all the surviving weft-faced tapestry woven products for the period under study. Bone beaters also suggest where and when tapestries were made in Egypt. If the pictorial evidence for the vertical loom is taken as evidence for continued tapestry production in Egypt, then production continued at least into the 19th Dynasty. If the term *mk* does reference tapestry-woven linen cloth then the use, if not also the production, of such cloth continued into the 20th Dynasty.

Publications of the tapestries found in Egypt so far show that slit, dovetail, eccentric (bent), and open work techniques[133] were used to delineate neighbouring fields of colour on decorated bag tunics, fringed cloth (hangings?), a blanket, sashes (including an Amarna-type sash), a quiver, gloves, gauntlets, arm guards, and other textiles of uncertain purpose.[134] These objects were woven with coloured linen threads rather than wool.[135] The bending of fibres when weaving in the wefts so as to achieve more rounded shapes, as in the weaving of hieroglyphic characters, compares with later Coptic 'eccentric' weft techniques.[136] While earlier examples of tapestry in Egypt show that there was some experimentation with the technique, later examples in Tutankhamun's tomb show that slit tapestry became the norm.[137]

The earliest of the preserved tapestries bears the ka-name of Thutmosis III.[138] It may date to his reign in the early 15th century BC. It certainly dates at least to the time of his grandson, Thutmosis IV, in whose tomb it was found. It may have been a family heirloom along with a tapestry bearing several lotus flowers and a cartouche elaborated with vultures of Amenhotep II. The three fragmentary tapestry woven cloths bearing hieroglyphs are all thought to be parts of clothing,[139] but not enough survives for a positive functional identification.

Examples from the tomb of the architect, Kha, from the early 14th century BC,[140] who worked during the reigns of Amenhotep II, Thutmosis IV, and Amenhotep III, add to the examples from this period and demonstrate that tapestry was available not only to those within the royal family. Whether these tapestries had been given to Kha and his wife, Merit, as gifts is unknown. They are not items of clothing and may instead have been wall or furniture coverings. Their design consists of tapestry-woven lotus flowers rather than hieroglyphic characters or emblems of power

[133] Vogelsang-Eastwood 2000, 275.
[134] Vogelsang-Eastwood 1993, 74–75, 138, 141–142; 1999, 24, 43, 57–59, 61, 88; 2000, 275.
[135] Thomson 1904, 143; Vogelsang-Eastwood 1993, 74.
[136] Thomson 1904, 143.
[137] Barber 1982, 445.
[138] Thomson 1904.
[139] Thomson 1904.
[140] Schiaparelli 1927, 129–130; Donadoni Roveri 1987, 213.

such as the falcon. Elizabeth Barber observed that a simpler approach was taken to the weave in these tapestries as opposed to those from royal contexts.[141]

The greatest variety and quantity of tapestries come from the tomb of Tutankhamun toward the end of the 14th century BC.[142] Their woven designs feature hieroglyphic inscriptions, geometric patterns, lotus flowers, and a falcon.[143] Among these tapestries was one blanket. The remainder all appear to have been pieces of clothing. The tapestry-woven gloves and gauntlets in his tomb are not typical of Egyptian attire; at least these tapestry-woven products are thought to have been imported.[144] Unlike most objects featuring tapestry weave, they were tailored by cutting away many parts of the fabric and sewing pieces together.[145] Used for horse and chariot riding, it is thought that these may have come as gifts from a ruler of Mitanni or Assyria. However, as noted above, the cutting away of parts of tapestry woven cloth does not seem to be a feature of Syrian or northern Mesopotamian tapestry products.

The only other semi-tailored garments incorporating tapestry weave from Tutankhamun's tomb are two bag tunics. The bag tunic was created by folding the fabric in half, sewing up the sides while leaving room for arm holes, and cutting a slit or a larger hole for the neck.[146] The bag tunic, one of only two items of clothing for which the Egyptian term, *mss*, is of relative certainty[147] came in long and short forms and was a new form of attire that was worn by people of all classes in the New Kingdom. The size and degree of decoration of a bag tunic differentiated the status of the people who wore them.[148] Tutankhamun's falcon tunic is particularly well designed because the weaving of the falcon around the neckline allowed the head of the king to resemble the god, Horus.[149]

In Gillian Vogelsang-Eastwood's study of the textiles from Tutankhamun's tomb, she notes one other example of a decorated bag tunic[150] that is of interest in connection with the way in which clothing and weaving technologies were exchanged. The warp-faced weave and embroidery technique used, the parallels between the figural design of the embroidery and seal carvings in Syria, and the method of folding the cloth, from the side rather than over the top, differ from standard Egyptian approaches to this specifically Egyptian garment. It is one of only a few examples of embroidery from pharaonic Egypt.[151] This tunic adds to the items that might have been received as part of gift exchange with Mitannian culture areas.[152]

Many of the tapestries in Egypt feature tapestry woven designs within a larger plain ground. Bands of tapestry woven motifs and elaborate closely set all-over designs also exist. Other than the fine falcon on Tutankhamun's tunic, the most elaborate figural design features captives and bows. This fragmentary tapestry was found in the Valley of the Kings.[153] It can not be associated

[141] Barber 1994, 264.
[142] Vogelsang-Eastwood 1999.
[143] Vogelsang-Eastwood 1993, 74; Vogelsang-Eastwood 1999, 24, 43, 57–59, 61.
[144] Vogelsang-Eastwood 1999, 88–89.
[145] Vogelsang-Eastwood 1999, 24.
[146] Vogelsang-Eastwood 1993, 134–138.
[147] Janssen 1975, 259–264; Kemp and Vogelsang-Eastwood 2001, 442–449.
[148] Vogelsang-Eastwood 1993, 7, 130–154.
[149] Vogelsang-Eastwood 1999, 58.
[150] Crowfoot and Davies 1941; Vogelsang-Eastwood 1999, 80.
[151] Barber 1982, 444; Vogelsang-Eastwood 2000, 280.
[152] Vogelsang-Eastwood 1999, 80.
[153] Daressy 1902, 302.

with the tomb of a specific individual,[154] but it appears to date to the 18th Dynasty. It combines rows of geometric patterns on the lower edge with larger fields containing the figures. The vertical inscription cited in the original publication appears to orient the piece, which then shows each captive lying face down above a bow. The red, black, and white colours of this tapestry were enhanced with the addition of blue and green paint.[155]

The preserved section is nearly half a meter on each side, 53 cm in preserved width and 47 cm in preserved height.[156] It comes from what appears to be the lower left corner of a larger tapestry with a fragmentary inscription between sections featuring captives and bows. The preserved section shows that the captives were arranged in at least three registers. To the left, parts of three bows and two captives are preserved. To the right are parts of two bows and two captives. If the full tapestry featured only the traditional nine bows and captives with comparable geometric rows at the top, it may have had three registers with three captives and three bows each. Such a complete tapestry would have measured not more than 80 cm in height and a bit more than a meter in width. It would have been an appropriate throw cover for a throne or a stool. Its use as a furniture cover for a stool would have been in keeping with the traditional depiction of the pharaoh trodding on the enemies of Egypt. It is possible, of course, that the nine captives and bows formed part of the edging for an even larger tapestry woven scene.

Following the 18th Dynasty, although the vertical loom appears in one tomb painting, there are no surviving examples of weft-faced tapestry until later periods in Egypt. One example of warp-faced weave survives in a long woven patterned linen band that formed part of a tunic of Ramses III of the 20th Dynasty. Often described as a girdle, it was a band that would have been attached to a tunic, much in the way that warp-faced bands formed part of the tunic of Tutankhamun described above.[157] Possibly tapestry products in general became less common following the 18th Dynasty as did so many other artistic experiments and innovations of that period that went out of fashion. It is interesting that the facial renderings of Ramses III, unlike his Ramesside predecessors, looked to the art of the Amarna period and earlier 18th Dynasty pharaohs.[158] Perhaps he also looked to some of the clothing innovations of that time. When tapestry re-emerged in Egypt, it was normally in the form of woollen products, some of which did not originate in Egypt.[159]

Tapestry weaving in the eastern Mediterranean from the Bronze Age into the Iron Age

For much of the eastern Mediterranean, only the find spots of bone beaters begin to suggest where tapestries may have been made. The contexts of these tools suggest who made these products and for whom. Parallels with other contemporary arts even point to their probable designs. While there are several sites in the Levant and Cyprus that preserve evidence for the

[154] Daressy 1902, 299.

[155] Daressy 1902, 302–303; Barber 1994, 264.

[156] Daressy 1902, 302.

[157] Peet 1933; Vogelsang-Eastwood 2000, 276. For further examples of warp-faced weaves or at least weaves that have a much higher warp thread count in proportion to weft threads, see examples from Tell el-Amarna in Kemp and Vogelsang-Eastwood 2001, 106–109. They comment that higher warp counts are far more common than higher weft counts.

[158] Freed 1999, 196. The preservation of cloth in the tombs of the Ramesside kings is generally poor, which impedes study of this interesting question of who in the 19th and 20th Dynasties did or did not adopt the colourful tapestry clothing that is featured in 18th dynasty wardrobes.

[159] *e.g.*, Sassanian period riding costume, see Fluck and Eastwood (eds) 2004.

use of bone beaters and other weaving tools, well preserved contexts from the 13th through the 11th centuries BC at Kition on Cyprus demonstrate clearly that tapestry weaving came to be the product of specialized weavers working in a large workshop possibly for a central authority as well as weavers who worked in a household context, also possibly for a central authority.

Families of specialized weavers who worked in the tapestry technique are known at Alalakh.[160] Household production for temple or palace authorities was the norm in Egypt. There may also have been workshops located outside the home, but the evidence for temple 'factories' for textile production in Egypt is unclear.[161] The association of bone beaters with household contexts in Egypt suggests that at lest some weft- or warp-faced textiles were made there.[162] The household context of production at Kition may have been similar to the contexts of production at Alalakh and in Egypt. The larger non-household workshop at Kition places the manufacture of dyed cloth and tapestry in particular for the first time in a definably non-household context.

On Cyprus, it is possible that several different kinds of looms were in use. However, in the absence of the wooden looms, the surviving evidence points entirely toward the use of the warp-weighted loom. The tool kit of spindle with whorl and loom with loom weights was in use by the Early and Middle Bronze Ages for working with linen and woollen fibres.[163] When animal husbandry turned increasingly toward populations kept for secondary products, especially wool, at the turn from the Middle to the Late Bronze Age,[164] a larger number of whorls and weights began to appear at Late Bronze Age sites on Cyprus, especially from the 13th to 11th centuries BC. At that time there was also an increasingly diversified and flexible tool kit, including significantly lighter loom weights as well as new tools, particularly the bone beaters and weights for making braided bands and cords.[165]

The largest quantity of bone beaters on Cyprus come from the extensively excavated Late Bronze Age settlement at Enkomi. The current pattern of discovery suggests that bone beaters were more common in the eastern part of Cyprus and, hence, possibly more strongly tied to the technology of tapestry weaving from the ancient Near East. However, small numbers of such tools come from several sites toward the south and west, with the third largest number from any site having been found in discard and tomb contexts at Palaepaphos (Kouklia).[166] The best preserved evidence for their use in weaving contexts was uncovered in Vassos Karageorghis's excavations at Kition.[167] Along with its neighbour, Hala Sultan Tekke, the settlement at Kition has produced

[160] Wiseman 1953, 79; Dietrich and Loretz 1966, 192.

[161] For detailed commentaries about the production of textiles in Egypt see Kemp and Vogelsang-Eastwood 2001, 427–476.

[162] Kemp and Vogelsang-Eastwood 2001, 452–476.

[163] See Smith and Tzachili 2012 for a detailed discussion of textile production on Cyprus and in Crete from the Bronze Age into the Iron Age, including textile fragments and the best preserved contexts of textile production on Cyprus.

[164] Spigelman 2008.

[165] *e.g.*, see Barber 1997 for the identification of cylindrical weights for band and cord weaving.

[166] See Smith 2001, 85 for a summary of bone beaters and the relevant published examples. Note that the questionable example cited there from Toumba tou Skourou is no longer considered to be an example of such a tool. I thank David Reese for his comments about this item. There is some evidence for such tools in Late Cypriot I contexts in a funerary context at Ayia Irini-*Palaeokastro*, see Pecorella 1977, 189, no. 176, fig. 487, but the examples are significantly smaller. They were crafted from less sturdy sheep or goat ribs rather than the ribs of cattle. All examples of beaters crafted out of the ribs of cattle date not earlier than the last centuries of the Bronze Age.

[167] On the tools see Karageorghis 1985, 9, 12, 24, 26, 59, 104, 109, 118, 128, 142, 144, 148, 151, 156, 160, 201, 209; on their contexts see Demas 1985, 32–33, 77–81, 112–115, 132–135, 153–157; Karageorghis 1985, 91, 94–95, 107–109, 123–127,

some of the most detailed material evidence for textile working from the Late Bronze Age eastern Mediterranean. Although contextual associations among beaters, loom weights, and other weaving tools at Hala Sultan Tekke are not as well preserved as at Kition, Hala Sultan Tekke has preserved better evidence for crushed murex[168] and the production and use of purple dye. For example, in a 12th century BC man's burial from Hala Sultan Tekke, there is evidence that he was wrapped in a purple woollen shroud that left traces of its colour in the soil.[169]

Excavations in Area I, Kition-*Chrysopolitissa*, revealed a household area with impermanent facilities for making textiles. Looms were set up when needed in courtyards. Through successive floor levels surrounding rooms had evidence for multiple activities and groups of weights were stored inside when they were not in use.[170] One floor preserved weights still in a row as fallen from a loom.[171] They average 67g each and represent a cloth of about 175cm in width.[172] Loom weights, whorls, grinders, a bronze pin, cord weights, and bone beaters were used here, suggesting that the textiles made were elaborate in decoration, perhaps in partial service for a central authority at Kition. The consistency with which part of the house remained unchanged even as rooms and courtyards were reconfigured to adapt to changing activities of the household suggest that this was the residence of a single family group over more than three hundred years.[173] Furthermore the seals found there demonstrate that later seal owners had strong ties to earlier seal owners in the same household.[174]

Area II, Kition-*Kathari*, was a large-scale, non-household-based work area.[175] The textile workshop had a horizontal area of at least 225m².[176] Not only were groups or sets of weights found clustered together, but a row of weights were uncovered in a room in a conceivably permanent location where light from the outside would have illuminated the weaving work.[177] That cloth was at least 80cm in width. Permanent installations, particularly vats for fulling, washing, and dyeing, were found along with the entire panoply of tools, including both bone beaters and cord weights, for making heavy, medium, and lightweight fabrics, decorated and undecorated. The workshop installations increased in number and size during the about three centuries of use. Textiles made here were patterned and manufactured in large numbers on a large scale.

This workshop formed part of a larger complex of buildings. To the north was a metal melting workshop. A building published as Temple 2, in connection with the ashlar-built and partly open areas of buildings published as Temenos B and Temple 1, served as a collection point for

145–151, 158–162, 178–183, 197–198, 202–203, 225–228, 235; Smith 2002; 2009, 34–41.

[168] Reese 1985, 348.

[169] Niklasson 1983, 169–213.

[170] Smith 2002, 299, fig. 7.

[171] Smith 2002, 301–2, fig. 12.

[172] I took the dimensions, including the weights of all the loom weights at Kition, during a study of this material. Those measurements form part of the Tools and Textiles database of the Danish National Research Foundation's Centre for Textile Research (CTR) and will appear in a publication based on the Tools and Textiles project. See Mårtensson *et al.* 2009, 388 for strong evidence that the total width of loom weights placed next to one another on a loom is identical or nearly identical with the width of the textile woven.

[173] Smith 2009, 71–74.

[174] Smith 2009, 71, 74–75.

[175] Smith 2002, 297–304, figs 8, 9, 13.

[176] Smith 2009, 34–41.

[177] Smith 2002, figs 11, 13.

scrap metal and materials, such as beads, for textile decoration.[178] Although textual evidence is limited, the find locations of marked objects and seals strongly supports the interpretation of this workshop as part of some form of administered and centralized textile production. The location of the buildings at the harbour of Kition suggests that some products were made for export. The comparative lack of administrative evidence from the two small temples nested among these workshop areas weakens an argument for administration by a temple authority. Nevertheless, the evidence for the shared use of animal products in the workshops and the temples suggests that all activities in this area were mutually dependent.[179]

As one moves from east to west on Cyprus there is an overlap between the use of bone beaters for tapestry work and an increased quantity of evidence for the use of cylindrical clay weights for braiding decorated bands and cords. This technology finds parallels in the southern Levant, but this kind of band-making technology stems from the Aegean.[180] In the far west of Cyprus at Maa-*Palaeokastro* there are no bone beaters and most evidence for weaving comes in the form of the cylindrical clay weights. Cypriot tapestry and cord-making both point to a technology that centred on geometric and figural designs arranged in horizontal bands.[181]

Bands that could be applied to larger cloths were known early in the second millennium of Mesopotamia.[182] Bands and trim form parts of several textiles mentioned in the Amarna letters and it seems that bands first came to form part of Egyptian clothing in the New Kingdom.[183] In the Iron Age, bands were characteristic of garments in the Near East and eastern Mediterranean, including those seen in Neo-Assyrian reliefs.[184] At least some bands and other trimmings were made to be removable[185] so that the washing of garments would not cause the colourful decoration to be stretched or to run. Gold and other metal ornamentation was also often attached so that it could be removed during the cleaning of a cloth.[186] Some cloth at Nuzi included *mardatum* sections, possibly bands of decoration, which could be attached with fasteners; presumably they could be added and removed as needed.

Bands of tapestry, potentially removable, would have made the wearing of tapestry woven designs more accessible. By the end of the Late Bronze Age, tapestry making centred on the eastern Mediterranean and on banded designs for clothing. Tapestry intended for clothing contrasts with the kind of colourful tapestry in Near Eastern royal contexts that was not meant to be worn. Removable bands of tapestry contrast with the ceremonial and perhaps infrequently or never worn tapestry-woven garments with permanently affixed tapestry decoration in royal contexts in Egypt.

[178] Smith 2009, 51–57, 66–68.

[179] Smith 2009, 103.

[180] Barber 1997; Burke 2010, 58 cites examples from the Middle through the Late Bronze Age on the Aegean islands and mainland Greece, but they also come from Early Bronze Age contexts as at Myrtos, see Warren 1972, and later contexts on Crete (*e.g.* Andreadaki-Vlasaki and Papadopoulou 2005); compare the function of similarly shaped tools in later Italian contexts thought to be connected with making bands in card weaving, Gleba 2007.

[181] Smith 2007, 359–361.

[182] Dalley 1980, 72–73.

[183] Vogelsang-Eastwood 1999, 29.

[184] Barrelet 1977 reinterprets the evidence put forth by Canby in 1971 and suggests that the decorative bands on Neo-Assyrian clothing were tapestry woven. Interestingly these garments are worn not just by royalty.

[185] Dalley 1980, 72–73 discusses the evidence that *sūnum* (trimmings) could be removed from and added to garments; Dalley 1991, 124.

[186] Oppenheim 1949, 174.

Garments made entirely or partly of tapestry-woven cloth were already known in the Near East at Nuzi; not specified as royal, this is the first sign of tapestry-woven cloth for a wider clientele.

Bands of figural decoration on the clothing of captives represented on faience tiles at Pi-Ramesses[187] may suggest that tapestry was worn by Syrians and other eastern Mediterranean peoples[188] who visited that palatial city toward the end of the Bronze Age. Some who wore garments with tapestry-woven designs at the end of the second millennium BC may have been royal. Others who wore it may have aspired to rule or have considered it appropriate attire when standing before their gods. By the first millennium BC, some tapestry was even destined for the garments of the gods. The Near Eastern or at least eastern Mediterranean origins of the Greek peplos woven for Athena, for example, may be found not only in the technique, but also in its probable banded decoration.[189]

How the technique of tapestry was passed on from weaver to weaver, over time, and across the Near East and Mediterranean varied, at least in part, with respect to the consumers of tapestry-woven products. Where Near Eastern, Egyptian, and eastern Mediterranean approaches to tapestry weaving, their designs, and their forms, came together most complexly was probably in the Levant. There the practices of weavers in Syria and the Lebanon may have been known for many generations. Egyptian preferences may also have been familiar as cities throughout the Levant came under Egyptian rule beginning in the 18th Dynasty.

The presence of small and unpierced bone beaters at sites such as the Egyptian garrison at Beth Shean[190] places them firmly in contexts where several artistic traditions are known to have come together. Not only were local Levantine arts created there, but some artists were trained in Egyptian methods as, for example, in the making of pottery.[191] The presence also of Aegean type cord or band weights[192] brings cloth production into an eastern Mediterranean sphere. Tapestry woven cloth at sites such as Beth Shean might thus have drawn on multiple traditions.

Furthermore, just as the purposes of tapestry woven products changed over time, as in Near Eastern contexts where a textile symbolic of the king came to include cloth suitable for some types of non-royal clothing, the techniques used for tapestry weaving did not always remain the same. Weavers on Cyprus, for example, did not always follow one path of production. Late Bronze Age and early Iron Age Cypriot bone beaters point to the production of banded designs using single pierced tools. These products, however, may have varied from city to city depending on the degree to which tapestry and band-woven braided products were produced in tandem.

Furthermore, by the later Iron Age on Cyprus a tool more similar to that found in the Iron Age Levant came into use. For example, in the excavations in Polis, Cyprus, by the Princeton Cyprus Expedition, three bone tools were uncovered that are small, flat, and unpierced.[193] They were

[187] Hayes 1937, 24–27, 33–38 details tiles featuring the enemies of Egypt. Red skinned figures in pl. VIII, bottom, wear garments featuring a band of figural design that forms part of a tasseled cloth.

[188] Barber 1991, 355–356.

[189] Barber 1991, 359–382; 1992, 115–116.

[190] James and McGovern 1993, 198.

[191] Mazar 1997, 71; Martin 2009.

[192] James and McGovern 1993, 188.

[193] The records from these excavations are housed in the Department of Art and Archaeology at Princeton University. The three bone tools were all found in 1986 in Trench E.F2:r09, registry numbers R1339/BI6, R1351/BI7, R1352/BI8. I thank Professor William Childs for permission to cite this as yet unpublished information.

found in a well stratified deposit with Late Archaic (6th century BC)[194] Cypriot and Attic pottery. Among the many loom weights from the excavations, up to twenty examples of various shapes were found in deposits related to that with the bone beaters and in deposits containing material from the same period that might have been disturbed by later building activity in the same area.

Polis during this period was the city kingdom of Marion. In another area of excavation, but from a roughly contemporary deposit, about 1km away in Polis-*Peristeries*, were found thousands of crushed murex shells attesting to a thriving purple dye industry.[195] In the 4th century BC a fuller and a *porphureus* (purple-dye worker or murex fisherman) are mentioned in grave stelae from Marion.[196] Possibly these beaters attest to a shift in tapestry weaving on Cyprus, one that moved away from banded designs made with single beaters and into larger fields of decoration made with multiple tools. Both the Cypriot Bronze Age preference for banded designs and a possible shift later in the Iron Age to larger fields of decoration could have led to Greek approaches to tapestry design in the first millennium BC when we known that the products of Cypriot tapestry weavers were celebrated there.[197]

Conclusion

Evidence for tapestries from texts, surviving textiles, tools, and areas of manufacture demonstrate that there were several different kinds of tapestry woven products, woven for different purposes, with different materials, by different kinds of tools, in different kinds of contexts, for different kinds of consumers. They were colourful products that were highly prized. Beyond that, as one looks at the different areas that made up the complex world of the ancient Near East, Egypt, and the eastern Mediterranean, there was little direct formal similarity among the tapestries of the Bronze and early Iron Ages.

Most tapestry products were intended for royal customers or those closely associated with them. However, while it was important in northern Mesopotamia and Syria to have products that formed part of the furniture and overall space occupied by the king, in Egypt the emphasis was on products worn by the king. There is some overlap in that a tapestry may have been draped over the shoulders of a ruler in northern Mesopotamia and at least one tapestry in Egypt might have served as the cover for a stool. Nevertheless, the uses of tapestry, a form of weaving that created a solid field of colour that paralleled the impervious nature of royal power, were suited to the way in which the king himself embodied that power. In Egypt it was in the body of the king that power was held, the king and representations of the king serving as points of communication between Egyptians and the gods.[198] In Mesopotamia it was the king, but especially the literal seat of the king, the throne, which symbolized power.[199]

[194] Bone beaters of a similar shape have also been found in contexts of the same period at Tarsus in Cilicia. Goldman (ed.) 1963, 384, fig. 177, no.13.

[195] Smith 1997, 90–91.

[196] Masson 1985, 87–88.

[197] Smith forthcoming.

[198] Baines 1995; Roth 2005, 9–10. Roth also makes the important point that the word pharaoh (great house) only came into use as a way of referring to the king during the reign of Hatshepsut. The 18th Dynasty was a time of great change and innovation in the art forms of Egypt even as the essential link between the king and power remained the same. Also see Gundlach 2003 on continuities and changes in the title of the king from the 18th into the 19th Dynasty.

[199] The importance of the image of the king seated on the throne and the association between enthronement and

Outside of the centres of kingly power, tapestry woven cloth became increasingly more available during the period under study. For the first time at Nuzi it is clear that only some tapestries are of royal quality. For whom tapestries were woven in the Levant is unclear, but it may have been for people who controlled resources more locally since tapestry cloth does not seem to have been as prominent in Egypt after the 18th Dynasty. In Cyprus certainly the production of tapestries was at most in the context only of an emerging bureaucratic state rather than a fully developed centralized government as found in much of the Near East and in Egypt.

It may be that the Egyptians learned their craft of tapestry from Syrian weavers who came to Egypt as captives during the reign of Thutmose III. However, while easily dyed woollen fibres were most likely used to make the *mardatum* textiles of Yamhad, Byblos, Alalakh, and Nuzi, in Egypt the weavers chose coloured linen threads and touch ups with paint. Furthermore, it is unclear whether the vertical loom would have been brought as a physical object into Egypt and it is even possible to question the absolute tie between that loom and tapestry weaving in the period under study. Possibly the Syrians and Egyptians built new vertical looms Egypt. Egyptian weavers may have adapted those looms slightly to suit their particular need to create curved hieroglyphic characters. Or they used a different loom technology altogether. Certainly the technology became intertwined with weaving on the more flexible warp-weighted loom and even with contexts of band weaving or braiding in the Levant and Cyprus.

Direct person to person teaching, observation of the weaving technique without direct verbal communication with a tapestry weaver, and adaptation of the observed processes and equipment all could have led to the development of area and client specific techniques. A further way in which ideas might have been transferred was through the analysis of tapestry-woven cloth. For example, Egyptian weavers might have examined cloth brought into Egypt and adapted what they saw to their own weaving with linen fibres, leading to both weft- and warp-faced products. The concept of full fields of colour might thus have been introduced into pre-existing approaches to weaving, leading to sections of tapestry weave in a larger plain field. Descriptions of the idea of tapestry without detailed knowledge of the precise technique or finished products might also have led weavers to independently invent their own approaches. A focus on bands rather than fuller field designs, different types of looms, or even differing contexts of household and larger workshop production favouring a team of weavers or a single weaver might have led to the divergent approaches and bone beating tools used.

It is also important to consider those regions where tapestries were rare and perhaps known only through imports, as in the Aegean, and those where tapestries, at least as far as we understand them today, were not used, as in Anatolia. During the Bronze Age there may have been a preference in Anatolia for solid colours[200] or textiles only with colourful edgings that were not made in the tapestry technique.[201] The emphasis in Cyprus on bands of designs seems to have made for context in which the Aegean preference for bands of cloth became intertwined with the technique of tapestry. It may thus have been through that process that other areas with warp-weighted

kingly power in Mesopotamia are well documented, see Buccellati 1964; Winter 1986.

[200] Veenhof 1972, 186 cites a text from Kanesh that stipulates that multicoloured textiles should not be purchased. That is the only use of the term, *barrumum*, multicoloured, among those texts. However in another context a cloak (*nahlaptu*) of Nuzi (Gašur) style is described as *bur-um-tú* (multicoloured), possibly a cloak with multicoloured trim.

[201] As in the clothing shown on Hittite relief vessels, *e.g.*, Özgüç 1988; Michel and Veenhof 2010, 252–253 note that there are few references to color in the texts from the Old Assyrian trading colony period..

weaving traditions, as in central Anatolia,[202] came later to adapt the art of tapestry to their own purposes. While there is much more to be learned from the texts, textiles, and tools associated with tapestry, one thing is clear; they did not form one single artistic tradition. They mirror the multiple cultures and their associated power structures that came into continual contact during the Bronze and early Iron Ages.

Abbreviations

AfO	Archiv für Orientforschung
AJA	American Journal of Archaeology
AOAT	Alter Orient und Altes Testament
ARM	Archives Royales de Mari
BASOR	Bulletin of the American Schools of Oriental Research
BibArch	Biblical Archaeologist
BibO	Bibliotheca Orientalis
BSA	Annual of the British School at Athens
BSAE	British School of Archaeology in Egypt publications
CAD	The Assyrian Dictionary of the Oriental Institute of the University of Chicago
CCEC	Cahier d'Études chypriotes
HSS	Harvard Semitic Series
JEA	The Journal of Egyptian Archaeology
JIES	Journal of Indo-European Studies
JNES	Journal of Near Eastern Studies
MRS	Mission de Ras Shamra
MVAG	Mitteilungen der vorderasiatisch-aegyptischen Gesellschaft
OJA	Oxford Journal of Archaeology
RAA	Revue des arts asiatiques
Rassyr	Revue d'assyriologie et d'archéologie orientale
SIMA	Studies in Mediterranean Archaeology
UgaritF	Ugarit Forschungen
WO	Die Welt des Orients

Bibliography

Amiet, P. 1960. Notes sur le répertoire iconographique de Mari a l'époque du Palais. *Syria* 37, 215–232.

Andersson, E., Cutler, J., Nosch, M.-L. and Smith, J. S. in press. Textile Tools from Kition, Cyprus. *In* M.-L. Nosch and E. Andersson (eds), *A Functional Typology of Textile Tools*.

Andreadaki-Vlasaki, M. and Papadopoulou, E. 2005. The habitation at Khamalevri, Rethymnon, during the 12th century BC. *In* A. L. D'Agata and J. Moody with E. Williams (eds) *Ariadne's Threads: Connections between Crete and the Greek Mainland in Late Minoan III (LM IIIA2 to LMIIIC). Proceedings of the International Workshop held at Athens, Scuola Archeologica Italiana 5-6 April 2003*, Athens, 353–97.

Baines, J. 1995. Kingship, Definition of Culture, and Legitimation. *In* D. O'Connor and D. P. Silverman (eds) *Ancient Egyptian Kingship*, Leiden, 3–47.

Barber, E. J. W. 1975. The PIE Notion of Cloth and Clothing. *JIES* 3, 294–320.

Barber, E. J. W. 1982. New Kingdom Egyptian Textiles: Embroidery vs. Weaving. *AJA* 86, 442–445.

[202] Burke 2010, 118 mentions bone tools at Gordion that might be similar to bone beaters, see Sheftel 1974, 213–218, pl. 35 for what are there described as "flat shuttles". However, no fragments of tapestry survive among the puslished fragments of cloth from that site. Bands of decoration are a feature of known Phrygian clothing, see *e.g.* Burke 2010, 158–160.

Barber, E. J. W. 1991. *Prehistoric Textiles: The Development of Cloth in the Neolithic and Bronze Ages with Special Reference to the Aegean*. Princeton.

Barber, E. J. W. 1992. The Peplos of Athena. *In* J. Neils, *Goddess and Polis: The Panathenaic Festival in Ancient Athens*, Princeton, 103–117.

Barber, E. J. W. 1994. *Women's Work: The First 20,000 Years: Women, Cloth, and Society in Early Times*. Princeton.

Barber, E. J. W. 1997. Minoan women and the challenges of weaving for home, trade, and shrine. *In* R. Laffineur and P. P. Betancourt (eds), *TEXNH: Craftsmen, Craftswomen and Craftsmanship in the Aegean Bronze Age. Proceedings of the 6th International Aegean Conference; 6e rencontre égéenne internationale, Temple University, 18–21 April 1996*, Aegaeum 16. II, Philadelphia, 515–519.

Barber, E. J. W. 1999. *The Mummies of Urümchi*. Princeton.

Barrelet, M.-T. 1977. Un inventaire de Kar-Tukulti-Ninurta: textiles décorés assyriens et autres. *RAssyr* 71, 51–92.

Bellinger, L. 1950. Textile Analysis: Early Techniques in Egypt and the Near East. *The Textile Museum, Workshop Notes 2*.

Beyer, D. 2001. *Emar IV: Les Sceaux, Mission archéologique de Meskéné-Emar, Recherches au pays d'Aštata*, Orbis Biblicus et Orientalis Series Archaeologica 20.

Breasted, H. 1906. *Ancient Records of Egypt: Historical Documents II: The Eighteenth Dynasty*, Chicago.

Buccellati, G. 1964. The Enthronement of the King and the Capital City in Texts from Ancient Mesopotamia and Syria. *In* R. D. Biggs and J. A. Brinkman (eds), *Studies Presented to A. Leo Oppenheim*, 54–64.

Burke, B. 2010. *From Minos to Midas: Ancient Cloth Production in the Aegean and Anatolia*. Ancient Textile Series, Oxford.

Campbell, T. P. 2002. *Tapestry in the Renaissance: Art and Magnificence*, New York.

Canby, J. V. 1971. Decorated Garments in Ashurnasirpal's Sculpture. *Iraq* 33, 31–53.

Cavallo, A. S. 1998. *The Unicorn Tapestries at The Metropolitan Museum of Art*. New York.

Childs, W. A. P. in press. *Greek Art and Aesthetics of the 4th C. BC*. Princeton.

Collon, D. 1975. *The Seal Impressions from Tell Atchana/Alalakh*, AOAT 27.

Collon, D. 2000. Syrian Glyptic and the Thera Wall Paintings. *In* S. Sherratt (ed.), *Proceedings of the First International Symposium, The Wall Paintings of Thera I*, Athens, 283–294.

Crowfoot, G. M. 1936–1937. Of the warp-weighted loom. *BSA* 37, 36–47.

Crowfoot, G. M. and Davies, N. de G. 1941. The Tunic of Tutankhamun. *JEA* 27, 113–130.

Dalley, S. 1980. Old Babylonian Dowries. *Iraq* 42, 53–74.

Dalley, S. 1991. Ancient Assyrian Textiles and the Origins of Carpet Design. *Iran* 29, 117–135.

Daressy, G. 1902. *Catalogue Général des Antiquities Égyptiennes du Musée du Caire nos 24001–24999, Fouilles de la Vallée des Rois, 1898–1899*, Cairo.

Demas, M. 1985. The Architecture. *In* V. Karageorghis and M. Demas (eds) *Excavations at Kition V. The Pre-Phoenician Levels Areas I and II Part I*, Nicosia.

Dietrich, M. and Loretz, O. 1966. Die Soziale Struktur von Alalah und Ugarit I. Die Berufsbezeichnungen mit der hurritischen Endung -huli. *WO* 3, 188–205.

Donadoni Roveri, A. M. 1987. Arte della tessitura, moda e arredo. *In* A. M. Donadoni Roveri, *Museo Egizio di Torino: Civilta' degli Egizi: La Vita Quotidiana*, Turin.

Dossin, G. 1939. Iamhad et Qatanum. *RAssyr* 36, 46–54.

Dunand, M. 1939. *Fouilles de Byblos I: 1926-1932*, Paris.

Durand, J.-M. 1983. *Textes Administratifs des Salles 134 et 160 du Palais de Mari*, ARM 21.

Durand, J.-M. 2009. *La Nomenclature des Habits et des Textiles dans les Textes de Mari: Matériaux pour le dictionnaire de Babylonien de Paris I*, ARM 30.

Edmunds, S., Jones, P., Nagy, G. and Marek, A. 2004. *Text and Textile: An Introduction to Wool-Working for Readers of Greek and Latin (DVD)*.

Ellis, R. S. 1976. Mesopotamian Crafts in Modern and Ancient Times: Ancient Near Eastern Weaving. *AJA* 80, 76–77.

Emery, I. 1966. *The Primary Structures of Fabrics: an Illustrated Classification*. Washington.

Fluck, C. and Vogelsang-Eastwood, G. (eds) 2004. *Riding Costume in Egypt: Origin and Appearance*, Leiden.

Freed, R. 1999. Akhenaten's Artistic Legacy. *In* R. E. Freed, Y. J. Markowitz and S. H. D'Auria (eds) *Pharaohs of the Sun: Akhenaten, Nefertiti, Tutankhamun*, Boston, 187–197.

Gates, M. H. 1984. The Palace of Zimri-Lim at Mari. *BibArch* 47, 70–87.

Giddy, L. 1999. *Kom Rabi'a: The New Kingdom and post New Kingdom Objects, The Survey of Memphis II*. Egypt Exploration Society Excavation Memoirs. London.

Gleba, M. 2007. Textile Production in Proto-historic Italy: from Specialists to Workshops. *In* C. Gillis and M.-L. Nosch (eds), *Ancient Textiles: Production, Craft, and Society*. Ancient Textile Series 1, Oxford, 71–76.

Goldman, H. 1956. *Excavations at Gözlü Kule, Tarsus, volume II. From the Neolithic through the Bronze Age*. Princeton/London.

Goldman, H. (ed.) 1963. *Excavations at Gözlü Kule, Tarsus, volume III. The Iron Age*. Princeton.

Gundlach, R. 2003. Sethos I. und Ramses II. Tradition und Entwicklungsbruch in der frühramessidischen Königsideologie. *In* R. Gundlach and U. Rössler-Köhler (eds), *Das Königtum der Ramessidenzeit: Vorassetzungen – Verwicklichung – Vermächtnis. Akten des 3. Symposiums zur ägyptischen Königsideologie in Bonn 7.-9. 6. 2001*, ÄAT 36.4, 17–53.

Hall, R. 1986. *Egyptian Textiles*. Aylesbury.

Hayes, W. C. 1937. *Glazed Tiles from a Palace of Ramesses II at Kantīr*. The Metropolitan Museum of Art Papers 3.

James, F. W. and McGovern. P. E. 1993. *The Late Bronze Egyptian Garrison at Beth Shan: A Study of Levels VII and VIII*, Philadelphia.

Janssen, J. J. 1975. *Commodity Prices from the Ramesside Period*. Leiden.

Janssen, J. J. and Janssen, R. M. 2000. *mk*. An Obscure Designation of Cloth. *Lingua Aegyptia* 7, 177–182.

Kantor, H. 1947. The Aegean and the Orient in the Second Millennium BC. *AJA* 51, 1–103.

Karageorghis, V. 1985. *Excavations at Kition V. The Pre-Phoenician Levels Part II*. Nicosia.

Kemp, B. 1989. *Ancient Egypt: Anatomy of a Civilization*, London/New York.

Kemp, B. and Vogelsang-Eastwood, G. 2001. *The Ancient Textile Industry at Amarna*, London.

Knudsen, J. R. 1915. *Die El-Amarna Tafeln*, Leipzig.

Köcher, F. 1957–1958. Ein Inventartext aus Kār-Tikulti-Ninurta. *AfO* 18, 300–313.

Lacheman, E. R. 1950. *Excavations at Nuzi V: Miscellaneous Texts from Nuzi Part II: The Palace and Temple Archives*. HSS 14.

Lacheman, E. R. 1955. *Excavations at Nuzi VI: The Administrative Archives*. HSS 15.

Lassen, A. W. 2010. Tools, Procedures and Professions: A Review of the Akkadian Textile Terminology. *In* C. Michel and M.-L. Nosch (eds), *Textile Terminology in the Ancient Near East and Mediterranean from the Third to the First Millennia BC*, Ancient Textiles Series 8, 272–289.

Lilyquist, C. 2005. Egypt and the Near East: Evidence of Contact in the Material Record. *In* C. H. Roehrig (ed.) *Hatschepsut: From Queen to Pharaoh*, New York, 60–67.

Lutz, H. F. 1923. *Textiles and Costumes among the Peoples of the Ancient Near East*, New York.

MacAlister, R. A. S. 1912. *The Excavation of Gezer 1902-1905 and 1907-1909, vol. II*. London.

Mårtensson, L., Nosch, M.-L. and Andersson Strand, E. 2009. Shape of Things: Understanding a Loom Weight. *OJA* 28, 373–398.

Martin, M. A. S. 2009. The Egyptian Assemblage. *In* N. Panitz-Cohen and A. Mazar (eds) *Excavations at Tel Beth-Shean 1989-1996, Volume III: The 13th–11th Centuries BCE (Areas S and N)*, Jerusalem, 434–477.

Masson, O. 1985. Eléments de la vie quotidienne dans l'épigraphie chypriote. *In Chypre: La vie quotidienne de l'antiquité à nos jours, Actes de Colloque, Musée de l'Homme*, 87–89.

Mayer, W. 1977. Mardatu (Teppich). *UgaritF* 9, 173–189.

Mazar, A. 1997. Four Thousand Years of History at Tel Beth-Shean: An Account of the Renewed Excavations. *BibArch* 60, 62–76.

Michel, C. and Veenhof, K. R. 2010. The Textiles Traded by the Assyrians in Anatolia (19th–18th centuries BC). *In* C. Michel and M.-L. Nosch (eds), *Textile Terminology in the Ancient Near East and Mediterranean from the Third to the First Millennia BC*, Ancient Textiles Series 8, 210–271.

Moortgat, A. 1952. Teppich und Malerai zur Zeit Hammurapis: Bemerkungen zum grossen Wandgemälde aus Mari. *BibO* 9, 92–93.

Moran, W. L. (ed.) 1992. *The Amarna Letters*, Baltimore/London.

Müller, K. F. 1937. Das Assyrische Ritual Teil I: Texte zum Assyrischen Königsritual. *MVAG* 41.3.

Niklasson, K. 1983. A shaft-grave of the Late Cypriote III period. *In* P. Åström, E. Åström, A. Hatziantoniou, K. Niklasson, and U. Öbrink, *Hala Sultan Tekke 8: Excavations 1971-79*, SIMA 45.8, 169–213.

Nougayrol, J. 1955. *Le Palais Royale d'Ugarit III*, MRS 6.

Oppenheim, A. L. 1949. The Golden Garments of the Gods. *JNES* 8, 172–193.

Oppenheim, A. L. (ed.) 1956. *CAD* 5: G.

Oppenheim, A. L. (ed.) 1960. *CAD* 7: I and J.

Oppenheim, A. L. (ed.) 1961 CAD 21: Z.

Oppenheim, A. L. (ed.) 1965. *CAD* 2: B.

Oppenheim, A. L. (ed.) 1971. *CAD* 8: K.

Oppenheim, A. L. (ed.) 1973. *CAD* 9: L.

Oppenheim, A. L. and Reiner, E. (eds) 1962. *CAD* 16: Ṣ.

Oppenheim, A. L. and Reiner, E. (eds) 1977. *CAD* 10: M Part I.

Özgüç, T. 1988. *Inandıktepe: an Important Cult Center in the Old Hittite Period*. Türk Tarih Kurumu yayınları 43.

Parrot, A. 1958. *Mission Archéologique de Mari II: Le Palais, Peintures murales*, Paris.

Pecorella, P. E. 1977 *Le Tombe dell 'eta' del Bronzo Tardo della Necropoli a mare di Ayia Irini 'Paleokastro'*, Rome.

Peet, T. E. 1933. The so-called Ramesses Girdle. *JEA* 19, 143–149.

Petrie, F. 1928. *Gerar*. BSAE 43.

Peyronel, L. 2007. Spinning and Weaving at Tell Mardikh-Ebla (Syria): Some Observations on Spindle-Whorls and Loom-Weights from the Bronze and Iron Ages. *In* C. Gillis and M.-L. B. Nosch (eds) *Ancient Textiles: Production, Craft, and Society*, Ancient Textile Series 1, Oxford, 26–35.

Pfeiffer, R. H. and Lacheman, E. R. 1942. *Excavations at Nuzi IV: Miscellaneous Texts from Nuzi Part I*. HSS 13.

Pfister, R. 1937. Les Textiles du Tombeau de Toutankhamon. *RAA* 11, 207–218.

Phillips, B. 1994. *Tapestry*. London.

Reese, D. S. 1985. Shells, ostrich eggshells and other exotic faunal remains from Kition. *In* V. Karageorghis, *Excavations at Kition V. The Pre-Phoenician Levels: Areas I and II, Part II*, Nicosia, 340–415.

Reiner, E. (ed.) 1980. *CAD* 11: N Part 1.

Reiner, E. (ed.) 2006. *CAD* 18: T.

Reiner, E. and Biggs, R. D. (eds) 1984. *CAD* 15: S.

Renger, J. 1977. Legal Aspects of Sealing in Ancient Mesopotamia. *In* M. Gibson and R. Biggs (eds) *Seals and Sealing in the Ancient Near East*. Bibliotheca Mesopotamica 6, 75–88.

Ribichini, S. and Xella, P. 1985. *La Terminologia dei Tessili nei Testi di Ugarit*. Rome.

Riefstahl, E. 1944. *Patterned Textiles in Pharaonic Egypt*, Brooklyn.

Roth, A. M. 2005. Models of Authority: Hatshepsut's Predecessors in Power. *In* C. H. Roehrig (ed.) *Hatschepsut: From Queen to Pharaoh*, New York, 9–14.

Roth, M. T. (ed.) 2005. *CAD* 12: P.

Schaeffer, C. F.-A. 1952. *Enkomi-Alasia 1: Nouvelles Missions en Chypre 1946-1950*. Paris.

Schaeffer, C. F.-A. 1954. More Tablets from Syria and Cyprus. *Antiquity* 28, 38–39.

Schiaparelli, E. 1927. *La Tomba Intatta dell' Architetto Kha nella Necropoli di Tebe*. Turin.

Seyrig, H. 1960 Antiquités syriennes: 78. Les dieux de Hiérapolis. *Syria* 37, 233–252.

Sheftel, P. A. 1974. *The Ivory, Bone and Shell Objects from Gordion from the Campaigns of 1950 through 1973*, PhD dissertation, University of Pennsylvania.

Smith, J. S. 1997. Preliminary comments on a rural Cypro-Archaic sanctuary in Polis-Peristeries. *BASOR* 308, 77–98.

Smith, J. S. 2001. Bone weaving tools of the Late Bronze Age. *In* P. M. Fischer (ed.) *Contributions to the Archaeology and History of the Bronze and Iron Ages in the Eastern Mediterranean. Studies in Honour of Paul Åström*. Österreichisches Archäologisches Institut Sonderschriften Band 39, 83–90.

Smith, J. S. 2002. Changes in the workplace: women and textile production on Late Bronze Age Cyprus. *In* D. Bolger and N. Serwint (eds) *Engendering Aphrodite: Women and Society in Ancient Cyprus*, American Schools of Oriental Research Archaeological Reports 7; Cyprus American Archaeological Research Institute Monographs 3, 281–312.

Smith, J. S. 2007. Theme and Style in Cypriot Wooden Roller Impressions. *CCEC* 37, 339–366.

Smith, J. S. 2009. *Art and Society in Cyprus from the Bronze Age into the Iron Age*. Cambridge.

Smith, J. S. 2012. Tapestries in the Mediterranean Late Bronze Age. *In* R. Laffineur and M.-L. Nosch (eds) *KOSMOS: Jewellery, Adornment and Textiles in the Aegean Bronze Age. Copenhagen, 19-23 April 2010*, Aegaeum 33, 241–250.

Smith, J. S. and Tzachili, I. 2012. Cloth in Crete and Cyprus. *In* G. Cadogan, J. Whitley, K. Kopaka, and M. Iacovou (eds) *Parallel Lives: Ancient Island Societies in Crete and Cyprus*. British School at Athens Supplement, 141–155.

Smith, S. 1921. *Cuneiforms Texts from Cappadocian Tablets in the British Museum Part I (Plates 1-50)*, London.

Smith, W. S. 1965. *Interconnections in the Ancient Near East: A Study of the Relationships between the Arts of Egypt, the Aegean, and Western Asia*, New Haven.

Spigelman, M. 2008. Investigating the Faunal Record from Bronze Age Cyprus: Diversification and Intensification. *In* A. McCarthy (ed.) *Island Dialogues: Proceedings of the Postgraduate Cypriot Archaeology Conference (POCA), 2006*, University of Edinburgh Archaeology Occasional Papers 21, 119–129.

Thomas, A. P 1981. *Gurob: A New Kingdom Town: Introduction and Catalogue of Objects in the Petrie Collection*, Egyptology Today 5.1.

Thomson, W. G. 1904. Tapestry-woven fabrics. *In* H. Carter and P. E. Newberry, *The Tomb of Thoutmôsis IV*, 143–144.

Thureau-Dangin, F. and Dunand, M. 1936. *Til-Barsib*, Paris.

Tuck, A. 2006. Singing the Rug: Patterned Textiles and the Origins of Indo-European Metrical Poetry. *AJA* 110, 539–550.

Tufnell, O. 1953. *Lachish III (Tell ed-Duweir): The Iron Age*. London/New York/Toronto.

Urton, G. 1997. *The Social Life of Numbers: A Quechua Ontology of Numbers and Philosophy of Arithmetic*, Austin.

Van Beek, G. and Van Beek, O. 1990. The Function of the Bone Spatula. *BibArch* 53, 205–209.

Van Soldt, W. H. 1990. Fabrics and dyes at Ugarit. *UgaritF* 22, 321–357.

Veenhof, K. R. 1972. *Aspects of Old Assyrian Trade and its Terminology*, Leiden.

Vogelsang-Eastwood, G. 1993. *Pharaonic Egyptian Clothing*. Studies in Textile and Costume History 2, Leiden.

Vogelsang-Eastwood, G. 1999. *Tut'ankhamun's Wardrobe: Garments from the Tomb of Tutankhamun*, Boreas.

Vogelsang-Eastwood, G. 2000. Textiles. *In* P. T. Nicholson and I. Shaw (eds), *Ancient Egyptian Materials and Technology*, Cambridge, 268–298.

Von Soden, W. 1963–1981. *Akkadisches Handwörterbuch*, Wiesbaden.

Warren, P. M. 1972. *Myrtos: An Early Bronze Age Settlement in Crete*, British School at Athens Supplementary Volume 7.

Waetzoldt, H. 2010. The Colours and Variety of Fabrics from Mesopotamia during the Ur III Period (2050 BC). *In* C. Michel and M.-L. Nosch (eds), *Textile Terminology in the Ancient Near East and Mediterranean from the Third to the First Millennia BC*, Ancient Textiles Series 8, 201–209.

Wiseman, D. J. 1953. *The Alalakh Tablets*, Occasional Publications of the British Institute of Archaeology at Ankara 2.

Winter, I. J. 1986. The King and the Cup: Iconography of the Royal Presentation Scene on Ur III Seals. *In* M. Kelly-Buccellati (ed.) *Insight Through Images: Studies in Honor of Edith Porada*, Malibu, 253–268.

Winter, I. J. 2000a. Le Palais imaginaire: Scale and Meaning in the Iconography of Neo-Assyrian Cylinder Seals. *In* C. Uehlinger (ed.) *Images as Media: Sources for the Cultural History of the Near East and the Eastern Mediterranean (1st millennium BCE)*, Orbis Biblicus et Orientalis 175, 51–87.

Winter, I. J. 2000b. Thera Paintings and the Ancient Near East: The Private and Public Domains of Wall Decoration. *In* S. Sherratt (ed.) *Proceedings of the First International Symposium, The Wall Paintings of Thera II*, Athens, 745–762.

Winter, I. J. 2002. Ornament and the Rhetoric of Abundance in Assyria. *Eretz-Israel* 27, 252–264.

Woolley, L. 1955. *Alalakh: An Account of the Excavations at Tell Atchana in the Hatay, 1937-1949*, Reports of the Research Committee of the Society of Antiquaries of London 18, London.

11. Spinning from old Threads: The Whorls from Ugarit at the Musée d'Archéologie Nationale (Saint-Germain-en-Laye) and at the Louvre

Caroline Sauvage

Introduction

The study of the Late Bronze Age spinning and textile industry in Ugarit and in the larger northern Levant has been, up to recently, neglected and material studies have generally concentrated on other artefacts, or on typological description of a few spinning related objects such as whorls and spindles.[1] Recent years have seen a growing interest for this specific industry and several studies dealing with texts, iconography and archaeological material are now ongoing.[2] The contribution proposed here is modest and mainly relates to the technical specifications of the spindle whorls. While working on the publication of Schaeffer's collection from Ugarit preserved at the Musée d'Archéologie Nationale de Saint-Germain-en-Laye (MAN), a group of whorls came to my attention. They have no specific context, but all come from the 1929–1935 excavations at Minet el-Beida and Ugarit, and therefore likely come either from Late Bronze Age tombs or domestic context. The relatively limited corpus is constituted by 11 stone or bone objects, one of them inscribed in Ugaritic with the word "spindle".[3] While recording the whorls for publication, I began to review the literature about this object category in Ugarit, and I realized that, ironically, despite their recognized used as spindle whorls and therefore weights, they have never been weighed. Moreover, they have been classified according to shape, but not according to technical uses or properties. Therefore, I needed parallels from Ugarit, and I found them in the Louvre Museum, amongst spindle whorls, which were previously published by C. Elliott and J. Gachet.[4] In this study, I included all whorl type artefacts, knowing that a few of them could turn out to be beads, buttons or other objects.[5] I assumed that including these objects within a large group may help in the identification and actually provide a basis of comparison for the elimination of non-whorl objects, based on their alteration, weight and moment of inertia. Therefore, this paper chiefly

[1] See Elliott 1991; Gachet 2007.
[2] See the ongoing study of J. P. Vita on the "archives est" (Vita 2004; Vita 2007; Vita 2008), and the collaborative study on texts, iconography, and unpublished archaeological remains by V. Matoïan and J. P. Vita; Matoïan and Vita 2009 (2010).
[3] Sauvage and Hawley 2012.
[4] Elliott 1991; Gachet 2007.
[5] Liu 1978; Barber 1991; Crewe 1998; Mårtensson, Andersson, Nosch and Batzer 2006b.

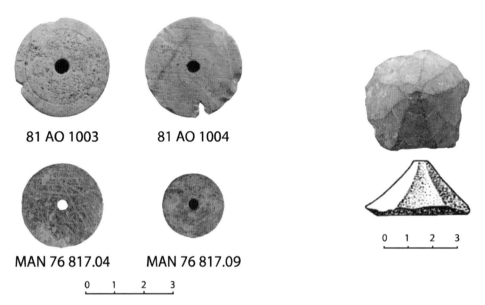

81 AO 1003 81 AO 1004

MAN 76 817.04 MAN 76 817.09

Figure 11.1. Manufacture traces on the flat face of whorls: MAN 76 817.09, MAN 76 817.04, AO 81–1004, AO 81–1003; photographs: C. Sauvage (courtesy of the Département des Antiquités Orientales – Louvre and of the Musée d'Archéologie Nationale).

Figure 11.2. Unfinished whorl, 81 AO 918, photograph: C. Sauvage (courtesy of the Département des Antiquités Orientales – Louvre) drawing after Elliott 1991, fig. 21.14 © Mission de Ras Shamra - Ougarit.

focuses on material from the MAN, but also addresses the corpuses of stone and bone and/or ivory whorls from the Louvre Museum. It reviews first the manufacture, shape and decorations of the whorls, and then discusses their function and uses on spindles and/or distaffs.

Manufacture

Manufacture traces are visible not only on most of the stone, but also on ivory objects from the Louvre and from the MAN. On both materials, manufacture traces are typically parallel and correspond to cutting and scraping of the flat surface, as exemplified on MAN 76 817.09, MAN 76 817.04, Louvre AO 81–1004, and AO 81–1003 (Fig. 11.1). One unfinished example preserved in the Louvre[6] shows that these objects were first roughly cut in a conical shape with a flat surface, this approximate shape was then refined to obtain a geometrical and often well polished object (Fig. 11.2). Circular marks on the dome part of the whorls, such as on MAN 76 817.09, as well as the few examples of circular and concentric lines on the flat part, such as on MAN 76 817.09, AO 13180, and AO 81–1003 (Figs 11.1–11.3), indicate that these objects were finished on a wheel.

On a few specimens, preparation marks for the implantation of the hole are visible on the flat part of the whorl. These marks can range from straight lines, forming an angle (84 AO 629, MAN 76780.03, MAN 76817.08), to curved lines arranged in a lozenge shape around the perforation,

[6] Louvre museum, 85 AO 753; see Elliott 1991, fig. 21.14; Caubet 2004, 177–178, object no. 217.

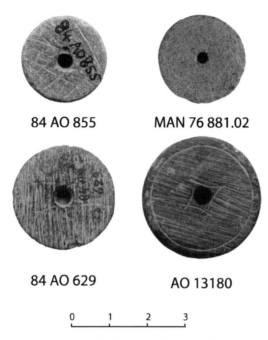

Figure 11.3. Hole implantation preparation marks on the flat face of the whorls 84 AO 629, MAN 76 881.02, AO 13180 and 84 AO 855; photograph: C. Sauvage (courtesy of the Département des Antiquités Orientales – Louvre and of the Musée d'Archéologie Nationale).

such as on AO 13180, where two of these lines are actually cut by the hole (Fig. 11.3). These lines, designed to help the implantation of the perforation, certainly allow for an easier and central perforation, which was essential for the balance of the spindle.[7] In Ugarit, the craftsmen cutting the whorls did their best to provide a central perforation, as exemplified by one specimen in the Louvre, 84 AO 855, where a preliminary, off-centre perforation was corrected with a more truly centred perforation (Fig. 11.3).

Whorl shape and size

The whorls from Ugarit range from objects that are dome shaped, to others which are conical with concave or convex sides. C. Elliott established 5 types in her publication.[8] Using her system, the most common is type 1 defined as dome-shaped, circular, with the convex face presenting a conical profile on the higher examples. Type 2 is circular, conical but with concave sides; type 3 has a high conical shape, splaying outwards towards the flat face to form a thin vertical edge; type 4 is dome-shaped, with convex sides splaying out towards flat face; and type 5 is square

[7] Barber 1991, 38; Crewe 1998, 13; Mårtensson, Andersson, Nosch and Batzer 2005–2006, 13. Contra see Ochsenschlager 1993, 54; Breniquet 2008, 117, arguing that a non-central perforation, and therefore a non-balanced spindle, does not affect the use of the object, nor the quality of the thread produced.
[8] Elliott 1991, 43–44.

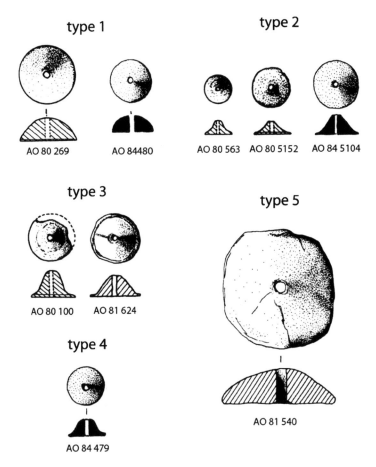

Figure 11.4. Whorl types according to Elliott; after Elliott 1991 (type 1: fig. 13.4–5, type 2: fig. 13.17–19, type 3: fig. 13.23–24, type 4: fig. 13.26, type 5: fig. 13.27) © Mission de Ras Shamra-Ougarit.

with plano-convex faces. Most types are actually variations of a conical-hemispherical shape, common in Cyprus[9] and the Near East (Fig. 11.4). In many instances, whorls from different types are similar to each other, especially for the few examples with a thin edge splaying out, and I am therefore not convinced that, in this case, the typological distinction between the whorls adds to their understanding.

Dimensions of the objects vary greatly, from 1.45cm to 6.35cm in diameter, and from 0.5cm to 3.1cm in thickness.[10] A diameter between 2cm and 3cm is most common, while thickness is generally around 1cm. Weight of the objects vary, from 1g to 173g, but most fall within a weight range of 3–20g or 3–35g (Fig. 11.5). Wide weight ranges might be considered "suspect", nevertheless

[9] Crewe 1998, type I. This type is especially common in the Late Bronze Age, for instance at Enkomi, Courtois 1984, 70–73 and 140–145, pl. 22, 42, 43; and at Kition, Karageorghis and Demas 1985, pl. XLIX, CCV.
[10] The thickness did not appear to be important for the finished produce.

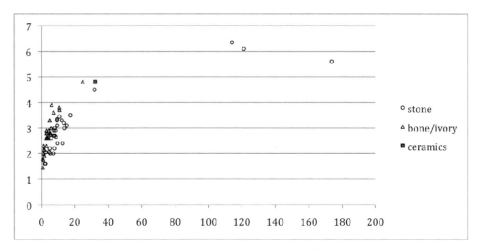

Figure 11.5a. Whorl material according to weight (x) and diameter (y).

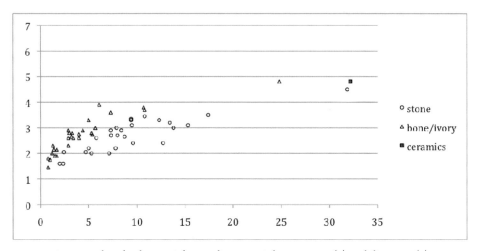

Figure 11.5b. Whorl material according to weight up to 35g (x) and diameter (y).

the unpublished inscription on one of the large whorls (MAN 76 780.03, 114.2g) validates the nature of the objects, and parallels from the Levant at tell Keisan show that a weight range comprised between 4g and 32g was common.[11]

The ratio between diameter and weight varies equally, and although differences between stone and bone/ivory artefacts appear and are clearly due to the density of the material, it is worth noting that the less dense ivory whorls permit spinning of finer thread from the same fibres.

The perforation of the objects is generally conical, as often the case on whorls,[12] with the bigger diameter on the flat surface and the smaller at the end of the dome. The tapering is small,

[11] Nodet 1980, 316.
[12] Crewe 1998, 11–13; Crewe 2002, 218.

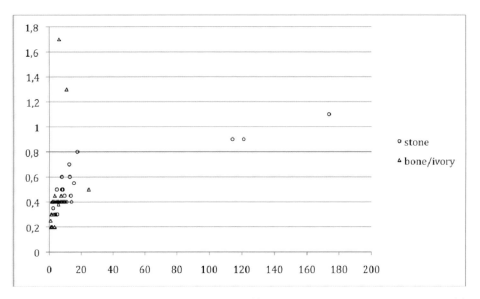

Figure 11.6a. Whorl material according to weight (x) and maximum diameter of perforation (y).

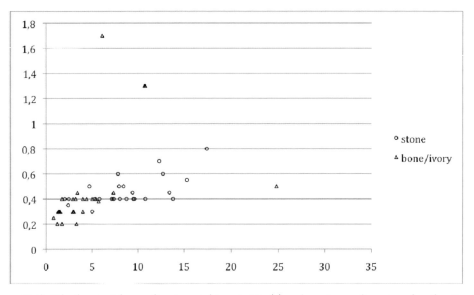

Figure 11.6b. Whorl material according to weight up to 35g (x) and maximum diameter of perforation (y).

about one millimetre in total difference between top and bottom, even on the biggest specimens. The diameter of the perforation itself varies from 0.2/0.3cm to 1.6/1.7cm, but the most common perforation size is about 0.4cm on the flat surface (Fig. 11.6).

According to Fig. 11.7, three groups of objects with different perforation size and weight can be distinguished. The first concerns light objects with a perforation ranging from 0.2cm to 0.8cm,

and with a clear cluster around 0.3–0.5cm. The variation within this group can be easily explained by the use of padding between the whorl and the spindle, to allow a firm hold of the whorl. It may also reflect use of spindles in different material, such as wood and metal, as exemplified by parallels from Enkomi,[13] and the Near East.[14]

The second group also in the lightweight range (<20g) concerns the bone/ivory whorls, with a perforation ranging from 1.3cm to 1.7cm. Our whorl sample only contained two objects with such a large perforation, but another almost complete ivory object (knob, shaft and whorl) AO 15758–RS4.4221[B], for which no weigh measurement is available, has its whorl perforated by a hole of 1.2cm.[15] This object can therefore demonstrate that the large perforation of ivory whorls was intended for their use on a larger shaft, such as here in ivory, but one might infer that similar wooden shafts existed, perhaps used with wooden whorls. Finally, a third group is visible and is characterized by a medium sized perforation (0.9–1.1cm) and an important weight (>100g). All the three whorls of this group are made of stone and could possibly have been used on a medium-large spindle, made of wood, ivory or maybe metal. The larger diameter of the shaft, when compared to the lightest whorls, would then probably have had technical merit and was certainly related to the heavy weight of the whorls, and possibly to heavy work such a plying different threads together.

Figures 11.5 and 11.6 show that whorls can be divided into four classes according to weight or dimension. All of the data clearly show one group of light and small 'whorls': under 3g and smaller than 2cm when made of stone, and smaller than 2.5cm when made of ivory.

The second group has a weight between 4g and 17g and a diameter between 2cm and 4cm for the stone examples and more than 2.5cm to 4cm when the object is made of bone/ivory. It has been argued that whorl-type objects weighing less than 10g were too light to be used as spindle whorls,[16] however, experimental spinning has conclusively demonstrated that whorls of 8g and even of 4g are suitable for spinning wool.[17] Therefore, the whorls from Ugarit falling into the 4–17g weight range may reflect wool spinning.[18] The third group is over 20g and has a diameter bigger than 4cm and, finally, the heavy group weighs over 100g and has a diameter bigger than 5cm.

The stone whorls from Ugarit were mainly made of steatite/chlorite schist, some of serpentinite, and a few from limestone.[19] The other large archaeological category is made of ivory and/or bone. So far, no locally made terracotta/ceramic whorls have been conclusively identified within the Late Bronze Age material, although one possible wheel-shaped terracotta whorl was found in the MAN collections (Fig. 11.8). MAN 76 695.02 is made of local clay, and its dimensions (ø: 4.8cm) and weight (32.12g) match the stone and ivory range (Fig. 11.7). However, its biconical shape and its uniqueness in the records are a bit suspicious, and it is therefore also possible that this terracotta was the wheel of a chariot model, relatively well attested in Ugarit.[20]

[13] See Crewe 1998, 15; Dikaios 1969, pl. 168 no. 44 and 45.

[14] For instance at Jebel Khalil, Crewe 2002, 219.

[15] Gachet 2007, cat. 137, 260.

[16] See for instance Carington Smith 1992.

[17] See for instance the experimental spindle with a whorl weighing less than 3g put on a wooden spindle weighing 1g. Mårtensson, Andersson, Nosch, Batzer 2006b, 4.

[18] As shown by experiment by the Danish Research Foundation's Center for Textile Research (whorls of 4, 8 and 18g).

[19] Elliott 1991; Chanut *forthcoming*; Sauvage *forthcoming*.

[20] For instance, tomb VI from Minet el-Beida, Schaeffer 1939, 32, 34, 90; Marchegay 1999, 756 E; Feldman and Sauvage

	Really light (beads?)	Light	Medium	Heavy
Weight	1–3g	3–17g	20–35g	100–200g
Diameter – stone	1–2cm	2–3.5cm	4.5–5cm	5–6.5cm
Diameter – ivory	1–2.5cm	2.5–4cm	-	-
Diameter – ceramic	-	-	4.5–5cm	-

Figure 11.7. Table of whorl type artefacts grouping according to weight, diameter and material.

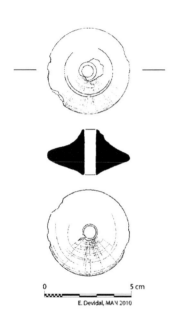

E. Devidal, MAN 2010

Figure 11.8. Terracotta wheel type whorl: MAN 76 695.02 (W. 32.12g). Drawing: E. Devidal.

Based on parallels from Near Eastern sites, such as Jebel Khalid,[21] where whorls in faïence have been found, it is possible that a few faience whorls were used at Ugarit. Two faience whorl-like objects, RS 23.540 and RS 23.539 with a central perforation, have been recently described (Fig. 11.9). Matoïan proposes a possible use as stands for ostrich egg rhyta;[22] based on a parallel with objects from Mycenae and Thera,[23] and on a possible parallel from the Uluburun shipwreck.[24] The faience objects from Ugarit are wider than most of the whorl corpus and present a diameter of about 6.7cm, and therefore are similar in their dimensions to the large stone whorls from Ugarit but also to the Uluburun glass stand. Their perforations are slightly tapered, with a perforation diameter ranging around 0.6cm and 0.75–09cm, and are also similar in size to the heavy whorls (Fig. 11.6a). Attrition marks around their hole -on their dome part- are clearly visible on the published drawing (Fig. 11.9), and suggest the insertion of a shaft. Moreover, the black, painted geometric pattern on the dome of RS 23.540 is reminiscent of spoken motifs found on whorls, without having an exact parallel.[25] Therefore, the identification of these objects as whorls is plausible, but the discussion must remain incomplete until weights are known.

As Elliott already noted,[26] the presence of unfinished objects (Fig. 11.2) attests that the stone whorls were made locally, and it is also possible to make the same statement for the ivory examples, because their shape and perforation dimensions are similar to the stone examples.

2010; Pilali-Papasteriou 1998.

[21] Crewe 2002, 217.

[22] Matoïan 2008a, 106.

[23] Foster 1979, 130–134 and 151.

[24] The Uluburun glass stand has a slightly different shape, and even if poorly preserved resembles a bun with concave sides, and a concave top surface (ø: 6.4cm). Its center is not preserved. See illustration in Pulak 2008, fig. 194b, 324.

[25] See below 'decoration'.

[26] Elliott 1991, 44.

Decoration

Few whorls are decorated, with motifs/patterns found either on the dome part of the whorls or on their flat surfaces. Decorations on the dome are more common. All three large stone examples from Ugarit, with a diameter ranging from 5cm to 6cm and a weight over 100g[27] bear decoration on their dome, in the shape of radius or spokes originating around the perforation and spaying over the dome to its edge (Fig. 11.10). One example has additional concentric circles cutting the radius/spokes. These larger examples are roughly finished compared to the smallest ones, which are often well polished. In these three examples, at least one spoke was more deeply engraved and extends to cut the edge of the whorl, forming a notch on its flat face. On AO 11658, eight spokes are deeply engraved and five notches were incised on the edge of AO 84 428.

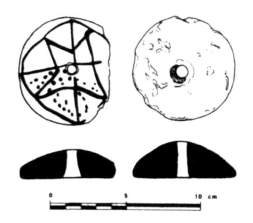

Figure 11.9. Two possible faience whorls RS 23.540 and RS 23.539; after Matoïan 2008a, 106, fig. 6 © Mission de Ras Shamra - Ougarit.

Similar 'spoke' motifs appear on ivory examples, but can be more refined (Fig. 11.11). At least two objects, RS 25.349[28] and RS 20.282[29] bear a deeper incision running from the hole to the edge, and it certainly had the same function as the stone examples. RS 20.282 (Fig. 11.11 no. 510) has a diameter of 2.75cm, a weight of 5.4g and a perforation ranging from 0.4cm to 0.3cm. The other example RS 25.349, published by Gachet is a larger (ø: 3.2cm; thickness 1.1cm; ø perf.: 0,4cm) and therefore probably slightly heavier (Fig. 11.11 no. 513). Both objects fit within the light group and have an average-size perforation.

Decoration on small stone examples (ø: 2cm to 3.5cm) is rare and consists of concentric circles on the dome, just around the outside edge or in the middle (Fig. 11.12). The decoration on 85 AO 753 is more complex and consists of two parallel circles, joined by several parallel strokes.[30] Only one example, AO 14827 bears a different type of decoration. It consisted originally of two men figures upside down, each head is facing the other's feet. But one of them was subsequently replaced by a deeply engraved cross (Fig. 11.13). An approximate parallel for this motif can be found in Cyprus, at Enkomi, with two cross motifs.[31]

Circles also appear on the flat face of the stone whorls, but are less common than decorations on the dome (Fig. 11.12). Such circular motifs on the flat surface also confirm that the whorls were finished on a wheel. Finally, it is worth mentioning that only one stone example, from the royal palace, was decorated on its flat surface with a rosette motif.[32] The unpublished inscribed spindle whorl MAN 76 780.03, which belongs to the large stone decorated examples, also bears its inscription on its flat surface.

[27] Two are about 115–120g and one is over 170g.

[28] Gachet 2007, no. 513, 316.

[29] Gachet 2007, no. 510 = AO 81 2193, 316.

[30] The decoration on ivory whorl RS 21.362 is similar but not identical, Gachet 2007, no. 511.

[31] Courtois 1984, fig. 42.12.

[32] RS 15.248; see Icart, Chanut and Matoïan 2008, pl. X.2.

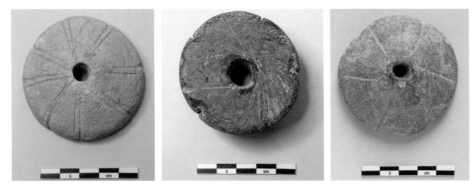

Figure 11.10. Large stone whorls decorated with spokes and characterized by notches, AO 11658, AO 84 428, MAN 76 780.03; photograph: C. Sauvage (courtesy of the Département des Antiquités Orientales - Louvre and of the Musée d'Archéologie Nationale).

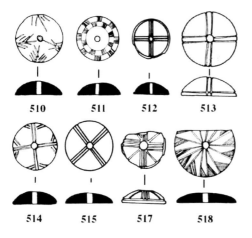

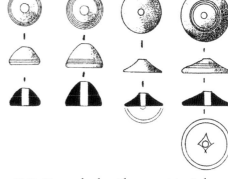

Figure 11.11. Ivory whorls with spoken motifs, after Gachet 2007, no. 510-515, 517-518 © Mission de Ras Shamra-Ougarit

Figure 11.12. Stone whorls with concentric circles on their dome and flat surface, after Elliott 1991, fig. 21, no. 4–5 and 12–13 © Mission de Ras Shamra-Ougarit

Figure 11.13. Whorl AO 14 827 (ø: 3.5-3.6cm; thickness: 0.9cm; W: 17.4g); photograph: C. Sauvage (courtesy of the Département des Antiquités Orientales - Louvre).

Figure 11.14. Small whorl from MAN 76 817.06 (ø: 2.4cm; thickness: 1.55 cm; W: 9.6g); with notch and rough area, drawing E. Devidal.

The deep incision was probably technical or functional and may have helped the thread stay on the whorl.[33] Such decoration and additional notch is only clearly visible on large stone models and lighter ivory examples. It may also appear on one small stone example from the MAN 76 817.06, but the evidence is not convincing because only the top of the dome, near the perforation, is chipped in a channel form, and the attendant side of the dome is rough compared to the surrounding well-polished areas (Fig. 11.14). Whorls with incisions or notches are known in the archaeological records in Mesopotamia at Jarmo and Sabi Abyad,[34] and in the Neolithic and Chalcolithic levels at Ras Shamra,[35] as well as in the proto-urban and early Bronze Age levels from Jericho. The notches on whorls exclude an alternative use to textile industry, and suppose that they were used on the top of the spindles.[36] The large whorl from the Louvre, AO 84 428 attests, with its five notches, the plying of five threads together.

Decorations appear mainly on the dome of the objects, the part most visible when a high-whorl spindle is in use. Their symmetrical character certainly produced a visual effect when the object was in motion and reinforced its rotation effect.

Moment of inertia (MI)

The moment of inertia is a determinant parameter for spindle whorls, essential to twist the thread. The moment of inertia is calculated with the radius and the weight of the object, and for an equal weight (greater density), a whorl with a smaller diameter will spin faster than a whorl with a bigger diameter. Thus, the bigger the moment of inertia, the slower the whorl spins, and the thicker the fibres involved. On the other hand, fine or soft/flexible fibres are spun with a whorl producing a small moment of inertia.[37] Therefore, variation in diameter and weight within a spindle whorl corpus is indicative of the spinning of different types of fibres. However, variations on the thickness of the thread spun with the same fibres are also possible through the use of different whorls and therefore of different weight range.

$$I = w \frac{R \cdot R}{2} \qquad \text{(w= weight; R = radius)[38] for dome shape/conical whorls}$$

$$I = w \frac{R \cdot R \cdot 0.75}{2} \qquad \text{(w= weight; R = radius)[39] for biconical whorls}$$

[33] Similar whorl size and decoration are found in Enkomi during the same period: no. 1506 and 1507; see Dikaios 1969, pl. 178.

[34] Breniquet 2008, 119.

[35] See Breniquet 2008, 120, fig. 27.1–3, after Bacquet 2001. In one case, two notches on the same hard limestone whorl with an off centered perforation attest plying of two times two threads; Bacquet 2001, 94; Breniquet 2008, 122. Whorl from level IV B 4; ø: 4.5cm; thickness: 0.7–0.9cm; Contenson 1992a, 110; Contenson 1992b, fig. 137.6, 146.

[36] Breniquet 2008, 119. Of course, the appearance of similar large whorls with spokes and possible notches at Enkomi (Dikaios 1969, vol. IIIa, pl. 178.1–2), raises the possibility that high whorls spindles were used in Late Bronze Age Cyprus only for plying; that a cultural change happened on the island sometimes between the Early Bronze Age, where the low whorl spindles were used (see demonstration by Crewe 1998, 8) and the Late Bronze Age, when Cyprus or at least Enkomi shows similarities with Ugarit in terms of architecture and material culture (see Yon 2007 for a good overview); or that Levantine people were living in Cyprus, as attested by texts; see Yon 2007, 17–24.

[37] Bocquet 1989, 117.

[38] Bocquet 1989, 117.

[39] Bocquet 1989, 117.

Artifact ID	Ø (cm)	H. (cm)	W. (g)	Material	Shape	MI (g/cm²)	Chips on edges: CE Chips on perforation: CP
84 AO 904–907	1.45	0.55	0.8	bone/ivory	Thin edges	0.21	–
80 AO 193	1.8	0.4	0.8	bone/ivory	C. (1)	0.32	–
81 AO 1005	1.75	0.5	1	bone/ivory	C. (-) Conical straight sides	0.38	–
84 AO 904–907	2	0.5	1.2	bone/ivory	Thin edges	0.6	–
MAN 76817.08	1.6	0.7	2	Stone	C. (1)	0.64	–
84 AO 565	1.9	0.55	1.5	bone/ivory	C. (1)	0.68	–
MAN 76817.11	1.6	0.6	2.37	Stone	C. (1)	0.76	–
81 AO 1157	1.9	0.8	1.7	bone/ivory	C. (1)	0.77	–
AO 84 264	2.15	0.5	1.4	bone/ivory	Thin edges	0.81	–
84 AO 487	2.3	0.6	1.3	bone/ivory	Thin edges	0.86	Polished area around perforation
81 AO 1155	2.15	0.5	1.7	bone/ivory	C. (1)	0.98	–
MAN 76817.09	2.05	0.6	2.44	Stone	Thin edges	1.28	CE (Really Small)
AO 27 602	2.3	0.85	2.9	bone/ivory	Thin edges	1.92	–
84 AO 563	2.3	0.7	2.9	bone/ivory	C. (1)	1.92	–
85 AO 84	2.6	0.9	2.9	bone/ivory	Thin edges	2.45	–
81 AO 921	2.05	0.9	4.7	Stone	C. (1)	2.47	CP
MAN 76817.07	2	1.2	5.3	Stone	C. (2)	2.65	CE – CP
AO 84 559	2.65	0.8	3.2	bone/ivory	Thin edges	2.81	Burnt
84 AO 938	2.6	0.8	3.4	bone/ivory	C. (1)	2.87	CE
AO 84 260	2.8	0.55	3	bone/ivory	Thin edges	2.94	–
85 AO 749	2.2	0.9	5	Stone	C. (1)	3.02	CE
84 AO 857	2.9	0.7	2.9	bone/ivory	C. (1)	3.05	–
81 AO 238	2.8	0.8	3.3	bone/ivory	C. (2)	3.23	–
81 AO 1154	2.6	0.8	4	bone/ivory	C. (1)	3.38	–
MAN 76817.05	2	1.3	7.13	Stone	C. (1)	3.56	–
84 AO 583	2.75	0.65	4	bone/ivory	C. (2)	3.78	CP ?
81 AO 1003	2.9	1	4.4	bone/ivory	C. (1)	4.62	–
84 AO 627	2.2	1.2	7.8	Stone	C. (1)	4.72	CE – CP
85 AO 747	2.6	0.9	5.8	Stone	Thin edges	4.90	CE – CP
AO 81 2193	2.75	0.8	5.4	bone/ivory	C. (1)	5.10	Deep incision/notch on dome and edge
81 AO 2194	2.8	1	5.3	bone/ivory	C. (2)	5.19	CE – CP
81 AO 1004	3	0.85	5.7	bone/ivory	C. (2)	6.41	CE
MAN 76881.02	2.7	0.8	7.33	Stone	C. (1)	6.68	CE, polished area around perforation
84 AO 567	3.3	0.6	5	bone/ivory	C. (1)	6.81	CE – CP
MAN 76817.06	2.4	1.55	9.6	Stone	C. (2)	6.91	CE (small notch on dome)
85 AO 752	2.7	1	8	Stone	C. (1)	7.29	CE – CP
MAN 76817.04	2.65	0.95	8.73	Stone	C. (1)	7.66	CP
84 AO 613	2.9	1	7.3	Stone	C. (2)	7.67	CE – CP

Artifact ID	Ø (cm)	H. (cm)	W. (g)	Material	Shape	MI (g/cm²)	Chips on edges: CE Chips on perforation: CP
85 AO 753	2.9	0.8	8.4	Stone	C. (1)	8.83	CE
84 AO 629	3	0.9	7.9	Stone	C. (2)	8.89	
84 AO 652	2.4	1.6	12.7	Stone	C. (1)	9.14	CE – CP
MAN 76817.10	3.1	1.1	9.47	Stone	C. (2)	11.38	–
AO 11655	3.9	0.5	6.1	bone/ivory	C. (1)	11.60	–
84 AO 402	3.6	0.65	7.3	bone/ivory	C. (1)	11.83	–
AO 13180	3.3	1.3	9.4	Stone	C. (2)	12.80	–
84 AO 855	3.35	1.3	9.4	Stone	C. (1)	13.19	CE –CP
84 AO 602	3	1	13.8	Stone	C. (1)	15.52	CE
85 AO 700	3.45	1.1	10.8	Stone	Thin edges	16.07	Polished area around perforation
85 AO 751	3.3	0.9	12.3	Stone	C. (1)	16.74	–
84 AO 636	3.2	1.3	13.4	Stone	C. (2)	17.15	Polished area around perforation, CE
85 AO 750	3.1	1.3	15.3	Stone	C. (1)	18.38	CE – CP
AO 27593	3.7	1.1	10.8	bone/ivory	C. (1)	18.48	–
AO 14827	3.5	0.9	17.4	Stone	C. (1)	26.64	CE –CP
MAN 76695 b	4.8	2.5	32.12	Ceramic	Biconical Wheel shape	69.38	CE – CP
83 AO 124	4.8	2	24.8	bone/ivory	C. (1)	71.42	–
81 AO 918 – unfinished	4.5	1.9	31.8	Stone	C. (2?)	80.49	NA
AO 11658	6.1	2.6	121.1	Stone	C. (1)	563.27	CE – CP Notch on dome/edge
MAN 76780.01	6.35	2.4	114.18	Stone	C. (1)	575.50	CE – CP Notch on dome/edge
84 AO 428	5.6	3.1	173.6	Stone	C. (1)	680.51	CE – CP Notch on dome/edge

Figure 11.15. Table of dimensions, material, shape of whorls, sorted according to their moment of inertia."C." is for "Conical", the number in bracket is after Elliott's types.

I arranged the whorls in Fig. 11.15 according to their moment of inertia, and I tentatively made groupings according to their weight, diameter and moment of inertia. Three groups can be clearly distinguished: all the whorls greater than 3cm in diameter and made of stone and bone/ivory have a moment of inertia higher than 10g/cm². The medium-weight whorl group previously defined has a moment of inertia between 69g/cm² and 80g/cm², and the large/heavy whorl group has a moment of inertia greater than 550g/cm².

Therefore, clear trends are observed for whorls with a moment of inertia ≥10g/cm², however, for the light objects with a MI <10g/cm², it is less easy to determine a clear trend. All the whorls, save two, that I previously categorized in the very light group (1–3g) have a moment of inertia <2g/cm², and it is in this group that one can find most of the whorls with thin edges. The other whorls of the light group have a moment of inertia comprised between 2g/cm² and 10g/cm².

Figure 11.16. Attritions around the hole on AO 11658 and MAN 76 817.04; attrition around the edge on MAN 76 780.03; photograph: C. Sauvage (courtesy of the Département des Antiquités Orientales - Louvre and of the Musée d'Archéologie Nationale).

The types as defined by Elliott do not overlap with our grouping, and no trend can be drawn from her types. However, the "thin edge" characteristic is perhaps a pertinent criterion, along with a lightweight material, and therefore a small moment of inertia. Such characteristics are more likely to define beads rather than spindle whorls. It is impossible to clearly state that all thin edged whorls are beads, because a few examples have a larger module and belong to groups with a bigger moment of inertia. However, their plausible use as spindle whorls does not imply that they were used as such.

Attritions and use marks

Among the corpuses from the MAN and the Louvre, wear due to use appears on some samples. The first type of wear consists of chips around the edges, either large, numerous and well distributed around the circumference of the largest examples, or smaller chips on smaller examples, or sometimes concentrated on one side (Fig. 11.16). Such damages could have been caused by the breaking of the thread, and thus the fall of the spindle to the ground. Whorls with chipped edges are in the weight class of 3–20g and of whorls of more than 100g. They do not appear on medium weight whorls, but this is certainly due to small sample size (n=2) and cannot therefore be held as representative for an entire class. The second type of use occurs as small asymmetrical chips around one or both perforations.[40] These could reflect insertion of another material (padding) between the spindle and the whorls to secure the whorl in place.[41]

The stone whorls were mostly found in the settlement (streets, houses, and also temples) while only a few came from tombs.[42] The opposite is true for the ivory examples, which mainly came from tomb contexts with only a few from 'domestic' contexts.[43] Were all the ivory examples

[40] Chips also appear around the largest side of the perforation, on the flat surface but such alteration is fare less common than chips on the dome.

[41] As noted by Crewe, some of this type of wear is a possible evidence for the object being strung horizontally as a bead or pendant or suspended vertically as a toggle; Crewe 1998, 61.

[42] See for instance, tomb III at Minet el-Beida, AO 11658, 84 AO 903.

[43] See for instance the three spindles with their whorls found in "dépôt 43" (Gachet 2007, cat. 135, 136, 137); the spindle and its whorl from the "Maison aux Albâtres" (Gachet 2007, cat. 139); the ivory shaft/spindle without whorl from the Royal Palace (Gachet 2007, cat. 138) and the ivory whorl from the Royal Palace (Gachet 2007, cat. 142). But these

were used daily? Or were they especially designed for funerary purposes or as prestige objects not used by their owner? Such questions are of course, almost impossible to answer, but because ivory and stone objects present (1) the same morphologies, (2) the same dimensions and weight range, and (3) similar chips and attrition marks, it is therefore possible that whorls made of the two materials were effectively used.

Decoration, morphology and function

The morphology of spindle-whorls is closely related to their function, and different sizes, shapes and weights suit different fibres. For example, a large and flat whorl will produce a slow spin and a looser and thicker thread, on the opposite, a squat shape will produce a finer tightly thread.[44] It is certain that the heavy stone examples are spindle whorls, because of the unpublished inscribed whorl with the word "spindle" preserved at the MAN,[45] and because of the presence of notches. Based on shape and incision similarities between the lighter ivory examples and the large stone examples, I infer that ivory artefacts of ~ 3cm in diameter, with a weight of 5g and a perforation of 0.4/0.3cm were also used as spindle whorls. Therefore, all objects with a weight of at least 5g have to be considered in studies of spindle whorls in Ugarit. Experimental studies also show that whorls of 4g can be use to produce a fine thread of wool, if the raw material is processed in a more sophisticated manner than for spinning with a 8g whorl.[46] So, it is possible that the group of artefacts ranging from at least 4g to 17g could all have been used for spinning wool. If so, then a fine and delicate thread would have been produced.[47] The careful finish of the smallest whorls and their polished surfaces could then have been designed for two functions. First, it could have meant their use as buttons or clothing decoration/embroidery for lightweight objects, with a small moment of inertia inferior to $2g/cm^2$, and thin edges splaying out. Alternatively, it would have fit with the delicacy of the thread while spinning, for the objects with a moment of inertia slightly higher, between $2g/cm^2$ and $10g/cm^2$.

The deep incision certainly allowed the thread to 'hold on' to the whorl while spinning. It is therefore possible to imagine that these whorls were used either to spin a different thickness of thread, a different fibre, or were used in a different production stage such as plying. Experimental flax spinning has demonstrated the tendency of thread to slip off the whorl when using a suspended low-whorl spindle with an 8g whorl,[48] and it is also known that flax was cultivated and used in Syria, along with wool.[49] Therefore, the small and/or light whorls of Ugarit with a moment of inertia of $5–7g/cm^2$ with a notch could have been used for flax. The large stone spindle

contexts cannot be classified within the 'ordinary' domestic contexts (Matoïan and Vita 2009 (2010)).

[44] Crewe, 2002, 218.

[45] Sauvage and Hawley 2012.

[46] See the experimental spinning with a 4g whorl were wool was washed in warm water, then combed to remove as much underwool as possible, before being spun; Mårtensson, Andersson, Nosch, Batzer, 2006b. It was also suggested after this experiment that the use of softer wool than the one used with bigger and heavier whorls would be preferable.

[47] See the illustration of the different thickness of thread produced with different weigh range of whorls; Andersson, Nosch, Wisti Lassen, *Methodological Introduction*, 10, fig. 8.

[48] Mårtensson, Andersson, Nosch, Batzer 2006a, 11, fig. 11.

[49] Remains of linen and woolen fabrics were found. See Barber 1991, 165–166; Bacquet 2001, 99; Breniquet 2008, 83–97 for further reference and details. Linen cultivation was well attested in Syria and Palestine (Wild 2002); and Mesopotamia since at least the PPNB, (Breniquet 2008, 88). Other types of fiber such as cotton, hemp, ramie or silk could potentially have been used; see Breniquet 2008, 98–101.

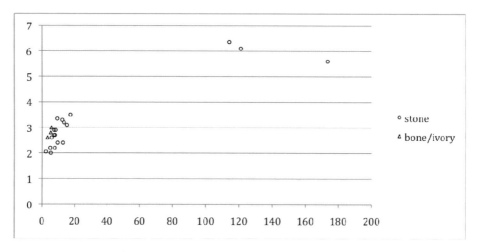

Figure 11.17a. Relationship between chips on edges and weight (x) and diameter (y).

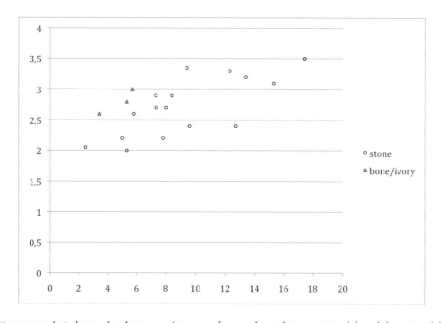

Figure 11.17b. Relationship between chips on edges and weight up to 20 g (x) and diameter (y).

whorls are very heavy in comparison with the other examples, have an important moment of inertia, above 550g/cm², and they are less common in the archaeological assemblage. Their use for coarser fibres or threads is possible, especially for MAN 76 780.03 with one notch. But, it is also possible that they were used in another spinning stage, such as for plying more than one thread into yarn, as demonstrated by the five notches of Louvre AO 84 428 (Fig. 11.10), certainly designed to ply five times five threads.

Spindles and Distaffs

The use of distaffs is mandatory to support fibres (*esp.* animal fibres) when spinning with a spindle and spindle-whorl.[50] Spindles and distaffs are attested together in the archaeological records since at least the late 3rd Millennium BC in Mesopotamia, at Kish and Abu Salabikh. In both cases, the rods identified as distaffs were about 20cm long and were "surmounted by a flat nail-like head".[51] In Ugarit, texts attest that both spindles and distaffs were used together by the ladies of the city, following the gesture of the goddess Asherah in the Baal Cycle:

> CTA 4.2: "(3) she takes her spindle ...
> (4) she takes a distaff in ...
> (5) her thread is woven (or plaited) into (a piece of) cloth (by/for) her."[52]

Therefore, I expect both objects in the archaeological record. At Minet el-Beida the harbor town of Ugarit, one ivory object with a knob in the shape of a pomegranate (AO 15758–RS 4.221B) was found in the so-called "dépôt 43" (Fig. 11.18). It has a whorl inserted almost in the middle of the preserved stick, while another (missing) part was attached on the lower end of the shaft, opposed to the knob.[53] The maximum diameter of this shaft is 1.35cm; its preserved length is 22.1cm. The whorl is 4.04cm in diameter, 0.42cm thick and its perforation is 1.2cm.[54] It would be tempting to interpret this object as a spindle because of the presence of the whorl, and because of a few middle-whorls spindles parallel from Anatolia.[55] However, it is difficult to imagine how to initiate the spin of this object on the pomegranate with one hand. Only one parallel is known and comes from the Artemision at Delos (shaft: L. 22.5cm, ø: 1–0.7cm; whorl: ø: 3.5cm, thickness: 0.7cm) however, it has its whorl set at 2cm from its largest extremity, opposing the pomegranate (Fig. 11.19).[56]

Figure 11.18 Distaff from Minet el-Beida AO 15758 – RS 4.221B, after Gachet 2007, no. 137 © Mission de Ras Shamra-Ougarit

[50] Breniquet 2008, 112. However, the shape of the distaff does not need to be elaborated, nor reworked; hence Breniquet proposes that the first attestation dates at least to the Uruk period, with a possibly earlier attestation in Çatal Hüyük; Breniquet 2008, 114.

[51] For more reference, see Barber 1991, 57–58, fig. 2.19.

[52] Binger 1997, 70.

[53] Gachet 2007, cat. no. 137, 121–123, 260.

[54] No information on the weigh is given by Gachet.

[55] See the third Millennium silver and gold or electrum "spindle" from tomb L at Alaca Höyük, or by the metal spindles from Horoztepe; Barber 1991 fig. 2.24 and 2.25.

[56] Gallet de Santerre and Tréheux 1947–48, 198–199, no. 36, fig. 16; Gachet 2007, 115.

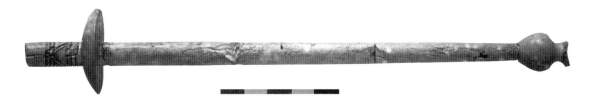

Figure 11.19. Ivory shaft with whorl and knob from Artemision at Delos; Gallet de Santerre and Tréheux 1947–48, 198–199, fig. 16 © EfA.

The position of the whorl on a spindle is culturally determined,[57] and it is known that Greece and the Aegean used low-whorl spindles. Therefore I would be tempted to orientate the pomegranate of the Delos object on the top, but then it is also difficult to imagine how to initiate the spin on the pomegranate. Gachet already noted that the presence of both a whorl and a pomegranate knob on the object raised a problem if one expects that the object was used as such, and she wondered if it was not a symbolic deposit.[58] An ivory or bone distaff with two whorls from Lindos, slightly more recent than the Ras Shamra examples, have been interpreted as a distaff by C. Blinkenberg (Fig. 11.20).[59] The preserved length of the object is 19.3cm, and it is 0.9cm in diameter. It has a whorl inserted on its preserved extremity, the finest one, and another whorl inserted some 7.5cm lower, on the shaft. The shaft bears engraved decoration of oblique grooves and cross-hatching (similar to the LBA ivory shaft decorations) on its upper part from the top whorl, down to a few centimetres below the low whorl. Its identification as a distaff is based on parallel with depictions from Greek vases and on parallels from archaeological objects from Etruria.[60] I propose that the Minet el-Beida object – if used as such – was not used as a spindle, but as a distaff. Its whorl would have sustained the fibres on the top of the spinner's hand, as shown on the later Greek representations. It is not possible to make the same statement for the Delos object because the whorl, placed at the lowest extremity of the shaft would have prevented the spinner's grip.[61]

Another ivory shaft from Ugarit (RS 4.221[A]) has similar dimensions, but no knob. Its preserved length is 22cm (part of it is missing), its diameter varies between 0.85cm and 1.27cm, but its whorl is bigger (diameter 3.1cm, thickness 1.35cm, perforation 1.1cm). Finally, a third, small shaft (RS 34.210) was found with a whorl: its preserved length is 13.3cm, and its diameter is 0.5cm. Its whorl is 1.9cm in diameter and 0.8cm in thickness and its perforation is probably of 0.5cm. Both

[57] Barber 1991, 53; Crewe 1998, 7; Crewe 2002, 218. In the ancient Near East and eastern Mediterranean, two spinning techniques co-existed: the low-whorl technique, attested in Bronze Age Anatolia, Cyprus and the Aegean. According to Barber, Anatolia actually used more of a 'middle' whorl technique, as exemplified by the metal spindles from tomb L at Alaca Höyük and Horoztepe. She assimilates the 'middle' whorl technique with a low whorl technique, Barber 1991, 60–61. The high-whorl technique is attested in Egypt, and Mesopotamia; Barber 1991, 56–58. On a low whorl spindle, the thread passes underneath the whorl, then around the spindle and finally passes back to the top of the spindle. It causes the thread to come in contact frequently with the extremities and down facing end of the whorls. On a high-whorl, only the maximum diameter area of the whorl would feel constant pressure from the thread; Crewe 1998, 61.

[58] Gachet 2007, 111.

[59] Blinkenberg 1931, pl. 13. 333, col. 135 no. 333.

[60] Blinkenberg 1931, col. 133–134.

[61] For the interpretation of this object, see below.

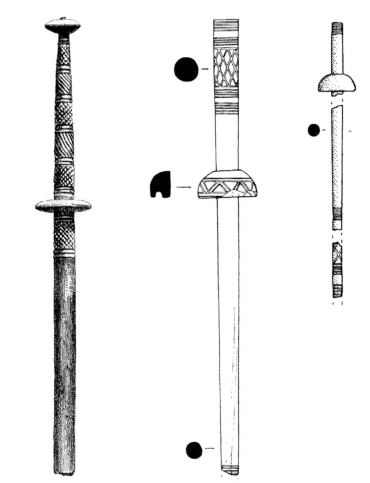

Figure 11.20 (left). Ivory distaff from Lindos; after Blinkenberg 1931, fig. 13.333.

Figure 11.21 (right). Spindles from Ugarit RS 4.221[A] (AO 15 757) and RS 34.210; after Gachet 2007, nos 136 and 139 © Mission de Ras Shamra-Ougarit.

of these objects are clearly spindles, and it is important to note that their whorls are inserted on the largest extremity of the shaft (Fig. 11.21). No knob was inserted in their top, but it would have been possible to insert knobs on such shafts. When a pomegranate knob is inserted on an ivory shaft, it is on its narrowest extremity. Several knobbed shafts with pomegranates were found without whorls on them and, as Gachet pointed out, are generally assigned another function. Because of the pomegranate, a symbol of fertility, the shafts were sometimes interpreted as feminine objects according to their resemblance to hair pins and kohl tubes.[62] The presence of the feminine symbol on their higher extremity of a few rods could be explained by the sex of their owners, as attested by CTA 4.2, if they were amongst spinning tools. They were also interpreted as sceptres by comparison to bronze examples with a fixed knob, which did not allow the insertion of a whorl.[63] Such bronze objects have been interpreted as cultic sceptres, after the claim that

[62] See for instance the silver pin from Vaphio in Greece, Immerwahr 1989, 397.
[63] Gachet 2007, 123–124 with further details and reference. See for instance the bronze shafts from Nami, Artzy 1995; and from Minet el-Beida, Gachet 2007, 122.

two examples were discovered in a "priest" tomb at tell Nami.[64] The identification of the owner of the tomb as a priest is based on the presence of incense burners, and of two bronze rods, one with pomegranate finial and the other with a pomegranate/poppy seedpod finial. The two bronze rods are about 30cm long and are therefore longer than the ivory examples, and their diameter is finer. The identification of the rods as cultic is mostly based on the presence of incense burners in the tomb, and on the presence of two ivory pomegranate rods (along with ivory rods) in the Lachish Canaanite temple.[65] But the Lachish objects were found together, with other ivories, and could as well have been votive offerings: "No recognizable object of worship came to light in the excavations, but on the shrine of III was a rich deposit of scarabs, cylinder seals, glass and faience vessels and several carved ivories. Some, at least, of these objects were more than a hundred years old when the Temple was destroyed. … All around, outside the walls, were circular refuse pits and dumps of rubbish. The later pits contained, besides pottery, a fair number of objects such as carved ivories, faience bowls and beads."[66] The Lachish ivory rods come from such a pit, which also contained an ivory comb, a box and an ivory disc,[67] and these objects are generally not interpreted as 'cultic'. If the bronze examples can attest that these objects were not used as a spindle because no whorl could be inserted on the shaft, it is however too arbitrary to attribute them the function of sceptres,[68] only based on a corpus of three objects solely attested in funerary contexts.

Ivory whorls and decorated shafts have been found in several parts of the eastern Mediterranean:[69] in the Levant, at Megiddo, Lachish, tell Dan, Hama and tell Kazel; in Cyprus, at Ayios Iakovos, Enkomi, Kition and Palaeopaphos; in the Aegean, at Perati and Delos; and aboard the Uluburun ship. In a few cases, a whorl was mounted on the shaft, such as in Minet el-Beida, but also Perati, Delos, *etc.*[70] In Megiddo, an ivory spindle had its two whorls facing each other and inserted between two ivory parts by a metal pin.[71] On all these examples, the whorls were placed on the largest extremity of the shaft, therefore pointing to similar uses of the objects. At Enkomi, a bone disc was found attached to an ivory or bone shaft by a rivet forming the end of the object.[72] If this object is a textile tool, it can be interpreted as a low-whorl spindle because it would be impossible to attach a hook on it, but as Barber pointed out, it can also be interpreted as a distaff, similar to those from the third millennium BC found at Kish and Abu Salabikh,[73] and similar to the one from Lindos. Alternatively, it could be thought of as a high-whorl hand-held spindle. In other cases, the decorated shafts were found with decorated whorls but were not mounted together.[74]

[64] Artzy 1990; Artzy 1995, 26–28.

[65] For the pomegranate rods, see Tufnell, Inge and Harding 1940, pl. XX no. 25, 26; for the ivory shafts without knob, see Tufnell, Inge and Harding 1940, pl. XX no. 23, 24, 27, 28. See also Gachet 2007, 125.

[66] Tufnell, Inge and Harding 1940, 19.

[67] Tufnell, Inge and Harding 1940, pl. XX, no. 21–21.

[68] Gachet 2007, 124.

[69] See Barber 1991, 62–63; Ward 2003, 533–535; Gachet 2007, 125–127 for the details and the bibliography. Barber also cites similarly decorated wooden shaft in the 18th–19th Dynasty Egypt found in Gurob.

[70] Gachet 2007, 125–127.

[71] Guy 1938, 170.

[72] Schaeffer 1952, 194–195, fig. 82; Barber 1991, 63.

[73] Barber 1991, 63, 58, fig. 2.19.

[74] For instance in Megiddo (Guy 1938, 170), in Hama (Riis 1948, 171–174, fig. 21, 209 A–B), and in Enkomi (Aström 1972,

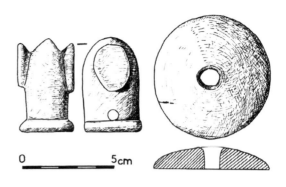

Figure 11.22. Knob (RS 19.54) and whorl (RS 18.150) with tablets in situ in the royal palace; after Schaeffer 1949, fig. 37 © Mission de Ras Shamra-Ougarit.

Figure 11.23. Drawing of the knob (RS 19.54) and whorl (RS 18.150) from the royal palace; after Schaeffer 1949, fig. 40 © Mission de Ras Shamra-Ougarit.

The presence of knobs on a shaft was certainly not essential to use it as distaff, but it would have made its use as a spindle difficult. The Delos object, as it is, could have been used neither as a spindle (because of the presence of the knob), nor as a distaff (because of the presence of the whorl) by an Aegean. It can be identified as a votive object, voluntarily deposited, and I therefore propose that what was deposited was neither strictly just a spindle, nor a just distaff. Instead, I interpret it as a three-piece spinning kit (shaft, whorl and knob). Such a kit could have been used alternatively as a spindle (shaft + whorl) or as a distaff (shaft + knob) by removing the unnecessary element. It is also possible that the object from "dépôt 43" at Minet el-Beida was a similar kit and therefore not a ready to use object. That removable decorative knobs were part of spinning tool kits may also be confirmed by the archaeological association of a limestone whorl and a faience knob with two 'ears' in the Royal Palace at Ugarit[75] (Figs 11.22–11.23). The whorl is about 6cm in diameter and has a perforation of almost 1cm, its perforation and dimensions compare to the large stone objects. Only two knobs of this type are known in Ugarit, and their use on a distaff could be an alternative explanation to their use on a sceptre or symbol of power.[76] I would therefore be tempted here to propose the identification of some knobbed rods as distaff based on their association with spindle whorls in tomb deposits,[77] and in the royal palace.[78]

Given archaeological evidence in Ugarit and elsewhere, the same type of shaft could have been used as spindle or distaff, depending on the placement of the whorl and/or the use of

609–610; Schaeffer 1952, 194–195, fig. 75, 82).

[75] Schaeffer 1962, fig. 37, 38 and 40; Matoïan 2008b, fig. 11, 205.
[76] See discussion of these objects in Coquinot, Bouquillon, Leclaire and Matoian 2008, 317–320.
[77] See for instance tomb III at Minet el-Beida.
[78] However, the large knobbed tripartite ivory rod from Qatna proves the existence of ivory scepter. But the proportions of the rod and knob are different: the rod is cylindrical and has a constant diameter, while the knob, in the shape of a papyrus capital, is about one third of the length of the shaft. For an illustration, see Pfälzner 2009, 136.

a knob. This would explain their wide diffusion in the Mediterranean world where the low-whorl spinning technique was common. It also explains the presence of several ivory shafts in the same contexts as spindle whorls.[79] If my hypothesis of spinning tool kits is correct, then it is possible to infer that in Ugarit they were composed at least of shafts, whorls in ivory and stone, and knob(s). Archaeological records preserved at least two (partial?) such kits in Minet el-Beida. Tomb III contained five ivory shafts,[80] one ivory and two stone whorls,[81] and an ivory knob.[82] "Dépôt 43" contained three ivory shafts,[83] several stone and ivory/bones whorls,[84] and the mounted pomegranate knob with the whorl from the Louvre.[85] Recent examples of Chancay from Peru (1300–1400 AD) show that an individual could own and use as many as 12 loose whorls, 57 spindles with whorls and 11 spindles without whorls,[86] and therefore, the previous examples are not unreasonable.

The appearance of almost identical ivory spinning objects in different cultural milieu, using different spinning methods (*i.e.* high-whorl spindles in the Near East *vs.* low-whorl spindles in the Aegean and Cyprus) illustrates the uncertainty of their use, diffusion and production. On all the ivory spindles from the Levant and the Aegean, the whorls are always positioned on the largest extremity or in one case near the middle of the shaft, and therefore they were all likely produced in the same cultural areas or from one common model. If such were the case, then (1) they were either all used in the same manner, maybe by near-easterners, though it is difficult to assert people's identity through material culture when dealing with objects made of prestigious material; (2) they were used 'upside down' in the Aegean and Cyprus; or finally (3) they were exchanged and deposited for their value as prestigious materials, reminiscent of a familiar object, but not actually used by their owners.

Conclusion

The whorl type objects of Ugarit were locally produced as attested by an unfinished example in stone. They were carefully manufactured, often finished on a wheel and the smaller they were, the better polished. Their central perforation was important for the craftsmen, and essential for the balance of the spindle. Archaeological records attest the use of whorls in ivory/bone and stone (steatite/chlorite schist, serpentinite and limestone). Both categories show attrition and use marks around their perforation and edges, attesting that they all were effectively used. It is possible that faience whorls existed, as two whorl-like objects with attrition around their perforation typical of the insertion of a shaft come from the royal palace. However, their diameter is slightly

[79] See also for instance tomb 9 in Kition, in which several ivory shafts and spindle whorls were found together; Karageorghis and Demas 1974. See also the textile workshop at Kition where several knobs were found; Karageorghis and Demas 1985; Smith 2009.

[80] RS 1.[109] AO 11656 (Gachet 2007, cat. 222); RS 1.[111] AO 11674 (Gachet 2007, cat. 146); RS 1.[119] AO 11648 (Gachet 2007, cat. 177); RS 1.[120] AO 11649 and AO 11650 (Gachet 2007, cat. 238).

[81] RS 1.[108] AO 11655 (Gachet 2007, cat. 140); AO 11658; 84 AO 903. In addition, four really small and light ivory whorls with thin edges were found, but were maybe beads: AO 30941–943 (former 84 AO 904–907), Gachet 2007, cat. 572.

[82] RS 1.[110] AO 11657 (Gachet 2007, cat. 465).

[83] Gachet cat. 135, 136, 137.

[84] See excavation notebook Schaeffer 1932, quoted by Gachet 2007 cat. 135.

[85] Gachet 2007, cat. 137.

[86] Liu 1978, 98.

larger than the stone and bone/ivory objects and therefore their use as spindle whorls need to be confirmed by weight measurements. The use of terracotta whorls cannot be confirmed for the moment because the only example from the MAN could have been a chariot model wheel.

I observed great variation on the weight and diameter of the whorls, from 1.45cm to 6.35cm and from 1g to 173g, with objects clustering in several groups: really light (<3g), light (<17g), medium (20–35g) and heavy (100–200g). The size of the perforation of the whorls is variable and can correspond to the use of padding between the whorl and the shaft, but also certainly corresponds to the use of different types of shafts. The average perforation has a diameter of 0.3–0.5cm. The size of the perforation fits the weight groups and one can observe a smaller perforation for the light examples, while the light and medium weight objects show an average perforation. Heavy examples display a larger perforation, probably due to their use on a larger shaft, for heavier duties or for a different stage in the spinning process. A few ivory examples within the light group display a particularly large perforation (>1.2cm) and were specifically used on larger shafts, as exemplified by a few complete ivory spindles. The whorls are mainly variation of a conical hemispherical shape common in the same period in the Near East and Cyprus. However, the few examples with a thin edge splaying out are generally of smaller dimensions, of lighter weight, and of smaller moment of inertia (inferior to 2g/cm²) than the rest of the corpus.

Only some objects were decorated, either on their flat face or on their dome. The engraved decoration typically consists of a geometric pattern made of (concentric) circle(s) and/or spokes. Only a few objects bear different motifs such as cross, men, rosette or even inscription. If the use of geometric patterns on the dome reinforces the visual effect of the spinning whorl, it also had a technical application. In fact, on the largest stone and on a few ivory examples one of the spokes is deeply incised and extends across the dome to form a notch on the edge of the whorl. The function of this notch was to hold the thread while spinning and it attests the plying of different thread together for the larger examples, and perhaps the use of a different fibre for the lighter ivory examples. The existence notches also suggests the use of a high whorl spindles for heavy as well as for light objects.

The study of the moment of inertia (MI) partly confirms the grouping established, for the heavy, medium and some of the light objects: all the whorls with a diameter bigger than 3cm have a MI higher than 10g/cm², the medium weight whorls have a MI between 69g/cm² and 80 g/cm², and the heavy objects have a MI greater than 550g/cm². The grouping is less evident when it comes to the remaining objects, with a MI inferior to 10g/cm², but the majority of the whorls in the light group have a MI inferior to 2g/cm², and mainly consists of whorls with a thin splaying edge. Such characteristics are more likely to define beads than whorls, and I would be tempted to disregard this extremely light group (<3g) in the study of spindle whorls, especially when the objects have thin splaying edges. Most of the whorls from Ugarit could have been used on spindles, except perhaps for the examples lighter than 3–4g, and under 2–2.5cm in diameter. The difference in object weights points to the production of different thread thickness, but also to different raw fibres (wool and linen) and production stages (spinning and plying).

It is during the Late Bronze Age that the finely decorated ivory shafts flourished in the eastern Mediterranean. They were widely distributed in the Levant from Megiddo to Ugarit, and also in Cyprus and the Aegean. A few were found intact, with their whorls attached, while others were found separated from whorls but associated with them in their find spots. Because of the

frequent attestation of ivory shafts, knobs and whorls in the same context, I proposed that these objects were likely associated with spinning and were possibly part of a spinning kit. The shaft, eventually toped by a knob, could have been used as a distaff, while the shaft and whorl were likely to be used as a spindle.

Acknowledgements

The research at the Saint-Germain-en-Laye Museum is funded by the generous contribution of the Leon Levy – Shelby White foundation – grant for archaeological publication. Work on the whorls was possible through the help and support of C. Lorre (curator, département d'archéologie comparé, MAN), and of B. André-Salvini and S. Cluzan (Musée du Louvre, département des Antiquités Orientales). They granted me access to their collections, allowed me to mesure, weigh and photograph the whorls, and to publish the results. I also want to thank C. Breniquet, L. Crewe, E. Andersson, H. Koefoed and the reviewers of this volume for their constructive comments, but of course, all mistakes remain mine.

Abbreviations

AO Antiquités orientales (Louvre)
MAN Musée d'Archéologie National (Saint-Germain-en-Laye)
RS Ras Shamra
RSO Ras Shamra – Ougarit

Bibliography

Andersson Strand, E. and Nosch, M.-L. 2007. *Technical Textile Tools Report. Methodological Introduction, Tools and Textiles* – Texts and Contexts Research Program, The Danish National Research Foundation's, Center for Textile Research, University of Copenhagen.

Artzy, M. 1990. Pomegranate Scepters and Incense Stand with Pomegranates found in Priest's Grave. *Biblical Archaeology Review* 16.1, 48–51.

Artzy, M. 1995. Nami, A Second Millennium International Maritime Trading Center in the Mediterranean. In *Recent Excavations in Israel. A View to the West*, Colloquia and Conference Papers no. 1, Archaeological Institute of America, 17–90.

Aström, P. 1972. *Swedish Cyprus Expdition vol. IV, 1D.* Lund.

Bacquet, M. 2001. *Les fusaïoles au Levant, des premières attestations au début du 5e millénaire avant J.-C.*, Mémoire de maîtrise, Université de Paris I. Paris.

Barber, E. J. W. 1991. *Prehistoric Textiles: the Development of Cloth in the Neolithic and Bronze Age, with Special Reference to the Aegean.* Princeton.

Binger, T. 1997. *Asherah, Goddesses in Ugarit, Israel and the Old Testament.* Sheffield.

Blinkenberg, C. 1931. *Lindos, fouilles de l'acropole 1902-1914. I Les petits objets. Texte et planches.* Berlin.

Bocquet, A. 1989. Le travail des fibres textiles au Néolithique récent à Charavines (Isère). In *Tissage, corderie, vannerie, IXe Rencontres Internationale d'Archéologie et d'Histoire, Antibes, octobre 1988.* Juan les Pins, 113–128.

Breniquet, C. 2008. *Essai sur le tissage en Mésopotamie, des premières communautés sédentaires au milieu du IIIe millénaire avant J.-C.* Travaux de la Maison René-Ginouvès. Paris.

Carington Smith, J. 1992. Spinning and weaving equipment. *In* W. A. Macdonald and N. C. Wilkie (eds) *Excavations at Nichoria II.* Minneapolis, 674–711.

Caubet, A. 2004. La maison et le monde des femmes. *In* Y. Calvet and G. Galliano (eds) *Le royaume d'Ougarit aux origines de l'alphabet*, catalogue d'exposition. Paris, 177–178.

Chanut, C. forthcoming. Examen pétrographique des objets en Pierre. *In* C. Sauvage and C. Lorre (eds) *La collection d'Ougarit de C. F. A. Schaeffer au Musée d'Archéologie Nationale de Saint-Germain-en-Laye.*

Contenson, H. 1992a. *Préhistoire de Ras Shamra: les sondages stratigraphiques de 1955 à 1976. I texte.* Paris.

Contenson, H. 1992b. *Préhistoire de Ras Shamra: les sondages stratigraphiques de 1955 à 1976. II Figures et planches.* Paris.

Coquinot, Y., Bouquillon, A., Leclaire, A. and Matoïan, V. 2008. Le "four aux tablettes" du *locus* 153 ("ex-cour V") du Palais royal d'Ougarit: nouvelles données sur le matériel non épigraphique. *In* V. Matoïan (ed.) *Le mobilier du palais royal d'Ougarit, RSO* XVII. Lyon, 307–326.

Courtois, J. C. 1984. *Alasia III, Les objets des niveaux stratifiés d'Enkomi (Fouilles C. F. A. Schaeffer 1947-1970).* Paris.

Crewe, L. 1998. *Spindle whorls: a study of form, function and decoration in prehistoric Bronze Age Cyprus,* Studies in Mediterranean Archaeology and Literature. Jonsered.

Crewe, L. 2002. Spindle-whorls and loomweights. *In* G. W. Clarke, J. P. Connor *et al.* (eds) *Jebel Khalid on the Euphrates: Report on the Excavations 1986–1996. Volume 1,* Mediterranean Archaeology Supplement 5. Sydney, 216–243.

Dikaios, P. 1969. *Enkomi: excavations 1948-1958.* Mainz am Rhein.

Elliott, C. 1991. The ground stone industry. *In* M. Yon (ed.) *Arts et industries de la pierre, RSO* VI. Paris, 9–99.

Feldman, M. and Sauvage, C. 2010. Objects of Prestige? Chariots in the Late Bronze Age Eastern Mediterranean and Near East. *Egypt and the Levant* 20.

Foster, K. P. 1979. *Aegean Faience of the Bronze Age.* New Haven.

Gachet, J. 2007. *Les ivoires d'Ougarit et l'art des ivoiriers du Levant au Bronze Récent, RSO* XVI. Paris.

Gallet de Santerre, H. and Tréheux, J. 1947–48. Rapport sur le dépôt égéen et géométrique de l'Artémision à Délos. *Bulletin de Correspondance Hellénique* 71–72, 148–254, pls XIX–XLVI.

Guy, P. L. O. 1938. *Megiddo Tombs.* OIP 33. Chicago.

Immerwahr, S. A. 1989. The Pomegranate Vase: its Origins and Continuity. *Hesperia* 58, 397–410.

Karageorghis, V. and Demas, M. 1974. *Excavations at Kition I, The Tombs.* Nicosia.

Karageorghis, V. and Demas, M. 1985. *Excavations at Kition V, The pre-Phoenician levels.* Nicosia.

Liu, R. 1978. Spindle-Whorls: Part 1. Some Comments and Speculations. *The Bead Journal* 3, 87–103.

Mårtensson, L., Andersson, E., Nosch, M.-L. and Batzer, A. 2006a. *Technical Report Experimental Archaeology Part 2:1 flax,* Tools and Textiles – Texts and Contexts Research Program, The Danish National Research Foundation's, Centre for Textile Research, University of Copenhagen.

Mårtensson L., Andersson E., Nosch M.-L. and Batzer, A. 2006b. *Technical Report Experimental Archaeology Part 2:2 Whorl or Bead?,* Tools and Textiles – Texts and Contexts Research Programme, The Danish National Research Foundation's, Centre for Textile Research, University of Copenhagen.

Matoïan, V. 2008. Des roches précieuses dans le Palais royal d'Ougarit: les calcédoines rubanées (agates). *In* V. Matoïan (ed.) *Le mobilier du palais royal d'Ougarit, RSO* XVII. Lyon, 191–213.

Matoïan, V. and Vita, J.-P. 2009 (2010). Les textiles à Ougarit, Perspectives de la recherche, *Ugarit Forschungen* 41, 467-504.

Nodet, E. 1980. Fusaïoles et pesons. *In* J. Briend and J.-B. Humbert (eds) *Tell Keisan (1971-1976), une cité phénicienne en Galilée.* Paris, 315–321.

Ochsenschlager, E. 1993. Village Weavers: Ethnoarchaeology at Al-Hiba. *In* J. N. Postgate and M. A. Powell (eds) *Bulletin on Sumerian Agriculture 7: Domestic Animal of Mesopotamia, Part I.* Cambridge.

Pilali-Papasteriou, A. 1998. Idéologie et commerce : le cas des figurines mycéniennes. *Bulletin de Correspondance Hellénique* 122, 239–260.

Pfälzner, P. 2009. Das Königtum von Qatna. In M. Al-Maqdissi, D. Morandi Bonacossi and P. Pfälzner (eds) *Schätze des Alten Syrien. Die Entdeckung des Königreighs Qatna,* 135–137.

Pulak, C. 2008. Exotic Materials and Prestige Goods. *In* J. Aruz, K. Benzel and J. E. Evans (eds) *Beyond Babylon, Art, Trade and Diplomacy in the Second millennium BC.* New Haven/London 324–325.

Riis, P.J. 1948. *Hama, fouilles et recherches 1931-1938 II.3 Les cimetières à crémation.* Copenhagen.

Sauvage, C. forthcoming. Les fusaïoles et l'industrie textile à Ougarit. *In* C. Sauvage and C. Lorre (eds) *La collection d'Ougarit de C. F. A. Schaeffer au Musée d'Archéologie Nationale de Saint-Germain-en-Laye.*

Sauvage, C. and Hawley, R. 2012. Une fusaïole inscrite au MAN. *In* V. Matoïan (ed.) *Études Ougaritiques III.* RSO. Leiden.

Schaeffer, C. F. A. 1939. *Ugaritica I, Études relatives aux découvertes de Ras Shamra*. Paris.

Schaeffer C. F. A. 1949. *Ugaritica II, Nouvelle étude relative aux découvertes de Ras Shamra*. Paris.

Schaeffer C. F. A. 1962. *Ugaritica IV, Découverte des XVIIIe et XIXe campagnes, 1945–1955. Fondements préhistoriques d'Ugarit et nouveaux sondages. Études anthropologiques. Poterie grecques et monnaies islamiques de Ras shamra et environs*. Paris.

Schaeffer C. F. A. 1952. *Enkomi-Alasia I*. Paris.

Smith J. 2009. *Art and Society in Cyprus fron the Bronze Age into the Iron Age*. Cambridge.

Tufnell O., Inge C. H. and Harding L. 1940. *Lachish II (Tell ed Duweir): The Fosse Temple*. Oxford.

Vita J.-P. 2004. RS 15.176 et RS 15.176bis, Deux bulletins ougaritiques de livraison de vêtements. *Ugarit Forschungen* 36, 523–531.

Vita J.-P. 2007. Les documents des archives est du Palais royal sur les textiles: une contribution à la connaissance de la procédure administrative à Ougarit. *In* J.-M. Michaud (ed.) *Le Royaume d'Ougarit de la Crète à l'Euphrate, Nouveaux Axes de Recherche*, 243–265.

Vita J.-P. 2008. Le texte administratif Ougaritique RS 15.115 (distribution de textiles): Remarques épigraphiques. *Studi Epigrafici e Linguistici* 25, 47–55.

Ward C. 2003. Pomegranates in Eastern Mediterranean Contexts during the Late Bronze Age. *World Archaeology* 34.3, 529–541.

Wild J. P. 2002. Anatolia, Mesopotamia and the Levant in the Bronze Age, c. 3500–1100 BC. *In* D. Jenkins (ed.) *The Cambridge history of Western Textiles*. Cambridge, 43–47.

Yon M. 2007. Au Roi d'Alasia, Mon Père. *Cahiers du Centre d'Études Chypriotes* 37, 15–39.

12. Throwing the Baby Out with the Bathwater: Innovations in Mediterranean Textile Production at the End of the 2nd/Beginning of the 1st Millennium BCE

Laura B. Mazow

In his chapter on textile production in the *Oxford Handbook of Engineering and Technology in the Classical World*, Wild[1] makes the rather surprising claim that "The fuller...was a well known figure from the Mycenaean period onward". While the professional fuller may have played a prominent role in the Classical world, where numerous fulleries have been clearly identified,[2] there is as yet no known fulling establishment dated to the Late Bronze or Iron Age that has been recognized in the east Mediterranean basin. In the textual record, written documents from as early as Neo-Sumerian Mesopotamia are replete with references to fullers and fulled wool,[3] and Mycenaean Linear B texts reference fullers among the high status occupations.[4] From an archaeological standpoint, however, the fuller and the craft of fulling is virtually unknown in these earlier contexts. In fact, although made in reference to the Northern Roman provinces, little, if anything, can be added to Wild's statement that "Virtually nothing is known about fulling before the Roman conquest, except that it existed."[5] Is fulling, therefore, part of the production sequence of textile manufacture that we have somehow missed in the archaeological record, or are the fuller's tools and equipment simply invisible to the archaeologist's eye? Alternatively, I would like to suggest that the fuller's equipment has simply gone unrecognized. I have previously suggested that *bathtubs* found in Cyprus and the Southern Levant in Late Bronze and Iron Age

[1] Wild 2008, 475.

[2] Pirson 2007, 463; but see Jongman 2007, 506–507. There is much confusion in the literature as to whether in the ancient world the term 'fuller' referred to the technological process of finishing or 'fulling' a fabric or to the more mundane activity of washing and laundering dirty clothes, or if a fuller's job included both activities, *e.g.*, Lutz 1923, 100; Smith 1890, 551–553; Waetzoldt 1972, 155; see Bradley 2002 for further explication. This ambiguity is enhanced by descriptions of these ancient technologies that use these terms interchangeably *e.g.*, Lutz's translations of Egyptian texts and his interwoven examples of ancient finishing and cloth cleaning techniques. Further confusion is added by references to fulling, which in its current meaning is a technology used on textiles made from animal hairs, in association with linen, although it may be that the ancient terminology did not differentiate between the materials and techniques as we do today, *e.g.*, Lutz 1923, 100; Smith 1890; Waetzoldt 1972, 153, 155; see Barber 1991, 220, note 6. For my current study of identifying an archaeological signature for fulling, it is not significant at this time that we be able to distinguish among these different activities; the processes, equipment and tools may have been similar.

[3] Petzel 1987, 26–28; Waetzoldt 1972, 153–174. Waetzoldt prefers the translation "finisher" for the Akkadian *aslag*.

[4] Palaima 1997; Palmer 1963, 191–198; Shelmerdine 1999; Ventris and Chadwick 1973, 123.

[5] Wild 1970, 82.

contexts may have functioned within the manufacture and production of textiles, specifically for fulling wool.[6] In the current paper, I propose a similar identification in the Aegean – that *bathtub* installations are the archaeological signature of fulling stations and reflect the fulling profession as mentioned in Linear B texts.

Fulling is part of the process of finishing a woven woollen textile. Together with scouring, which is the process of cleaning the wool and removing the natural lanolin and other greases, fulling thickens the cloth and causes the fibres to mat and intertwine, thereby creating a more compact weave.[7] Historical textual evidence suggests that a fuller may have both processed new cloth and laundered dirty clothes.[8] Fulling, scouring and laundering need hot water and a detergent to keep the lanolin in suspension. Fulling also requires some form of agitation, such as kneading, stomping or pounding on the wet wool, after which the cloth is rinsed in a vat or stream of flowing water, hung to dry and stretched on frames or tenters. Mesopotamian, Egyptian and classical Talmudic texts[9] describe a water-filled tub or vat, a long staff or pole to stir the wool and a special bat to beat the cloth.[10] Roman sources document that fulling was often performed by walking in a tub in which the wool was soaked in a solution of warm water and detergent, most often stale urine or fuller's earth.[11] Although as noted earlier fullers are mentioned in Linear B documents, these texts do not report on the fulling process, and therefore little is known of the fuller's technique in the pre-Hellenistic Aegean.

Documentary evidence indicates that fulling was a specialized, professional craft,[12] and woven cloth was brought to the fuller from across a wide region.[13] Fulling equipment, including the physical plant and tools of the trade, reflect an investment of capital[14] and therefore at least in the Roman world fulleries, also called *Fullonica* or *Fullonium*,[15] were often established in urban environments,[16] where we see either large workshops located along main thoroughfares or private fullonica attached to wealthy households.[17] References in 14th century Linear B documents may reflect a similar situation, where at least some fullers were employed as craft specialists attached to the royal court.[18]

Fullers require access to running water, so that fulleries often include either large storage tanks

[6] Mazow 2008.

[7] Hills 1990, 816.

[8] Forbes 1964; Pekridou-Gorecki 2004; Smith 1890, 551; Wild 1970, 2008. But see above footnote 2.

[9] One should keep in mind, however, that while historians tend to bring together data from a wide range of geographic and chronological sources in an attempt to more fully flesh out the meager evidence, different techniques, activities and processes may have been utilized in Egypt, Mesopotamia and the Mycenaean world. Compiling these together as one homogenous tradition may impede our ability to recognize technological differences, developments and boundaries, something that I plan to pursue in future research.

[10] Forbes 1964; Lutz 1923, 99–101; Petzel 1987, 26–28, 172–173.

[11] Jacob 1969; Smith and Wayte 1890, 553. In *The Natural History* (Book 28), Pliny recommends human urine as a preventative for gout because fullers, whose professional activities kept their feet steeped in urine, were unlikely to be troubled with gout.

[12] Forbes 1964; Pekridou-Gorecki 2004; Wild 1970, 2008.

[13] Barber 1992, 274.

[14] Pekridou-Gorecki 2004; Wild 1970, 82.

[15] Smith and Wayte 1890, 553.

[16] Wild 2003, 90.

[17] Forbes 1964; Moeller 1976, 80; Wild 1970, 82.

[18] Palaima 1997. Egyptian texts may also suggest a social distinction between "the washer [or fuller] of the Pharaoh" or the "royal chief bleacher," and the lower status washers and launderers. See Lutz 1923, 99–100.

or are located along streams. However, water storage or riverine location is not unique to fulleries and therefore these features are not sufficiently diagnostic.[19] The only diagnostic feature of a fullonica, as Wild states, are "the alcoves … containing the tubs in which the cloth was trodden." [20] Bradley further argued that to meet sufficient criteria to be identified as a fullonica "we would expect clear indication of a number of stalls, each with space for its own tub in which cloth may have been trodden. One would expect dividing walls between the stalls or evidence for rails to provide support against slipping."[21]

Given this information, how might a fulling workshop be recognized in the archaeological record of the Late Bronze and Iron Age? Can we reconstruct an archaeological signature of fulling? Can we link the archaeological evidence with the references in the Linear B documents?

In the archaeological record of the Levant and Eastern Mediterranean basin, a number of installations have been identified as "bathtubs".[22] These are large, bath-shaped basins, constructed of limestone or clay. Typically, they have from two to four handles or lugs on the exterior; some have a small round hole cut through the base or side wall, possibly for drainage, and/or a sunken depression at one end, often referred to as a 'sump'. A few have additional modifications such as small 'seats', ledges or lugs that are generally explained as bath accessories. Some of these large tubs sit on a paved surface; others are embedded in the floor or engaged in a plastered installation, such that the dumping or pouring out of the tub's contents by tipping the basin, as usually suggested, seems difficult if not impossible to enact without damaging the installation beyond repair. Furthermore, the fact that *bathtubs* are often built-in installations indicates that the handles may not have played a significant role in the tub's use.[23]

Bathtubs have been reported from a variety of contexts, including tombs, sanctuaries, and private homes or large official rooms of elite residences. A number have also been found in industrial areas or areas defined as workshops but these contexts have been assumed to be secondary,[24] or that the association between *bathtubs* and workshops is one of ritual and production.[25] The recurrent discovery of *bathtubs* in industrial areas or workshops, however, suggests that these production contexts may not necessarily be secondary but areas associated with the primary function of *bathtubs.*

In my original survey of *bathtubs* in Cyprus and the Southern Levant,[26] I noted that a number of tubs were found in contexts that included a variety of weaving tools, such as both spool-shaped and 'Levantine' pierced loom weights; plying or twining bowls; large ceramic vats, which Sherratt[27] suggests may be connected with weaving; spindle whorls; and worked ceramic sherds,

[19] Wild 1970, 85–86.

[20] Wild 1970, 86.

[21] Bradley 2002, 26.

[22] *E.g.,* Cook 1959; Dothan 2003; Karageorghis 1998. For this paper, I will not be discussing the 'bathtub-shaped' burial *larnakes* found in tombs on Crete, and will limit myself to those *bathtubs* found in non-funerary contexts. The similarity between the two types of installations is the topic of further research and will be discussed separately.

[23] See Mazow 2008.

[24] Karageorghis 1998. But see now an interesting discussion of *bathtubs* at Akotiri, Thera, where Kriga posits a possible association between *bathtubs* and industrial activities, see Kriga 2003. I would like to thank Dr A. Papalas, Department of History, East Carolina University for his assistance in translating this article.

[25] *E.g.,* Collard 2008.

[26] Mazow 2008.

[27] Sherratt 1998.

which may have functioned as bobbins or spools as Petrie[28] and Cartland[29] proposed. While not conclusive evidence, the co-occurrence of *bathtubs* and weaving equipment seems strongly suggestive of a functional relationship and I have suggested that in these contexts *bathtubs* may have been used to scour and/or full wool.[30] In that previous study, I noted that the best evidence for the use of *bathtubs* at a large scale fullery comes from the site of Maa-*Palaeokastro* on Cyprus, where more than 12 clay tubs were found in Building III, a building whose plan includes a long narrow corridor backed by a series of rooms separated from each other by short partition walls.[31] When compared to reconstructions of Roman fulleries,[32] it is hard to miss the striking parallels between the arrangement of tubs at Maa and reconstructions of industrial sized Roman *fullonicae*, including the small individual cells, each with its own *bathtub* installation embedded in the floor. This pattern also fits the criteria for identifying fulling installations noted by Wild and Bradley.[33] Wild, in particular, describes a fulling installation in Roman Italy where "the terracotta bowls containing the mixture [of water and fuller's earth or stale urine] were set in the ground in rows of stalls and workers could rest their arms on the low dividing walls."[34]

Thus, while we have good evidence for a correlation between textile manufacture and *bathtubs* in Cyprus and in the Southern Levant, can we see this pattern replicated elsewhere in the Mediterranean world, especially given the reference to fullers in Linear B documents? Was the fuller, as Wild suggested, a relatively well known profession in the Mycenaean textile production system?

In non-burial contexts, *bathtubs* in the Aegean are reported from similar contexts to those noted for Cyprus and the Southern Levant.[35] T. Smith,[36] in her dissertation on late Bronze Age Argolid water management strategies, catalogued 14 examples of *bathtubs*: five from Mycenae; one from Tiryns; one from Midea; one from Zygouries and six from Pylos. The most common description of *bathtubs* finds them in rooms described as "bathrooms" set deep within large palatial buildings, the most famous of which is the tub from Pylos Room 43, adjacent to the "Queen's Megaron". To add to Smith's list, a tub from Thebes that often goes unmentioned in *bathtub* catalogues is also interpreted by the excavators as standing in a bathroom within a palatial residence.[37] Mycenaean Thebes was badly damaged by later construction projects and only partially excavated in small probes in and around the modern town; therefore it is difficult to reconstruct its architectural plan.[38] The significance of this site to our understanding of the function of *bathtubs*, with its large collection of Linear B tablets mentioning wool/LANA that were found in a workshop in proximity to a *bathtub*, has generally gone unnoticed.

[28] Petrie 1917, 53.
[29] Cartland 1918.
[30] Mazow 2008.
[31] Karageorghis and Demas 1988.
[32] *E.g.*, De Ruyt 2001; Pietrogrande 1976.
[33] Wild *op. cit.*
[34] Wild 2003, 90.
[35] *Ibid.*
[36] Smith 1995.
[37] Spyropoulos 1975, 16, 67.
[38] Spyropoulos 1975, 53–55. Confusion in the labeling of excavations areas in the various publications only adds to the difficulties in interpreting this site, see Shelmerdine 1997, 188, note 9. The issue is further confused in Demakopoulou's 1990 publication.

The Theban workshop[39] is an alignment of three rooms dated to LHIIIB. Spyropoulos termed the southern room "The Archives Room" based on the discovery of a group of tablets. The excavators called the middle room "The Bathroom" due to the recovery therein of a *bathtub, in situ* albeit broken. Only a small part of the third room, called "The Third Room," was excavated. The block of three rooms was preserved with a relatively solid wall in the west, but along the east side the architecture was damaged. The excavators reconstructed these rooms as "The West Wing" of a larger building. Spyropoulos suggested that this area was where industrial and administrative activities took place and identified the entire complex as the "great Mycenaean Palace of Thebes".[40]

Spyropoulos compared the Theban *bathtub* to the Late Helladic tub from Zygouries and the Pylos tub from Room 43, and points the reader to the latter example for a description of how *bathtubs* functioned. Although never discussed outright, Spyropoulos' description of finds reflects the common idea that tubs were used for personal bathing, an assumption that is also seen in Blegen and Rawson's reconstruction of the Pylian *bathtub*.[41] In the bathroom at Thebes, the elliptically-shaped clay *bathtub* was discovered built into a shallow pit up against Wall 1, the wall that separates the "Bathroom" from the "Archive Room." A large stirrup jar was found broken but *in situ*, standing to the northeast of the tub. Opposite the tub to the north was a long orthogonal base described as a "step" and one square posthole. Spyropoulos reconstructed a second posthole to the east, lining up these postholes with the location of two opposing holes in Wall 1. In doing this, he reconstructed small partition walls encircling the tub "to divide the bath area from the rest of the room" and thus "[i]n this way a small room was created exclusively for the bath."[42] Spyropoulos implies that *bathtubs* and bathing were a luxury, identifying the "bath" as one of those objects that can be considered "better' and at all events of another sort."[43]

Spyropoulos alternatively referred to the room adjacent to the tub room as either an archive or a workshop. Embedded within the room's floor were a number of installations, including a row of pits, a shallow channel, a row of stones and a hole in the floor. He hypothesized that a hole in the floor in the southwest corner of the room may have held the base of a "spindle" or "balance," and reconstructed wooden drying racks affixed in the three holes along the length of the shallow channel. Spyropoulos suggested that activities in this room included "washing and cleansing of the wool and probably its weighing and storing."[44] Spyropoulos also proposed that wool trading may have taken place here, and suggested that a seal impressed disk "constituted the 'trade-mark' of the Royal workshops of the Mycenaean Palace of Thebes,"[45] which "no doubt show[s] the guarantee of the Palace control on the quality of the product (wool)."[46]

It is clear from Spyropoulos' report that, although he recognized activities in a wool workshop included the wetting, washing and treading of wool, he described these activities as restricted to

[39] But see Shelmerdine 1997 for an alternative reconstruction.

[40] Spyropoulos 1975, 26, 67.

[41] Blegen and Rawson 1966.

[42] Spyropoulos 1975, 21.

[43] Spyropoulos 1975, 66.

[44] Spyropoulos 1975, 23–24, 53.

[45] Spyropoulos 1975, 53.

[46] Spyropoulos 1975, 40, his parenthesis.

the archive room.[47] No connection was made between the wool workshop and the adjoining *bathtub* room, except maybe to allow for an after work bath, and no further relationship was suggested between the Linear B texts and the activities undertaken therein. In an article on Mycenaean administrative practices, Shelmerdine dismisses the Theban "Bathroom" as providing any relevant data that might assist in identifying the function of this area.[48] Alternatively, I propose that the bathroom and the bath in particular may hold the key for identifying the room's, and even the building's function, as well as the relationship between these rooms and the tablets.

In her article, Shelmerdine remarks that the room in which the bath was found is rather large for a bathroom, comparing it to the much smaller tub room at Pylos (Room 43), which at 16.46 sq. m.[49] was half the size of the Theban bathroom. Interestingly, she implies the *bathtub's* use for wool washing by her suggestion that Sypropolous' partition walls could have served as privacy walls "perhaps indicat[ing] that [the tub] was a bathing place for people, *not just for wool*,"[50] as in Spyropolous' report, she places wool washing activities in the Archive room/Wool workshop, not in the Bathroom. More significantly, Shelmerdine rejects Sypropolous' idea that the archive room, which she calls "Room 1," was a wool workshop. She reconstructs his drying racks and hypothetical balance or spindle as shelves for storing wool, arguing that it would have been impractical to place washed tufts of raw wool on drying racks prior to the advent of fleece shearing technologies.[51] Instead, she proposes this room as a "repositor[y] and clearing house[],"[52] where raw wool was stored before being sent on to spinning and weaving workshops elsewhere for further processing.[53] There are, however, other activities associated with wool processing that may require periods of drying, such as washing, bleaching, dying and/or fulling.[54] All of these activities, and particularly fulling, can take place once the wool has already been woven into a textile. Reconstructing drying racks for finished, possibly fulled, textiles eliminates the problem foreseen by Shelmerdine of drying tufts of raw wool. Can we envision here racks of drying textiles that were first fulled in the adjoining *bathtub*, with the partitioned area around the tub as the remnants of the fuller's stall as described by Wild[55] and Bradley[56] to be a key feature for recognizing a fulling installation? In this reconstruction of the Theban wool workshop, the *bathtub* room would have been used to full woven woollen textiles. They would then have been dried in the archive/workshop room, where the textiles could have also undergone other finishing processes such as teasing, napping, trimming and pressing, or they could have gone on elsewhere for these activities.

The seventeen Linear B texts found in the Archive room may also fit such activities. Chadwick[57] analyzed these texts and identified them as a discrete group. Almost all of the tablets mention

47 Spyropoulos 1975, 23–24.
48 Shelmerdine 1997.
49 Blegen and Rawson 1966, 186.
50 Shelmerdine 1997, 388, italics mine, although it is not clear on what she bases this assumption.
51 A technique that seems not to have been introduced before the advent of iron sheep-shears, see Bernabé and Luján 2008, 218; Wild 2003, 48.
52 Shelmerdine 1997, 394.
53 Shelmerdine 1997, 389.
54 For dying see Barber 1991, 225–226, 275; for fulling, including washing and bleaching, see Barber 1991, 216, 274 and 284.
55 Wild 1970.
56 Bradley 2002, 26.
57 Chadwick 1975, 86.

wool/LANA and describe the distribution of specific quantities of wool to individuals or groups,[58] many of whose professional titles reflect that those who received the wool worked within the textile industry.[59] These texts do not mark the sale or export of finished goods or simply the storage of raw materials, but record transactions among steps within the organization of textile production.[60] One text in particular, OF 34, describes both 'new' (*ne-wa*) and 'old' (*pa-ra-ja*) wool. Shelmerdine[61] suggests that this may be a reference to long term storage. An alternative suggestion is that this text references the dual role of the fuller as both finisher of new cloth and launderer of old, that is to say, already worn items.[62]

Furthermore, one of the functions of the fuller, who received woven cloth from a number of sources,[63] may have been to serve as a central place, collecting the goods and converting them into finished products. In fact, drawing again on examples from the classical world, it fell under the province of some of the Roman fulleries to organize the trade in the finished product.[64] This suggestion would fit well with the model of Aegean textile production described by Barber as a "domestic workshop," a segmented system where the tasks, and those performing them, are geographically disbursed but tied into a centralized organization of production through the palace bureaucracy.[65]

It is becoming increasingly clear that Mycenaean palaces included craft activities and workshop areas among their various functions, if not even as a major focus of the palace.[66] If one of the tasks of Mycenaean administrative systems was organizing raw materials that required a high degree of crafts specialization, such as activities performed by attached specialists for the production of added-value prestige items,[67] then fulling, with its technique of improving the quality of a woollen textile, would certainly fit this model. If this system was centred on the palatial structures as argued by Schon,[68] Halstead[69] and Killen,[70] then it would follow that fulling, like perfumed oils[71] and chariot construction[72] among others, would be one of the craft activities located on the palace premises. This picture fits the Linear B evidence for the high status of fullers, the textual association of fullers with the *wanax*, and the location of *bathtubs* within the Mycenaean palaces.

My study of Bronze Age fulling practices is still at a preliminary stage, but opens the door for alternative explanations of *bathtubs* that are not dependent on our modern ideas of cleanliness and hygiene or ritual purity. While bath-shaped basins might have had a number and variety of uses, some are clearly found in relation to textile production. Linear B references to fulling note

[58] Chadwick 1975, 86–88.
[59] Chadwick 1975, 90.
[60] Cf. Shelmerdine 1997, 389.
[61] Shelmerdine 1997, 389.
[62] But see Bradley 2002; Wild 2008, 475.
[63] Pekridou-Gorecki 2004.
[64] Forbes 1964, 89.
[65] Barber 1991, 284–285.
[66] Laffineur and Bettancourt 1997; Preziosi and Hitchcock 1999.
[67] Galaty and Parkinson 2007, 7.
[68] Schon 2007.
[69] Halstead 1999.
[70] Killen 2008.
[71] Shelmerdine 1984.
[72] Schon 2007.

the existence of the fulling technology and the practice of the craft in the fourteenth century Aegean. While we cannot, as yet, support Wild's statement that fulling was a well-known activity in the Mycenaean world, I suggest that a contextual study of clay *bathtubs* provides good evidence to link the textual and archaeological records.

Acknowledgements

I would like to thank the organizers of the Textile Workshop at the 7th ICAANE for organizing this session and the ensuing publication.

Bibliography

Barber, E. J. W. 1991. *Prehistoric Textiles: The Development of Cloth in the Neolithic and Bronze Ages*. Princeton.

Bernabé, A. and Luján, E. 2008. Mycenaean Technology. *In* Y. Duhoux and A. Morpurgo Davies (eds) *A Companion to Linear B: Mycenaean Greek Texts and Their World, Vol. 1*, Louvain-la-Neuve, 201–233.

Blegen, C. W. and Rawson, M. 1966. *The Palace of Nestor at Pylos in Western Messenia*. Princeton

Bradley, M. 2002. 'It all comes out in the wash': Looking harder at the Roman *fullonica*. *Journal of Roman Archaeology* 15, 21–44.

Cartland, B. M. 1918. Balls of Thread Wound on Pieces of Pottery. *Journal of Egyptian Archaeology* 5, 139. and plate XII.

Chadwick, J. 1975. Part II: The Linear B Tablets. *In* T. G. Spyropoulos and J. Chadwick (eds) *The Thebes Tablets II*. Salamanca, 86–106.

Collard, D. 2008. *Function and Ethnicity: 'Bathtubs' from Late Bronze Age Cyprus*. Sävedalen.

Cook, J. M. 1959. Bathtubs in Ancient Greece. *Greece and Rome* 61, 31–41.

De Ruyt, C. 2001. Les Foulons, Artisans des Textiles et Blanchisseurs. *In* J.-P. Descoeudres (ed.) *Ostie – Port et Porte de la Rome Antique*. Genène, 186–191.

Demakopoulou, K. 1990. Palatial and Domestic Architecture in Mycenaean Thebes. *In* P. Darcque and R. Treuil (eds) *L'Habitat Égéen Préhistorique*. Paris, 307–317.

Dothan, T. 2003. The Aegean and the Orient: Cultic Interactions. *In* W. G. Dever and S. Gitin (eds) *Symbiosis, Symbolism and the Power of the Past: Canaan, Ancient Israel, and their Neighbors from the Late Bronze Age through Roman Palaestina*, 189–214.

Evans, A. 1964. *The Palace of Minos at Knossos, Vol I*. London

Evans, A. 1964. *The Palace of Minos at Knossos, Vol. III*. London

Forbes, R. J. 1964. Washing, Bleaching, Fulling and Felting. *In* R. J. Forbes (ed.) *Studies in Ancient Technology*, vol. IV. Leiden, 82–98.

Galaty, M. L. and Parkinson, W. A. 2007. Introduction: Mycenaean Palaces Rethought. *In* M. L. Galaty and W. A. Parkinson (eds) *Rethinking Mycenaean Palaces II*. Los Angeles, 1–17.

Halstead, P. 1999. Towards a Model of Mycenaean Palatial Mobilization. *In* M. L. Galaty and W. A. Parkinson (eds) *Rethinking Mycenaean Palaces: New Interpretations of an Old Idea*. Los Angeles, 35–41.

Hills, R. 1990. Textiles and Clothing. *In* I. McNeil (ed.) *An Encyclopaedia of the History of Technology*. New York, 803–854.

Jacob, A. 1969. Fullonica. *In* C. Daremberg and E. Saglio (eds) *Dictionnaire des Antiquités Grecques et Romaines*, vol. 12. Paris, 1348–1353.

Jongman, W. M. 2007. The Loss of Innocence: Pompeian Economy and Society Between Past and Present. *In* J. J. Dobbins and P. W. Foss (eds) *The World of Pompeii*. London/New York, 499–517.

Karageorghis, V. 1998. Hearths and Bathtubs in Cyprus: A 'Sea Peoples' Innovation? *In* S. Gitin, A. Mazar and E. Stern (eds) *Mediterranean Peoples in Transition*. Jerusalem, 276–282.

Karageorghis, V. and Demas, M. 1988 *Excavations at Maa-Palaeokastro 1979–1986*. Nicosia.

Killen, J. T. 2008. Mycenaean Economy. *In* Y. Duhoux and A. Morpurgo Davies (eds) *A Companion to Linear B: Mycenaean Greek Texts and Their World, Vol. 1.* Louvain-la-Neuve, 159–200.

Laffineur, R. and Betancourt, P. P. (eds) 1997. *TEXNH: Craftsmen, Craftswomen and Craftsmanship in the Aegean Bronze Age.* Philadelphia.

Lutz, H. F. 1923. *Textiles and Costumes among the Peoples of the Ancient Near East.* New York.

Mazow, L. B. 2008. The Industrious Sea Peoples: The Evidence of Aegean-Style Textile Production in Cyprus and the Southern Levant. *In* T. Harrison (ed.) *Cyprus, the Sea Peoples and the Eastern Mediterranean: Regional Perspectives Of Continuity And Change. Scripta Mediterranea* Vol. XXVII–XXVIII, 291–321.

Moeller, W. 1976. *The Wool Trade of Ancient Pompeii.* Leiden.

Palaima, T. G. 1997. Potter and Fuller: The Royal Craftsmen. *In* R. Laffineur and P. P. Betancourt (eds) *TEXNH: Craftsmen, Craftswomen and Craftsmanship in the Aegean Bronze Age*, vol. II. Philadelphia, 407–412.

Palmer, L. R. 1963. *The Interpretation of Mycenaean Greek Texts.* Oxford.

Pekridou-Gorecki, A. 2004 Fulling, Fuller. *In* H. Cancik and H. Schneider (eds) *Brill's New Pauly: Encyclopaedia of the Ancient World* Vol. 5. Leuven, 576–577.

Petrie, W. M. F. 1917. *Tools and Weapons, Illustrated by the Egyptian Collection in University College, London, and 2,000 Outlines from Other Sources.* London.

Petzel, F. E. 1987. *Textiles of Ancient Mesopotamia, Persia, and Egypt.* London.

Pietrogrande, A. L. 1976. *Le Fulloniche.* Rome.

Pirson, F. 2007. Shops and Industries. *In* J. J. Dobbins and P. W. Foss (eds) *The World of Pompeii.* London/New York, 457–473.

Preziosi, D. and Hitchcock, L. A. 1999. *Aegean Art and Architecture.* Oxford.

Schon, R. 2007. Chariots, Industry, and Elite Power at Pylos. *In* M. L. Galaty and W. A. Parkinson (eds) *Rethinking Mycenaean Palaces II.* Los Angeles, 133–145.

Shelmerdine, C. W. 1984. The Perfumed Oil Industry at Pylos. *In* C. W. Shelmerdine and T. G. Palaima (eds) *Pylos Comes Alive: Industry and Administration in a Mycenaean Palace.* Los Angeles, 81–95.

Shelmerdine, C. W. 1997. Workshops and Record Keeping in the Mycenaean World. *In* R. Laffineur and P. P. Betancourt (eds) *TEXNH: Craftsmen, Craftswomen and Craftsmanship in the Aegean Bronze Age*, vol II. Philadelphia, 387–396.

Shelmerdine, C. W. 1999. Administration in the Mycenaean Palaces: Where's the Chief? *In* M. L. Galaty and W. A. Parkinson (eds) *Rethinking Mycenaean Palaces: New Interpretations of an Old Idea.* Los Angeles, 19–24.

Sherratt, S. 1998. "Sea Peoples" and the Economic Structure of the Late Second Millennium in the Eastern Mediterranean. *In* S. Gitin, A. Mazar and E. Stern (eds) *Mediterranean Peoples in Transition.* Jerusalem, 292–313.

Smith, T. K. 1995. *Water Management in the Late Bronze Age Argolid, Greece.* UMI dissertation service.

Smith, W. 1890. Fullo. *In* W. Smith and W. Wayte (eds) *A Dictionary of Greek and Roman Antiquities.* London, 551–553.

Spyropoulos, T. G. 1975. Part I: The Excavation. *In* T. G. Spyropoulos and J. Chadwick (eds) *The Thebes Tablets II.* Salamanca, 10–81.

Ventris, M. and Chadwick, J. 1973. *Documents in Mycenaean Greek.* Cambridge.

Waetzoldt, H. 1972. *Untersuchungen zur Neusumerischen Textilindustrie.* Rome.

Wild, J. P. 1970. *Textile Manufacture in the Northern Roman Provinces.* Cambridge.

Wild, J. P. 2003. The Romans in the West, 600 BC–AD 400. *In* D. Jenkins (ed.) *The Cambridge History of Western Textiles.* Cambridge, 77–93.

Wild, J. P. 2008. Textile Production. *In* J. P. Oleson (ed.) *The Oxford Handbook of Engineering and Technology in the Classical World.* Oxford, 465–482.

13. Textile Production and Consumption in the Neo-Assyrian Empire

Salvatore Gaspa

Textile Manufacture in the Economy of Ancient Assyria

The present study is an overview on textile production and consumption in Assyria in the evidence of the texts of the Neo-Assyrian Empire (9th–7th centuries BC). As to production, documents from the archive of Nineveh allow us to evaluate how the raw materials and the finished textile products were managed by the central administration of the Assyrian state. Special attention shall be given to the study of the activity of the various palace-linked textile workers and, among them, of the female weavers in the light of both Middle and Neo-Assyrian texts. Textile consumption in Assyria shall be examined by taking into consideration the palace, the government, and the private sectors. The data extracted from Middle and Neo-Assyrian sources concerning the production and consumption of textiles of different use in the Assyrian society are illustrated through a number of charts.

The manufacturing of textiles is one of the oldest activities emerging from textual evidence of ancient Assyria. According to economic documents found in the 19th–18th century BC Assyrian trading colonies in Anatolia, textiles were a fundamental component of the merchandise exported by Assyrian merchants to Anatolia.[1] Old Assyrian letters show that the female relatives of the merchants were largely responsible for producing the textiles necessary for trade. For example, we have information about numerous varieties of textiles, the amount of wool needed for textile manufacturing, the quality, finishing treatment, and other important details about the finished products.[2] In addition to this home-based production, a large part of the textiles exported to Anatolia from Assyria derived from an institutional textile industry.[3] It has been suggested that this institutional textile industry, which, however, begins to be attested in the Middle Assyrian period, probably began during the Old Assyrian period and that the expansion of this economic sector towards an export-oriented production was probably due to the large amount of wool that the city of Assur received from local sheep-farmers. The local textile industry also became

[1] Dercksen 2004, 14. On the textiles produced in Assur or in its vicinity and exported to Anatolia, see Michel and Veenhof 2010, 210, 218, 219, 222, 225–226.
[2] Veenhof 1972, 103–123.
[3] Dercksen 2004, 15–17. See also Thomason in this present volume.

an important factor for the economic development of the Neo-Assyrian Empire. In addition to wide variety of locally produced textiles destined to the needs of the ruling elite and Assyrian state there were textile products imported from abroad that entered Assyria as luxury items. The Assyrian expansion of the first millennium BC allowed the Assyrians to open up new trade horizons. The circulation of goods (both as raw materials and finished textile products) and textile specialists within the imperial territory was certainly favoured by the establishment of an efficient road system linking the main cities of the homeland to the provincial centers and rural villages on the remote periphery and by a more widespread control of the administrative apparatus. Unfortunately, an idea of the wealth of this local textile industry can only be derived from epigraphic sources and, on iconographical level, from the reliefs decorating the royal palaces and monuments as well as from various artifacts dating back to the first millennium BC, since no physical remains of Assyrian textiles have survived, except for textile fragments found in the Neo-Assyrian royal graves of Nimrud more than twenty years ago. In origin, these fragments consisted of finely executed and decorated linen fabrics which presumably clothed or shrouded the buried body or, alternatively, were just placed on top of it.[4] These remnants were also characterized by embroidered tassels and decorative elements (gold rosettes, stars, circles, triangles, carnelian beads) which were originally sewn onto the garments. The study which follows will try to shed light on the rich textile industry that developed during the Neo-Assyrian period (9th–7th centuries BC) in the light of the documents from the main archives.

The Textile Industry in the Neo-Assyrian Empire

As in other Near Eastern regions, textile workers in Assyria used wool fibers (*šaptu/šipātu*)[5] and linen fibers (*kitû*).[6] These common raw materials were used by weavers and tailors to produce textiles. Information about the different stages of textile manufacture in the first millennium BC Assyria can be found in the professional titles of the workers involved in the different phases of wool and linen processing, *i.e.* dyeing, fulling and bleaching, weaving, stitching and dress-making, and last but not least cloth-washing. However, written documentary sources did not provide information on the linen and wool processing phases that occurred before the spinning and weaving phases. As regards linen, once harvested, the flax had to be pulled, rippled, retted, bracked, scutched, and hackled, while wool had to be plucked, washed, and combed.[7] Wool derived not only from sheep fleece, but also from goat hair.[8] Different species of wool-bearing sheep were the subject of administrative records: a Middle Assyrian inventory of sheep and goats from Tell Billa includes sheep from the land of Ḫabḫu (a region to the north of Assyria) as well as other wool-bearing sheep.[9] Middle Assyrian documents also show that city governors received wool

[4] Crowfoot 1995, 113.

[5] CTN 3, 4 r.9; ND 2355:14 (CTN 5, 193, pl. 38); PVA 213, 215; SAA 1, 33:19; SAA 3, 10:18; 11:11; 34:42; SAA 10, 87 r.3; SAA 11, 28:13; 100:3; SAA 12, 68:19; SAA 17, 136:9; SAA 18, 19:3; 103:15; StAT 2, 164:11; 243 r.7.

[6] CTN 2, 155 r. v 13'; Ki 1904–10–9,154+r.49, 50 (*Iraq* 32 [1970], 152–153, pl. XXVII); PVA 212, 234; SAA 7, 62 iv 8'; 96 r.3'; 97 r.1; 103:4'; 104 r.2'; 108 r. ii' 3', 5', 7'; 109 iii 2'; 111:7, r.2', 4'; 112:10'; 115 i 1, 11, ii 5, 23, r. ii 3, 13, 15; 128:4; 129:6', 10'; SAA 11, 26 r.8; SAA 16, 82 r.5; StAT 2, 164:10, 16.

[7] McCorriston 1997, 522–523.

[8] See CTN 3, 4 r.9; PVA 215.

[9] Billa 36:3–4 (JCS 7 [1953], 131, 160).

and (goat) hair directly from the shepherds.[10] The use of goat hair continued in the first millennium: an administrative list from the North-West Palace of Kalḫu records amounts of wool and goat hair,[11] most likely destined to be processed by weavers working at the local palace-linked textile factory. The plucking or carding of wool is probably witnessed by the word *gerdu*, 'plucked or carded wool',[12] commonly used in some Neo-Assyrian contracts, where it is associated with the word *kurru*, the fluid used by tanners in leather processing.[13] Three terms refer to the tuft of wool, namely *itqu*,[14] *nipšu*,[15] and *siggu*.[16] The dyeing activity basically consisted of placing the textile materials in a solution of water and natural dyes such as madder, woad, and murex snail, and a mordant to set the dyes to the fibers. This was performed by the *ṣāpiu*, 'dyer',[17] also called *muṣappiu*,[18] a specialization of which was probably the *mubarrimu*, 'polychrome dyer'.[19] Dyed wool came in different colours, as witnessed by terms such as *argamannu*, 'purple wool',[20] *ḫašḫūru*, 'apple-coloured wool',[21] *ḫašmānu*, 'greenish blue wool',[22] *ḫinziribu*, 'blue-green colour',[23] *inzurātu*, 'scarlet',[24] *napāsu*, 'red wool',[25] *sāntu*, 'red wool',[26] *sūntu*, 'red wool',[27] *ṣalittu*, 'blue-black wool',[28] *ṣirpu*, 'red-dyed wool',[29] *šeburtu* (a colour of wool?),[30] *tabrību*, 'red wool',[31] *takiltu*, 'blue-purple wool',[32] *uqnâtu*, 'blue wool',[33] *urṭû*, 'greenish-blue, light-blue wool'.[34] A generic term indicating coloured wool is *barruntu*,[35] while *tabrīmu* denotes a polychrome variety.[36] Madder (*ḫūrutu*)[37] was used to dye the fibers red. The dye called *ḫuḫḫurāti* (a scarlet dye?)[38] was also used for this purpose.

[10] MARV III, 73.

[11] CTN 2, 254.

[12] SAA 6, 20:3; 96:16; SAA 14, 90:12; 176:5; 204 r.1; 350 r.6; 463 r.3; StAT 2, 243 r.7.

[13] ADW 23 e.12; 28 r.25; 33 r.20; CTN 2, 15 r.28; 17 r.23; 45 e.21; SAA 6, 20:3; 96:16; SAA 14, 90:12; 176:5; 204 r.1; 350 r.6; 463 r.3; StAT 2, 243 r.7. See Radner 1997, 189–192.

[14] PVA 217.

[15] van Driel 1969, 194, A 127:19'; Menzel 1981, no. 49B:3'; SAA 7, 174:6'; SAA 10, 321 r.8, 14.

[16] SAA 3, 14 r.13; SAA 7, 96:9'.

[17] SAA 5, 205:8; 296 r.3. For dyers in the Middle Assyrian period, see Whiting 1988, 100:2.

[18] MSL 12, 238 r. ii 15; SAA 12, 65:4'.

[19] MSL 12, 238 r. ii 14.

[20] ND 2311:6 (*Iraq* 23 [1961], 20, pl. X); SAA 10, 182:12, r.5; TH 62:3.

[21] PVA 208.

[22] PVA 207.

[23] PVA 209.

[24] PVA 205.

[25] BIWA A iii 43; F ii 66; Fuchs 1994, Prunk 130; Zyl 25; RIMA 3, A.0.103.1 iii 12; Tadmor 1994, Summ 7:48.

[26] PVA 210; SAA 11, 26 r.11; SAA 16, 63:29; 82 r.6; 83 r.5; 84 r.1, 6.

[27] CTN 2, 1:7', 8'; PVA 204. But see AEAD, 101b: "violet wool".

[28] PVA 203, 211; SAA 3, 35:33; SAA 16, 82 r.7; 216:11.

[29] PVA 220. For Middle Assyrian attestations, see KAV 99:22; 100:14; 105:12, 15.

[30] TH 62:1.

[31] CTN 2, 1:6'; Ki 1904–10–9,154+r.37 (*Iraq* 32 [1970], 152–153, pl. XXVII); ND 2758:6' (*Iraq* 23 [1961], 48, pl. XXVI); PVA 206; SAA 3, 14 r.13; 34:15, 42; 35:33; SAA 7, 64 r. i' 7'; 66 r. ii' 9'; 96:10'; 105:5', 12'; 110:1, 4, 7, 10, r.1; 115 r. i 10, 13, 16, 17, 19; 116 r.4'; 121 r. i' 5; 174:6'; 176 r.2'; SAA 11, 36 ii 19; StAT 3, 1:8, r.18, 19.

[32] SAA 18, 103:15.

[33] StAT 3, 1 r.29; TH 62:4.

[34] PVA 207; TH 62:2.

[35] PVA 219.

[36] KAR 141:12, 16, 21 (TuL, 88).

[37] SAA 7, 115 ii 6; 116 r.4'.

[38] SAA 7, 115 r. i 12, 15, 19; 121 r. i' 5.

In fact, two administrative records list the amounts of this dye for (the processing of) red wool.[39] The mordant frequently used by the Assyrian dyers to set the colour was alum (*gabû*). The wide use of this mineral explains the importance of occupations specialized in the procurement of this material: interestingly, the *ša-gabêšu*, a worker in charge of collecting or processing the alum[40] is among the professionals who were transferred from Assur to Kalḫu under the reign of Assurnaṣirpal II (883–859 BC). As for wool terms, it is clear that other qualifications were certainly used in addition to those mentioned above. An inventory text from Kalḫu, which records a number of unsheared rams (*labšūte*),[41] also mentions varieties of sheep called *ṣu'ubtu* (a sheep with a white curly fleece?)[42] and UDU.SI.LUḪ,[43] the latter being a wool qualification which is also found in the name of the textile TÚG.SI.LUḪ.[44] Apart from wool and linen, textiles were also made from *būṣu*, 'fine linen, byssus'.[45] There is no evidence of silk, although it has been suggested that this imported material was indicated with the logogram for linen (GADA).[46] Instead, references made by Sennacherib to the wool-bearing trees in his royal garden and the fact that people collected and wove this type of wool into garments,[47] show that cotton was known in this period. Bleaching and fulling were executed by a specialist called *ašlāku*.[48] The fullers were divided into teams under the supervision of the *rab ašlāki*, 'chief fuller'.[49] Among the substances used by fullers was also natron (*nitiru*), which occurs in a Neo-Assyrian letter in association with alum.[50] The terminology of textile products is much varied; however, its clarification is beyond the aim of this study.[51] Evidence for the lexicon of textile products, especially garments, may be found in administrative and legal documents from the archives of Nineveh (Kuyunjik), Assur (Qal'at Šerqāṭ), Kalḫu (Nimrud), Guzāna (Tell Ḥalaf), Šibaniba (Tell Billa), and Tušḫan (Ziyaret Tepe). Most of the texts dealing with textiles in the Neo-Assyrian period are documents issued by the central administration of Nineveh and concern the accounting of textile products in the context of transactions made in the palatine milieu involving palace professionals. These documents include labels, presumably attached to the textiles (SAA 7, 93–106),[52] a group of lists on regular tablets with one or more

[39] SAA 7, 115 r. i 12–13, 15–16, 19; 121 r. i' 5.

[40] SAA 12, 83 r.15. For a discussion on this occupation, see Radner 1999, 122, 124, 125.

[41] ND 2311:13 (*Iraq* 23 [1961], 20, pl. X).

[42] SAA 5, 256:12.

[43] SAA 12, 73:3'.

[44] CTN 2, 1:4'; PVA 256; SAA 7, 96:10'; 97:2'; 105:5; 117 r.5; StAT 3, 1 r.3, 7. I wonder whether the so-called 'SI.LUḪ-textile has to be identified with the Middle Assyrian *siraḫ*-garment which is attested in syllabic writing in MARV III, 5 e.25' [x TÚ]G.*si-ra-aḫ*. Jakob explains the word *siraḫ* as a variant of the textile qualification *sirnaḫ* (Jakob 2003, 420). However, the sign LUḪ may also be read as RAḪ; accordingly, the name of the textile in question should be rendered as *si-raḫ* in all the Neo-Assyrian attestations. Further, both the Middle Assyrian *siraḫ* and the Neo-Assyrian SI.LUḪ designate a woollen textile. In Neo-Assyrian texts it is described as a textile made of red and black wool (SAA 7, 110:1–3; cf. StAT 3, 1 r.20); among the various types of SI.LUḪ there were also a Gutian (PVA 261) and a Tabalean variety (StAT 3, 1 r.24).

[45] SAA 1, 34:11; SAA 7, 62 r. ii 5, iii 3.

[46] Good 2007, 146. An amount of 31 talents of *ṭi-bu* GADA, 'twine of silk(?)', occurs among imported wool and minerals in a letter of the 7th century BC, see SAA 16, 82 r.5.

[47] Luckenbill 1924, E1 vii 56, viii 64.

[48] CTN 3, 36 r.16; NATAPA 2, 73 r.36; StAT 3, 3 r.28; 34:4, r.13; ZTT 6:5; ZTT 7:5. On the occupation of the Middle Assyrian fuller, see Jakob 2003, 428–429.

[49] NATAPA 2, 72:2; SAA 7, 4 r. ii 9; 12:3; SAA 11, 36 i 17, ii 21; SAA 12, 77 i 4'; SAA 14, 424 r.25; StAT 2, 141 r.15.

[50] SAA 16, 82 r.8–9.

[51] For a discussion on the Neo-Assyrian textiles, see Villard 2010, 388–397.

[52] Fales and Postgate 1992, xxvi.

columns of text, which also list textiles (SAA 7, 107–109), and memoranda on cloths to be given to the administration and distributed to individuals (SAA 7, 112, 113). A different category of administrative texts is specifically devoted to the management of raw textile materials, *i.e.* wool and flax, as well as madder. These records contain information on the quantities of wool (SAA 7, 110), wool and flax (SAA 7, 111; 115), or wool and madder (SAA 7, 116). This second category is particularly interesting since it provides a number of details about the different uses of raw materials. One of the two records listing flax and wool amounts is divided into four columns (SAA 7, 115): two on the obverse and two on the reverse. The account, which was probably written under the reign of Esarhaddon (680–669 BC), refers to the consumption (*akiltu*) of linen, wool, and madder in a specific period of time by a number of cities, palaces, professionals for different purposes. The text is divided into four sections (see Chart 13.1): the first section is dedicated to linen fiber, the second to madder, and the third to red wool, while a fourth section relates to linen. Quantities of the listed items are expressed in the Assyrian weight units, *i.e.* talents (one talent = *c.* 60.6 kg or 30.3 kg) and minas (one mina = *c.* 1.01 kg or 0.505 kg).[53] Although the actual period of the expenditure of flax, wool, and madder is not specified in the headings of each of the four text sections, it most likely corresponds to a whole year in light of two references included in the second linen section and in the madder section.[54] The consumption of textile materials mostly relates to cities in central Assyria, such as Nineveh, Kalḫu, Assur, Adian, and Kilizi, but the first linen section also mentions Naṣībina, a town in the Ḫabūr basin. The raw materials were mainly used by high-state officials and palace-linked professionals, as well as individuals whose occupation is unknown. Textile professionals are also mentioned in the account such as tailors, who receive the linen[55] and the madder.[56] Other professionals listed are textile workers who produced special types of cloths, such as scarf weavers[57] and armor-makers or dealers[58] who consumed quantities of madder. As for the destination of the textile materials, the finished products are not always recorded. Unfortunately, the few attestations regarding finished products do not specify the place (city, palace unit) or the professional or individual involved. However, it is clear that the accounting statements mostly concern textiles used in palaces and temples. According to the text, linen for producing blankets, and veils of unknown use for the temple of Ištar (for devotees or personnel affiliated to the goddess?), beds, chairs, sandals of the Palace. There are also quantities of linen used for producing threads and twines and for preparing the hind-part of torn garments. Another amount of linen was used for special requirements and for boats. References regarding the use of red wool are limited to a generic mention of statues, presumably relating to statues of gods clothed with red woollen garments and to regular consumption, which also included special and unspecified needs. This section also provides information on the quantity of scarlet dye needed to dye specific amounts of red wool: 22 talents of *ḫuḫḫurāti*-dye were needed for seven talents and ten minas of red wool, while 30 talents and 20 minas of dye were needed for 15 talents and ten minas of wool.[59] In short, 22 talents of red

[53] On the heavy and light norms of the Assyrian weight system, see Postgate 1976, 64–66.

[54] SAA 7, 115 r. i 2, ii 6.

[55] SAA 7, 115 i 13, r. ii 7.

[56] SAA 7, 115 ii 21.

[57] SAA 7, 115 r. i 7.

[58] SAA 7, 115 r. i 8.

[59] SAA 7, 115 r. i 11–16.

wool could be produced with 53 talents of this type of dye.[60] Unlike the picture provided by the consumption of linen and wool, we find more details on the textiles which were produced by using madder. This type of colorant was used for dyeing garments and other textile products. The text mentions gowns, tunics, cloths for military units (wraps for the Gurraeans, ... cloths for the chariot-fighters, cloaks for the archers), as well as *išḫu*-cloths for the wrappings of sashes and linen twines. The use of a quantity of madder 'for the entrance' was probably allocated to the dyeing of fibers for the drapes or carpets that adorned the doorway of the royal residence. Other amounts were allocated to the gate-overseer(s), presumably to dye garments used by these professionals, and to boats. The last allocation refers to linen for boats mentioned in the first linen section of the text. The use of madder for boats is not mentioned; perhaps, the listed amounts of linen and madder corresponded to quantities that were transported by boatmen through the waterways of the imperial territory during the year for trading purposes. According to another administrative document (SAA 7, 116), the central administration received wool and madder from different Assyrian provinces and cities. The text is separated into columns and although the top of the tablet with the column headings is broken, we may suppose that the second column was created by the scribe to record the amounts of madder. If so, the contribution made by Karkemiš must have consisted of 100 talents of red wool and two talents of *Rubia tinctorum*.[61]

Textile artisans

Let's now look at the activity of the textile artisans. Professionals involved in the production of garments and other textile products were principally the *ušpāru*, 'weaver',[62] and the *kāṣiru*, 'tailor'.[63] The head of the teams of weavers and tailors working for the Palace were respectively the *rab ušpāri*, 'chief weaver',[64] and the *rab kāṣiri*, 'chief tailor'.[65] In some cases, the connection of these professionals to the palace households is clearly stated. Palace tailors are mentioned in contracts from Assur[66] and Nineveh.[67] A chief tailor of the king of Babylonia is mentioned in a fragmentary letter sent to Assurbanipal.[68] We know that there were palace weavers working for the magnates of the Assyrian Empire, as witnessed by a letter regarding wool to be supplied to

[60] SAA 7, 115 r. i 17–19. However, Postgate considers unlikely that *ḫuḫḫurāti* is to be referred to a dye. See Fales and Postgate 1995, 197. See also AEAD, 38a s.v.: "a dye or a kind of wool".

[61] SAA 7, 116:4'. Red wool and madder are also mentioned in *ibidem* r.4'.

[62] CTN 1, 1 ii 6, r. i 27e; CTN 2, 91 r.32, 34, 35; 97 r.2; CTN 3, 145 r. i 16; MSL 12, 238 r. i 16; NATAPA 1, 35 r.25; ND 2803 i 15, 25 (*Iraq* 23 [1961], 55–57, pls. XXIX-XXX); ND 2316:6 (*Iraq* 16 [1954], 40, pl. VII); ND 5448 r.21 (*Iraq* 19 [1957], 128, pl. XXVIII); SAA 6, 13 r.2', 3'; 19 r.11'; 90 r.11; 91 r.3'; 96 r.14; 271 r.10; 294:1'; SAA 7, 23 r.10; 172 r.10; SAA 11, 202 ii 17'; 222 r.11; SAA 12, 83 r.7; 94:3; SAA 13, 145:7; 186 r.3, 9; SAA 16, 83:7; 84 r.8; ZTT 22:12.

[63] ADW 51 r.8; Borger 1956, Frt J i 12; MSL 12, 238 r. i 31; NATAPA 1, 35 r.24; NATAPA 2, 75 r.32; SAA 4, 142:9; 144:9; SAA 5, 215:16; SAA 6, 31 r.23; 81 r.6; 91 r.2'; 124 r.7, 8; 313:4; SAA 7, 20 r. i' 3; 21:8'; 22:4'; 115 i 13, ii 21, r. ii 7; SAA 10, 294 r.28; SAA 11, 177:6'; SAA 15, 214 r.1; ZTT 22:12.

[64] SAA 6, 90 r.10; 163 r.14'; 190:5.

[65] CTN 2, 51 r.9; MSL 12, 238 r. i 30, 32; SAA 3, 20 r.4, 6; SAA 5, 91:3; SAA 7, 126:5; SAA 16, 63 r.16; 76 r.4; SAA 18, 21:12, r.2; 123 r.6, 10, 11; 157:7', 8'; 168 r.1'; 178:2.

[66] NATAPA 2, 75 r.32.

[67] SAA 6, 91 r.2'.

[68] SAA 18, 168 r.1'.

weavers.[69] Furthermore, a weaver belonging to the vizier's household is named as a witness in a Ninevite contract.[70] The household of the Assyrian queen also had its own textile workers. In a document regarding a donation of a devotee to a priest of Ninurta, the owners of the man being sold are two brothers, sons of Issār-šumu-iddina, weaver of the queen.[71] We also know that the weaving activity was performed by women, as confirmed by attestations of the professional title *ušpārtu*, 'female weaver'.[72] In fact, dependent women working for the Palace are documented both in royal letters and in administrative texts. In a letter sent by the crown prince Sennacherib to Sargon II, the king's female weavers (*ušpārāti ša šarri*) are mentioned as being the only ones who can select the wool brought by the envoys of Kummuḫ to the Assyrian king as a tribute.[73] Evidently, the expertise of these royal female weavers regarding the quality of wool was not only highly esteemed, but also well known outside Assyria. Another female weaver is mentioned in a schedule, dating to the reign of Assurbanipal, together with other individuals.[74] Foreign women also worked as weavers in the palace household. In fact, an administrative document listing Egyptian deportees and their possessions mentions four female weavers;[75] of these women only the name of Eša-rṭeše is preserved.[76] This is also documented in texts of the Middle Assyrian period, which show that the palace weavers also included people of Cassite and Hurrian origin, most likely deportees.[77] We also know that the weaving activities performed by these female weavers were supervised by other women. An astrological report informs us that a certain Damqâ was given female weavers to supervise.[78] This aspect is confirmed by a Middle Assyrian list of textiles and female weavers (detailed below), where the groups of women are followed by a chief female weaver.[79] It should be pointed out that the role of women in the textile industry was deep-rooted in the social and economic history of Assyria. As mentioned, already in the Old Assyrian period, women of the city of Assur were directly involved in producing textiles for exporting and selling by Assyrian merchants in the Assyrian trade outposts of Anatolia. An institutional textile industry managed by the palace's central administration is documented in texts of the Middle Assyrian period. A three-columned list of the reign of Tukultī-Ninurta I (1233–1197 BC) from Assur records garments in association with quantities of wool, measured in minas, and weavers, the majority of which are women (MARV III, 5).[80] This document possibly records the work quotas of textile products that

[69] SAA 16, 83:7–8.

[70] SAA 6, 19 r.11'.

[71] SAA 12, 94:3.

[72] SAA 1, 33 e.24; SAA 11, 169 r.4; SAA 12, 63:7'. For Middle Assyrian attestations, see, *e.g.*, Billa 61:10 (JCS 7 [1953], 135, 166); MARV III, 5:4'–r.33', 38'–39'.

[73] SAA 1, 33:19–r.3.

[74] SAA 12, 63:7'.

[75] SAA 11, 169 r.1–4.

[76] SAA 11, 169 r.3. See PNA 1/II, 407a.

[77] Hurrian names are frequent both among weavers and chiefs of weavers, see Jakob 2003, 412–416 and fn. 6 for references. Three Cassite weavers are documented in a list of barley rations, see MARV III, 3 r.59–61. Note that in Jakob 2003, 413 the attestation referring to the third Cassite weaver Ilī-Adad has been omitted.

[78] SAA 8, 305 r.6–8.

[79] MARV III, 5:7' MÍ.*a-ḫu—bal-ti* GAL—M[Í.UŠ.BAR.MEŠ], *ibid.* 15' MÍ.*pi-ri-im-du-gi-li* GAL—MÍ.UŠ.BAR.MEŠ, *ibid.* e.24' MÍ.*ud-ḫ* [*a-me-ni* GAL—MÍ.UŠ.BAR.MEŠ], *ibid.* r.31' MÍ.d*iš*$_8$*tár-ki-mu-ia* GAL UŠ . BAR.MEŠ].

[80] MARV III, 5. An Assur list of feminine names of the Middle Assyrian period has been considered as referring to female weavers, see Weidner 1935–36, 42–43, text no. 100 and the comment of Liverani in McCorriston 1997, 537.

were needed by the central administration.[81] If so, the amounts of wool listed would have been processed by the weavers to produce the required textiles. This list includes various garments and other textile products, some of which were used by the Assyrian army (see Chart 13.2). According to the text, the palace weavers, which are organized into nine teams, were in charge of producing a piece of tabby,[82] perhaps to be used for tents in military camps, various types of 'togas' and coats,[83] leggings,[84] caps,[85] and other clothing items.[86] In addition, an unspecified amount of raw material, namely coloured fabric, is given to two female weavers for producing the hem of 12 'togas'.[87] It is interesting to note that the duties of the weavers also include the production of covers for chariots.[88] The textile material used for this purpose was probably applied to the inner cover of the vehicle. Other textile materials are used for specific parts of the chariots, called 'the necks'.[89] As for the composition of the teams of weavers, we may see that the several groups of workers comprised a number of weavers ranging from a minimum of two to a maximum of seven individuals. Since most of the groups are formed by women, the inclusion of only four men leads to speculate that they may be specialists. In fact, two men are in charge of working on the chariots,[90] while another two weavers are in charge of producing *lippu*-garments.[91]

In the Neo-Assyrian era, palace households in the main cities of Assyria proper and provincial capitals included a large number of palace women. As it has been suggested, it is probable that the *šakintu*, 'the harem manageress', and the palace women living in various central and peripheral palaces of the imperial territory were involved in part of a large-scale textile industry controlled by the central administration.[92] If so, the large amounts of flax and wool recorded in the aforesaid list (SAA 7, 115) were distributed to and consumed by various palace households and cities and were probably processed into finished textile products by the palace women living in the palaces of the cities mentioned in the text. The palace households included royal women and weavers, consisting of around 50 to 100 royal women and 20 individuals in the case of weavers,[93] as shown by an account of rations from Kalḫu of the reign of Sargon II (721–705 BC).[94] In this connection, it is interesting to note that 25 weavers worked in the Review Palace of Kalḫu during the reigns of Adad-nerari III and Shalmaneser III (*c.* 792–774 BC).[95] It is evident that the textile professionals working for the Palace came from different regions of the empire. An administrative document from the royal archive of Nineveh lists 145 weavers from different places of the imperial territory on its reverse side, namely from the province of the Chief Cupbearer, Raṣappa, the province

[81] Postgate 2001, 375.

[82] MARV III, 5:1' TÚG.ḪI.A *si-ru*. See Jakob 2003, 418: "Zeltdach".

[83] Togas are listed in MARV III, 5:8', 38', 39', while coats of various type occur in *ibid.* 9', 10', 16', 18', 20', e.26'.

[84] MARV III, 5 r.32' 3-*šu*? TÚG.*šá-ḫar*.MEŠ UD.MEŠ. But see Jakob 2003, 419, where the term is dubitatively referred to the *šaḫartu/šakintu*-garment.

[85] MARV III, 5 r.33'.

[86] MARV III, 5 e.25', r.28', 36', 37'.

[87] MARV III, 5 r.38'–39'.

[88] MARV III, 5 r.34' 3 [x]-*ú*?-*tu* TÚG.*na-ak-bu-šu ša* GIŠ.GIGIR.

[89] MARV III, 5 r.35' 3 x [x x]x TÚG *ša* GÚ.MEŠ *ša* GIŠ.GIGIR.

[90] MARV III, r.34'–35' (Kidin-Gula and Uṣur-Bēl-šarra).

[91] MARV III, r.36'–37' (Ariberu and Šamaš-dugul).

[92] Teppo 2007, 266–268.

[93] Teppo 2007, 267, note 55.

[94] ND 2803 (*Iraq* 23 [1961], 55–60, pls XXIX–XXX).

[95] Gentili 2002–2005, 109.

of the Palace Herald, Urzuḫina, Māzamua, Arrapḫa, Kār-Aššur, and Laḫīru.[96] The majority of these places, with the exception of the Syrian city of Raṣappa, are located in the north- and south-eastern regions of the Assyrian Empire. Most of the weavers are located in Kār-Aššur (30 individuals), in the province of the Chief Cupbearer (25), in Arrapḫa (25), in Laḫīru (20), and in Raṣappa (20). We also know that teams of weavers could move from their dwelling to other cities as requested by the king. This may be seen in a letter concerning the production of 'togas' for the king. According to the message, a certain Balasî, an official in charge of the wool depots of the Palace, had to supply red wool to the weavers of Ištar of Arbela. These weavers were then expected to go to the city of Kurbail to make the textiles.[97] The possible link between the palace women and textile operations may also be inferred by the archive of Til Barsip (Tell Aḥmar). The archive was located in a building which, at the time of its destruction, served as a workshop for weaving and dyeing activities.[98] A document of the reign of Assurbanipal (*c.* 636 BC) from this small private archive relates to the purchase of a slave by a local *šakintu*.[99] The manageress in question had probably to do with the activities taking place there; the loom weights and terracotta basins which were found in the same building confirm that weaving and dyeing operations were really performed in that place, presumably by women of the local royal harem.[100]

The professional sphere of weavers also includes workers specialized in weaving of the polychrome border of garments and special textile products widely consumed in Assyria. This is evident by the occupations of the *ušpār birmi*, 'weaver of multicoloured border',[101] and the *ušpār ṣiprāti*, 'scarf weaver'.[102] A document from the archive of the Aššur Temple in Assur attests the profession of the *rab kitê*, 'linen master',[103] but it is not certain whether he was in charge of flax and the relative phases of storing, distributing, and processing or of finished products, *i.e.* linen garments. In the latter case, he may be intended as a weaver or tailor who only produced linen cloths. Apart from the production of woollen and linen textiles, there is evidence to show that the processing of felt was also practiced in first millennium BC Assyria. This coarse and thick fabric derived from the pressing and fulling of carded woollen fibers and was produced by the worker called *sēpiu*, 'felt-worker'.[104] The activity of this professional worker is well documented in Middle Assyrian textual evidence,[105] which also contains references to the *rab sāpi'ē*, 'chief felt-worker',[106] the *sāpi'u ša ḫarrāne*, 'felt-worker for the caravan',[107] and the *sāpi'u Ḫattāiû*, 'felt-worker from the land of Ḫatti'.[108] The raw materials used by the felt-workers derived from bovine and goat hair remnants from the processing of leather and, as already observed, wool fibers.[109] The Assyrian term

[96] SAA 7, 23 r.1–10.
[97] SAA 16, 84:8–r.11.
[98] Teppo 2007, 258–259.
[99] Dalley 1997, 82–83, text no. 13.
[100] Parpola 2008, 22, note 35.
[101] ADW 9:4; 27 r.8'; SAA 6, 42 r.8; SAA 12, 27:24; 94:5. This profession is intended by Lassen as "tapestry weaver", see Lassen 2010, 279.
[102] CTN 3, 145 r. ii 14; SAA 6, 301:4; SAA 7, 115 r. i 7; SAA 12, 83 r.8; SAA 16, 55:2.
[103] StAT 2, 1 r.1.
[104] SAA 12, 65:3'.
[105] See MARV I, 59 e.6; MARV II, 15 r.4'; MARV III, 53 r.11. For a discussion on this activity, see Jakob 2003, 431–435.
[106] MARV III, 53:6; 57:5; VAT 8863:15 (Freydank and Saporetti 1989, 75).
[107] MARV III, 7:7–e.8; VAT 19554 r.14 (Cancik-Kirschbaum 1999, 93).
[108] MARV III, 53 r.11–12.
[109] Jakob 2003, 434–435.

for felt is *taḫapšu*.[110] This material was used to produce not only clothing items, such as garments, headdresses, and footwear, but also bags, rugs, and tents. The actual operation of stitching was probably performed by the *mukabbû*, who may have been a "seamster, stitcher, dressmaker, clothes mender".[111] Other cloth professions have been interpreted as referring to the peddling trade, but there is no conclusive proof of this in Neo-Assyrian period.[112] As a working hypothesis, it is possible that the following workers were tailors directly engaged in the manufacturing of textile products after which they were commonly named. Thus, the *ša-sāgātēšu* was probably a peddler or an expert in the production of *sāgu*-garments,[113] a textile product intended as a 'sackcloth, tunic', the *ša-ḫalluptīšu* was a maker or dealer of *ḫalluptu*, 'harness, armor',[114] and the *ša-kubšīšu* a sort of fez-maker.[115] In any case, it is clear that these professionals were subordinate members of the palace and temple households.[116] They were probably commissioned to produce these three commodities (*sāgu*, *ḫalluptu*, *kubšu*) by the palace. In fact, *sāgu*-garments were cloths of daily use, perhaps for soldiers, and the production of harnesses or armors is closely linked to the supply of military equipment to the Assyrian cavalry.

Carpets were another important textile and were used to embellish and decorate the king's residence. However, although palace relief sculptures from Nimrud, Khorsabad, and Nineveh clearly show that finely elaborated fringed carpets adorned the entrances and rooms of the royal residences,[117] the terminology on carpet manufacture is not fully understood. The occupation involved in this type of activity was probably that of the *kāmidu*, a *nomen professionis* which has been intended as meaning 'knitter, carpet-knitter'.[118] The *kāṣiru* is another profession that is considered as having to do with knotting or carpet making.[119] A Middle Assyrian inventory text from Kār-Tukultī-Ninurta (Tulūl al-'Aqir) mentions decorated carpets (*mardutu*) as the product of the activity carried out by the *ušpārus* and *kāṣirus*.[120] The carpet weaving activity probably involved also the temple workers of presumably Median origin called *ḫunduraius*,[121] but this is still disputed.[122] In any case, it is clear that in Assyria specialized weavers were not only needed to produce these

[110] Cancik-Kirschbaum 1999, 85–87.

[111] MSL 12, 238 r. ii 26.

[112] Radner 1999, 120–126.

[113] NATAPA 2, 67:2.

[114] SAA 7, 115 r. i 8; SAA 12, 83 r.14.

[115] As 19:12; As 29:15 (Radner 1999, 123); SAA 6, 342:4; SAA 11, 213 iii 2'; SAA 12, 63:2'; SAA 14, 155:8; SAA 15, 73 r.11, 12.

[116] Radner 1999, 125.

[117] On the stone threshold slabs from royal palaces imitating woven floor coverings, see Albenda 1978, 1–34.

[118] MSL 12, 238 r. ii 27. See AEAD, 45b. Instead, in CAD K, 121a the lemma is generically intended as denoting "a craftsman making a special type of woven cloth".

[119] Good 2007, 147. See also Ahmad and Postgate 2007, 67 no. 51 r.8: "carpet-maker".

[120] VAT 16462 r. iii 27', 32'–33' (AfO 18 [1957–58], 306). See Barrelet 1977, 56–58. Critical observations on the possibility that both these skilled labourers were the producers of *mardutu*-textiles are expressed in Lassen 2010, 278–279. Lassen suggests that the textile in question was a type of pattern weaving (tapestry?), see Lassen 2010, 279.

[121] NATAPA 1, 23:2; 54 e.1'; 35:9; App. 2, Ass. 9573b:2; ND 1120:17 (*Iraq* 14 [1952], 2, pl. XXIII = van Driel 1969, 200); SAA 13, 41:6; StAT 3, 73:9. In some texts, the same profession is known as *ḫarḫaraiu*, 'Harharean', see NATAPA 1, 28:3; StAT 3, 73:7. For the *rab ḫunduraiu*, 'chief hundurean', see NATAPA 1, 21:2; 22 r.18; 35:8; 39 r.7; 52 r.6; App. 2, Ass. 9573e B:8'.

[122] For the interpretation of the *ḫunduraius* as craftsmen specialized in weaving activities, see Fales and Jakob-Rost 1991, 23–24.

valuable commodities knot by knot,[123] perhaps using vertical or ground looms,[124] but also to repair them. Another Assyrian document of the second millennium BC mentions textiles and carpets belonging to Ištar of Arbela, presumably used to decorate the interior of the local temple, which needed to be repaired.[125] Another important textile occupation was performed by the *pūṣāiu*, which has been interpreted as referring to a bleacher or a launderer.[126] Individuals having this professional title are mentioned in a census tablet of the reign of Sargon II regarding people from the Ḥarrān region[127] and, possibly, also in a debt note of the reign of Assurbanipal from Kalḫu.[128] However, nearly all the attestations of the first millennium BC come from Babylonian archives.[129] In Babylonia, laundry concerned both the clothes of the gods and those of ordinary people. These workers were at the service of both the temple and private households. According to the laundry contracts of the Neo-Babylonian period, the launderer working for the private sector undertook to wash the dirty cloths of private clients over a period of time. The launderer was paid in silver, dates, or barley.[130] This activity could be performed by different textile professionals, such as tailors and clothes menders, as clearly shown by two Neo-Babylonian texts.[131] Evidence regarding this profession is lacking in Neo-Assyrian texts, which makes it hard to verify whether the official laundry business also served the private sector. We presume that specialists in cloth-washing were certainly members of palace and temple households in Assyria. Middle Assyrian texts refer to textiles that have been washed (*ša masiūni*)[132] and textiles that have not been washed (*lā masiūtu*),[133] but it is not clear whether they relate to the actual washing of the cloth or the fulling activity.[134] The hypothesis that the washermen were an important and specialized group of professionals in the Neo-Assyrian Empire is suggested by the existence of a village called 'Launderer (or Fuller?) Town' (*Āl pūṣāie/ašlākê*),[135] a possible indication that groups of workers mainly performed their activities in the same area, because it probably offered better environmental conditions for this purpose.[136]

As known, textile professionals are documented in texts originating from the central administration. Consequently, the information coming from the Neo-Assyrian texts reflects their working relationship with the palace and temple. Thus, it is unclear as to whether these workers were also at the service of the private sector, even if there is no reason to think that this did not

[123] On the technical point of view, it is not clear whether the Assyrian carpets were tapestry woven (like the *kilim*) or knotted. For the suggestion that the use of pile carpets spurred the interest in representing stone versions of carpets in Assyrian palace reliefs since the second half of the 8th century BC, see Albenda 1978, 1.

[124] Ellis 1976, 76–77.

[125] MARV III, 8 r.35'–36'.

[126] ND 5452 r.16 (*Iraq* 19 [1957], 130, pl. XXXII); SAA 11, 209 r. iii 29'.

[127] SAA 11, 209 r. iii 29'.

[128] ND 5452 r.16 (*Iraq* 19 [1957], 130, pl. XXXII). However, the title is broken. The assumption that it should be read as *pūṣāiu* is followed, on the authority of Parker, also in PNA 3/I, 1154b.

[129] See the attestations quoted in CAD P, 538.

[130] Waerzeggers 2006, 83–91.

[131] Waerzeggers 2006, 85, text no. 3:2; Bongenaar 1997, 313 note 296.

[132] KAV 108:4–6.

[133] KAV 103 r.22–23.

[134] In a fragment of the Middle Assyrian Laws the activity of the fuller is expressed by the verb *masā'u*, 'to wash', see Jakob 2003, 429.

[135] SAA 14, 161:4 URU.LÚ*.TÚG.UD.MEŠ. Mattila prefers to translate the toponym as 'Fuller Town'.

[136] Postgate 1987, 268.

happen in Assyria. As to the organization of the labor, it is known that since the 8th century BC palace employees were organized along military lines into cohorts (*kiṣru*), under the control of a cohort captain (*rab kiṣri*).[137] This is also true for textile workers. From the legal documents of the Nineveh royal archive of the reign of Sennacherib (704–681 BC) we learn that a certain Nabûtî acts as a witness for harem women in two contracts relating to the purchase of people and properties. In one text, he is simply qualified as a weaver, but in the other, he bears the professional title of 'cohort commander of the weavers'.[138] It has been suggested that the organization of crafts and trades through military hierarchies, perhaps introduced by Tiglath-pileser III and certainly expanded by Esarhaddon, was probably adopted by the palace to organize the civilian personnel within its employ.[139] Therefore, it is possible that the cohorts of textile artisans, as those of other professionals, were created by the Assyrian government because they were strongly needed for the maintenance of the palace and temple organizations as well as the Assyrian army.

Textile Consumption within the Palace, the Government, and Private Sectors: An Overview

The aforementioned list of flax and wool amounts shows that some quantities of raw materials, precisely linen and madder, were given to the tailors. In the text, these recipients of raw textile materials are collectively referred to as the *bēt kāṣir*, 'the house of the tailor(s)'.[140] This designation certainly indicated the workshop where the tailors produced the cloths for members of the Assyrian royal family and of the ruling elite in the main cities of the empire. Every central and provincial palace household presumably had its own house of tailors. With the wool and linen received by the administration these textile workers produced a great variety of finished products. Garments and other clothing items were the main textiles mentioned in the Neo-Assyrian sources. The texts issued by the central administration document the use of cloaks, togas, tunics, shirts, fringed shawls, wraps for different purposes, gowns, sashes, mantles, different types of coats made of coarse fabric for ordinary use and as standard dress items to be used as uniforms by the soldiers. Other clothing items were footwear, veils, bandages, and loincloths. Headdresses produced by the textile workers included caps, mitres, turbans, and head scarves. Textile labels from Nineveh show that red and black, followed by white, were the main colours used in the Assyrian garments. The texts also frequently mention multicoloured textiles.[141] Red, in particular, came in different qualities (see Chart 13.3). It could be of the country-/mountain-type (KUR = *mātu*, 'country' or *šadû*, 'mountain'), perhaps to be intended as natural red coloured, opposed to other red dye varieties, such as 'red of the port' or 'commercial red' (KAR = *kāru*) and the so-

[137] Postgate 1979, 210–212; 1987, 259.

[138] SAA 6, 91 r.3'. Perhaps, another cohort commander of textile workers is Aḫi-pāda. He is attested in a harvest record from Nebi Yunus and bears the title of LÚ.GAL-*ki-ṣir* TÚG.ME (SAA 11, 24 r.7). Fales and Postgate do not offer any translation of the logogram TÚG.ME and prefer to render the professional title as 'cohort commander of ...'. Since the logogram TÚG corresponds to the word *ṣubātu*, but a translation like 'cohort commander of cloths' does not make any sense, it is possible that we have here an unusual writing for (LÚ.)TÚG.ME, 'fullers'. If so, our Aḫi-pāda was probably a cohort commander of fullers.

[139] Postgate 1987, 260.

[140] SAA 7, 115 i 13, ii 21, r. ii 7.

[141] For the colours of the Neo-Assyrian textiles see Villard 2010, 397–398.

called 'limestone red' (*pūlu*).[142] Black too could be of the country-/mountain-type.[143] Moreover, for a number of garments the texts specify the colour of the front-piece (ZAG = *pūtu*), usually red, and the presence or absence of sleeves. Unfortunately, the evidence about actual coloured textiles is too scanty to confirm the textual data. Physical remains of Assyrian textiles from the Nimrud tombs comprise both undyed and dyed fragments: some of them are tinged with purple and red, others show white, brownish, and greenish parts.[144] An idea on the colours of the textiles used by the Assyrian ruling elite may also be formed on the basis of the traces of colours which are still visible on some palace reliefs and wall paintings: for example, traces of red colour may be observed on the tiara of the king Sargon II on the relief 19 of the royal palace in Khorsabad (end of the 8th century BC),[145] while the extant wall paintings of the Assyrian palace at Til Barsip document the use of black, white, red, and blue for garments, footwear, throne drapery, and trappings (8th–7th centuries BC).[146] Of some garments, namely cloaks, tunics, wraps or coats, and short-cut gowns were also produced varieties known as 'of the house' (*bētu*), perhaps meant as ordinary varieties to be used indoors.[147] A list of textiles mentions house-wraps for women.[148] Textile products other than garments included bed-clothes and other textiles for decorating and enhancing the royal residences, such as blankets, rugs, bedcovers, bedspreads, and pillows. In addition, royal palaces and temples were decorated with drapes, curtains, carpets, and mats of every sort (see Fig. 13.1).

Ceremonial occasions such as royal banquets at palace and cult ceremonies in temples also required the use of appropriate textiles, such as napkins, towels, and table-cloths. Representations of royal scenes on the Neo-Assyrian palace reliefs from Kalḫu, Khorsabad, and Nineveh give us further evidence of the richness of the items of clothing used by the king, the members of the royal family, and the officials, of the drapery adorning the throne, as well as of the cushions, napkins, and cloth coverings which were used in royal drinking and banqueting occasions, to mention just a few examples.

Given the palace-oriented status of the above-discussed Assyrian textile industry, it is clear that the needs of the palace and of the temple absorbed most of the consumption of the produced textiles. The palace sector was composed by several establishments in various cities.[149] Within the needs of the palace we have to include textiles which served to the king and the royal family, the court, the high state officials, and the palace personnel in the daily life (Figs 13.2–3).

In addition to the textiles produced by the palace workshops, the income of textiles for the Palace also included the products, both raw and finished, which reached the Assyrian royal residences in form of booty, tribute, and audience gifts from different regions and contributors. Reports on the king's military campaigns in the Neo-Assyrian royal inscriptions inform us that the textile products which the Assyrians acquired from the conquered territories were usually

[142] See Fales and Postgate 1992, xxviii.

[143] See SAA 16, 82 r.7.

[144] Crowfoot 1995, 117–118. See also Villard 2010, 398, who mentions white, red, and yellow coloured fragments of decorated textiles discovered in Sultantepe.

[145] Relief 19, courtyard III, façade L (AO. 19873). See the reproduction in Botta and Flandin 1849–50, pl. 12.

[146] See, *e.g.* the scene of the room 47 in Matthiae 1998, 183.

[147] See Fales and Postgate 1992, xxvii.

[148] SAA 7, 107 r.3'.

[149] For an overview on the palace sector of the economy of the Neo-Assyrian Empire, see Postgate 1979, 200–202.

Figure 13.1. Pavement slab of the North Palace of Nineveh imitating a fringed carpet with an elaborated design: the centre field shows square quatrefoil panels surrounded by rows of rosettes, while the outer border is decorated by a lotus-and-bud garland (from Albenda 1978, pl. 24, detail).

constituted by three standard commodities, *i.e.* multicoloured and linen garments, and wool. Sometimes, the last item is specified as regards the colour; thus, we know that wool entering the Assyrian booty and tribute could be blue-black, blue, blue-purple, purple, and red.[150] Another possible confirmation of textiles imported in Assyria as booty comes from a group of Babylonian cuneiform dockets found in Khorsabad and Kalḫu. These dockets, with the bundles of wool to which they were tied, were carried out to Assyria after the capture of Dūr-Yakīn, the city of the Chaldean king Marduk-apla-iddina II.[151] Alternatively, it is also possible that these dockets witness a peaceful trade between Assyria and the Chaldean kingdom.[152]

As far as the government sector of the Assyrian Empire is concerned, it is evident that its chief

[150] RIMA 2, A.0.100.5:72, 107; A.0.101.1 i 79, 87, 88, 95, 97, ii 79, 81, 123, iii 7, 47, 55, 67, 71, 74, 78, 87; A.0.101.2:30, 47, 50; A.0.101.17 iii 107, 114; A.0.101.19:89; A.0.101.73; A.0.101.74; A.0.101.76; RIMA 3, A.0.102.1:95'; A.0.102.2 ii 22, 23, 25, 28, 29, 40; A.0.102.6 iii 13–14; A.0.102.8:41'; A.0.102.84; A.0.102.90; A.0.104.7:7; Tadmor 1994, Ann 14:3; Ann 21:10'; Ann 25:1', 10'; Ann 27:9; St 3A:21–22; Summ 4:14'; Summ 7:28, r.12'; Summ 9 r.8; Mayer 1983, line 366; Fuchs 1994, Ann 407, 449; Prunk 181–182; Fuchs 1998, IVb 49'-51'; Levine 1972, ii 18, 38; Luckenbill 1924, C1:56; Borger 1956, Nin A ii 76; Nin B i 22.

[151] Joannès 2010, 401–402.

[152] Dalley and Postgate 1984, 139.

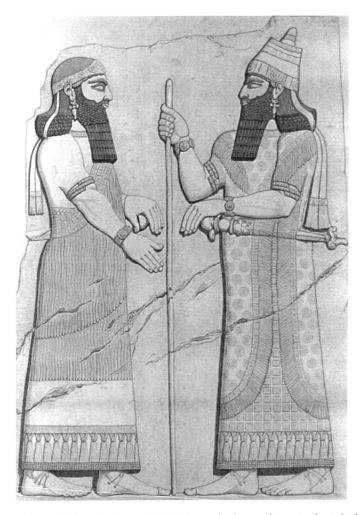

Figure 13.2. The crown prince and the king Sargon II in their royal robes as shown in the Relief 19, Courtyard III, Façade L, of the Royal Palace of Khorsabad. The crown prince and the king wear fringed shawls over long tunics with short sleeves and tasselled hem. The king's dress appears to be much more elaborated than that of the prince: the shawl, which is different from that of the prince and covers the entire figure, is decorated by rosettes, while the tunic shows a design with square motifs (from Botta and Flandin 1849-50, pl. 12).

preoccupation was the supply of the army.[153] Accordingly, a large set of goods of textile nature was supplied to the units of the Assyrian army as military equipment: these goods included uniforms (mail-shirts, short kilts, knee-length tunics, waist-belts, leggings, see Fig. 13.4), harnesses, saddlecloths, and other textiles of practical use to transport and store goods and as shelter (bags, sacks, tents, *etc.*).

The management of the cultic affairs in the Assyrian temples, especially in the temple of the

[153] On the government sector's role in the economy of the empire, see Postgate 1979, 202–205.

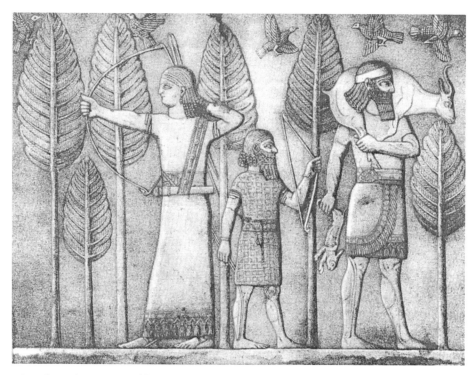

Figure 13.3. Palace dependent personnel hunting in the royal park in a relief from the Royal Palace of Khorsabad: the work garments used by these hunters include both long tasselled and knee-length tunics with waist-belts (from Layard 1853, pl. 32).

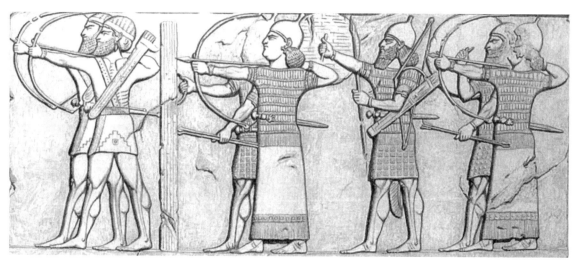

Figure 13.4. Assyrian soldiers in their uniforms as shown in the Relief 1, Room 5, of the Royal Palace of Khorsabad. Garments worn by the military personnel included short kilts with waist-belts and mail-shirts which could be worn over long fringed robes or knee-length tunics (from Botta and Flandin 1849–50, pl. 86). The type, the quality, as well as the decoration and, we presume, the colour of the military dress probably served to communicate hierarchical differences among soldiers.

national god Aššur in Assur, also required a large consumption of textile products for the adorning of the statues of the gods and for the dressing of the priestly personnel in various events of the state cult which took place during the Assyrian religious year. According to the list SAA 7, 115, a certain amount of linen fiber issued by the palace stores was used to fabricate curtains(?) (*maldudu*) of the temple of Ištar,[154] while seven talents and ten minas of red wool were employed to dress (divine) statues.[155] But what about the consumption of textiles in the private sector of the Assyrian society? Information on the textiles exchanged in the private transactions may be found, for example, in three marriage contracts coming from different archives and periods of the first millennium BC (see Chart 13.4). The items included in the dowry lists of these contracts,[156] presumably reflecting the social status of the Assyrian upper class living in Assur and Kalḫu, comprise what seem to be bed-clothes and garments. While the Assur text only includes garments, the two contracts from Kalḫu list both bed-clothes and items of clothing. Although the order of the listed commodities changes in the two Nimrud texts, some items of the two groups, *i.e.* bedcovers or blankets (*dappastu*) and some types of garments (*gulēnu, gammīdu, ḫuzūnu, urnutu*), appear to have been characteristic components of brides' wardrobes of the first millennium BC. That some of the textiles of these dowries must be intended as *éléments de literie* is also evident from an inventory text from Nineveh, which qualifies the textiles *dappastu, qirmu, gulēnu, qarrāru*, and SI.LUḪ as pertaining to the bed of the goddess Šērūʾa.[157] Finally, it is interesting to note that a number of the Assyrian dowry components (*dappastu, gulēnu, kitû, naṣbutu, qirmu*) also characterized the personal accoutrements of Babylonian women in the Late Babylonian period (6th-3rd centuries BC).[158] As for the prices of the textile products in the Neo-Assyrian period, the references to the costs of raw and finished goods seem to be limited to two texts. In a note regarding silver from Nebi Yunus, an unspecified quantity of shorn wool is said to cost 20 talents 13 minas 18 $\frac{1}{3}$ shekels of silver (*c.* 1225.44 kg).[159] Instead, a record of private transactions made by some merchants in the city of Ḥarrān shows that two linen tunics were purchased for one mina and 23 shekels, five linen 'togas' for half a mina, 4 $\frac{5}{6}$ minas of (black) wool and $\frac{1}{3}$ mina of red wool for one mina.[160] Consequently, the price in silver per unit of the two finished products was respectively around 41 shekels (*c.* 0.70 kg or 0.35 kg) for the tunics and 6 shekels (*c.* 0.101 kg or 0.0505 kg) for the 'togas', while one kilogram of coloured wool was *c.* 11 heavy shekels or *c.* 22 light shekels (*c.* 0.193 kg).

These observations about textile production and consumption in the Neo-Assyrian Empire may certainly contribute to enlarge our knowledge of the role of textiles in the societies of first millennium BC Mesopotamia, although many other important aspects of the Mesopotamian textiles, for example, their being powerful social indicators and the values that they conveyed by means of colour, pattern, form, and decoration, need to be explored by future research.

[154] SAA 7, 115 r. ii 3–4 [SÍG.GAD]A *a-kil-tú* / [(x x) *a-n*]*a mal*ʹ*-di-di šá* É—ʺ15ʹʺ, '[Linen fib]re, consumption: [... talents, fo]r the *curtains* of the temple of Ištar'.

[155] SAA 7, 115 r. i 10–11 [S]ÍG.ḪÉ.MED *a-kil-tú* / 7 GÚ 10 MA UGU NU, '[R]ed wool, consumption: seven talents and ten minas, *upon statues*'.

[156] CTN 2, 1:3'–12'; ND 2307:14–19, e.23–r.5 (*Iraq* 16 [1954], 37, pl. VI); StAT 2, 164:10–14, 16.

[157] SAA 7, 117 r.3–6. See Villard 2010, 390.

[158] See Roth 1989–90, 30–32 for references.

[159] SAA 11, 100:1–3.

[160] SAA 11, 26 r.5–12.

Chart 13.1. Neo-Assyrian account of flax and wool consumption for textiles (SAA 7, 115)

a) Linen (lines i 1-21, ii 1-5): 274 talents.

Quantity	Cities	Palaces	Professionals	Destination
30 talents	Central City of Nineveh			
20 talents		Review Palace of Nineveh		
10 talents		Review Palace of the New Corps		
20 talents		House of the Queen		
5 talents		New Palace of Kalḫu		
5 talents		Review Palace of Kalḫu		
10 talents	Adian			
[...] talents	Naṣibina			
[...] talents	Aliḫu			
[...] talents				for blankets
[...] talents		Domestic quarters		
[...] talents			tailor(s)	
[...] talents			horse-trainers	
[...] talents			treasurer	
[...] talents			palace manager of the Central City	
[...] talents			manager of the Review Palace	
[...] talents	Inner City (Assur)			
[...] talents	Kilizi			
[...] talents	Adian			
[...] talents			Ḫubtu-Aššūr	
50 talents				
10 talents				for occasional needs and the boats

b) Linen (ll. r. ii 3-20): 30 talents, 21 minas

Quantity	Cities	Palaces	Professionals	Destination
[...]				for the curtains(?) of the Ištar temple, for beds and chairs, for the whole year
[x+]5 minas			tailor(s)	
[...] minas			cupbearer	
[...] minas		Domestic quarters		
[...] minas			the man in charge of the rickshaw	
[...] minas			basket-dealer	
[x+]1 minas				for the sandals of the Palace
40 minas				for thin linen thread
2 talents				for twine of linen
3 talents 10 minas		New Palace (of Kalḫu)		
2 minas				for the hind-part of mangled garments/ rugs(?)
1 talent			Šār-Issār	

c) *Madder (ll. ii 6–r. i 9): 109 talents*

Quantity	Cities	Palaces	Professionals	Destination
30 talents				for the ... and the entrance
20 talents				for 600 gowns and 600 tunics
3 talents			Epâ	for the gate-overseer(s)
2 talents	Aliḫu			for the boats
3 talents				for the *išḫu*-cloths
2 talents				for the wrappings of sashes
8 talents 10 minas				for 500 wraps of the Gurraeans
2 talents				for [the ...-*cloths*] of the chariot-fighters and for the cloaks of the archers(?)
2 talents			tailor(s)	
2 talents			Šār-Issār	
5 talents				for twine of linen
2 talents			exorcists	unspecified, but for the whole year
20 talents			hide-soakers of Nineveh	
5 talents			hide-soakers of the entrance	
2 talents			weavers of scarves	
1 talent			armour-maker/dealer	

d) *Red wool (ll. r. i 10-19, ii 1-2): 22 talents*

Quantity	Cities	Palaces	Professionals	Destination
7 talents 10 minas				for (divine?) statues
15 talents 10 minas			deputy	
[...] talents				for regular consumption, including occasional needs

Chart 13.2. Middle Assyrian list enumerating work quotas of palace weavers with quantities of wool and of finished products (MARV III, 5).

Quantity of raw material (wool)	Manpower (number of weavers)	Finished product
[... minas?]	6	1 piece of tabby (for tent)
9 minas	6 (including the chief weaver)	1 white toga of the t[op(?) ...] 1 coat [...] of 2(?) shekels 3 coats of red wool
9 minas	7 (including the chief weaver)	1 coat of red wool ¹/₃ mina of red wool for the sleeves and breast-pieces 1 coat of red wool ... 15 shekels of red wool 4 white coats
7 minas	3	[...] *sirah*-garments [...] coats ...
3 minas	4 (including the chief weaver)	1 work garment/textile(?)
1 mina 2 minas	2	3 pairs of leggings (1 pair = ¹/₃ mina) 6 white caps (1 cap = ¹/₃ mina)
(not indicated)	2 (men)	3 [...] of covering for chariots 3 [...] textile for the "necks" of chariots
(not indicated)	2 (men)	5 *lippu*-garments in accordance with the writing-board of the Palace (2 ½ *lippu*-garments each)
(not indicated)	2	multicoloured pieces of cloth for the hem of 12 togas (the hem of 6 togas each)

Chart 13.3. Common qualifications of textile products in Neo-Assyrian administrative sources.

Item	QUALITY: "of the house"	COLOUR: "red of the country"	COLOUR: "red of the port"	COLOUR: "with front part"
elītu "upper garment, (fringed) shawl"		√		
gulēnu "cloak, coat, tunic"		√	√	√ (red)
ḫullānu "cloak, wrap"	√			
kubšu "cap, mitre"		√		
kusītu "toga"		√		
maqaṭṭu "short gown"	√		√	√ (black, red)
maqaṭṭutu "short gown"	√			
muklālu "cape, tippet, shawl"			√	√ (red)
naṣbutu "sash holder"				√ (red)
qirmu "mantle, overcoat, wrap"		√	√	√ (red)
raddīdu "veil(?)"			√	√ (red)
sasuppu "napkin, towel"	√	√		√ (red)
ṣipirtu "scarf, sash, waist-belt"			√	
ša-IŠ "dust garment(?)"			√	√ (black, red)
šitu (a textile)		√	√	√ (red)
urnutu "tunic"	√	√	√	√ (red)

Chart 13.4. Textile products in dowry lists of Neo-Assyrian marriage contracts.

Textile category	Item	CTN 2, 1 Provenance: Governor's Palace, Kalḫu (Nimrud) (date lost, 8th century BC)	StAT 2, 164 Provenance: Archive N31, Assur (Qal'at Šerqāṭ) (reign of Esarhaddon, 675 BC)	ND 2307 (*Iraq* 16 [1954], 37, pl. VI) Provenance: Ziggurat Terrace, Kalḫu (Nimrud) (after reign of Assurbanipal, 622 BC)
1. Bed-clothes and other textiles	*qarrāru* "bedspread"			√
	dappastu "bedcover, blanket"	√		√
	qirmu "mantle, overcoat, wrap"			√
	TÚG.SI.LUḪ (a textile: pillow?)	√		
2. Garments and other textiles	*kiṣiptu* "cut-off piece, scrap (of a garment)"	√		
	ša-ḫili (a garment)	√		
	[...] *ša ḫatannu* "a ... -cloth of the bridegroom"	√		
	naḫlaptu "wrap, coat"	√		
	ḫulsu (a garment)	√		
	gulēnu "cloak, coat, tunic"	√		√
	gammīdu (a garment or rug)	√		√
	šaddīnu "toga"			√
	bēt rēši (a textile: pillow?)			√
	kuzippu "cloak, suit (of clothes)"			√
	urnutu "tunic"		√	√
	TÚG.UŠ (a textile: long side of a cloth?)			√
	kitû "linen garment, tunic"			√
	maqaṭṭutu "short gown"		√	
	naṣbutu (a coat or sash holder)		√	
	ḫuzūnu (a garment)		√	√
	pazibdu (a garment)		√	
	[...]*rakatu* (a linen textile)		√	

Abbreviations (for other abbreviations included in the article see CAD)

ADW Ahmad, A. Y. and Postgate, J. N. 2007 *Archives from the Domestic Wing of the North-West Palace at Kalhu/ Nimrud*, Edubba 10.

AEAD Parpola, S. *et al.* 2007 *Assyrian-English-Assyrian Dictionary.* Helsinki.

BIWA Borger, R. 1996, *Beiträge zum Inschriftenwerk Assurbanipals.* Wiesbaden.

CAD *The Assyrian Dictionary of the Oriental Institute of the University of Chicago*, 1956–2010.

CTN *Cuneiform Texts from Nimrud.*

CTN 1 Kinnier Wilson, J. V. 1972 *The Nimrud Wine Lists: A Study of Men and Administration at the Assyrian Capital in the Eighth Century BC*, Cuneiform Texts from Nimrud 1.

CTN 2 Postgate, J. N. 1973 *The Governor's Palace Archive*, Cuneiform Texts from Nimrud 2.

CTN 3 Dalley, S. and Postgate, J. N. 1984 *The Tablets from Fort Shalmaneser*, Cuneiform Texts from Nimrud 3.

CTN 5 Saggs, H. W. F. 2001 *The Nimrud Letters, 1952*, Cuneiform Texts from Nimrud 5.

KAV Schroeder, O. 1920 *Keilschrifttexte aus Assur verschiedenen Inhalts*, Wissenschaftliche Veröffentlichung der Deutschen Orient-Gesellschaft 35.

KAR Ebeling, E. 1919/22 *Keilschrifttexte aus Assur religiösen Inhalts*, I–II, Wissenschaftliche Veröffentlichung der Deutschen Orient-Gesellschaft 28/34.

MARV I Freydank, H. 1976 *Mittelassyrische Rechtsurkunden und Verwaltungstexte*, I, Vorderasiatische Schriftdenkmäler der Staatlichen Museen zu Berlin 19, N.F. 3.

MARV II Freydank, H. 1982 *Mittelassyrische Rechtsurkunden und Verwaltungstexte*, II, Vorderasiatische Schriftdenkmäler der Staatlichen Museen zu Berlin 21, N.F. 5.

MARV III Freydank, H. 1994 *Mittelassyrische Rechtsurkunden und Verwaltungstexte*, III, Wissenschaftliche Veröffentlichung der Deutschen Orient-Gesellschaft 92.

MSL Materials for the Sumerian Lexicon.

NATAPA 1 Fales, F. M. and Jakob-Rost, L. 1991 *Neo-Assyrian Texts from Assur. Private Archives in the Vorderasiatisches Museum of Berlin, Part I*, State Archives of Assyria Bulletin 5.

NATAPA 2 Deller, K., Fales, F. M. and Jakob-Rost, L. 1995 *Neo-Assyrian Texts from Assur. Private Archives in the Vorderasiatisches Museum of Berlin, Part II*, State Archives of Assyria Bulletin 9.

ND *siglum* of the texts from Nimrud.

PNA 1/II Radner, K. (ed.) 1999 *The Prosopography of the Neo-Assyrian Empire*, 1/II: B–G.

PNA 3/I Baker, H. D. (ed.) 2002 *The Prosopography of the Neo-Assyrian Empire*, 3/I: P-Ṣ.

PVA Landsberger, B. and Gurney, O.R. 1957/58 The Practical Vocabulary of Assur, *Archiv für Orientforschung* 18 (1957–58), 328–341.

RIMA 2 Grayson, A. K. 1991 *Assyrian Rulers of the Early First Millennium BC I (1114-859 BC)*, The Royal Inscriptions of Mesopotamia, Assyrian Periods 2.

RIMA 3 Grayson, A. K. 1996 *Assyrian Rulers of the Early First Millennium BC II (858-745 BC)*, The Royal Inscriptions of Mesopotamia, Assyrian Periods 3.

SAA State Archives of Assyria, vols 1–18, 1987–.

StAT Studien zu den Assur-Texten.

StAT 2 Donbaz, V. and Parpola, S. 2001, *Neo-Assyrian Legal Texts in Istanbul*, Studien zu den Assur-Texten 2.

StAT 3 Faist, B. 2007, *Alltagstexte aus neuassyrischen Archiven und Bibliotheken der Stadt Assur*, Studien zu den Assur-Texten 3.

TH Friedrich, J. *et al.* 1940 (1967 reprint) *Die Inschriften vom Tell Halaf. Keilschrifttexte und aramäische Urkunden aus einer assyrischen Provinzhauptstadt*, Archiv für Orientforschung, Beiheft 6.

TuL Ebeling, E. 1931 *Tod und Leben nach den Vorstellungen der Babylonier.* Berlin Leipzig.

ZTT Ziyaret Tepe texts, see Parpola 2008.

Bibliography

Albenda, P. 1984. Assyrian Carpets in Stone, *Journal of the Ancient Near Eastern Society of Columbia University* 10, 1–34.

Barrelet, M. Th. 1977. Un inventaire de Kar Tukulti Ninurta: textiles décorés assyriens et autres, *Revue d'assyriologie et d'archéologie orientale* 71, 51–92.

Bongenaar, A. C. V. M. 1997. *The Neo-Babylonian Ebabbar Temple at Sippar: Its Administration and Prosopography*, Publications de l'Institut historique-archéologique néerlandais de Stamboul 80.

Borger, R. 1956. *Die Inschriften Asarhaddons, Königs von Assyrien*, Archiv für Orientforschung, Beiheft 9.

Botta, P. E. and Flandin, E. 1849–50. *Monument de Ninive*, I–V.

Cancik-Kirschbaum, E. C. 1999. ^{lú}sāpi'u/sēpû – Eine akkadische Berufsbezeichnung aus dem Bereich der Textilherstellung. *In* B. Böck, E. Cancik-Kirschbaum and Th. Richter (eds) *Munuscula Mesopotamica. Festschrift für Johannes Renger*, Alter Orient und Altes Testament 267, 79–93.

Crowfoot, E. 1995. Textiles from Recent Excavations at Nimrud, *Iraq* 57, 113–118.

Dalley, S. M. 1996–97. Neo-Assyrian Tablets from Til Barsib, *Abr-Nahrain* 34, 66–99.

Dalley, S. M. and Postgate, J. N. 1984. *The Tablets from Fort Shalmaneser*, Cuneiform Texts from Nimrud 3.

Dercksen, J. G. 2004. *Old Assyrian Institutions*, Publications de l'Institut historique-archéologique néerlandais de Stamboul 98.

van Driel, G. 1969. *The Cult of Aššur*, Studia Semitica Neerlandica 13.

Ellis, R. 1976. Mesopotamian Crafts in Modern and Ancient Times: Ancient Near Eastern Weaving, *American Journal of Archaeology* 80, 76–77.

Freydank, H. and Saporetti, C. 1989. *Bābu-aḫa-iddina: Die Texte*, Corpus Medio-Assiro 2.

Fuchs, A. 1994. *Die Inschriften Sargons II. aus Khorsabad*, Göttingen.

Fuchs, A. 1998. *Die Annalen des Jahres 711 v. Chr. nach Prismenfragmenten aus Ninive und Assur*, State Archives of Assyria Studies 8.

Gentili, P. 2002–2005. Preliminary Remarks on the Palatine Distribution System in the Neo-Assyrian Empire, *State Archives of Assyria Bulletin* 14, 89–111.

Good, I. 2007. Cloth in the Babylonian World. *In* G. Leick (ed.) *The Babylonian World*, New York London, 141–154.

Jakob, S. 2003. *Mittelassyrische Verwaltung und Sozialstruktur. Untersuchungen*, Cuneiform Monographs 29.

Joannès, F. 2010. Textile Terminology in the Neo-Babylonian Documentation. In C. Michel and M.-L. Nosch (eds) *Textile Terminologies in the Ancient Near East and Mediterranean from the Third to the First Millennia BC*, Ancient Textiles Series 8. Oxford, 400–408.

Lassen, A. W. 2010. Tools, Procedures and Professions: A Review of the Akkadian Terminology. *In* C. Michel and M.-L. Nosch (eds) *Textile Terminologies in the Ancient Near East and Mediterranean from the Third to the First Millennia BC*, Ancient Textiles Series 8. Oxford, 272–282.

Layard, A. H. 1853. *Monuments of Nineveh*. London.

Levine, L. D. 1972. Two Neo-Assyrian Stelae from Iran, *Royal Ontario Museum, Art and Archaeology; Occasional Paper* 23, 34–45.

Luckenbill, D. D. 1924. *The Annals of Sennacherib*, Oriental Institute Publications 2.

Matthiae, P. 1998. *Ninive*. Milan.

Mayer, W. 1983. Sargons Feldzug gegen Urartu – 714 v. Chr. Text und Übersetzung, *Mitteilungen der Deutschen Orient-Gesellschaft* 115, 65–132.

McCorriston, J. 1997. The Fiber Revolution: Textile Extensification, Alienation, and Social Stratification in Ancient Mesopotamia, *Current Anthropology* 38/4, 517–549.

Menzel, B. 1981. *Assyrische Tempel*, I–II, Studia Pohl, Series Maior 10/1–2.

Michel, C. and Veenhof, K.R. 2010 The Textiles Traded by the Assyrians in Anatolia (19th–18th centuries BC). *In* C. Michel and M.-L. Nosch (eds) *Textile Terminologies in the Ancient Near East and Mediterranean from the Third to the First Millennia BC*, Ancient Textiles Series 8. Oxford, 210–271.

Parpola, S. 2008. Cuneiform Texts from Ziyaret Tepe, Tušḫan (2002–2003), *State Archives of Assyria Bulletin* 17, 1–113.

Postgate, J. N. 1976. *Fifty Neo-Assyrian Legal Documents*. Warminster.

Postgate, J. N. 1979. The Economic Structure of the Assyrian Empire. *In* M. T. Larsen (ed.) *Power and Propaganda. A Symposium on Ancient Empires*, Mesopotamia, Copenhagen Studies in Assyriology 7, 193–221. Copenhagen.

Postgate, J. N. 1987. Employer, Employee and Employment in the Neo-Assyrian Empire. *In* M. A. Powell (ed.) *Labor in the Ancient Near East*, American Oriental Series 68, 257–270.

Postgate, J. N. 2001. Assyrian Uniforms. *In* W. H. van Soldt, J. G. Dercksen, N. J. C. Kouwenberg, and Th. J. H. Krispijn (eds) *Veenhof Anniversary Volume. Studies Presented to Klaas R. Veenhof on the Occasion of His Sixty-Fifth Birthday*, Publications de l'Institut historique-archéologique néerlandais de Stamboul 89, 373–388.

Radner, K. 1997. *Die neuassyrischen Privatrechtsurkunden als Quelle für Mensch und Umwelt*, State Archives of Assyria Studies 6.

Radner, K. 1999. Traders in the Neo-Assyrian Period. *In* J. G. Dercksen (ed.) *Trade and Finance in Ancient Mesopotamia. Proceedings of the 1st MOS Symposium, Leiden, December 19–20, 1997*, Publications de l'Institut historique-archéologique néerlandais de Stamboul 84, 101–126.

Roth, M. T. 1989–90. The Material Composition of the Neo-Babylonian Dowry, *Archiv für Orientforschung* 36/37, 1–55.

Tadmor, H. 1994. *The Inscriptions of Tiglath-pileser III, King of Assyria*. Jerusalem.

Teppo, S. 2007. The Role and the Duties of the Neo-Assyrian *šakintu* in the Light of Archival Evidence, *State Archives of Assyria Bulletin* 16, 257–272.

Veenhof, K. 1972. *Aspects of Old Assyrian Trade and Its Terminology*, Studia et documenta ad iura orientis antiqui pertinentia 10.

Villard, P. 2010. Les textiles néo-assyriens et leurs couleurs. *In* C. Michel and M.-L. Nosch (eds) *Textile Terminologies in the Ancient Near East and Mediterranean from the Third to the First Millennia BC*, Ancient Textiles Series 8. Oxford, 388–397.

Waerzeggers, C. 2006. Neo-Babylonian Laundry, *Revue d'assyriologie et d'archéologie orientale* 100, 83–96.

Weidner, E. F. 1935–36. Aus den Tagen eines assyrischen Schattenkönigs, *Archiv für Orientforschung* 10, 1–48.

Whiting, R. M. 1988. A Late Middle Assyrian Tablet from North Syria, *State Archives of Assyria Bulletin* 2, 99–101.